The Hasselblad Manual

The Hasselblad Manual
Seventh Edition

Ernst Wildi

AMSTERDAM • BOSTON • HEIDELBERG • LONDON
NEW YORK • OXFORD • PARIS • SAN DIEGO
SAN FRANCISCO • SINGAPORE • SYDNEY • TOKYO
Focal Press is an imprint of Elsevier

Focal Press is an imprint of Elsevier
30 Corporate Drive, Suite 400, Bur.lington, MA 01803, USA
Linacre House, Jordan Hill, Oxford OX2 8DP, UK

Library of Congress Cataloging-in-Publication Data
Application submitted

British Library Cataloguing-in-Publication Data
A catalogue record for this book is available from the British Library.

ISBN: 978-0-240-81026-3

For information on all Focal Press publications
visit our website at www.elsevierdirect.com

Typeset by Charon Tec Ltd., A Macmillan Company, (www.macmillansolutions.com)

08 09 10 11 5 4 3 2 1

Printed in China

Contents

■ ■ ■ ■

Preface

■ ■ ■ ■

Since the first edition of *The Hasselblad Manual* was published more than 20 years ago, Hasselblad has taken giant steps into high-tech electronics and introduced updated and sophisticated digital cameras with the automation, the operating conveniences, and the programming possibilities that let you customize the camera operations to your personal photographic approach.

I have had the opportunity over many years to conduct lectures and workshops in the United States and in more than 50 other countries on five continents. This activity encouraged me to find better ways for operating and using Hasselblad equipment to produce effective images of the highest quality in any field of photography and these ideas, which apply to digital and film photography, are discussed in this seventh edition. *The Hasselblad Manual* can also serve as an instruction book for the major Hasselblad items that can be especially helpful to photographers purchasing equipment on the used camera market where the original instruction manual is often missing.

Because Hasselblad items are frequently changed and updated and some items are discontinued, do not consider the *Manual* as an updated Hasselblad catalog listing. The book describes the use and operation of all important Hasselblad items whether they are still manufactured today or not. You can obtain the latest catalog from a Hasselblad agent or by visiting the Hasselblad websites, www.hasselblad.com or www.hasselbladusa.com. Besides updated product specifications and a wealth of information that can be helpful in your photography, these websites also include a gallery of great Hasselblad photography that can be an inspiration to your own photographic efforts.

I would like to thank the photographers who enhanced the visual effectiveness of the Manual with examples of their photographic accomplishments. Some of these pictures were created on film, many others digitally, and if so, they were created in the camera with little or no manipulations in the computer. I mention this specifically because the purpose of *The Hasselblad Manual* is to show how Hasselblad cameras and lenses, not computers, can help create great photographic images. For the same reason, the captions for most photographs do not mention the recording media, film or digital, that was used to produce the image. I did this purposely to emphasize that the same camera techniques and approaches could have produced the images either digitally or on film. I hope that these photographs will inspire you simply for their visual effectiveness regardless of whether you work digitally or with film.

I also want to thank my friends and experts at Hasselblad for their wonderful help and cooperation in producing *The Hasselblad Manual* and for giving me permission to publish the diagrams from their instruction manuals and technical data sheets.

Ernst Wildi
September 2008

Hasselblad from Film to Digital

■ ■ ■ ■

HISTORY OF THE HASSELBLAD CAMERA SYSTEM

In 1948, the Hasselblad 1600F was unveiled as the world's first 2¼ single-lens reflex (SLR) camera with focal plane shutter speeds up to $\frac{1}{1600}$ second, with interchangeable viewfinders, film magazines, and Kodak Ektar lenses. In 1952, the 1600F model was superseded by the 1000F, which was identical in design but had shutter speeds only up to $\frac{1}{1000}$ second.

The 1954 Photokina, held in Cologne, was used to introduce the Hasselblad Supreme Wide Angle camera, with a fixed 38 mm $f/4.5$ Zeiss Biogon mounted in a Compur shutter. This camera was updated in 1959 and renamed the Superwide C, modified in 1980 to the SWCM, renamed the 903SWC in 1988, and renamed the 905SWC in 2001. The Superwide camera design was also available in a special version known as the MKWE for photogrammetric applications.

The next major step in the history of Hasselblad SLR cameras came in 1957, when the 500C model replaced the 1000F. The basic camera design and component interchangeability were kept, but in place of a focal plane shutter, a Compur shutter was built into each Carl Zeiss lens to allow electronic flash to be used at all shutter speeds up to $\frac{1}{500}$ second. The 500C was superseded by the 500CM in 1970, the 503CX in 1988, the 503CXi in 1994, and the current 503CW in 1997. A similar camera model appeared in 1989. Called Classic, this model became the 501C in 1994 and was changed to the 501CM in 1997.

The 500EL motor-driven camera model appeared in 1965 and became the 500ELM in 1970, the 500ELX in 1984, the 553ELX in 1988, and the 555ELD in 1998. The 500 EL design formed the basis for the 500EL Data camera, specially produced for NASA. On July 20, 1969, the 500EL Data camera became the first still camera to take pictures on the surface of the moon. A camera based on the NASA data camera design was available as the MK70 model, used mainly for photogrammetric applications.

In 1965, Hasselblad started the publication of the *Hasselblad Magazine*, later known as the *Forum*.

Hasselblad history continued with the introduction of major products as follows:

1977 — Schneider Variogon C 140–280 mm zoom lens (changed to CF type in 1988). The 2000FC focal plane shutter camera and four F lenses without shutters, including a 50 mm Distagon with floating lens element design. The 2000FC model was superseded in 1982 by the 2000FC/M, in 1984 by the 2000FCW, and in 1988 by the 2003FCW.

1982 — PCP 80 slide projector. C shutter lenses changed to CF types.

1985 — First 2× teleconverter made by Zeiss. Changed to a Hasselblad 2XE converter in 1994 and complemented with a 1.4XE converter in 1996.

1990 — PC Mutar with shift capability. Hasselblad ProFlash, replaced in 1996 by the D Flash 40.

1991 — 205TCC camera with TCC lenses and TCC film magazines. The 205TCC was renamed the 205FCC, and TCC lenses were renamed FE in 1995.

1994 — 203FE camera and 201F focal plane shutter camera without metering system.

1995 — FlexBody, complemented in 1997 by ArcBody with three special Rodenstock lenses.

1998 — 202FA camera. XPan dual format camera for 35 mm film with 45 and 90 mm lenses. 30 mm lens added in 1999. Was superseded in 2003 with XPan 11.

1999 — 300 mm $f/2.8$ lens and teleconverter.

2002 — Hasselblad H camera system. The H1 camera model was later updated to the H2, H2D and H3, H3D models with more professional integration for digital imaging.

2004 — To be competitive in the age of digital imaging, Victor Hasselblad AB combines with Imacon A/S in Denmark, a manufacturer of digital backs and scanners. The company name remains Hasselblad AB. A variety of digital backs and scanners are added to the product line carrying either the Imacon or the Hasselblad product name. Today all products for film photography or digital imaging carry the Hasselblad trade name.

2007 — Introduction of the H3D-II cameras with large 3-inch viewing screen, the HVM waist-level viewfinder, and 28 mm HCD extreme wide angle lens for digital recording with H cameras. This was the first Hasselblad lens with Digital Apo Correction (DAC).

2008 — Introduction of the H3D IIMS multishot version of the H3D11-39 model. Also introduction of H2F camera, an H2 version for film photography and digital imaging, the global positioning system (GPS) for H3D cameras and the new Phocus software.

THE UPDATED CAMERA SYSTEM

The advent of electronic imaging changed the product line of all camera manufacturers including Hasselblad. Equipment that was popular for film recording was modified or discontinued and equipment designed specifically for digital recording was introduced.

A few examples from the streamlining process in the Hasselblad product line: The updated motor drive built into the H cameras and the availability of a detachable motor winder for the 503CW camera eliminated the need for the special motor-driven EL cameras. Since slanted verticals (in an architectural shot, for example) can now be straightened in after-image manipulations in a computer, the need for cameras with shift control like the FlexBody and ArcBody or shift lenses like the PC Mutar was reduced. While the XPan camera offers the simplest way of producing panoramic images, the need for a special panoramic camera is no longer essential because such images can be produced in the computer by stitching together a number of images taken with a regular digital camera. With most visual presentations done with computers, at least in the professional field, slide projectors are seldom used today. The PCP 80 is therefore no longer made. Wide angle lenses like the 28 mm HCD with its 91 degree angle of view can now produce extreme wide angle pictures digitally where a photographer previously might have used a special wide angle camera like the Superwide.

While today's Hasselblad product line is reduced, it still includes the cameras, lenses, and accessories that are important and helpful for creating great images digitally or with film in any field of amateur or professional photography.

CONTENT IN THE NEW HASSELBLAD MANUAL

Since the Hasselblad Manual is recognized as a complete reference book for the use and operation of Hasselblad equipment, all the important items that have been part of the Hasselblad camera line are discussed in the manual regardless of whether they are still manufactured or have been discontinued. The manual does not mention specifically what items are still manufactured.

I feel that this is the correct approach. Many photographers all over the world still use equipment that is no longer made and because discontinued cameras, lenses, and accessories are often still available in camera stores and can certainly be found on the used camera market. Furthermore since Hasselblad introduced the first camera in 1947, the company has made many friends and loyal followers all over the world who not only enjoy taking pictures with Hasselblad cameras but love to study and talk about Hasselblad products. Photographers who still love to work with Hasselblad equipment that may be 10, 20, or even 30 years old like to be informed about the happenings within the Hasselblad organization and are simply proud of being part of the Hasselblad family. I feel it would be a letdown for all of these long time friends and loyal supporters of Hasselblad to see *The Hasselblad Manual* that only discusses digital imaging and only the digital cameras that are manufactured today.

Updating Discontinued Camera Models

The advent of digital imaging outdated and made completely obsolete most amateur and professional film cameras such as the very popular 35 mm SLR models. Not so with Hasselblad. Every SLR camera model made in the last 10, 20, or even 30 years for film photography, even if they are no longer manufactured today, become equally great tools for modern digital imaging by simply attaching a digital back instead of a film magazine. This applies to the popular 500 models and the other cameras in the V system such as the 200 models with the beautiful built-in exposure metering system as well as the cameras designed for special applications. For example, the Hasselblad FlexBody with its tilt capability equipped with a digital back is an excellent camera for digital tabletop, food, product, or other close-up photography when you need more depth of field than the camera lens can produce. The ArcBody, with its shift capability equipped with a digital back, is an updated and compact camera for digital interior or exterior architectural photography eliminating the need for carrying a large view camera on location. The PC Mutar mounted on a Hasselblad V system camera offers another great approach for digital architectural work or any other application where shift control results in a more effective image. Both the PC Mutar and the ArcBody often allow a good architectural image to be produced with straight verticals eliminating the need for time-consuming after manipulations.

THE HASSELBLAD CAMERA SYSTEMS

The Hasselblad camera system was reclassified in 2002 and the various camera models were grouped into three systems — the H, the V, and the X.

The Hasselblad H Camera System

At Photokina 2002, Hasselblad introduced the H1 camera, a modern medium-format camera with a versatile built-in metering system, motor drive, incredibly fast and accurate automatic

focusing, and lens shutters synchronized up to $\frac{1}{800}$ second for flash. To produce a compact, medium-format camera for handheld photography with the speed and convenience of smaller DSLR models, Hasselblad created a completely new compact camera design and made it for the 6 × 4.5 cm rectangular film format and for electronic imaging with the largest sensor available at this time.

The H1 camera was updated to the H2 and H3 models for more integration with digital backs. The latest H3D and even newer H3D-II models provide the most professional integration between camera and digital sensor unit so that they can be considered digital medium-format cameras, not film cameras with an attached digital back. For the film photographer, Hasselblad produces the H2F, a camera with the quality, the controlled automation, and the most updated operating features that produce great 6 × 4.5 film images in the simplest way on 120 or 220 roll film. Some digital backs can also be attached to the H2F.

The H cameras are the first Hasselblad cameras since 1957 that do not offer component interchangeability with the existing 500 and 200 series cameras, except for the tripod coupling. An adapter is available for using CF, CFi, CFE, and CB lenses on the H camera models. The aperture, shutter speed, and focus settings must then be made manually; exposure readings must be made with the aperture manually closed down. This operation somewhat reduces the benefits of the H operating features, but allows you to use the complete assortment of Carl Zeiss lenses that you may have from your film photography.

Since the H cameras are made in cooperation with the Fuji Photo Film Co., the H lenses are made by Fuji. The lenses are made to the same standards and precision as those produced by Carl Zeiss, and their quality is constantly controlled and verified by the optical experts at Hasselblad. The lenses of the H system therefore provide the photographer with the ultimate image quality in the 6 × 4.5 cm image format as well as in digital recording.

The Hasselblad V Camera System

The V system line of cameras includes all the 500 models, including the current 503CW model, all the motor-driven EL models, the Superwide cameras, the FlexBody and ArcBody, all the 200 models with focal plane shutter, and the cameras from the 2000 series. The V system cameras let you record film images in the 6 × 6 cm square or in the 6 × 4.5 cm rectangular format by simply changing the film magazine. You can attach Hasselblad digital backs with sensor sizes 36.7 × 49.0, 36.7 × 36.7, or 33.1 × 44.2 to V system cameras for electronic imaging.

The V system cameras are completely mechanical and battery independent. Batteries are used in the 200 series for the metering system and in the EL models for the film transport. The V system cameras are still superb cameras for controlled photography in the studio and for handheld photography on location.

The Hasselblad X Camera System

The Hasselblad X system includes the XPan cameras, lenses, and accessories that were developed in cooperation with Fuji Photo Film Co. and involve a camera concept completely different from that of any other Hasselblad camera. There is no component or lens interchangeability between the XPan and any of the other Hasselblad camera systems.

The XPan is shaped like a 35 mm camera, and the pictures are made on 35 mm film in standard cassettes with 36, 24, or 12 exposures. The images on the 35 mm film can be made in the standard 24 × 36 mm size or in a 24 × 65 mm panoramic format. You change the format with a simple turn of a knob, which automatically adjusts the viewfinder image and the frame counter in the camera. You can produce images of both formats on the same roll of film.

SELECTING THE SHUTTER TYPE AND CAMERA OPERATION

During the Hasselblad history, cameras have been produced where the film needs to be advanced manually and models with a motorized film transport. There also have been camera models with focal plane shutters in the camera and others with shutters in the lenses.

Focal Plane Shutters

All Hasselblad cameras in the 200, 2000, and 2003 series, and XPan models have focal plane shutters that provide short shutter speeds up to $\frac{1}{1000}$ second on the XPan and up to $\frac{1}{2000}$ second on the medium-format models.

A focal plane shutter scans the image area from side to side or top to bottom. As a result, different image areas are exposed to light at different times. The flash must fire when the shutter is open over the entire image area; otherwise, only part of the area is exposed. Flash pictures must be made at slower speeds. The top shutter speed for flash is $\frac{1}{125}$ second on the XPan and $\frac{1}{90}$ second on the other V system Hasselblad focal plane shutter models (see Figures 1-1 and 1-2).

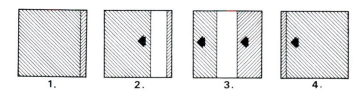

Figure 1-1 With a focal plane shutter, the image is exposed progressively by a slit that moves across the image area. (1) The shutter curtain is closed. (2) The first shutter curtain moves, creating a slit that begins the exposure. (3) The second shutter curtain follows the first. (4) The shutter is closed.

Figure 1-2 At longer shutter speeds, the second shutter curtain begins to move only after the first has reached the other side. Flash synchronization is possible at the moment when the entire image area is uncovered (3).

Lens Shutters

The other type of shutter is in the lens, sometimes called a central shutter, giving the C designation to such lenses in the Hasselblad V system (HC for H lenses). Shutter blades open and close at the set speed, exposing the entire film area at the same time (Figure 1-3). Flash pictures can be made at all shutter speeds.

Figure 1-3 With a lens shutter, the entire image area is exposed from the moment the shutter opens until it closes.

Since the shutter blades open from the center and close again toward the center, exposures can vary slightly depending on the lens aperture but the variations are within acceptable limits even for critical photography. The H cameras can be programmed for "true exposures," which takes into account the set aperture.

Lens shutters, with the shutter blades moving around the optical center, provide the smoothest and quietest shutter operation with the minimum of camera motion or vibrations. The maximum shutter speed, however, is limited to $\frac{1}{800}$ second on the H camera lenses and $\frac{1}{500}$ second on the other shutter lenses. It is recommended to have shutter lenses cleaned and lubricated at regular intervals depending on frequency of use.

Manual or Motor-Driven Camera Operation

On the Hasselblad H and XPan camera, and all EL models, the film is advanced automatically via a built-in battery-operated electric motor. On all the other models in the Hasselblad V line, the film is advanced, and the shutter is cocked manually by a single turn of a knob or crank. On the 503CW, the 503CXi, the 200 models, and on some of the 2000 cameras, a motor winder can be attached, thus giving you the option of advancing the film manually or automatically.

The Advantages of a Motor-Driven Camera

Motor drives were originally built into film cameras mainly for advancing the film automatically to the next frame. The motor drives, however, also make the camera, lenses, and shutters ready for the next image and therefore offer benefits and operating convenience in digital

imaging also. Motor drives eliminate the danger of moving a tripod-mounted camera, helpful in all controlled photography outdoors or in the studio where most photographers shoot more than one picture of the same subject. This is essential in digital imaging when you work in the multishot mode, when you need two images to reduce excessive contrast, increase the sharpness range, or combine images in other ways in computer manipulations.

Sequence operation (shooting pictures continuously during a single press of the shutter release) is another advantage, especially in sport and action photography. The fastest speed is 2 pictures per second on the H models and about 12 pictures in 9 seconds on other motor-driven models.

For most digital and film photographers a motor-driven camera is beneficial for making a second and subsequent pictures without ever removing your eye from the viewfinder whether you work from a tripod or handheld. With a tripod-mounted camera you need not even look into the viewfinder but instead look directly at the subject. This is especially helpful in fashion and child photography where you must maintain complete visual contact with your subject.

Motor-driven cameras also present the possibility of remote releasing. You no longer need to stand behind the tripod-mounted camera. You can be close to the subject, watch expressions closely, play with a child, and snap the shutter whenever the situation is right. Wireless remote releasing is possible on the H models — the 555ELD and the 503 cameras equipped with motor winder.

HOLDING AND SUPPORTING THE CAMERA

All Hasselblad models are ideally suited for handheld work and for working from a tripod. The H models, operated like a 35 mm film or a digital SLR camera, are an exceptionally beautiful tool for handheld photography.

Handheld Photography

For optimum steadiness, hold the camera with both hands and press the viewfinder eyepiece toward your eye and forehead. This creates two forces that oppose each other — the hands pressing the camera toward the eye, and the eye and forehead pressing in the opposite direction (Figure 1-4). This is also the best handheld approach in digital work and is the main

Figure 1-4 Handheld photography. The best camera steadiness is obtained when two forces work against each other. With a waist-level finder, the hands press the camera upward and the eye pushes it downward. With a 90-degree eye-level finder, as on the H cameras, the hands press the camera horizontally toward the eye and with the 45-degree prism finder, the two forces work diagonally.

reason why I like to suggest to all digital photographers to use the viewfinder of the camera to view the image rather than the Preview screen where you must hold the camera a foot away from your eyes so you can see the image on the preview screen. This approach cannot possibly provide a steady support for any camera and is a main reason for blurred pictures.

Consider handheld camera use also for selecting the best camera angle, even if you plan to use a tripod for the final picture. Move around the subject with the handheld camera: view the scene or subject from every angle, from different distances, through different lenses; go down on the ground and view it from below; and go as high as possible and look down. In digital photography, evaluate the different composition on the Preview screen. Set up the tripod, and place the camera on it only after you have exhausted all possibilities and have found the most effective camera position.

Shutter Speeds and Apertures

To reduce the danger of camera motion blurring the picture, shutter speeds must be relatively short. How short depends on many factors, including your own steadiness, your method of holding the camera, the focal length of the lens on the camera, and whether it is windy or calm. The longer the focal length, the shorter the recommended speed.

Based on an often seen suggestion, the shutter speed should not be longer than the inverse of the focal length: $\frac{1}{60}$ second for a 60 mm lens and $\frac{1}{250}$ second for a 250 mm lens. It is a good rule to follow in most situations. I have found, however, that I can use somewhat longer speeds in many situations especially with the H cameras, and I have photographed at $\frac{1}{30}$ and even $\frac{1}{20}$ second with the 80 mm lens and have found the image sharpness completely up to my expectations.

Handheld photography limits the choice of aperture, a drawback in many situations indoors and outdoors. As shutter speeds must be short, the existing light may not be sufficient to photograph at small apertures that provide the desired depth of field. This is the main reason I always carry a small tripod, even for outdoor photography, and use it often even in bright sunlight. It allows me to use any desired aperture and shutter speed combination with any lens and in practically any lighting situation.

Camera Grips and Handles

The H camera has a beautifully designed battery holder and motor drive that also serves as an excellent grip for handheld photography in the horizontal or vertical format. Brackets or grips can be attached to some V system camera models, but be aware that these accessories do not ensure a steadier camera in handheld work. They make carrying the camera more convenient. Detachable motor winders can make a good support for handheld work but they are not designed for carrying the camera between shots.

Reasons for Using a Tripod

Camera steadiness is only one reason for using a tripod. With a mounted camera, you probably spend more time in evaluating the image and are more critical in composing the scene

or subject effectively in the camera. Furthermore, after the composition is made and the lens is focused, you no longer need to look into the viewfinder or on the viewing screen. You can look directly at the subject, which is extremely valuable when you are photographing people. It allows you to communicate more directly with your subjects and direct the people as well as allowing you to take several identical images.

While the mirror and shutter operation in Hasselblad cameras, especially the H models, is beautifully dampened to reduce motion within the camera, you may still want to pre-release a tripod-mounted camera. It is my standard approach with any lens as it is a simple and fast procedure with any Hasselblad camera.

Selecting a Tripod

For studio work you naturally want to use a sturdy studio type. If tripods are taken in the field there must be a compromise between steadiness and portability. The new carbon fiber types seem to offer a good compromise.

A few other points to look for in the tripod design:

- A convenient and fast leg-locking arrangement.
- Convenient camera operation, which is mainly determined by the choice of tripod head. I prefer ballheads. To turn the camera, tilt it sideways or up and down, you need to tighten or loosen only one knob.
- The tripod should bring the camera up to eye level by simply extending the legs, without using the elevating extension. Elevating extensions are for making minor adjustments in the camera height.

Operating the Tripod-Mounted Camera

Most photographers work with a tripod-mounted camera by attaching a release cord and then staying far enough away to avoid any body contact with the tripod or camera. This is a good approach with heavy studio tripods and a necessary approach when working at very long focal lengths or at shutter speeds of about ½ second or longer.

In other situations, especially when working with a lightweight portable tripod, you can also operate a tripod-mounted camera by keeping both hands on the camera or one hand on the camera and the other on top of the tripod with both pressing the tripod and camera toward the ground and perhaps keeping the eye at the viewfinder eyepiece (Figure 1-5C). It is almost like holding the camera as in handheld photography but with the tripod serving as an additional support. You can release the shutter with or without a release cord. If carefully done, pressing the camera release is just as good. You do not have to use the pre-release, but I usually do whenever practical. I use this approach for practically all outdoor photography at shorter shutter speeds up to about ⅛ second and with lenses up to 250 mm. This approach gives me sharp images from a lightweight tripod.

Monopods can be used instead of tripods for location work when exposure times do not exceed ¼ second (see Figure 1-5).

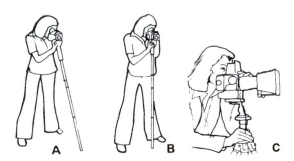

Figure 1-5 Using monopods and tripods. (A) The steadiest position for a monopod is when it forms the third leg of a tripod, with the photographer's spread legs as the other two. The face is firmly pushed against the camera. (B) The camera is not as steady when the monopod is vertical. (C) At shorter shutter speeds, you can prevent camera motion by pressing the camera and tripod firmly toward the ground with the hands and face, an excellent approach with lightweight tripods.

Tripod Coupling

I highly recommend using a tripod coupling on a tripod, monopod, or any other camera stand (see Figure 1-6). as it allows fast and convenient attaching and removing of the camera. Newer Hasselblad tripod couplings have built-in spirit levels for accurate leveling of a camera.

Figure 1-6 Tripod coupling. With a Hasselblad tripod quick coupling permanently attached to the tripod head, you can slide the camera onto the accessory and lock it into place by turning the lever. The latest tripod couplings also have built-in spirit levels.

Image Size and Format in Digital Imaging and Film Photography

The image size recorded in a digital sensor unit (digital back) or digital camera is determined by the size of the sensor in the camera or digital back. Sensors in Hasselblad digital cameras or digital backs can be 36.7×36.7 mm, 33.1×44.2 mm, or 36.7×49 mm, the largest presently available for any camera, including view cameras.

All of these Hasselblad sensors are much larger than the 23×15 mm APS-C sensor used in most professional digital SLR cameras. The Hasselblad sensors are also considerably larger than the 24×36 mm full frame sensor found in a few digital SLR cameras. To be more specific, the area of the 36.7×49 mm sensor is more than $5\times$ larger than the APS-C sensor area and more than double that of the full frame type. The sides of the 36.7×49 mm sensor are more than twice as long as the sides of an APS-C sensor recording a subject more than twice as large, and about $1.5\times$ larger than in a full frame digital camera (Figure 2-1).

Therefore, digital Hasselblad cameras offer the same advantage of recording a much larger and sharper image in the camera as- they do in film photography compared to 35 mm or APS cameras. These larger images also offer the photographer much greater possibilities for cropping and changing the image shape. For digital photography Hasselblad offers the same compromise between quality and camera portability that made Hasselblad medium-format cameras popular for critical and serious black and white and color film photography for so many years.

DIGITAL IMAGE QUALITY

The digital image is formed on the sensor in the camera or digital back by pixels that are light sensitive to either green, blue, or red. The resolution is indicated by the total number of pixels, which is obtained by multiplying the number of pixels along either side of the sensor. For example, a 39 megapixel specification is obtained by multiplying the 5412 and 7212 pixels along the image sides. Most professional digital SLR cameras have resolutions from 6 to 12 megapixels, some newer ones going as high as about 20 megapixels. Hasselblad digital backs or cameras offer resolutions from 22 to 39 megapixels.

The number of pixels is directly related to the image quality produced in the camera. The higher the number of pixels, the better the image quality but only if everything else is equal,

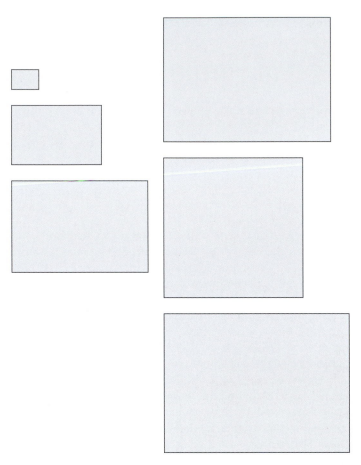

Figure 2-1 Digital Sensor size comparison. The Hasselblad sensor sizes, with the 36.7 × 49.0 sensor on bottom right, the 36.7 × 36.7 sensor in the middle right, and the 33.1 × 44.2 sensor at the top right are shown in comparison to the sensor sizes in other digital cameras. All three Hasselblad sensors are considerably larger than the full frame sensor of 24 × 36 mm (bottom left) found in a few digital SLR cameras, and much larger than the more common sensors, the APS type with a size about 15 × 23 mm (middle left) found in most professional SLR cameras and the even smaller Compact type (top left).

especially the size of the sensor, the size of the pixels, and the performance of the lenses. Lenses of questionable quality limit the image sharpness in digital recording as they do in film photography but to an even higher degree. In digital cameras, the performance of the lenses, especially in regards to the chromatic abberation, distortion, and image brightness in the corners of the images, can be improved somewhat by what is known as DAC (digital auto correction). This correction, however, shows benefits only in an image that is recorded with a hight quality lens. Some camera manufacturer's claim may give the impression that a specific camera produces higher quality images because of DAC. Such a statement is not based on any true facts. DAC does not produce high quality in an image taken with a lens of questionable

or poor quality. The topic of DAC is discussed more in the chapter on lenses where you can also find an MTF diagram that shows how much DAC improves the quality in an image created by a 35 mm HC lens on H cameras.

Pixel Size

Digital cameras are promoted, separated, and distinguished mainly by the pixel number with the conveying message that a camera with a higher pixel number produces a sharper image. While the pixel number increases resolution, the number of pixels is only part of the quality story. The pixel number can be increased in two ways, either by placing more pixels on the same size sensor in which case the pixels need to be smaller, or by increasing the size of the sensor in which case the pixel size may not have to be reduced or can even be increased. It is no problem for a manufacturer to increase the number of pixels and produce a digital camera with a fabulous megapixel number but the more pixels the manufacturer puts on the same size sensor the smaller the pixels need to be. The benefits in image quality from such a sensor where tiny pixels are cramped onto a small sensor then become questionable because larger pixels do perform better photographically with increased information gathering power. A larger pixel collects more light and its signal needs to be less magnified thus creating less "noise," as it is called in digital imaging. Small sensors are more susceptible to noise especially when used at higher ISO values. The increase in the sensor's dynamic range produces images with a better tonal range from the deepest shadows to the brightest highlights, better colors, finer tonal gradation, and more attractive shadow details allowing for the production of gigantic prints. The improvements are usually especially noticeable in the highlights. The larger Hasselblad sensors offer these improvements because they not only allow a larger pixel number but also pixels of a much larger size. Hasselblads provide 16× more information with a 16-bit depth providing 65,536 shades of gray compared to a 12-bit depth with 4096 shades of gray on a typical DSLR camera.

Because of the danger of creating noise, digital photographers are advised to photograph at the lowest possible ISO setting. This is certainly good advice, but it also means that in low light situations you may have to choose between using a higher ISO which allows shorter shutter speeds or a lower ISO which may require longer shutter speeds that may create unsharpness due to camera motion. In such a case a higher ISO is definitely recommended especially with Hasselblad. The larger sensor with larger pixels can produce better image quality at ISO 400 than a smaller sensor with smaller pixels at ISO 100 just as the newer 400 ISO negative or transparency films produce considerably sharper images with finer grain than the older films at ISO 100. A file with all the information from the larger sensor with larger pixels will also survive post manipulations much better.

Sensor Size

The size of the pixel needs to be considered seriously and is determined by the size of the sensor. A typical DSLR camera may have an APS-C sensor with 8 megabytes on the image area of about 340 square mm. The Hasselblad 36.7 × 49 mm sensor of 39 megabytes has more than 4× as many pixels on an image area that is also 5× larger. There are not only more pixels but all the pixels are larger. The greater number of larger pixels is what sets medium-format digital imaging apart just as the medium format did in comparison to 35 mm in film photography.

With the constant and rapid changes in digital cameras, selecting the larger Hasselblad digital format will likely keep the equipment updated for a longer time period reducing or eliminating the danger that the equipment will become outdated within a short time, a common fear with the rapid and constant new developments in digital camera equipment. Working with the larger digital Hasselblad format, rather than the digital SLR cameras that other photographers use, may also help professional photographers to attract new clients for high paying quality jobs and keep these clients for future assignments.

Just as in film photography exposure is another determining factor for image quality but in digital work, perfect exposure is even more critical, something to remember especially by photographers used to the great exposure latitude of color negative films. Digital exposures are even more critical than they are with transparency films.

SENSOR SIZE AND FOCAL LENGTH OF LENS

The 36.7×49mm Hasselblad sensor is the largest sensor that can be fit into a camera designed for the 6×4.5 film format, and is very close to the 42×54 image size of a 6×4.5 negative or transparency. This close size relationship between digital and film images is advantageous because the camera lenses cover practically the same area on this large sensor as they do on a film magazine 16. You do not have to re-think what focal length lens to use. The conversion factor is only 1.1. The standard 80mm becomes equivalent to one just slightly longer with an 88mm focal length. The 35mm wide angle is still a superb wide angle lens that performs like one of 38mm. For all practical purposes you can use all the lenses as you would, or have done, or still do when working with film.

As discussed in more detail in the chapter on lenses, area coverage is determined by the focal length of the lens in relation to the film format or the sensor size. An 80mm lens covers a larger area on the 6×4.5 film format than it does on 35mm. On most digital SLR cameras (except the full frame type) the sensor is much smaller than the 35mm film format, so you need to work with a conversion factor of $1.5\times$ or larger. Digital recording requires a wide angle lens to cover the same area as the standard lens does in film photography. Extreme wide angle lenses are practically nonexistent for digital recording. The specification sheets for such digital cameras usually do not mention the actual focal length of the lens on the camera but give you a focal length that is equivalent for the 35mm film format.

With a Hasselblad 36.7×36.7 sensor the focal length factor is 1.5 compared to the 2¼ square format so the 80mm lens performs like one of 120mm focal length. The 50mm wide angle covers the area of a 75mm lens in film photography. With a 33.1×44.2 sensor you multiply the focal length of the lens by $1.25\times$ compared to the 6×4.5 film format, so the 80mm lens covers the area equivalent to a 100mm type on film and can still be considered a standard focal length.

IMAGE SIZE IN FILM PHOTOGRAPHY

Except for the XPan model, Hasselblad cameras are made for the medium format, which combines many of the advantages of 35mm and large format photography. By simply switching the magazine on any camera model, you can record images digitally, on black and white or

color film, and on instant recording film. You can also record them on either 120 or 220 roll-film or on 70 mm long rolls (Figure 2-2). On all V system cameras, you can also produce the images in the square or rectangular format.

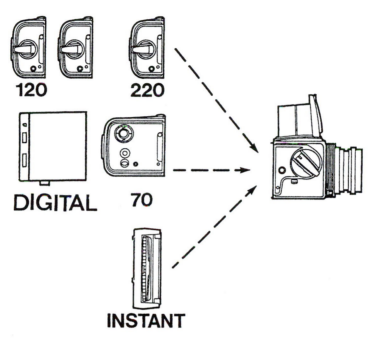

Figure 2-2 Magazines for electronic imaging. A digital imaging back can be attached to most Hasselblad cameras in the V system in place of a film magazine. Some H cameras are, or can be, equipped with various digital backs, an instant film magazine HMi 100, or a film magazine HM 16-32 for 120/220 rollfilm. H3DII cameras are supplied with a digital back and are for digital imaging only.

The 2¼ × 2¼ in. Square Format

Since 1947 many photographers selected Hasselblad V system cameras not only because of the larger image format but because they liked recording images in the square format (Figure 2-3). The 2¼ × 2¼ in. (6 × 6 cm) square format established the popularity of the medium-format cameras. The exact image size is 54 × 54 mm, with 12 images on one roll of 120 film and 24 on the 220 type.

Many good points can be made about photographing in the square format. You do not have to decide the final image shape when you take the picture. A square can be changed beautifully into a rectangular image without losing image sharpness if you leave the long image side in its original length of 54 mm. You also do not have to decide which way to turn the camera when you take the picture. The 12 square images from a 120 roll of film make beautiful proof sheets on a sheet of 8 × 10 in. paper, with all the images right side up, so you never need to turn the proof sheet.

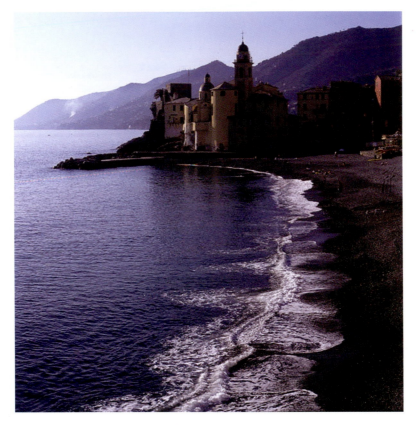

Figure 2-3 Square image format. Most outdoor scenes can be composed effectively in the rectangular or square format. In either format, we must compose to have important image elements going from side to side and from bottom to top. The white waves lead the eye from the bottom left to the Italian village at sunset on the upper right. (Photo by Ernst Wildi.)

The 6 × 4.5 cm Format

In the V system cameras, you can obtain images in the 6 × 4.5 format by attaching a film magazine A16, A32, earlier E16, or E32 types. The Hasselblad cameras in the H system are made specifically for the rectangular 6 × 4.5 format so you need to turn the camera for vertical pictures. The H cameras and viewfinders are beautifully designed for doing this handheld or on a tripod.

The exact image size of the 6 × 4.5 cm format is 54 × 42 mm, which corresponds closely to the shape of standard enlarging papers. Because the long side of the image is the same as on the 6 × 6 square, image quality is identical. The 6 × 4.5 cm images are not smaller images, only images of a different shape. When you photograph in the 6 × 4.5 format, you must decide before you photograph whether the picture should be horizontal or vertical. In return, you obtain more images on the film: 16 on 120 type and 32 on 220 rollfilm (Figure 2-4).

Figure 2-4 Film format size comparison. The Hasselblad 2¼ square (6 × 6) format (top right) and the 6 × 4.5 format (bottom right) are shown in comparison to the 35 mm film format (left).

The Superslide Format

Hasselblad used to offer a special film magazine (A-16S) for the Superslide size of 41 × 41 mm small enough for transparencies to be projected in 35 mm projectors. While projected Superslides are very effective, the format never became very popular partially because some 35 mm projectors could not project Superslides without darkening the corners of the images.

The Panoramic Format

Images are considered panoramic when the long image side is at least twice as long as the other side. With the Hasselblad XPan camera, you can create panoramic pictures 24 × 65 mm right in the camera on standard 35 mm film.

The medium-format film image size, or the image size on the 36.7 × 49 mm sensor, is also large enough so that you can create effective panoramic images of perhaps 18 × 54 mm or 18 × 49 mm by simply printing only a portion of the original image or masking the

transparencies in the panoramic shape (Figure 2-5). Hasselblad produced a panoramic mask that fit into the rear of the newer V series cameras to mask off the unused area of the film.

In digital imaging, panoramic pictures can be created in the computer by stitching together overlapping images taken in the same location with the same camera and lens.

The 6 × 7 cm Medium Format

Hasselblad never produced a camera for the 6 × 7 cm medium format because the 20% difference in the longer image dimension did not produce sharper images, reduced the number of images on a roll of 120 film from 12 to 10, and would have required a larger camera that no longer provided the mobility and convenience that made Hasselblads such great tools not only for critical studio work but candid, handheld location and wedding photography as well.

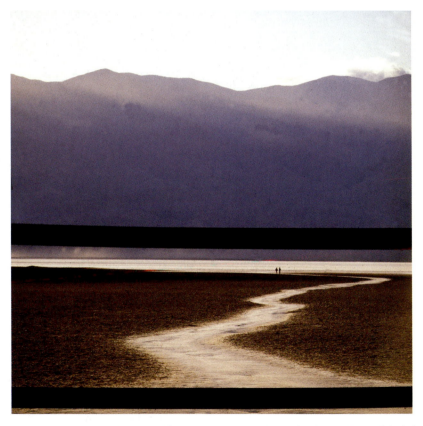

Figure 2-5 Creating panoramic images. The images created on the large Hasselblad digital sensors or the Hasselblad medium film format are large enough so they can be changed into panoramic shapes while maintaining image quality. (Photo by Ernst Wildi.)

DECIDING ON THE IMAGE SHAPE IN DIGITAL AND FILM PHOTOGRAPHY

When photographic images are used in advertising, on magazine covers, in brochures and catalogs, or for many editorial purposes, the final image shape is determined by the use of the image. In most other cases, the photographers determine whether the image should be square, rectangular, or panoramic and make their decision based on personal preference for a specific shape or based on what format seems to be most effective for the photographed subject or scene. I have seldom found a problem composing subjects or scenes in the square or the rectangular format, even though I originally worked with motion picture cameras where you had no format choice and every scene had to be composed in the horizontal format.

While I personally like the equal dimensions in width and height that give the square a pleasing and harmonious quality and also allow me to change the square into a rectangle

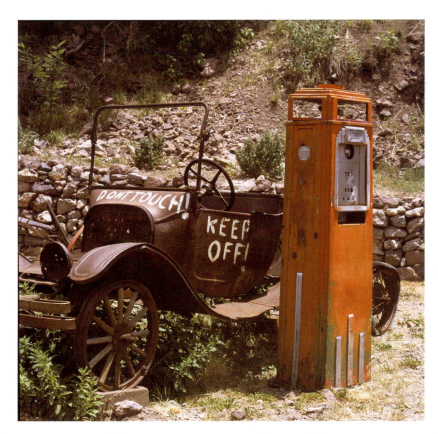

Figure 2-6 Composition in different formats. Scene in a Western ghost town composed in the square format with the brightly colored gas pump to the right and the old car filling the area all the way to the left border. This same composition could have been created in the horizontal format from a camera position somewhat more toward the left. (Photo by Ernst Wildi.)

without losing image quality, I feel that almost any subject, at least outdoors, can be effectively composed as a square, a horizontal, or a vertical. Doing so naturally requires photographing the subject or scene from a somewhat different camera position, perhaps even at a different focal length (Figures 2-6 and 2-7).

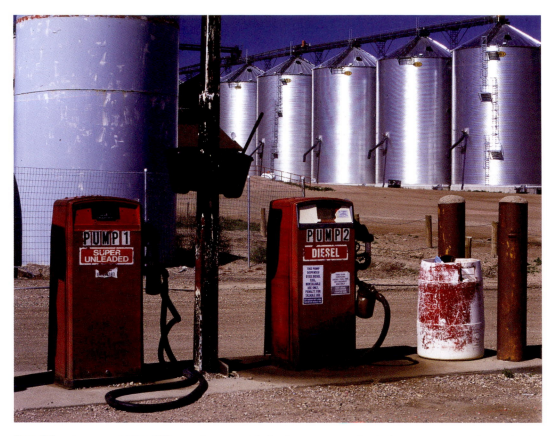

Figure 2-7 Composing in different formats. While this scene in the Dakotas seems to fit perfectly into the horizontal rectangle of the H camera, it could have been effectively composed as a vertical rectangle or a square by concentrating on the two pumps and silo on the left side. (Photo by Ernst Wildi.)

Digital Imaging with Hasselblad

■ ■ ■ ■

DIGITAL OR FILM

Some photographers, especially professionals, still need to decide whether to work digitally or with film at least for certain jobs. The decision may be based on personal preference perhaps the way colors and contrast are recorded in either media, on a clients preference, the use of the image, the size of the enlargements, or other reasons. If a digital image is desired or necessary just for the purpose of having the final image in digital form for storage or for image manipulations, you want to keep in mind that such an image does not necessarily have to be recorded in the camera in digital form. Any image, black and white or color, on negative or transparency film, can be scanned and changed into a digital image. Hasselblad produces a line of professional Flextight scanners for this purpose. A scanned image can be retouched or manipulated in the computer just like a digital original.

DIGITAL IMAGING IN THE MEDIUM FORMAT

When digital imaging became a new photographic media, medium-format film cameras became digital imaging tools by attaching a digital back to existing camera bodies rather than completely new cameras designed specifically for digital imaging. Since most medium-format cameras were designed with interchangeable camera backs, this was a logical and simple solution and was also used by Hasselblad in combination with digital backs made by various manufacturers. This approach worked well since Hasselblad cameras were recognized as good tools for any type of studio or location film photography and produced superb image quality in combination with the Carl Zeiss lenses. It was also an economical solution as Hasselblad photographers did not need to invest in a completely new camera and lens system, and because one and the same digital back could be attached to different Hasselblad camera models including cameras with shift and tilt control.

Digital technology, however, has also changed drastically over the last 15 years, and Hasselblad realized the importance of keeping up with the trend toward digital photography. The company sped up the development of new digital recording devices and digital cameras through the merger with Imacon, a recognized manufacturer of high quality digital backs and scanners. The work within this new Hasselblad company resulted in a rapid development of completely updated and integrated packages of lenses, cameras, viewfinders, digital capture units, and software. The first product from this new design approach is the H3D camera,

which can be called a true digital medium-format DSLR camera. Combined with a sensor that is almost as large as the 6×4.5 film format, this camera is now recognized as a full frame DSLR medium-format camera.

HASSELBLAD'S ADVANTAGES IN DIGITAL IMAGING

In addition to the superb image and tonal quality created by the large Hasselblad sensor units with larger pixels, digital imaging with Hasselblad can help a professional or amateur photographer in other ways. If you presently do your film photography with Hasselblad, you do not need to invest in a completely new digital camera and lens system. Just invest in (or rent) a digital back and switch from the film magazine to the digital back. For most Hasselblad camera models, you have a choice of different digital backs with different specifications so you can select one (or rent one) that you feel is best for your particular type of photography.

The interchangeable component design allows you to use the same camera, lenses, and accessories for film photography as for electronic imaging. In addition to the financial advantage, this is helpful when you may still use film for some applications or clients and digital imaging for others.

Working with the same camera in both media gives you more time to think about image quality, composition, and photographing the subject in an effective fashion rather than constantly switching cameras and worrying about operating each camera in the proper fashion. Working with the same camera and lenses for film and digital photography makes sense because recording either type of image is based on the same principles and requires the same camera and lens operation. The image is simply recorded on a different medium. The real differences between film and digital photography come after the image is recorded in the camera, when you have to decide whether to leave the image as it is or change or improve it and how to store it for possible future use.

Most Hasselblad digital backs can also be used on various Hasselblad cameras, so you can select the camera model that is best for a specific job; use a 200 model camera because of its excellent built-in metering system, or take advantage of the shift and tilt controls in the ArcBody or FlexBody for an architectural job. By investing in one back, you can convert two or three different film cameras into cameras for digital imaging. If you do not own some of these special Hasselblad camera models, look into rental possibilities.

Furthermore, the Hasselblad CF digital backs are designed with an adapter system so they can also be used on other makes of medium-format and view cameras. You do not need to buy another digital back for other cameras that you might be using.

The Question of Obsolescence

With new digital equipment introduced constantly and the new features of these cameras promoted to the point of giving the photographer the impression that their present equipment is completely outdated, photographers, especially professionals, are naturally concerned about obsolescence of their equipment. Many photographers feel, or are told, that upgraded equipment produces better image quality and therefore might improve profitability.

There are certainly good reasons to be concerned about obsolescence, but consider carefully whether new equipment makes your photography or digital process more precise or more convenient, improves your productivity or profitability, or allows faster shooting if this is important in your field of photography. While this concern for obsolescence also applies to Hasselblad, I feel it is greatly reduced for various reasons but especially regarding image quality. The sensors in the present Hasselblad cameras and digital backs are much larger than those in typical professional digital cameras, even larger than a sensor that could physically fit inside digital cameras, even the full frame types. With the Hasselblad sensors having a much higher pixel number as well as considerably larger pixels, Hasselblad's present image quality is far beyond what can be accomplished even in the most updated digital cameras and is likely to remain that way for some time in the future. Hasselblad digital cameras and digital backs are also constantly updated to produce high quality results for a longer period of time (Figure 3-1 and 3-2).

As a result, the Hasselblad cameras or digital backs are more likely producing updated high quality digital results for a longer time period and do not have to be replaced as often, if

Figure 3-1 H System digital image. A beautifully composed image in Las Vegas recorded digitally in the H3D-31 Hasselblad camera with HC 2.2/100mm lens at ISO 800 setting. (Photo by Paul Claesson.)

at all, as other digital cameras. Your computer is more likely outdated before your Hasselblad camera. And when the time for a change or update eventually arrives, you may only need to replace the back and not the entire camera and lens system or Hasselblad may be able to upgrade your camera or sensor unit.

Figure 3-2 V system digital image. A beautiful digital creation made visually effective by the two completely different patterns — the sharp outlines in the electrical component box and the free flowing bright red graffiti. Photographed with Hasselblad CFV 16Mp digital back with 36.7 × 36.7 sensor at ISO 50 on a V system camera with Sonnar 250 mm lens. (Photo by Bob Gallagher.)

PHOTOGRAPHY'S TWO-STAGE PROCESS

Film photography has always been considered a two-stage process with stage one recording the image in the camera and stage two involving the development of the black and white or color film and printing the image from the negative, if such film was used in the camera. Most Fine Art black and white photographers still work like this, developing the film themselves and making their own prints. Most other film photographers, even professionals in fields like portrait and wedding photography limit their own involvement to taking the picture and then

let outside sources do the rest. While Fine Art film photographers often spend much more time working on an image in the darkroom than they did or do when creating the image in the camera, most other film photographers spend most or all the creative time behind the camera.

Digital imaging in color or black and white is also a two-stage process with stage one taking the picture and stage two working on the image in the computer. As in film photography, most digital casual photographers however limit their own work to stage one, taking the picture in the digital camera and then letting an outside source do stage two. For serious digital photographers and professionals on the other hand stage two has become the more important step in creating the image and many serious digital photographers, probably most of them, spend hours, perhaps days working on an image in the computer while they spend just a few minutes recording the image in the camera. The entire photographic process in regards to the time spent in stages one and two is completely reversed from what it used to be in film photography. Nothing wrong especially since the main enjoyment for many digital photographers comes not from creating the image in the camera but from working with the image in the computer, retouching it, improving the quality by making it brighter, darker, or sharper or by adding a soft touch or changing colors in the entire image or part of it. A new image with little resemblance to the original photograph can also be created by making the images more effective by changing the composition or the background, or producing double exposures by combining different images.

The main interest for these enthusiasts or professionals is creating images in the computer not in the camera. This is understandable not only because sitting in front of a computer may be more pleasurable than working with cameras, lenses, and accessories out in the cold, heat, fog or rain but also because these computer manipulations have created completely new possibilities for creating photographic images, new enthusiasm for photography, and have attracted newcomers to photography who never before had a serious interest in cameras. These new developments can only benefit photography as the work on the computer may develop the photographer's artistic capabilities. Before working on the computer, you naturally want to evaluate the image to determine what changes should be made and to what extent, if any, the image should be manipulated. I also like to remind news photographers that you need to be aware that any image manipulations, even minor ones, are frowned upon. News pictures are supposed to show things as they were when recorded in the camera. If you feel that the image must be changed even in a minor fashion, you must inform the picture editor.

Since creating the original image still involves a camera, I also hope that digital photographers will continue to consider the camera and lens, not the computer, the main component for creating the digital image, unless you like to become recognized as a "computer photographer" and your images as computer produced works of art rather than camera or photographic art. Some years from now this separation between camera and computer produced images may be reduced or may completely disappear and all images may become recognized as computer photography.

RECORDING A PERFECT IMAGE IN THE CAMERA

This trend toward computer produced images made some photographers concentrate all their artistic efforts to the work on the computer screen. Retouching and changing the image

has become their main photographic activity, perhaps, influenced by the often heard comment that one no longer needs to be concerned about creating an image of the highest quality in the camera since all the faults, including unsharpness, can be corrected afterwards. As a result, some digital photographers consider the effective use of camera and lenses in a secondary fashion. They no longer realize the importance of planning a shot and no longer operate the camera with the same feeling that previous film photographers had. The extensive automation in modern digital cameras has also encouraged photographers toward the snapshot approach of letting the built-in automation decide the camera operation and the lens settings. This trend toward uncontrolled shooting and pushing the camera release without carefully analyzing the situation and the camera and lens settings seems also to have taken place among professional photographers, especially in wedding photography. Many wedding photographers who changed from film to digital will tell you that they shoot twice as many pictures with a digital camera than they ever did on film. Since wedding photography means mainly photographing whatever happens in front of the camera, there may very well be financial advantages in this new approach, but one must also question whether this approach leads to better photography and produces better photographers.

While many faults can be corrected and images can be improved in the computer, you must realize that most image manipulations are not done easily, need special software, require much computer knowledge if they are to look professional, and are also very time-consuming if you want to do them yourself and costly when done on the outside. Unless your main interest is in creating completely new images in the computer, I feel that you will be most successful in your digital photography, will get you away from snap shooting, and will make you a better photographer if you try to record an image in the camera that is as perfect as possible and needs little or no after work on the computer. Work with your digital camera or digital back as you might have worked with film assuming that nothing can be changed afterwards and that the image recorded in the camera is the image that you and your client will see. Some of the new computer-educated photographers may consider it old-fashioned and out-of-date if you fiddle around with your camera and lenses trying to determine the best camera and lens settings and trying different lenses and experiment with filters, or when you evaluate the subject carefully to find a camera position that produces the visually most effective image. Do not let that bother you. Trying to produce a perfect and visually stimulating image on the digital sensor or on film is still the sign of a good and creative photographer. Working in this fashion is an especially recommended approach with Hasselblad cameras and lenses, which offer a wealth of wonderful possibilities for creating fascinating images in the camera in the simplest and most enjoyable fashion (Figure 3-3).

Naturally you always want to investigate what corrections or retouching can be made to improve the image and, if you do such work, make certain that the retouched areas have the same qualities as the unmanipulated areas so the corrections are not obvious and are not distracting.

Since I still consider the use of the camera and lenses most important for creating effective digital images, and since I consider *The Hasselblad Manual* a book that should help create good images in the camera, the information and instructions regarding the after manipulations of the image, which usually involves Photoshop and other image manipulating hardware, is limited just as information about film processing and darkroom techniques was

Figure 3-3 Film image. Picture taken with 250 mm telephoto lens on ISO 400 transparency film in a 205 camera using the built-in metering system to determine exposure. The bright reflection on the water was accurately composed to lead directly to the end of the broken-down pier and the lamp post in the foreground. (Photo by Ernst Wildi.)

never a part of the *Manual* in the years of film photography. All the photographs published in the *Manual* are also images as they were recorded in the camera without any, or very minor computer manipulations. That means that all the images could have been created on film or digitally using the same camera techniques and for this reason I do not mention the media used in most illustrations. By doing this, I hope that the photographs inspire you to use the cameras to produce more effective visuals instead of worrying about which media was used.

To learn the possibilities of image manipulation, all photographic magazines today have helpful and interesting articles on these topics, numerous books are available that discuss any and all aspects of image retouching and manipulations and workshops on these topics are constantly held at least in the United States. Study as much as you can, I highly recommend attending workshops conducted by recognized digital photographers.

The Hasselblad Manual goes into great detail about all the camera operations, the options you have in the camera, and lens controls to produce images in the camera with the

qualities and characteristics that you or your client expects. Follow these suggestions whether you work digitally or with film. To me this is still the basic and most important part of photography regardless of whether you create the images on film or digitally.

HELPFUL COMPUTER MANIPULATIONS

While it is helpful trying to produce a perfect image in the camera, it must be mentioned that the computer offers many possibilities for improving images in ways that are difficult, impractical, or impossible to do in the camera. This may involve nothing more than eliminating distracting elements within the subject or scene or in background areas (Figure 3-4).

Digital imaging has also opened possibilities for producing images with photographic qualities that are impossible to produce in the camera on film or digitally. The two most valuable ideas involve creating images with a wider range of sharpness and with more details in shadow and/or highlight areas. The contrast range, the amount of details that are recorded in shaded and lighted areas, is limited in film and digital photography. In the computer you can combine two identical images: with one exposed for details in the shaded areas and the other exposed for highlight details. Combining the two can produce an image with details in shaded and lighted areas that is impossible to cover in the original image.

The maximum range of sharpness in a camera-recorded image is determined by the lens and the lens settings with the maximum range obtained with the shortest focal length lens set to the smallest aperture. In the computer you can combine two or three identical images but one focused for the shorter and the other for the longer distances with a third set for the medium range. The final images can have a sharpness range far beyond what is possible in camera-recorded images without tilt control. Double and multiple exposures for the purpose of creating different and perhaps better works of art is another great possibility offered by the computer.

Producing architecturals with straight and parallel verticals is difficult or impossible without special camera equipment that allows shifting the lens or image plane but can be done relatively easily in the computer. Other helpful possibilities for improving the technical quality of images in the computer are discussed further in the text.

HASSELBLAD DIGITAL CAMERAS AND CAMERA BACKS

Digital Camera Backs

The Hasselblad H1 and H2 cameras and all the different Hasselblad V system camera models can be changed from film to digital by attaching a digital back in place of a film magazine. This includes the camera models used for special applications like the FlexBody and the ArcBody. You can produce just about any type of digital image in any field of photography right in the camera and eliminate time-consuming image manipulations afterwards.

In addition to the Hasselblad digital backs described in the manual, a number of other companies also manufacture digital backs with different sensor sizes and resolutions that can also be used for digital imaging with the different Hasselblad camera models. This list includes digital backs made by Imacon before and for some time after the merger with Hasselblad. Most are known under the trade name Ixpress.

Figure 3-4 Retouching the image. (A) While every attempt was made to create a perfect image in the camera, there was no way to avoid the distracting white air conditioner while maintaining good composition. (B) Retouching the image in the computer solved the problem. (C) Creating a good example of the benefits of digital imaging. (Photo by Ernst Wildi.) (D) The photograph of the green train station had disturbing, unacceptable reflections in the blue sky area which could easily be eliminated by retouching the digital image. (Photo by Ernst Wildi.)

I suggest that you investigate all the possibilities for digital imaging with Hasselblad; study the features and the specifications of the various backs to determine which one is best suited for your purpose. Be aware that some backs only work with specific camera models while others can be used on different Hasselblad models and also other medium-format and view cameras, with or without adapters. Rent some of these backs so you can try them yourself.

Hasselblad has gone a step further in the H3D and the newer H3DII models by completely integrating camera and digital back so the camera becomes a true digital camera. This offers a number of important benefits to the digital photographer that do not exist in a camera with an attached digital back. On these latest H3DII camera models, all components, the lens, the capture unit, the software are an integrated system so these cameras are true DSLR medium format cameras. The H3DII models replace the earlier H3D cameras.

HASSELBLAD DIGITAL CAMERAS

H3D and H3DII Camera Models

The latest H3DII camera models that replace the H3D models have basically the same features but have a larger and brighter 3-in. diagonal preview screen, 62×47 mm in size with a lower power consumption. The H3D display is 2.25 in. diagonally. Image noise has been reduced with a better, fan free cooling system for the sensor, an integrated GPS option, and the menu on the preview screen can be operated from the controls on the LCD display. The Hasselblad Global Image Locater (GIL) accessory can be used on both models. The H3D cameras can be used for 6×4.5 film photography by attaching the Hasselblad magazine HM 16-32. The H3DII camera models cannot be used for film photography because of the new ultra focus system in these cameras which is designed for producing the most precise focusing for digital imaging with the lens set at any aperture value. The digital sensor unit can be removed for the sole purpose of cleaning the sensor.

Hasselblad H3DII-39 Camera

H3DII single shot camera model with 39 Mpixel sensor unit (digital back) specifically designed for the H3DII camera with 36.7×49.0 mm sensor with 5412×7212 pixels, ISO 50–400 with HC 80 mm f2.8 lens, and HVD full-frame viewfinder.

Hasselblad H3DII-39MS Camera

Same camera as above but with multi-shot capability. It can also be used for single-shot digital photography.

Hasselblad H3DII-22 Camera

H3DII single shot camera model with 22 Mpixel sensor unit (digital back) specifically designed for H3D camera with 36.7×49.0 mm sensor with 4080×5440 pixels, ISO 50–400 with HC 80 mm f/2.8 lens and HVD full-frame viewfinder.

Hasselblad H3DII-31 Camera

H3DII single shot camera model with 31 Mpixel sensor unit (digital back) specifically designed for H3DII camera with 33.1×44.2 mm sensor with 4872×6496 pixels, ISO 50–800 with HC 80 mm f/2.8 lens, and HVD full-frame viewfinder.

The four digital Hasselblad cameras mentioned above are completely integrated digital cameras, not medium-format cameras with a digital back attached. As a result these cameras cannot be used with any other digital backs made by Hasselblad or any other company. These cameras also cannot be used for film photography. While the sensor unit (digital back) is removable mainly for the purpose of cleaning the charge couple device (CCD), it is not designed for use on any other Hasselblad camera or other types of medium format camera but can be attached to a view camera with the H mount adapter.

Hasselblad 503CWD Digital SLR V System Camera

A Hasselblad 503 camera with 80mm $f/2.8$ Carl Zeiss CFE Planar lens and CFVII 16 Mpixel single shot digital back with 36.7×36.7 mm sensor with 4080×4080 pixels, ISO 50–400.

The digital back can be removed and used on other V system cameras as described in the section Hasselblad CFV Single Shot Digital Back. The 503CWD digital camera can also be used for 2¼ square or 6×4.5 film photography by attaching a film magazine A12, A16, or A24.

The original 503CWD camera was sold as a special anniversary model with Victor Hasselblad's signature underneath the LCD display on the digital back. The camera was sold together with a CFV (not CFVII) digital back.

THE DIFFERENT HASSELBLAD DIGITAL BACKS

Hasselblad CF 39 Single Shot and CF 39MS Single and Multishot

39 Mpixel sensor, 36.7×49.0 mm with 5412×7212 pixels, ISO 50–400.

Hasselblad CF 22 Single Shot and CF 22MS Single and Multishot

22 Mpixel sensor, 36.7×49.0 mm with 4080×5440 pixels, ISO 50–400.

The digital backs CF 39 and CF 22 do not attach directly to any camera body but in combination with an adapter that is a separate item and must be ordered separately. This arrangement was done purposely because it allows the photographer to use the same digital back on earlier Hasselblad H cameras, on all V system models including 200 and 2000 models equipped with shutter lenses, and on 202, 203, and 205 models also with F lenses after a slight camera modification. This digital back can also be used on practically all other makes of medium and large format cameras. You do not have to purchase a new back if you want to do digital imaging with another camera, just purchase the adapter which also comes with a mask for the viewing screen on that particular camera. Flash sync input cables are necessary on some models. The CF digital backs cannot be attached to H3D camera models where the digital back is part of the camera system.

Hasselblad CFVII Single Shot Digital Back

16 Mpixel sensor, 36.7×36.7 mm with 4080×4090 pixels, ISO 50–400.

The Hasselblad CFV digital back can be attached to Hasselblad V system cameras including FlexBody, ArcBody and 200 and 2000 models equipped with shutter lenses in combination

with Flash sync input cable. Cameras can be modified for use with non-shutter lenses. The CFVII back is also usable on view cameras with a Hasselblad V system adapter. The CFVII digital back has some improvements over the CVF type including a larger priview screen with a 2.5 inch diagonal. (The diagonal on the CFV is 2.2 inches) The controls are identical, are in the same location and are operated in the same way.

Consult the Hasselblad Web sites mentioned in the Preface or contact the Hasselblad agent in your country for exact information about adapting and using the Hasselblad digital backs on specific camera models.

HASSELBLAD FILM CAMERAS

Hasselblad H2F

This is basically the H2 camera but without some of the features that are required mainly in digital imaging. The H2F (F stands for flexible) has all the wonderful features that make the H cameras such wonderful tools for studio and location photography in the 6 × 4.5 film format from a tripod or handheld. While the H2 is basically designed for film photography, it can be used for digital imaging with Hasselblad CF and CFH digital backs but does not have the integration of the lens, camera and software of the digital Hasselblad models. The camera cannot be used with digital backs from other sources.

In addition to the H2F, all H system cameras except the H3DII can be used for film photography by attaching a film magazine HM 16-32.

Hasselblad 503CW

In addition to the current 503CW, all other V system camera models can be equipped with any Hasselblad film magazine or a Hasselblad digital back.

RECORDING THE DIGITAL IMAGE IN THE CAMERA

Basics of Digital Imaging

In digital imaging, the image is recorded on a light-sensitive sensor instead of light-sensitive film. The sensor in Hasselblad digital cameras and digital backs is a CCD with millions of light-sensitive areas on its surface. An array color filter in front of the sensor filters the light so that some pixels only receive red, others only green, and others only blue. The electronic signals from the sensor are then processed and stored as a digital file. The electronic image is made up of red, green, and blue components that combine to form an RGB image which is then processed in FlexColor or the newer Phocus software into a Hasselblad 3F file. This file can be made into a DNG, TIFF, JPEG, or other file format.

You may want to keep in mind that a digital camera or digital back requires power and you cannot take digital images without power. Make certain that you always have power available so you can continue with your digital photography.

Figure 3-5 Single shot operation. A single shot system delivers one color per pixel.

Single-Shot and Multi-Shot

All Hasselblad digital backs and digital cameras can be used in the single-shot mode which is standard on digital cameras and is illustrated in Figure 3-5. Single shot means recording a single image on the sensor just as we record a single image on film. This is a very satisfactory digital imaging approach that produces good image quality and is usable for any type of subject, stationary or moving, in any field of photography recorded with a handheld camera or from a tripod.

The CF-39 and CF-22 digital backs are also available in a multishot version that increases the file size and dimension and reduces the noise problem and problems with moiré even further. A capture with the CF-22 in the 4-shot mode is 134 MB dimension 5440 × 4080 pixels and in the 16-shot mode 515 MB dimension 10880 × 8160.

As the name indicates, in the multishot mode you record several identical images, the CF-22 offering the option of 1, 4, or 16 shots, the CF-39 1 or 4. The sensor in the camera has pixels that are covered by a color filter array making some pixels record only red, others green, and still others blue. In the single shot mode, 25% of the total pixels record red, 25% record blue, and 50% are used to record green. In the multishot mode the camera takes several identical pictures but with the sensor moved in 1 pixel increments in between each shot for a 4-shot mode or ½ pixel for a 16-shot mode available only on the 22 MS back. The 4-shot mode is illustrated in Figure 3-6.

In the multishot mode all pixels in the sensor record red, all pixels record blue, and all pixels record the green image. In a 22 Mpixel sensor with 4080 × 5440 pixels, we now have 22 Mpixels of red information, 22 Mpixels of blue information, and 22 Mpixels of green thus producing the utmost in digital image quality for still lifes, architectural work, product photography, and copying where utmost image sharpness is a prime requirement. Multishot mode is a function of the software and is completely controlled by the FlexColor or Phocus software and is described in detail in the FlexColor and Phocus instruction manual. It can be done only with the camera connected to a computer. Multishot mode is mostly used with studio flash and the time delay between shots, which can easily be a number of seconds and may be determined by the time that is necessary for recharging the flash.

Since a multishot capture is a multiple exposure, it must be made with a tripod-mounted camera and I also suggest using a sturdy tripod to eliminate any possible camera vibrations. The lighting situation also must be very stable between shots.

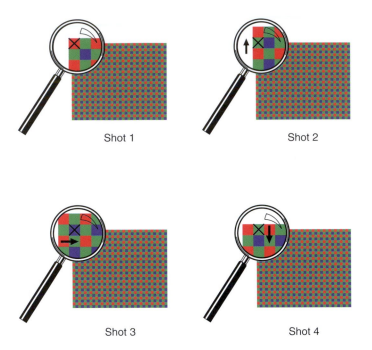

Shot 1

Shot 2

Shot 3

Shot 4

Figure 3-6 Multishot recording. This shows how the sensor moves in one pixel increments in a 4-shot multishot operation. The sensor is moved by high precision piezo motors.

LENSES FOR DIGITAL RECORDING

Some manufacturers of digital cameras emphasize that lenses for digital recording must have different quality requirements, must be designed to focus the light more directly to each pixel, and that lenses designed for film recording do not provide the best or satisfactory quality, especially on the edges of the image. While there is some truth to these facts, they apply only to specific sensor designs and to extreme wide angle lenses.

New Lens Designs for Digital Imaging

The Carl Zeiss lenses in the V system and the HC lenses in the H system which are designed to produce the utmost image quality on film are also superb lenses for digital imaging. While lenses used exclusively in digital imaging still need to be designed to produce superb image quality, they can have a slightly higher degree of distortion and chromatic aberration because these lens faults can be further corrected in the computer. This may allow lens designers to come up with somewhat simpler lens designs and more compact lenses. This new development is called Digital Auto Correction (DAC) in the Hasselblad system. No computer or software, however, can produce a high quality image from an inferior lens. The computer can only improve the quality from a good lens. You must start with a lens that was optically designed

to produce great image quality without the computer software. This topic is further discussed in Chapter 14.

The HCD 28 mm wide angle (Figure 3-7) is one lens of this type in the Hasselblad line. It is designed to cover only the digital sensor format of 36.7 × 49.0 mm, not the larger film format, which explains why this lens can only be used for digital recording and only with the H3D and H3DII camera models. These cameras transmit the lens data, the focal length, the aperture, and the distance setting to the computer which then makes the corrections. Future HC lenses will undoubtedly be designed in the same fashion.

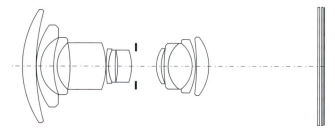

Figure 3-7 A 28 mm wide angle lens design. Lens design of HCD 28 mm extreme wide angle lens for H3D and H3DII cameras.

Infrared Filter

Since digital sensors are very sensitive to infrared light, all Hasselblad digital cameras and digital backs have an infrared filter in front of the sensor to eliminate the infrared and near-infrared rays (IR) from reaching the sensor. Without the filter the digital image would be unusable. You do not have to be concerned about this filter unless you plan to do infrared photography.

Digital cameras or digital backs cannot be used for infrared photography unless the filter is removed, which can only be done at the Hasselblad factory and also involves re-calibrating the sensor position as infrared rays form the image in a different plane. Some photographers have used a camera with the IR filter removed for regular digital color photography by placing an infrared blocking filter such as BG 39 in front of the lens. The AF system in the camera works as long as the filter is on the lens for regular photography. With the filter removed for infrared photography, you must focus manually. If you plan to do extensive infrared work in addition to "regular" photography, a logical solution that might come to mind is working with two different digitals backs, one with and one without the infrared filter so you simply change backs depending on the type of photography. In such a case, the back without filter may need to be, and possibly can be adjusted for the focus shift, but at this writing, no specific details are available. Check with Hasselblad before you decide on this solution. Using infrared film in a film magazine is another solution but infrared films are difficult to find and also require very special storage conditions and processing.

Infrared photography must be done through a filter that absorbs practically all visible light. This can be a dark red filter or a true IR blocking filter which is opaque to the eye. This filter on the lens makes it impossible to use the automatic focusing system. You must focus the lens manually setting the distance opposite the infrared index on the lens.

Infrared Photography

Infrared photography with digital cameras is a fascinating field for the experimenting and creative photographer interested in recording the world in a different fashion. With a Hasselblad digital camera or digital back properly converted, infrared photography actually becomes simpler than with film, especially as it eliminates all the problems with the special film processing that is necessary. Infrared photographs can be created in black and white or color with the conversion to black and white done after the image is captured. With infrared photography you can show the world revealing something spectacular, something that you can never see with the naked eye. Infrared photography can be done at any time of the day and in any type of daylight and you can produce spectacular images in the middle of the day when you normally try to avoid creating pictures.

Infrared photography is done with a special IR passing filter, also called black filters or a deep red filter on the lens. With this filter on the lens, you photograph almost entirely with IR wavelengths. With the camera set for automatic white balance the colors in your images can vary wildly, usually with very red colors. A better approach is to set the white balance for green grass. Infrared photography can also produce very interesting, often beautiful results in portrait photography usually with lightened skin tones, dark eyes, and red hair.

DIGITAL RECORDING MEDIA

In all digital Hasselblad cameras and digital backs, the images can be recorded on compact flash (CF) cards in the camera, on the accessory Hasselblad ImageBank, or in the computer. The used media is shown on the main menu, on the preview screen, and also when the zoom out control is moved to the very end.

CF Cards

CF cards are made by various companies in sizes from 1 to 16 GB. Two brands recommended by Hasselblad are Sandisk Extreme IV and Lexar Professional 133×. The GB value indicates the number of images that can be recorded on a card and is about 18 images from a 39 sensor on a 1 GB type. While the number of images is limited, the CF card eliminates the need for any cable connections and makes the camera flexible for handheld work.

The CF cards are inserted on the right side (seen from the rear) of the sensor unit (digital back) after opening the card holder cover. Insert it so the connector holes face the slot with the brand label toward the rear. If you feel resistance, the card is probably facing the wrong way. It should slide in easily. Press the card in a little further and close the cover.

The card is removed by opening the cover then pressing the release button below the card holder slot slightly, then completely, which pushes the card out so you can remove it. You can copy the contents from a CF card to the ImageBank so you can use the same card for more images or to back up the recorded data. This is like copying the content of a word processing file to a disc as a back-up. It is easy to copy images from a CF card to the ImageBank.

The ImageBank II

The Hasselblad ImageBank II is a separate, battery-powered accessory unit that can be carried on a belt and is connected to the socket at the bottom on the left side of the sensor unit with a standard FireWire 800 cable. This 100 GB unit, which is basically an external FireWire hard disc, can store a large number of images without stopping to reload a new CF card. But you have a cable connection going from the camera to the ImageBank. The number of images depends on the file size and varies from about 1900 to 4300; to be more specific 4330 for 16 Mpixels, 3340 for 22 Mpixels, 2288 for 31 Mpixels, and 1887 for 39 Mpixels. There is basically no difference between storing the images on a card or in the ImageBank II. With the H3D cameras you must use the Hasselblad ImageBank II. The older version, just called "ImageBank" cannot be used with these cameras.

Copying Files to ImageBank-II You can copy files from a CF card to an ImageBankII by connecting the ImageBank to the camera with a FireWire cable. This will free up space on the card, but the images remain on the card until deleted. To copy files, press MENU and navigate to STORAGE. Press the button and navigate down to COPY. Press the button that brings up the confirmation dialog. To confirm press the OK button. To cancel press the EXIT button. Press STOP to cancel the process. All the batches and files are copied to the ImageBank in a newly created folder. When you connect the cable to the ImageBank again later, a new folder is created automatically.

Working with the CF Card

Working with the CF card is nice especially when working handheld since there are no cables to worry about. The drawback of the limited capacity of the card can be eliminated by transferring the images to the ImageBank II as soon as you have filled up one or several cards. This transfer can be done in the field during a shooting break. This procedure combines the mobility of shooting without any cable connection with the massive storage capacity of an external hard drive. In shooting sessions where you have access to a computer, you can make this transfer directly to the computer from the camera using a FireWire cable and run FlexColor or Phocus to automate the process. If you do not want to interrupt the shooting session, you can also remove the full card from the camera and insert it into a compact CF card reader connected to the computer.

Direct Connection to Computer

The sensor unit on the camera can be connected directly to the computer using a FireWire cable from the FireWire port on the computer to the connector on the side of the sensor unit on the camera. This is normally called tethered shooting. On the H3D cameras, the connector port on the sensor unit is protected by a self-closing flap. Align the FireWire cable connector as shown on the flap then press it against the flap until it stops. Tethered to a computer, you can see the image on the large computer screen and control many functions such as all exposure settings and ISO from the computer using the FlexColor or Phocus software. The

focus control, however, is controlled from the camera. The computer mode offers practically unlimited storage capacity since the images are stored on the computer's hard drive, but the limited mobility makes this approach suitable mainly for studio use. Connected to a computer, the screen and menu system on the sensor unit are disabled.

The live video function is a nice advantage of shooting tethered. Enabling this mode produces low resolution images on the screen updated approximately every second. A part of the low resolution image can be enlarged to 100% for critical manual focusing.

Programming the Media

If you are connected to a computer or connected to just one medium, for example having a CF card in the camera, the camera automatically selects the medium and shows it on the menu screen. When connected to several media, for example, if you have a CF card in the camera but also a FireWire connection to the ImageBank, you must select the media. Depress the MENU button, go to STORAGE (Figure 3-8A) which brings up the MEDIUM menu (Figure 3-8B), navigate down to MEDIA and use the + or − buttons until the blue line is over the selected media. In Figure 3-8, the blue line is over the CF card. Press OK. When connected to a computer, the screen and menu system in the camera are disabled. As a shortcut on the H3D camera models, you can also press the button on the grip that is used for film wind-off.

(A) (B)

Figure 3-8 Navigating the media. When a CF card is in the sensor unit and the unit is also connected to another medium such as the ImageBank, you must tell the camera which media to use. Go to MENU, then navigate to STORAGE (A), which brings up the display (B). The blue line around the CF indicates that the images will be recorded on the CF card.

Formatting

Before you start using a new medium for the first time, a new CF card, or a new ImageBank element, it is recommended that you format the new unit to allow the sensor unit to use the media more efficiently. To format, press MENU and select the media to be formatted. Go to STORAGE and FORMAT. You will receive a message showing the media to be formatted and an "are you sure" message. Press OK and you will see the message "formatting." If you format a medium that has images on it, the formatting process will delete all the images.

FILE FORMATS

Discussions on digital imaging usually include a discussion about the different file formats TIFF (tagged image file format), JPEG (Joint Photographic Experts Group), and RAW (raw data). JPEG is a popular format especially in digital cameras also used by amateurs producing good image quality when images need not be enlarged drastically.

Hasselblad digital cameras and digital backs record in the RAW format only, which is the format preferred and used by most professionals. Raw captures RAW data from the camera sensor and produces an image that is exactly as recorded by the sensor in the sensor unit. This format provides the best image quality from the camera, which is valuable when the image needs to be enlarged drastically.

All camera manufacturers have their own versions for the raw format. Hasselblad's version is 3F raw (3FR). This file format with lossless image compression reduces the required storage space by 33%. The 3FR files can be converted with the FlexColor or Phocus software into Adobe's raw format DNG (digital negative).

DIGITAL BLACK AND WHITE PHOTOGRAPHY

You cannot produce black and white images in the Hasselblad digital cameras or digital backs. Black and white images must be created in the computer from recorded color images. You also have the option, and perhaps the most satisfactory solution, to attach a film magazine to the Hasselblad camera models that are made for use with film magazines and produce your black and white images on your favorite black and white film as most Fine Art photographers still do.

Although some Fine Art photographers feel that black and white images produced in the computer can have the same beautiful tonal qualities as those produced on black and white film, many black and white Fine Art photographers continue using film, develop the film, and produce the images themselves based at least to some degree on Ansel Adams' Zone System Theory.

The Digital Black and White Possibilities

The latest developments in digital cameras and printers combined with the variety of software programs for processing the image in the computer has created a new interest in black and white digital photography, especially in the professional field and for Fine Art photography. Many critical photographers feel that digital black and white images can come close to, or even match, the quality of the best black and white film images, if perhaps not today, they will certainly do so in the near future since new software programs for this purpose are introduced constantly.

These digital black and white images can be created in a much more pleasant atmosphere without a darkroom and its messy chemicals. The digital process not only offers all the known darkroom possibilities for changing the image, such as lightening or darkening the entire image or certain areas and changing the overall image contrast, but offers possibilities and manipulations that the darkroom photographer could only dream about. As a further advantage, you can see the results of these manipulations immediately without waiting for an image to be completely developed. You can also print the final image in a warmer or colder

black and white tone or as a sepia print. All these new computer possibilities have already created a new interest in black and white Fine Art photography, especially from photographers who never considered such work before, and it is generally felt that this trend will continue at an even faster pace.

With Hasselblad, black and white images are created in the computer, not in the camera, which at first may be considered as a disadvantage. This is not the case for most photographers. Serious film photographers interested in both black and white and color photography often photograph scenes and subjects both on black and white and color film. This not only requires a change of magazine (or camera) but also a different approach to exposure and the use of color filters on the camera. With a Hasselblad digital camera or digital back you take just one picture in raw and then decide on the computer, where you have all the time in the world to evaluate the image, possibilities for changes in the gray tones and then decide whether you want to print it as a color image or change it to a monochrome or finish it in both. If you shoot raw, as you do on Hasselblad, you have possibilities of creating black and white images with the richest tonality in dark and light areas.

Seeing the World in Black and White

If you have not done serious black and white photography on film, you must realize that effective black and white images require a completely different visualization approach. Unlike color images, where the visual effectiveness is often created solely by the presence of vibrant, saturated colors, black and white photographs depend mainly on the compositional arrangement of lines and shapes and even more often by lighted and shaded areas that are created by the light. The human eye is drawn toward areas of greatest contrast, which may be created by areas of greatly different colors or by light and dark areas. Dark shaded areas, with little detail that may be unacceptable in color, may be an affective part of a black and white image. To create effective black and white images you must see the world in elements of light, tone, and pattern, and it will not be long until you discover what is needed to create effective black and white images.

A special color of light, such as the warm color of the late afternoon sunlight that may give your outdoor color image its special quality, may add nothing to a black and white image and is effective in a black and white image only if it also creates interesting lines within the composition. You must realize that all colors are recorded in different shades of gray tones. A red object, the attention-creating element in a color picture, surrounded by green foliage may be recorded in black and white in almost the same gray tones as the surrounding green area and be lost as an important image element. The directors of photography in black and white motion pictures were aware that the world looks different on black and white film and often evaluated the scenes through a viewing filter that showed the scene similar to the way it would be recorded on film.

Creating the Digital Black and White Image

While some images recorded in color may also look great in black and white just as they are, more often they can be improved, or they are effective as black and whites only if they are

modified in the digital darkroom by changing some or all of the gray tones. There are different techniques available in programs like Photoshop to make the conversion. Study the different programs, such as channel mixer, black and white adjustment layer and others, read special books on this subject and talk to successful photographers to determine which approach is best for your particular purpose. As described in Chapter 17, each color is recorded in a special shade of gray; red may have a similar gray tone as green. Various software programs, such as Channel Mixer, allow you to change the gray tones of every color in the original to any desired degree. In such a program, you work with red, green, and blue channels adjusting each to lighten or darken the gray tones of any color to any degree. You can darken red and lighten blue or whatever separates the various elements within the picture. What you actually do in the computer is exactly what film photographers do by placing filters over the camera lens, for example, using a yellow or red filter to darken blue skies. This process is described in detail and illustrated on the color chart in Chapter 17. Further in Chapter 17 you can read that a filter of a certain color lightens the gray tones in colors that are the same as the filter or at least are on the same side of the wheel and darkens those that are on the opposite side of the wheel. A green filter lightens green and darkens red. Study that part of the manual. You will find it helpful when creating black and white images on the computer.

Black and white film photographers make extensive use of all these different color filters when they record the image in the camera. Because the Hasselblad black and white image is created in color in the camera, you do not use the filters mentioned above that change gray tones on a black and white image on the camera lens.

However, do not overlook using the filters that improve color images, especially the polarizers and the split neutral density types for images that you plan to convert to black and white. Also keep in mind that images to be converted to black and white need perfect exposures. As discussed in Chapter 15, evaluate the histogram of your color picture carefully making certain that the image has details in both the lighted and shaded areas. The histogram should just reach the far right to ensure details in the highlights instead of being reproduced as pure white and should not be heavily based toward the left hand side to retain shadow detail.

Operating the H Cameras for Digital and Film Photography

■ ■ ■ ■

Hasselblad H camera models are basically operated in the same fashion for digital imaging and film photography, but keep in mind that the H3DII is for digital imaging only and the H2F and earlier camera models are designed for film photography, but usable with some digital backs. The H2F is used with film as discussed below and the H3DII is used for digital imaging as discussed here and in Chapter 5. This chapter addresses the H camera operations that must be observed and used for producing high quality images in either medium. The necessary special steps for producing digital images are discussed in Chapter 5. The location and operation of some of the camera controls may vary slightly depending on the H camera model. If anything is different from the way it is described in the manual, check the instruction manual for your particular camera model.

THE H CAMERA SYSTEM CONCEPT

Because the Hasselblad H cameras have the operating features and the automation found in modern cameras, you can take high quality pictures digitally or on film without learning much about the camera and lens operations. For the simplest photographic approach set the camera for automatic focusing and the desired metering mode (Center Spot is my suggestion for automatic use), set the camera for Programmed Exposure mode. In this mode the camera is programmed to choose the aperture and shutter speed. Compose the picture, and press the shutter release. If, on the other hand, you want to decide how each image is to be recorded in the camera, the H cameras give you complete control over every step in the process. This is done in a simple, sophisticated fashion that will likely add enjoyment and fascination to your photographic hobby or profession. You can select your preferred metering and focusing modes, which provide perfect exposures and maximum image sharpness for specific subject areas and lighting situations. You can program an almost unlimited number of functions and operations that can simplify your photography, customize the camera operation for your style of photography, and help you create the results you are trying to produce. With the H cameras you do not have to match your photographic approach to what the camera can do. Instead, you program the H camera operations for the way you like to work and for the results you are trying to achieve. The images that come out of the H camera will satisfy you even more when

you evaluate the sharpness and effectiveness that only the larger medium film format and the larger digital sensors can provide.

Rather than repeat all the exact operational details that are in the instruction manual, I will concentrate on explaining how the features in the H cameras and lenses can and should be used to produce high quality pictures in the simplest fashion. I suggest that you keep the instruction manual handy in case you need detailed instructional data. The instruction manuals are also readily available on Hasselblad Web sites.

Hasselblad H Camera Models

The original H1 camera model, introduced in 2002, came out in 2004 as an H1D model in combination with a specially made Ixpress 132 C22 megapixel digital back. This camera model could not be used with any other digital backs but allowed a film magazine to be attached. The H2 model introduced in 2005 supplied power to the CFH digital back and made automatic lens corrections in FlexColor possible. The H2 is usable for film photography and digital imaging. The H2D with DAC software correction and sold with a digital back is strictly for digital imaging and cannot be used for film photography.

The H3D models introduced in 2006 are integrated digital cameras where the different components, camera, digital sensor unit, and lens can communicate back and forth. H3D camera models are sold with 22 Mpixel or 39 Mpixel sensor units both 36.7×49.0 mm in size. A third H3D model has a 31 Mpixel sensor 33.1×44.2 mm in size. H3D cameras have full support for DAC and the ultra focus automatic focusing system. The capture for the H2D and H3D cameras is in the raw file format called 3FR. The metering pattern is slightly different from the original version and now measures 2.5% of the image area in the Spot mode, 25% in the CentreSpot mode and 95% in CentreWeighted (average) mode. The H3D models also come with a full frame viewfinder that magnifies the sensor area $3.1\times$, and they can be used with the Global Positioning System (GPS) accessory.

The 22, 31, and 39 Mpixel sensor units on the three H3DII camera models introduced in 2007 have a large 3-in. preview screen making it necessary to relocate the operating controls on the sensor unit. The controls, however, work basically in the same fashion. To produce an updated digital camera that is completely integrated for the most modern approach to digital imaging, Hasselblad felt it necessary to design the Hasselblad H3DII camera for digital imaging only. Keeping the original concept of building a camera for film and digital photography would have required compromises that are no longer accepted by updated digital photographers. The new H3DII camera models have an integrated cooling sink to dissipate charge couple device (CCD) heat reducing image noise. The new cameras also have a programmable extra mirror delay that reduces the danger of mirror motion affecting the image quality.

Since the H3DII cameras can only be used for digital imaging, in 2008 Hasselblad introduced the H2F model. This camera has all the beautiful features and automation of the original H2 model but is designed for film photographers. It uses the same film magazine described below for the 6×4.5 image format on 120 or 220 film. The H2F camera can be used with some Hasselblad digital backs but lacks most of the functionality of the modern digital camera such as the integration between camera, lens and software and also requires external cable connections. The introduction of this camera model shows that Hasselblad has not

forgotten the devoted film photographers and still sees a future for film photography. With the introduction of the H2F model, in addition to the H3DII, you can select a Hasselblad camera with the operation, features, and sophisticated automation that makes photography a pleasure whether you work digitally or with film.

The basic camera operations on all H models are the same, and everything discussed in this chapter applies to all models unless indicated differently. Figure 4-1 shows the H camera and its controls, which apply to all the different models.

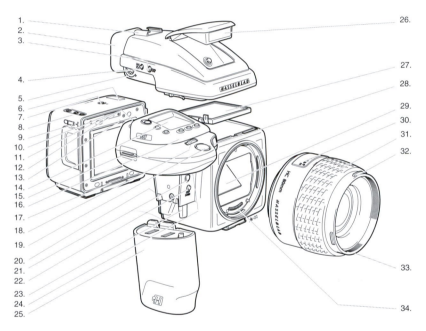

Figure 4-1 The H1 camera and camera controls. Note that controls 10, 11, and 12 are at the rear of the grip and are not visible here. (1) Flash unit hot shoe; (2) rubber eyecup; (3) exposure mode and metering mode selector button; (4) exposure compensation button; (5) eyepiece adjustment dial; (6) magazine LCD; (7) LCD illumination button; (8) magazine control buttons; (9) magazine settings lock; (10) AE-L button; (11) film wind-off button; (12) user button; (13) rear control wheel; (14) grip LCD; (15) support strap lug; (16) camera control buttons; (17) magazine databus; (18) front control wheel; (19) shutter release button; (20) battery holder button; (21) release cord socket; (22) stop down button; (23) battery holder retaining lever; (24) mirror up button; (25) battery holder; (26) flash unit; (27) viewfinder screen; (28) focus assist light; (29) mirror; (30) distance and depth-of-field scales; (31) focusing ring; (32) lens shade bayonet; (33) filter screw thread; (34) databus connection; (35) viewfinder release button; (36) flash unit catch; (37) viewfinder attachment hook; (38) viewfinder databus connection; (39) magazine release button; (40) flash PC socket; (41) camera strap lug; (42) lens release button; (43) magazine support; (44) databus connection; (45) quick coupling tripod plate; (46) film tab holder; (47) magazine darkslide key; (48) film holder key; (49) magazine support groove; and (50) databus connection.

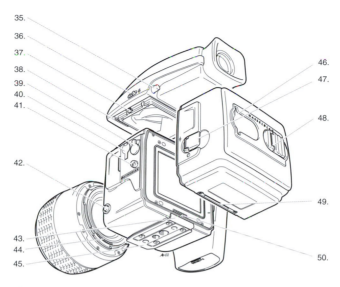

35.
36.
37.
38.
39.
40.
41.
42.
43.
44.
45.
46.
47.
48.
49.
50.

Figure 4-1 (Continued)

REMOVING THE BOTTOM PLATE

The H cameras delivered from the factory have a plastic bottom plate that can be left on the camera for handheld photography. It needs to be removed for mounting the camera on a tripod or stand. To do so, lift the security catch while pushing the plate back. To re-attach, slip it over the camera foot until it stops.

BATTERY OPERATION

The original H cameras were powered by three CR-123 lithium (or equivalent) batteries in a battery holder as part of the camera grip. Insert or change the batteries by pressing the Battery Holder button on the battery holder while swinging the battery holder retaining lever down and pulling the battery holder downward. The battery cassette is released and the batteries are changed after pressing the red button.

The newer H camera models including the H3D models are powered from a rechargeable 7.2 V battery in the battery grip that looks exactly like the battery holder and is removed from and attached to the camera in the same fashion. To slide the battery cassette or battery grip back into the grip, align the two upper lugs with the slot in the grip, slide it back into position, and swing back the battery holder retaining lever until it clicks position.

Battery life depends on many factors, especially how long the camera is left in the Active mode, and therefore cannot be predicted. A low-battery charge is indicated by a battery symbol on the grip LCD. When the batteries are almost completely exhausted, a low battery warning or a "replace battery" warning on the latest camera models appears on the screen, and the camera no longer functions. When this warning appears, change or recharge the batteries.

To recharge, remove the battery grip from the camera, insert the cable from the charging unit to the outlet in the battery grip, and connect the charger to a proper power outlet. The red light will come on indicating that the battery is charging. The red light flashes when the battery is completely charged. The battery in the rechargeable battery grip must be recharged only with the Hasselblad battery charger BC-H Li-Ion 7.2 V DC, and this charging unit should not be used for recharging anything else.

Because camera operation is completely dependent on batteries, you should always carry a backup set such as a second rechargeable 7.2 V battery grip or an accessory reserve lithium battery grip that holds three CR-123 lithium batteries.

Removing or changing the battery does not erase any functions programmed and saved into the camera, because the memory in the H camera does not need the power from the battery to store such data. Unsaved data, however, will be lost. Aperture and shutter speed are not saved and will revert to the default settings of $f/5.6$ and $\frac{1}{125}$ second when the battery is removed.

H3DII Battery Operation

The H3DII cameras have a full screen battery status check that can be accessed by depressing and holding down the Illumination/Battery Check button that is now marked with an illuminated battery symbol. The screen shows the firmware version, the number of exposures taken since the last battery or recharge change, and a battery status icon (Figure 4-2).

Figure 4-2 Battery status. Depressing the Battery Status/Illumination button on H3DII cameras brings up the firmware version, the number of exposures taken since the last battery charge or change, and the status of the battery in the camera (left). The new cameras also show Replace Battery instead of Low Battery (right).

The amount of power consumed from the battery depends on the way you operate and work with the camera. The information in this chapter must therefore be considered only as an estimation. For example, the percentage figure is simply based on the power left in the battery not taking into account how much power you personally use for each exposure.

H3DII Battery Warning

On the H3DII cameras a battery warning signal on the preview screen of the sensor unit can be seen in addition to an audible signal heard when the battery charge goes below a certain level. The signal for the camera battery appears on the top right of the screen as a flashing yellow battery symbol when the battery should be re-charged and changes to red when the battery power is completely exhausted. When working with the Image Bank, the same battery

symbol working in the same fashion appears on the left side of the preview screen indicating when the Image Bank battery needs re-charging or changing (Figure 4-3).

Figure 4-3 Battery warnings on H3DII. A flashing yellow warning icon appears on the top right of the screen when the camera battery power is low. The same signal appears on the left of the screen for the battery in the Image Bank. Both signals turn to red when the battery is exhausted.

AUDIO FEEDBACK SYSTEM

To inform you or warn you of various camera functions or possible problems the newer H3DII cameras offer an audio system with 14 different sounds. In addition to the sounds shown in Figure 4-4, Button Press is a simple mechanical click.

ATTACHING AND REMOVING LENSES

To attach a lens to the camera body, align the red index on the rear lens mount with the red index on the camera body; then turn the lens approximately one-quarter turn until it clicks into position. To remove lenses, press the Lens Release button (item 42, Figure 4-1) on the side of the camera, and turn the lens in the opposite direction. Do this while holding the lenses by the metal lens barrel, not by the rubber focusing ring. As there is no mechanical connection between camera and lens, lenses can be removed or attached at any time. Keep the electronic Databus connections between camera body and lenses clean and do not touch them with your fingers. Attach rear covers to detached lenses and place a front cover on the camera body if it is stored without a lens attached.

Chapter 14 discusses lens design, lens characteristics, and lens quality, and the proper selection, effective use, and operation of various HC focal length lenses for creating high quality images in detail. Close-up photography and the use of close-up accessories on the H camera are discussed in Chapter 19.

VIEWFINDERS AND FOCUSING SCREENS

Eye-Level Finders

Because you must turn the H cameras to take vertical pictures, viewing from behind the camera is the logical approach especially when photographing handheld. The H cameras therefore

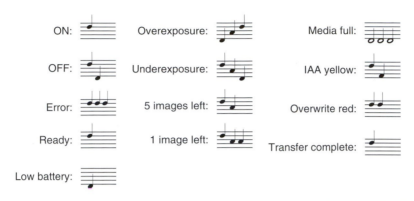

Figure 4-4 Audio feedback. The H3DII cameras have 14 different sounds to provide immediate information. In addition to the 13 sounds shown above, the Button Press is a normal mechanical click.

come equipped with an eye-level viewfinder, which is beautifully designed for handheld photography in the vertical or horizontal format. The viewfinder HV 90× on most camera models has a 2.7× magnification and shows the full image area of the 6 × 4.5 film format. The H3D camera models have an HVD 90× viewfinder and a focusing screen that shows only the area of the 36.7 × 49.0 mm sensor (on the H3D-31 with an edged line on the screen for the smaller sensor). Because the sensor area is a few millimeters smaller than the 6 × 4.5 film area, magnification in the finder could be increased to 3.1×. The HVD 90× finder can be used for film photography on the H3D model but there is some vignetting at the bottom of the image. To see the full film area you need the HV 90× type. The finders and operating controls are otherwise identical.

The Acute Matte focusing screen, with the indicated spot meter and automatic focusing areas, shows 100% of the image recorded on the film or 100% of the area covered on the 36.7 × 49.0 sensor in the H3D models.

Attaching and Removing Viewfinders

You can attach or remove both eye-level viewfinders from the camera without removing the film magazine, digital back, or lenses. To remove a finder, press the Viewfinder Release button (item 35, Figure 4-1), and lift the finder upward. To attach a finder, hold the finder at a slight angle and slide it forward and downward until it clicks into position. Make certain that it is locked on both sides.

As the camera's exposure metering system is in the viewfinder, the finders have electronic Databus connections at the bottom to transfer data from the camera to the finder and vice versa. The viewfinders have two Exposure Control buttons on the side of the camera grip for setting the light-metering mode and for setting exposure compensations.

Removing the Focusing Screen

Unlike on other Hasselblad camera models, the focusing screen is firmly held in place and does not fall out even if you turn the camera upside down after removing the viewfinder. To remove

or change a screen, remove the viewfinder. On the right side of the camera next to the grip you will see a chrome piece that is used to hold the viewfinder in place. In front of the chrome piece, closer to the lens, you will see a black piece with an opening in the center. This piece is part of the screen. Insert a ball point pen or similar object in the opening and lift upward. To replace the screen, place the screen properly in the recess on the left side then push down the right side with a ball point pen so the screen locks in position. Re-attach the viewfinder.

Adjusting the Eyepiece Diopter Correction

The viewfinders are designed so the entire focusing screen can be seen with or without eyeglasses. The longer rubber eyecup is most practical for viewing without glasses. A shorter one is available for viewing with glasses. More details about viewing with or without glasses are found in Chapter 7. When deciding whether to view with or without eyeglasses, keep in mind that the eye-level finders on the H cameras can be adjusted over a wide diopter range so you can probably see a sharp image either way.

After you make that decision, you must adjust the finder to your eyesight. To do so, it is best, but not necessary, to remove the lens from the camera so you see nothing but the focusing screen. Turn the eyepiece adjustment control (item 5, Figure 4-1) on the side of the finder until you see a sharp image of the spot meter and focusing indications on the screen. After the first adjustment, move your eye away from the finder, look at something in the distance for a few seconds to relax your eye, and then view through the finder again to see whether the image is still sharp. If it is not, make a new adjustment and repeat the process. If you make this adjustment with a lens on the camera, make certain that you adjust the diopter correction for a sharp image of the screen markings, not of the image itself.

Waist-Level Viewing

Since viewing from the top has many advantages especially when the camera is used on a tripod or used at low angles, the H models can also be equipped with the HVM waist-level finder. This can also be a good choice when working with people or professional models as it is easier to maintain eye contact and direct the subject. The finder has a 3.25× magnification but no built-in diopter corrections as this should not be required by most photographers. Hasselblad, however, makes a holder for custom made diopter correction lenses if they are needed.

The waist-level finder does not have the metering electronics of the eye-level types so you have no metering system in the camera. This should not be a serious drawback since this finder is most likely used in the studio with studio electronic flash. You use *The Hasselblad Manual* exposure mode and set the aperture and shutter speed based on the reading from a handheld exposure meter or based on past experience.

WORKING WITH FILM MAGAZINES

The H Film Magazine

The HM16–32 film magazine is designed for the 6 × 4.5 cm format and can be used with 120 and 220 roll film without manual adjustment. When you use bar-coded film, the pressure plate

in the magazine automatically adjusts for the different thickness of 120 film with paper and 220 film without paper to ensure that you obtain images with the very best image sharpness no matter which film you use. If needed, you can buy either additional complete film magazines or additional film inserts.

Removing and Attaching the H Film Magazine

The H film magazines have a built-in darkslide curtain that can be closed and opened manually by turning the magazine darkslide key (item 47, Figure 4-1 and Figure 4-5).

The darkslide curtain is closed, covering the film area, when the dot on the darkslide key points toward the closed mouth symbol and the darkslide indicator below the key shows red. The darkslide curtain is open when the dot on the key points toward the open mouth symbol and the signal is white. As with all Hasselblad cameras, the magazine can be removed only when the signal is red (curtain closed), and pictures can be taken only when the signal is white. A warning, "the darkslide is closed," appears on the grip display and in the viewfinder if you try to take pictures with the curtain closed.

To remove the magazine from the camera body, turn the Magazine Release button (item 39, Figure 4-1) on the camera body to the right while pressing the central round part of the circular button toward the camera body. The darkslide curtain cannot be opened on a detached magazine because this would expose the film in the magazine to light.

You attach a magazine by simply placing the magazine support groove (item 49, Figure 4-1) into the support and pressing the magazine toward the camera body. Do not touch the Databus connections with your fingers. Place the protective cover on the magazine and

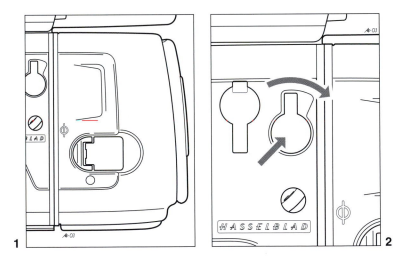

Figure 4-5 (1) The side view of the magazine shows the darkslide key with the darkslide indicator below. (2) When removing the magazine, press the lower round part of the lever first toward the camera. Keeping it pressed, turn the upper part of the lever toward the magazine.

camera body when the two are detached. The rear of the H camera body has a curtain to protect the film in the magazine from exposure to light before and after the exposure is made. It opens — moves sideways — when the release is pressed.

Removing a Digital Sensor Unit

There are only two reasons for detaching the sensor unit from H3D camera models: for cleaning the outside surface of the IR filter and for attaching a film magazine to the H3D (not the H3DII). The sensor unit is therefore designed more like a part of the camera rather than a separate component that is changed constantly as is done in film photography. Removing the unit is purposely made somewhat more difficult with a special locking device that is completely hidden underneath the viewfinder. You cannot remove the sensor unit without first removing the viewfinder. After the viewfinder is removed, you will see a small black button on top of the sensor unit. That is the locking device. To remove the sensor unit, push this small black button toward the rear while pressing the center of the chrome button on the side of the sensor unit toward the camera and to the right. The sensor unit is re-attached by placing the grooves at the bottom of the sensor unit on the unit support on the camera body and firmly pressing the top of the sensor unit toward the camera body. Re-attach the viewfinder. Always attach the CCD/filter cover to the sensor unit when it is detached from the camera. Do not touch the infrared filter.

Magazine Settings

The film data programmed into the film magazine and shown on the display are transferred electronically into the camera system with the necessary power coming from the batteries in the camera when the magazine is on the camera. When the magazine is detached the data are retained by the power from a small CR-2032 3 V lithium battery located in the bottom plate of the magazine; you can see the battery cover after removing the film insert. To change the battery, insert a small coin into the battery cover and turn about 20 degrees counterclockwise and insert the new battery with the + polarity uppermost.

A battery should last one to two years depending on use. Because the power to an attached magazine comes from the camera, the magazine works properly even if the magazine battery is dead. The data programmed into the magazine, however, are not retained when the magazine is removed from the camera. Figure 4-6 shows the magazine programming controls.

Programming the Magazine Settings

Bar-coded films marked as Bar Code System B or EL (for easy loading) automatically tell the magazine whether it is 120 or 220 film and what sensitivity it has. The bar-code symbol also appears on the LCD display on the magazine (Figure 4-7). No settings need to be made but the magazine must be set to Bar Code mode, which is indicated by a small B symbol on the magazine LCD (see Figure 4-5). You can override the ISO of a bar coded film.

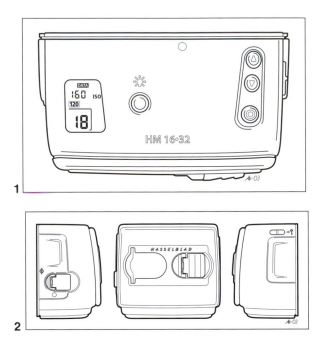

Figure 4-6 The magazine controls. (1) Illuminate the magazine LCD display on the left by pressing the Illumination button (the one with the light bulb icon). The function selector is at the bottom right, with the up/down controls above it. (2) The rear view of the magazine shows the film tab holder on the left and the film holder key on the right. The magazine settings lock is pictured on the right.

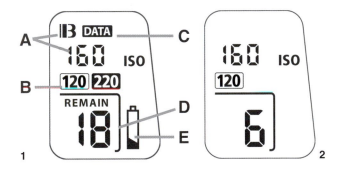

Figure 4-7 Magazine LCD display. (1) A: Film sensitivity and bar code; B: film length; C: data must be set to ON if imprinting is desired; D: frame counter, if REMAIN is set to ON, the frame counter shows the remaining number of exposures; and E: low battery symbol. (2) Example of display with film length and sensitivity set manually. Five frames have been exposed, and the battery is in good condition.

If you use film that does not have the bar code, you must program the type (120 or 220) and the film sensitivity into the magazine. Follow these steps:

1. Move the settings lock switch (item 9, Figure 4-1) on the side of the magazine to the unlocked position (toward the camera) covering up the white area.
2. Repeatedly press the Function Selector button until the desired menu FILM SPEED, FILM LENGTH, DATA, and FRAME COUNTER appears on the magazine LCD panel.
3. Set the correct values for each menu by pressing either the Up-Change button or Down-Change button until the desired values show on the magazine LCD panel.
4. After the settings are made, lock them by setting the lock control (item 9, Figure 4-1) in the direction of the arrow, away from the camera body so that the white area is visible. The locking button is also marked with a key symbol and an arrow, which might help you to remember that you lock the settings by turning the key in the direction of the arrow, moving the lever in the same direction. To illuminate the panel, press the Illumination button on the magazine. With the magazine attached to the camera, the LCD is illuminated when the Illumination button on the camera is pressed.

You can program the camera so that the ISO value does or does not show on the grip display as discussed in the section Custom Options found later in this chapter.

Setting the Frame Counter

You can set the frame counter in the film magazine to show either the number of the next frame to be exposed or the number of unexposed frames remaining on the roll of film. Set the desired mode before loading the film. With the setting lock control in the unlocked position, press the Function Selector button until REMAIN and ON or OFF appear. Press the Up or Down button to change between ON and OFF. ON indicates that the frame counter will count the remaining number of frames. Lock the setting by moving the setting lock in the direction of the arrow.

Because most cameras show the number of the next frame, your first thought is probably to do the same on the H camera. This approach works well if you always work with either 120 or 220 film. However, if you use the two film lengths interchangeably, it makes more sense to set the counter to REMAIN. If the counter shows 4, for example, you know you have 4 images left, whether you have 120 or 220 film in the camera.

Loading the Film

To load the film with the magazine on or off the camera, fold out the film holder key (item 48, Figure 4-1) and turn it 90 degrees counterclockwise. This allows you to remove the film holder. Remove the paper band completely from the new roll of film, and place the spool on the bottom side of the film holder (clearly indicated by an arrow pointing away from the spool), with the film rolling in the direction of the arrow. Place the take-up spool on the other side (clearly indicated by an arrow pointing toward the spool), again with the film entering in the direction of the arrow.

Slide the beginning of the paper leader into the slot in the spool as usual. I recommend that you manually wind the film one or two turns onto the spool before reinserting the holder into the magazine to ascertain that the film is firmly attached. Lock the insert with a clockwise turn on the film holder key (item 48, Figure 4-1). Open the darkslide curtain if necessary.

When the camera is turned on, the film winds automatically to frame 1, and the camera's motor drive automatically winds it to subsequent frames. It also automatically winds up the paper trailer at the end of the roll. If you do not want the film to wind automatically to frame 1, but when the release is pressed the first time, you can do so with a custom option described later in this chapter.

To change film, simply remove the film holder from a detached or mounted magazine and replace the exposed film with a new roll (Figure 4-8). If the film is not wound to frame 1 or for some reason an ERROR warning appears on the display and in the viewfinder, the camera cannot be released. To ensure proper film operation, I can make four suggestions:

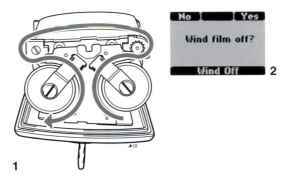

Figure 4-8 (1) Proper film path from feed reel on the right to the take-up reel on the left. (2) A partially exposed roll of film can be rewound and removed only after you confirm the message on the grip LCD panel.

1. Always insert the film holder by pressing it in the center toward the magazine shell (not on the left or right side) to assure that it is locked on both sides.
2. After you insert the loaded film holder and the camera is turned on, make certain that you hear the sound of the film wind for about two seconds.
3. Always check that the display on the camera, in the viewfinder, or on the magazine shows the number 1 (or the last frame number when set to REMAIN).
4. You can program the camera so that it operates only with film properly loaded. You do this with the magazine exposure lock as described under the custom options in Figure 4-24.

Imprinting the Film

The H camera allows you to imprint the dark area along each image with data such as the date and time when the image was made, the aperture and shutter speed, the metering mode, the photographer's name and copyright symbol, and other helpful data. To make certain that the imprint appears on the film, you must program the film magazine accordingly:

1. Unlock the setting lock lever (item 9, Figure 4-1).
2. Press the function selector repeatedly until DATA appears (see FIgure 4-7).
3. Press either the Up or the Down control until ON or OFF appears, and set to ON if you want to imprint data.
4. Place the locking lever into the locked position.

You now specify the desired imprint by watching the LCD display on the camera grip (shown in the next section, Camera Operation) and operating the controls around the display. You have six options for imprinting the film. Follow the steps below:

1. Press the Menu button next to the display, and turn the front wheel until SETTINGS appears.
2. Press the ISO/WB (Drive) control, and turn the front wheel until IMAGE INFO (Menu 4.2) appears.
3. Click Enter (Drive) control and turn front wheel if necessary to 4.2.1 IMPRINT TYPE. From here on, functions only work with a film magazine, not when a digital sensor unit is attached.
4. Click ISO/WB (Drive) control, and turn the front wheel to access six options for imprint combinations (Figures 4-9 and 4-10):
 - IMP.TYPE 1: Prints all relevant exposure information.
 - IMP.TYPE 2: prints basic exposure information aperture, shutter speed, and exposure correction.

Figure 4-9 The operating procedure for imprinting.

- DATE & TIME: Prints date and time only.
- TEXT & DATE: Prints the preset custom text and the date.
- TEXT & INFO: Prints the preset custom text and basic exposure information.
- TEXT: Prints the preset custom text only.

If you want to imprint only type 1 or type 2, select the type by turning either the front or the rear wheel, and then click the ISO/WB (Drive) button.

Text Setting

If you also want to imprint text, press Menu and turn the front wheel to SETTINGS, turn the front wheel to show TEXT (Menu 4.2.2), and click the ISO/WB (Drive) button, which brings up the text display. Turning the front wheel moves the cursor sideways, and turning the rear wheel moves it up and down. This allows you to choose the desired letters or symbols. The screen can show only three lines of characters at a time, but you can scroll up or down by

Figure 4-10 The various LCD displays for imprinting.

turning the rear wheel. The selected letter or symbol is highlighted and is saved by clicking the Sel (Select) (AF) button. The text string appears on the bottom of the screen. Proceed in the same way with any additional desired letters or symbols. Click the ISO/WB (Drive) button when you are finished.

To erase a character, place the cursor into the X box on the left by turning the front and/or rear wheel. Clicking the AF button now erases the figure, number, or the symbol highlighted on the Imprint line on the panel.

You can move the highlighted area in the Imprint line one character to the left or right by placing the cursor over either one of the arrow boxes on the left. Placing the cursor in the X box and clicking the AF button erases the highlighted character.

You can print a total of 37 characters in TEXT (including spaces) and a total of 32 characters in TEXT & DATE, or TEXT & INFO (Figure 4-11).

Imprinting Date and Time

To imprint the date and time, follow these steps:

1. Press Menu and select SETTINGS with the front wheel. Then press Enter (Drive). Turn the front wheel to DATE & TIME (Menu 4.3).
2. Press the Enter (Drive) button, and use the front wheel to move the cursor to mark hours, minutes, year, month, and day. Make the change by turning the rear wheel.
3. Press the ISO/WB (Drive) button to save the change.

With a sensor unit attached, you receive the message "set date and time on sensor unit."

Figure 4-11 LCD display for (1) imprinting date and time and (2) imprinting text.

The Instant Film Magazine

The instant film magazine HMi100 for the H camera has the Databus connections and a dial for programming the ISO value on the magazine. This magazine is basically attached and detached from the camera the same way as other film magazines. It also has a darkslide with a clearly marked handle in bright red that must be removed to take a picture. The darkslide must be inserted when the magazine is removed from the camera.

CAMERA OPERATION

Activating the Camera

The controls for activating the camera are on top of the camera grip, with the information visible on the LCD display (see Figure 4-12). You activate the H camera by pressing the ON/OFF button next to the LCD display for half a second. This puts the camera in the Standby mode with the LCD display showing the H camera logo followed automatically by the ON mode. After 10 seconds (or whatever time is programmed into the camera with the custom option) the camera goes back into the Standby mode. Clicking the ON/OFF button, the Stop Down button (item 22, Figure 4-1), or depressing the release (item 19, Figure 4-1) halfway always changes the camera back to the Power On (Active) mode with the Home screen showing the standard information display. Leaving the camera in Standby mode, instead of turning it off completely, allows you to reactivate the camera instantly during a shoot. You can illuminate the LCD display on the grip by pressing the Illumination button (the one with the light bulb symbol). The light goes off automatically when the camera goes into Standby mode or when the button is pressed again.

The length of the time the camera remains in the Active (Standby) mode can be changed from 5 to 30 seconds as described later in the Custom Options section. A longer standby cycle naturally uses more battery power. To save battery power even more when the camera is stored or not used for some time, turn it off by pressing the ON/OFF switch for half a second.

Figure 4-12 The operating buttons around the grip LCD panel (clockwise from upper left): Flash/Exit, AF/ON, ISO/WB (originally called the Save (Drive) button), Menu, Illumination/Battery Status (originally called the Illumination button and has a light bulb symbol), On/Off/Profiles/Esc, and the rear control wheel (item 13, Figure 4-1) at the rear of the grip. The Shutter Release button (item 19, Figure 4-1) is on the top with the front control wheel (item 18, Figure 4-1) behind it.

The Camera Operating Controls

All the major controls necessary for operating the camera and programming information into the camera are grouped around the LCD display on top of the camera grip where they can be operated conveniently with one hand. The controls are as follows.

The Shutter Release button (item 19, Figure 4-1), when pressed halfway, activates the focusing and metering systems. Pressing the release halfway always saves a change and returns directly to normal operation (the Home screen). Fully pressed, it makes the exposure or turns on the self-timer or interval timer and moves the film to the next frame (unless the camera is set for multiple exposures).

The controls are, starting from the upper left: Flash; AF; Drive (called the ISO/WB button on the H3DII cameras), which is used mainly to lock all the settings; Menu; the Illumination Button; and ON/OFF. The Flash button brings the Flash menu on the screen (described in more detail in the section Flash Photography). It also brings up the ISO for digital imaging, which is changed with the front wheel and the color temperature, which is changed with the rear wheel. The control is sometimes indicated on the screen by the word EXIT because

it is also used to exit a setting without saving the changes. If the button is pressed one second or longer, a beeper (if turned on) will be heard, indicating that all buttons and control wheels (except release) have been locked and cannot be changed. To unlock them, press the button again for one second or longer. The AF button, in addition to other functions, allows you to select the focusing mode, as described in detail later in the section Focusing the H Camera. The Drive button (ISO/WB button on H3DII models) also indicated on the screen with SAVE, serves various functions, but is used mainly to save functions programmed into the camera. The front control wheel (item 18, Figure 4-1) controls the commands in the upper part of the LCD screen indicated by sideways-pointing arrows. It also lets you make changes in the aperture/shutter speed combination while maintaining the EV value, thus not changing the exposure in A, S, P, and Pv modes. The Menu button allows access to the menu settings.

Pressing the control with the light bulb symbol illuminates the display on the camera and magazine. It turns off when the button is pressed again, when the camera goes into Standby mode, and when it is turned off. The red ON/OFF button, also marked Profiles/Esc, activates the camera when pressed for half a second. To turn the camera completely off, press the button again for at least half a second. Clicking the button in the Home screen allows access to the Profiles screen. If a function in the camera (such as a long exposure or self-timer) is active, this button escapes from the function and returns the LCD display directly back to the Home screen. Finally, the rear control wheel (item 13, Figure 4-1) controls the setting information on the lower part of the screen indicated by up or down-pointing arrows. It also allows changes in the exposure settings for manual bracketing.

The H3DII Operating Controls

The operating controls on the H3DII camera are located in the same positions and operate basically the same way with a few exceptions. What used to be called the Drive control on the display panel is now indicated as the ISO/WB button because it can also be used to set the ISO and the White Balance setting here instead of on the sensor unit. The control is, however, still used to lock and save settings. The illumination control with the light bulb is now known as the Illumination/Battery status control. When holding down this button, a full screen image will appear that shows the firmware version and the number of exposures taken since the last battery recharge or change. This gives you an idea of how many more exposures can be made before re-charging is necessary. At the bottom of the screen, there is a battery symbol with the amount of charge shaded within the battery indicated as a percentage. The Low Battery warning has been replaced with a Replace Battery warning (see Figure 4-2).

Preparing the Camera for Operation

Before you photograph with the H camera, you should set the desired Drive mode, the focusing, the light metering, and the Exposure mode to match your desired photographic approach for your subject.

Setting the Drive Mode

On H3DII cameras, press MENU and then use the front wheel to select Drive. This gives you the same Drive modes as described below for the other camera models.

On the other H camera models, the three options (see Figure 4-13) are set as follows:

1. After activating the camera, click the ISO/WB (Drive) button, and turn the front wheel until you see SINGLE, CONTINUOUS (also MULTI EXP on original models only) on the display.
2. Lock the chosen setting by pressing the ISO/WB (drive) button. The original camera models had a Multi Exposure mode which is not seen in later models because the Multi Exposure mode cannot be used with digital cameras or digital backs. Double and multiple exposures today are made in the computer not in the camera.
3. In the Multi Exposure mode, you set the number of images that should be superimposed by turning the rear wheel. For a double exposure with two images, turn the rear wheel to number 2. The camera makes the first exposure without advancing the film but will advance the film after the second exposure or whatever number was programmed into the camera. If the programmed multiple exposure drive mode is no longer desired, click the Esc (ON/OFF) button.

Figure 4-13 The grip LCD display for single exposures (left), for continuous operation (center), and for multiple exposures set for three exposures (right).

Releasing the Camera

Before taking a picture, you also must decide whether the exposure should be made with the release on the camera, with the built-in self-timer, or in the Interval mode. Pressing the Release button halfway focuses the lens if the lens is set to Auto Focus. If it is set to AF-S mode, the focus will also be locked as long as you keep the release pressed halfway. Pressed halfway also saves any settings and returns the LCD display to the Home screen. When you press the release completely, the picture is taken and the film is advanced to the next frame (unless the camera is set for multiple exposures).

Before you make the exposure, I suggest that you check, whenever possible, that the aperture and shutter speed shown in the viewfinder and on the display produce the desired results.

The camera can also be released using a 0.5 m (20 in.) accessory release cord attached to the release cord socket (item 21, Figure 4-1).

Operating the Self-Timer

The self-timer built into the H camera can be programmed for the desired delay time from 2 to 60 seconds. It can also be programmed so that the mirror lifts up the moment the release

is pressed or just before the exposure is made. The camera can be set so that the mirror goes down or stays up after the exposure.

The programming procedure is as follows (see Figure 4-14):

1. Click the Menu button, and turn the front control wheel until SELF-TIMER appears on the display. Click the ISO/WB (Drive) button, and use the front wheel to select the left icon and the seconds figure. Turn the rear wheel to the desired delay in seconds.
2. Turn the front wheel to select the middle icon, and you will see DELAY MIRROR UP or MIRROR UP DELAY. Turn the rear wheel to the desired mode, and press the ISO/WB (Drive) button to lock it. In MIRROR UP DELAY, the mirror lifts up the moment the release is pressed, which is the best assurance for eliminating the possibility of camera vibration. If you like to see the image as long as possible, set it to DELAY MIRROR UP. The mirror lifts up just before the exposure is made.
3. Turn the front wheel to the right icon and either MIRROR GOES DOWN or MIRROR REMAINS UP. Select the desired mode by turning the rear wheel, and lock it by clicking the ISO/WB (Drive) button. In MIRROR GOES DOWN the mirror returns to the viewing position after each exposure. When set to MIRROR REMAINS UP, it stays up for subsequent self-timer operation. Click the MUP (Mirror Up) button (item 24, Figure 4-1) to bring the mirror down.
4. When the self-timer is programmed, press the AF (ON) button to activate the self-timer function. When you press the release, the exposure is made with the self-timer at the set delay. Pressing the button again will deactivate the self-timer, which is indicated at the bottom of the screen. The self-timer can also be activated by double-clicking (within one second) the MUP button or by programming the User button to activate the self-timer. The self-timer is deactivated after use unless it is programmed to remain in the camera, as described in the section Custom Options. To stop a self-timer sequence in progress, click the Esc (ON/OFF) button.

Figure 4-14 shows a sample program for a self-timer operation, and Figure 4-15 shows the mirror controls.

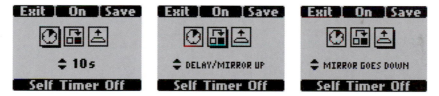

Figure 4-14 Self-timer operation on the LCD display set for a 10-second delay (left), for the mirror to lift after the delay and just before the exposure is made (center), and for the mirror to go down after the exposure (right).

Interval Exposures

The H camera also allows you to take sequences of pictures automatically at preset intervals from 1 second to 24 hours (time-lapse still photography). Follow these steps (see Figure 4-16):

1. With the camera set on a sturdy tripod, press the Menu button and turn the front control wheel to INTERVAL. Now press the ISO/WB (Drive) button, and turn the front wheel to the number of exposures. Set the desired number by turning the rear wheel.

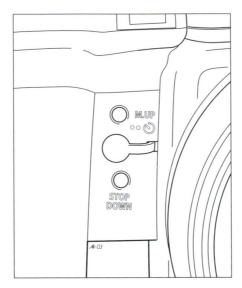

Figure 4-15 The controls at the front of the camera (from top to bottom): Mirror Up button, (item 24, Figure 4-1), release cord socket (item 21), and Stop Down button (item 22).

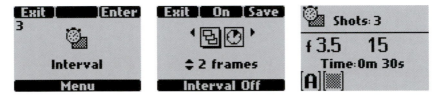

Figure 4-16 Grip LCD display for interval exposures (left) and programmed for two frames (center). The display with three frames remaining in a sequence of one frame every 30 seconds made in the Automatic (A) mode with average metering (right).

2. Turn the front wheel to the interval duration, the clock.
3. Turn the rear wheel to the desired interval from 1 second to 24 hours.
4. Click the ISO/WB (Drive) button.
5. Activate the setting by clicking the ON (AF) button, and start the sequence by pressing the release. An interval setting can be stopped in mid-sequence by clicking the Esc (ON/OFF) button.

PHOTOGRAPHING WITH THE H CAMERA

Customizing Your Camera with Custom Options

Although the H camera is ready for photography without any further instructions, I recommend that you study the custom options before you start working with the camera (see the section Custom Options later in this chapter). You will undoubtedly want to use some of

these options to make the camera operations ideal for the way you like to photograph specific subjects. Some custom options allow you to put data on the display that might be helpful. Other options provide easy manual bracketing or allow easy and instant locking of a spot meter reading so that you can re-compose without a change in the exposure setting.

You will probably program some of these options, such as those that apply to the metering and focusing mode, into the camera and leave them there for all your photography. Others you may program for specific cases only.

FOCUSING THE H CAMERA

Focusing Options and Settings

The focusing area for the automatic focusing system in the H cameras is clearly indicated by a small rectangular area within the spot meter circle in the center of the focusing screen. In Auto Focus, you point this focusing area at the part of the composition on which the lens must be focused. The focusing system has only one focusing area and the area is small to allow you the most precise focusing for the most important subject area in your photographs.

Automatic focusing with the H cameras can be programmed for either Single or Continuous mode. In Single-shot mode (AF-S), the shutter release is blocked until the lens has time to focus on the center area. Because the automatic focusing in the H cameras is extremely fast, this setting is not likely to cause an objectionable delay in any situation, therefore AF-S is a good choice for most photography. In Continuous mode (AF-C), the shutter can be released instantly for instant pictures, which you may want to consider in action photography.

The desired focusing mode is set as follows with the camera in the active mode:

1. Press the AF button on top of the display.
2. Turn the front control wheel to either Manual (MF), Single-shot (AF-S), or Continuous (AF-C) mode. Press the ISO/WB (Drive) button.

Precise focusing in dim light or with low-contrast subjects is best achieved with the AF assist light. As described in the section Custom Options, the red AF assist light can be programmed so that it is always used in the camera or so that the assist light is used in an external flash. The latter may be preferable because it is located farther away from the camera and is more powerful. It can also be turned off if it is objectionable to the people in front of the camera.

The LED Focus Aids

A correct focus setting, whether done manually or automatically, can be indicated in the viewfinder with two LEDs in the shape of arrowheads (Figure 4-17).

This option can be changed as described in the section Custom Options. It gives you the option of programming the camera so that the LEDs are always visible, are visible only when the release is pressed halfway (the default setting), or are never visible. If a lens is not focused

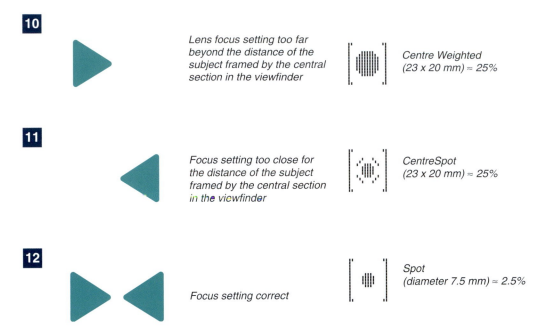

Figure 4-17 Focus aids. The Focus aids in the viewfinder show whether the focus setting on the lens is beyond the subject distance (top, #10) too close (middle, #11), or correct (bottom, #12).

properly in the Manual mode, only one arrow is lit, indicating in which direction to turn the focusing ring. Proper focus is achieved when both LEDs are lit. Flickering of the LEDs indicates that proper focus is not possible, perhaps because the subject is beyond the minimum focusing distance of the lens. In the Automatic Focusing mode, both arrows are lit when the camera has locked focus, and both arrows are flashing when the camera cannot find focus.

Automatic Focusing

Using the Automatic Focusing mode is recommended not only because it is fast and convenient, but because it is more accurate than the manual approach. You must realize that the lens will always focus on the subject area within the focusing area in the center of the composition. This produces good results in many cases. In many compositions the main subject may not be in the center but placed toward one side or the top or bottom of the image. In such cases you cannot let the camera decide where to focus. Instead, you must make this decision and focus on a specific subject area. The H cameras let you do this beautifully in two ways while maintaining the precision and speed of the Automatic Focusing mode.

Locking a Focus Setting with the Release In this approach, you point the focusing area at the desired subject area anywhere within the composition. Press the release halfway, and keep it pressed while you move the camera for the final composition in the viewfinder; then press

the release completely. The distance setting is maintained as long as the release is pressed halfway. If you remove the pressure on the release button purposely or accidentally and press the release again, the cameras will focus on the new subject in the focusing area. After the picture is taken, the distance setting is no longer locked and adjusts to whatever subject area is in the center of the composition. If you want to maintain the focus setting for several pictures, you need to keep the release in the halfway position between exposures which is impractical.

If you want to maintain the focus setting for a number of exposures of the same subject or the same location — perhaps to bracket daylight or flash exposures or to end up with different poses of a model — you have another, better option with the AF drive.

Setting the User Button to AF Drive Figure 4-18 shows the controls at the rear of the camera grip including the User button. This is used in this Focusing mode and is my favorite focusing approach in outdoor photography.

You can set this focusing option using the following shortcut:

1. Depress the AF button, set the camera for manual focus (MF), and lock with the ISO/WB/(Drive) button.
2. Click the Menu button and then the User button on the rear part of the camera grip.
3. Turn the rear wheel to AF DRIVE.
4. Click the ISO/WB (Drive) button, or press the release halfway.

Although the camera is set to manual focus, focusing is automatic when you press the User button.

Figure 4-18 The controls at the rear of the camera grip (from top to bottom): the AE Lock (AE-L) button, the button for rewinding partially exposed film, and the User button.

To focus a lens, point the measuring area at the desired subject part and click the User button. The lens now focuses automatically on that part of the composition and locks the setting automatically. You can now move the camera to re-compose the image and press the release to take the picture. The focus setting stays locked until you press the User button again to focus on something else. This option maintains the fast, precise, Automatic Focusing mode while giving you the opportunity to decide on the focusing area within the composition. To get out of this mode, change from Manual to Automatic Focusing mode. If the User button does not work as mentioned, it may have to be programmed accordingly.

Ultra-Focus

When working with the H camera models, focusing the lens with the automatic focusing system is highly recommended as it is unquestionably more accurate than manual visual focusing. This is especially true for digital work since the sensors in the H cameras are covered by a protective glass and an infrared filter, both of which create a slight change in the focus setting. In Ultra-Focus, automatic focusing also makes the focus setting for the aperture that is going to be used for the picture. Again, this may be slightly different from the focus setting at the maximum aperture. While these variations are small, the automatic focusing system in the H cameras (known as Ultra Focus) assures the best possible focus setting with any lens used at any aperture.

Focusing Override

There are undoubtedly cases when you may want to make a manual adjustment on the automatic focus setting; for example, to change the depth-of-field range toward the front or back of the focused distance. With a fence leading to a house some distance away, you want the house sharp but also want as much depth-of-field as possible in the front. To achieve this effect, you can let the camera focus automatically on the house but then adjust the focusing ring manually toward the closer distances to place the house close to the end of the depth-of-field range while keeping a good part of the fence acceptably sharp.

When working from a tripod with a composition where the main subject is not in the center area, you may find it more convenient to leave the camera set up for the desired composition and focus on the main subject manually instead of turning and moving the mounted camera to bring the focusing area over the main subject.

Both of these problems can be solved with manual focusing. The H camera, however, offers a better solution — the Manual Override option — which eliminates the need for switching from the Manual to the Automatic Focusing mode and vice versa. With the camera left in Automatic Focus, you can manually override and adjust the distance setting on any lens.

In the first example, let the camera focus automatically on the building by pressing the release halfway; keeping the release pressed halfway, turn the focusing ring manually to the desired distance. Press the release completely to make the exposure. In the second example, with the camera set to Automatic Focus, press the release halfway, focus the lens manually for the main subject, and then press completely to make the exposure. You must keep in mind that in Manual Override, the camera is still set for automatic focusing (AF-S or AF-C), so you must keep the release pressed halfway while refocusing. If instead you let the release go and press it again halfway, a new focusing cycle starts.

Manual Focusing

Because the Automatic Focusing system focuses more accurately and faster than most photographers can do manually, I see little reason for using the Manual focusing mode. The H camera, however, offers the option of manual focusing, and the LED focusing aids make manual focusing accurate. This is something to be appreciated, especially by photographers who have problems focusing a lens visually.

Depth-of-Field

In many cases, the focus setting and the lens aperture must be made based on the desired depth-of-field. All H lenses, except for the zoom, have depth-of-field scales. The use of these scales and the setting of the focusing ring are discussed in Chapter 16. To set the lens for a specific depth-of-field range, focus (manually or automatically) on the closest subject to be sharp and then read the distance on the lens. Do the same for the subject at the longest distance. Then set the focusing ring accordingly, either manually or with the manual override.

METERING AND EXPOSURE CONTROLS

The H Camera's Metering Modes

The Metering mode refers to the method of taking the meter reading of the subject or scene. For more details read Chapter 15. The H cameras give you a choice of either average metering, now indicated as CentreWeighted, center area metering now indicated as CentreSpot, or true spot metering indicated as Spot in the later cameras.

The set mode is always indicated in the viewfinder and on the grip LCD display and can also be imprinted on the film. The subject areas measured in each approach are shown in Figure 4-19. The spot area is also engraved on the camera's focusing screen. The mode is naturally based on personal preferences. Most of my readings are made in the Spot mode where I can see on the focusing screen exactly what area is measured. Sometimes I switch to the CentreSpot mode.

Setting the Metering Mode

To set or change the metering mode, proceed as follows:

1. Click the Exposure Mode button (item 3, Figure 4-1) on the viewfinder.
2. Turn the rear wheel until the desired Metering mode and symbol appear on the display.
3. Press the ISO/WB (Drive) button to lock the setting.

Exposure Modes

"Exposure mode" refers to the way the meter reading is transferred to the aperture and shutter speed settings. You can set the H camera for either manual exposure (M) or automatic exposure, Program (P) or Program Variable (Pv), or Aperture Priority (A) or Shutter Speed Priority (S).

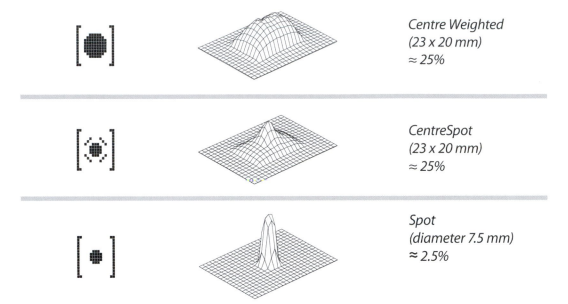

Centre Weighted
(23 x 20 mm)
≈ 25%

CentreSpot
(23 x 20 mm)
≈ 25%

Spot
(diameter 7.5 mm)
≈ 2.5%

Figure 4-19 Metering areas. This diagram shows sensitivity distribution with an HVD 90× finder. CentreWeighted (top) on a 23 × 20 area (25%), CentreSpot (middle) also on a 23 × 20 area but concentrated on the center area, and Spot (bottom) in a 7.5 mm area, about 2.5% of the total area. The three metering modes are indicated with the symbols shown on the left for CentreWeighted (top), CentreSpot, and Spot (bottom).

Setting the Exposure Mode The desired exposure mode is set as follows:

1. Press the Exposure Mode button (item 3, Figure 4-1).
2. Turn the front control wheel until the desired mode appears on the display.
3. Press the ISO/WB (Drive) button.

The selected aperture and shutter speed are shown in all modes in the viewfinder and on the grip LCD display. In all automatic exposure modes, you can change the selected aperture/shutter speed combination in an interlocked fashion without changing the EV value and thus the exposure. This is done by turning the front wheel.

The Programmed (P) and Programmed Variable (Pv) Modes In both programmed modes, the camera selects both the aperture and the shutter speed that its electronic brain considers best for that particular light situation. This point-and-shoot approach provides amazingly accurate results in many cases. It can certainly be considered for fast candid shooting when there is no time for a manual selection of aperture and shutter speed, and when subjects are of more or less average brightness and without a mixture of large shaded and brightly lit areas.

The Pv mode is identical to P but selects aperture and shutter speed based not only on the subject brightness but also on the focal length of the lens on the camera. For example, it

avoids longer shutter speeds for longer focal length lenses. This is the recommended setting for exposure automation if you work with different focal length lenses. The P and Pv modes should be used only with the camera set for CentreWeight or CentreSpot metering.

Shutter Speed Priority (Shutter Pr) or (S) Mode The electronically controlled shutter speed range of the central shutter in the H camera lenses is from $\frac{1}{800}$ second to 18 hours, including B and T modes. Shutter speeds are indicated on the display and in the viewfinder with an "s" when the speeds are longer than one second (2s means two seconds); for fractions of a second there is no "s" (30 means $\frac{1}{30}$ second).

In the Shutter Priority mode, you select the desired shutter speed by turning the front control wheel. The camera selects the aperture that provides the correct exposure for the metered area. Shutter Speed Priority is the recommended mode when you are photographing moving subjects, where the shutter speed determines how moving subjects are recorded in the camera. You may also want to consider Shutter Priority for handheld photography, which gives you the opportunity to set a shutter speed that is short enough to reduce or eliminate blur caused by camera motion. Such shutter speeds can be relatively long because the H camera is beautifully designed for handheld work, providing good camera steadiness at relatively long shutter speeds. I have obtained pictures with beautiful sharpness at shutter speeds that I have not dared to use for years, such as $\frac{1}{30}$ second and even $\frac{1}{20}$ second with an 80 or 110 mm lens.

Aperture Priority (Aperture Pr) or (A) Mode Because the depth-of-field range must be considered in many images, Aperture Priority (A) mode is a logical approach for most photography. The A mode allows you to preset the aperture to a value that produces the desired depth-of-field. You set the desired lens aperture by turning the front control wheel. The camera then selects the appropriate shutter speed. Aperture Pr mode is also a good choice because the camera sets the shutter speeds much more accurately than the $\frac{1}{2}$ or $\frac{1}{3}$ increments possible in Manual mode.

With the function and operation of the automatic exposure modes so beautifully designed, I personally see no good reason for using the Manual mode. It does, however, exist in the camera. When working in the Aperture Priority mode, I suggest that you always check the set shutter speed before releasing the shutter. This is especially recommended in hand-held photography making certain that the set speed is short enough for possible camera movement.

Manual Exposure Mode (M) In the Manual mode, you set the aperture by turning the front control wheel, and you set the shutter speed by turning the rear control wheel. For correct exposure, you turn either the front or the rear wheel (or both) until the pointer over the exposure scale in the finder is positioned above the central index. The deviations to the left or right are indicated in $\frac{1}{3}$ EV values on the scale. In the Manual mode, aperture and shutter speed settings are and remain locked.

Figure 4-20 illustrates various operating and exposure settings on the grip LCD panel, and Figure 4-21 shows the operating and exposure information on the viewfinder display.

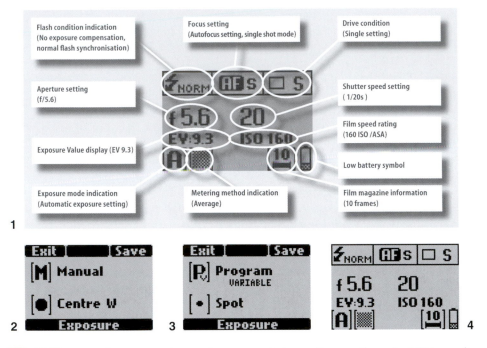

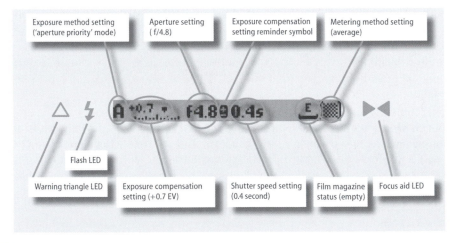

Figure 4-20 (1) The complete operating and exposure information on the grip LCD panel. (2) The camera is set for manual exposure in the center weighted mode. (3) The camera is set for programmed variable exposures in the spot metering mode. (4) The camera is set for automatic focusing and automatic exposures in the average metering mode with either frame 10 coming up or 10 exposures left on the roll, depending on how the magazine is programmed.

Figure 4-21 The operating and exposure information on the viewfinder display.

Metering Approaches

In all automatic exposure modes, the lens settings change as the camera's metering area is moved to darker or lighter subject areas. This is ideal in fast candid shooting or when you are following moving subjects. This change in the lens settings happens while you compose and before you take a picture and again after the picture is made.

In more critical work or whenever you have time for a more complete subject evaluation, you probably want to determine what the exposure should be rather than let the camera make this decision for you. You probably want to base the meter reading on specific subject areas discussed in detail in Chapter 15, and not necessarily on what happens to be in the center of the composition.

A practical and fast metering approach in the CentreSpot or Spot metering mode is as follows:

1. Evaluate the subject or scene, and check whether there are areas of average brightness (18% reflectance) and also receive the amount of light that looks appropriate for correct exposure.
2. If you find such areas, point the metering area at that part of the subject or scene and take the meter reading. You can press the AE Lock button to lock the setting so you can re-compose and take the picture.
3. If there are no areas of average brightness, measure a darker or lighter area and compensate.

Complete details about exposure, metering, and subject brightness are found in Chapter 15.

Locking the Exposure

In many cases, the subject area that you measure in the CentreSpot or Spot metering mode is not in the center of the composition so you must move the camera to re-compose. Before doing so, you want to lock the exposure setting. This is easily done by pressing the AE lock at the rear of the camera grip before you move the camera. A locked setting is indicated in the finder and on the display by an L between the aperture and shutter speed indications. You unlock the setting by pressing the same button again. If the AE Lock does not work as described, it may have to be programmed accordingly. To change the locked aperture and shutter speed settings without changing the EV (exposure), turn the front control wheel.

Because the settings are unlocked after the exposure they require a new meter reading. This approach works fine when you are taking only one picture in a specific location. When you are taking many pictures in the same location and the same light, as is usually the case when you are photographing people or animals, I suggest using the Permanent Locking mode described under custom option AE LOCK and QUICK ADJUST, and then turn the rear wheel to Saved. Make the meter reading as suggested by pointing the measuring area at the selected part in the composition, and then click the AE Lock. Re-compose and take the picture. The locked exposure and any exposure adjustments that are made with the rear wheel are not reset when you release the camera. You can unlock the settings by pressing the AE Lock button again.

Locking Exposure Values in the Spot Metering Mode

In the Spot metering mode, there is another way to lock lens settings without the need for relocking the exposure after each picture. This is done by programming custom option SPOT MODE into the camera. Follow these steps:

1. Set the camera to CUSTOM OPTIONS. Turn the front wheel to SPOT MODE.
2. Turn the rear wheel so the display shows ZONE (not NORMAL) at the bottom.
3. Lock the setting by pressing the ISO/WB (Drive) button.
4. You now take the meter reading by pointing the spot meter area at the part of the subject that you want to measure. Press the AE Lock, which sets and locks the setting and shows ZONE 5 on the display and viewfinder. Re-compose and take the picture.
5. Proceed the same way for the next picture. If desired, you can place the reading into a different zone — for example, Zone 7 for a reading of white snow — by turning the rear control wheel. You can also point the spot meter area with the locked setting at other subject areas. The display then shows the deviation in zone values so that you know the difference in subject brightness. For example, a Zone 4 reading indicates that the new area is one EV value darker. If you want to use the spot meter without this locking approach, set the SPOT MODE to NORMAL (the default setting).

Exposure Compensations

To make all the exposures somewhat darker or lighter in Manual or Automatic Exposure mode, you can program an exposure compensation from –5 to +5 EV values into the camera. Proceed as follows:

1. Press the Exposure Compensation button (item 4, Figure 4-1) on the viewfinder.
2. Turn the front or rear control wheel until the desired adjustment value is visible on the display.
3. Press the ISO/WB (Drive) button. The adjusted value is visible in the viewfinder with a + or – indication.
4. Click the Exposure Compensation button on the finder, and set the value to zero if you no longer want the compensation, or as a shortcut to setting the value to zero, press the AF button. You can also input a temporary exposure adjustment in any of the automatic modes by turning the rear wheel with the amount of the adjustment shown on the scale in the viewfinder LCD display. It can be programmed as a fixed adjustment by setting custom option AE LOCK and QUICK ADJUST to SAVED.

Exposure Bracketing in Digital Imaging

In digital imaging, the exposure obtained with a specific lens setting can be seen on the histogram and on the display screen and can be adjusted immediately. The Bracketing mode is seldom used, but it is still an important control in film photography.

Manual Exposure Bracketing

In the Manual exposure (M) setting, you can bracket exposures by changing either the aperture or the shutter speed manually. The deviation from normal exposure is shown on the display and in the viewfinder with a + or − value adjustment.

In all automatic light measuring modes, you can bracket by using the rear control wheel, only if the wheel function is programmed appropriately. This is done with custom option, REAR WHEEL and QUICK ADJUST. Program this option into the camera as described under the section Custom Options. Turn the rear wheel to YES (the default setting). Save the setting by clicking the ISO/WB (Drive) button.

Turning the rear control wheel now adjusts the exposure by changing the aperture only in Shutter Priority mode (S) and changing the shutter speed only in the Aperture Priority (A) setting. Set to programmed (P) or (Pv); the camera will decide which one to change. In all cases the adjustments are indicated as + or − on the display and in the viewfinder. Because the indications appear in the viewfinder, you can bracket without removing your eye from the finder.

Automatic Exposure Bracketing

Automatic exposure bracketing in ⅓-, ½-, and 1-stop exposure increments on up to nine frames on the H3D models (up to five on earlier models) can also be programmed into the camera (Figure 4-22).

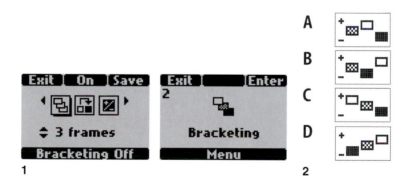

Figure 4-22 (1) The grip display for automatic bracketing. (2) The bracketing sequence options: A, Normal/over/under; B, Normal/under/over; C, Over/normal/under; and D, Under/normal/over.

With the camera set to the Continuous Drive mode, the exposures are made automatically while the release is kept pressed, and the camera stops when the cycle is completed. In the Single-frame mode, the bracketing cycle is made by pressing the release for the number of frames. If you no longer need or want automatic bracketing, click the Esc (ON/OFF) button. If you do not do this, exposure bracketing stays programmed in the camera and subsequent pictures will be made with the programmed bracketing compensation rather than the exposure determined by the meter. This is true even if the pictures are taken in a completely different location and after the camera has been deactivated.

Programming Automatic Bracketing

To program automatic bracketing, follow these steps shown in Figure 4-23.

1. Click the Menu button and turn the front wheel until BRACKETING appears.
2. Click the ISO/WB (Drive) button, which brings up the three bracketing symbols on top of the display. Select the leftmost icon, and turn the rear wheel to set the desired number of frames.
3. Select the middle icon with the front wheel and change the desired exposure sequence with the rear wheel.
4. Select the rightmost icon with the front wheel, and change the desired amount of exposure adjustment.
5. Click the AF button. The status line at the bottom of the LCD will now show BRACKETING ON.
6. Click the ISO/WB (Drive) button to lock. To go back to normal operation, click the Esc (ON/OFF) button.

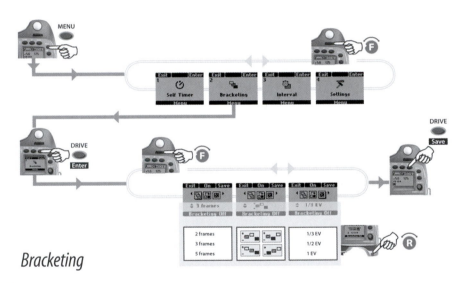

Figure 4-23 The operating sequence for automatic bracketing.

OTHER OPERATING AND IMAGE CREATING CONTROLS

Manual Diaphragm Stop Down Control

As with all SLR cameras, the lens diaphragm is normally wide open to produce the brightest image on the focusing screen. In many situations, you may want to evaluate the image as it will be recorded at a smaller aperture to see the amount of blur in foreground and background areas.

You can do this by using the manual Stop Down button (item 22, Figure 4-1) at the front of the camera. Pressing the button closes the aperture to the preset value. The aperture stays

closed until you release the button. If the control does not work as described, it may have to be programmed accordingly.

The Mirror Lock-Up Control

Normally, the mirror flips up when you press the release and goes back into the normal viewing position after the picture is made. As with all SLR cameras, it is recommended that you lock the mirror up for longer exposures with a tripod-mounted camera. This is done by depressing the MUP button at the front of the camera.

In the locked-up mirror position, the shutter in the lens is closed, the aperture is closed, and the rear auxiliary shutter is open. A locked-up mirror is still locked up after an exposure and must be brought into the normal viewing position by clicking the Mirror Lock-Up button again. If the MUP button does not work as described, it may have to be programmed. MUP custom option must be set at MIRROR UP.

While the mirror lock-up option is a good choice when working from a tripod, it must be mentioned that the extremely smooth shutter operation in the H camera reduces the need for this procedure. This allows photography from a lightweight tripod or monopod at slow shutter speeds of $\frac{1}{15}$ or $\frac{1}{8}$ second with standard lenses if the tripod or monopod is used as described in Chapter 1.

CUSTOM OPTIONS

Setting the Options

H cameras give you the possibility of programming custom options that allow the camera to operate and perform many functions based on your personal preference and specific photographic approach thereby simplifying your photography. This gives you more time to concentrate on creating effective images instead of worrying about technicalities and camera operations.

The custom options can be accessed in two ways. Here is the first:

1. Press the Menu button.
2. Turn the front control wheel to SETTINGS.
3. Click the ISO/WB (Drive) button and turn the front wheel to CUSTOM OPTIONS.
4. Click the ISO/WB (Drive) button. Turning the front wheel now brings the options to the screen.

You can accomplish the same thing in a somewhat faster way as follows:

1. Press the Menu button.
2. Press the User button, which brings up a custom option User Button Function.
3. Turning the front wheel now brings up all the other custom options (see Figure 4-24).

You change or set the options at the bottom by turning the rear wheel. After programming any option, you must save it by clicking the ISO/WB (Drive) button. You can, however, change

more than one option before you press Save. Each programmed option remains in the camera until it is changed.

Options in Different Camera Models

The options vary somewhat depending on the H camera model. The list in Figure 4-24 shows first the options that were in the original H1 camera and are also in the newer models followed by options that are only in newer models. Some of the newer options are shown in Figure 4-25. The change that was made on the H3DII is described in the next section. Also note that some options appear on the H3D models only if a film magazine is attached and

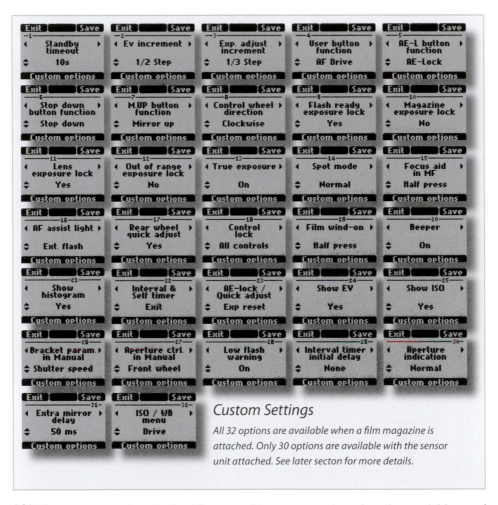

Figure 4-24 The custom option display. There are 32 custom options, but the available number depends on the camera model and whether a film or digital magazine is on the camera.

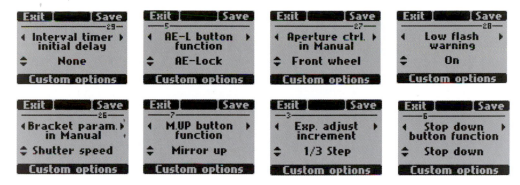

Figure 4-25 New custom options. Custom options found in newer H camera models.

some only with a digital sensor unit on the camera. These exceptions are clearly indicated in the list of custom options.

Use and Application of the Custom Options

- **Standby Timeout**: Allows you to set the length of time that the camera remains in the active state from 5 to 30 seconds. Ten to 15 seconds is a good time. Do not set to NONE because it drains the battery excessively.
- **EV Increment**: Gives you the choice of making aperture and shutter speed settings in intervals of either $\frac{1}{3}$, $\frac{1}{2}$, or 1 EV value.
- **User Button Function**: Allows you to select and program into the camera one specific camera function that you use often in your photography: for example, automatic bracketing or mirror up. You can then access this particular operation instantly by simply pressing the User button at the rear of the camera grip. The various User button options are listed later in this chapter.
- **Control Wheel Direction**: Lets you set the direction to CLOCKWISE or ANTI-CLOCKWISE, which then determines how the various settings change when you turn the control wheels; for example, whether the aperture values go up or down when you turn the wheel one way.
- **Flash Ready Exposure Lock**: When set to YES, locks the shutter so that it does not release until a flash unit, used in a dedicated fashion, is fully charged. This works only with the built-in flash and dedicated flash units attached to the hot shoe, not to the PC connection.
- **Magazine Exposure Lock** (Film Exposure Lock): In H3D only with film magazine attached. When set to YES, prevents the shutter from being released if there is no film in the magazine. This option also shows the signal NO FILM on the display.
- **Lens Exposure Lock**: When set to YES, prevents the camera from being released without a lens on the camera. The LCD display also shows NO LENS.
- **Out of Range Exposure Lock**: When set to YES, prevents you from taking pictures when the parameters (aperture and shutter speed) are outside the possible range.
- **True Exposure**: The actual amount of light that falls on the image plane from the opening and closing of a central shutter depends slightly on the size of the lens aperture. The True Exposure ON setting compensates for such variations and provides the most precise exposures at any aperture and shutter speed combination.

- **Spot Mode**: When set to ZONE, allows convenient locking of a spot meter reading with the AE-L button. The camera assumes that the meter reading was made of an 18% reflectance area for a Zone 5 reading. If you do not plan to use this option, set it to NORMAL.
- **Focus Aid in MF**: Allows you to set the arrowhead focus aids so that they are always visible in the finder (ALWAYS), visible only when the release is pressed halfway (HALF PRESS), or never visible (OFF). HALF PRESS is the suggested setting.
- **AF Assist Light**: The AF assist light in the H camera grip is actuated when the custom option is set to CAMERA. The EXTERNAL FLASH setting actuates an AF assist light in an external flash unit if equipped for it.
- **Rear Wheel Quick Adjust**: Set to YES, allows the rear control wheel to make EV (exposure) adjustments in the automatic modes by changing either the aperture or the shutter speed. Great for manual bracketing. Set to NO, the rear wheel changes the EV (aperture and shutter speed simultaneously) to maintain the same exposure as turning the front wheel does.
- **Control Lock**: When set to ALL CONTROLS, locks all controls and buttons except the release. Set to WHEELS, it locks only the control wheels. OFF disables all locking functions.
- **Film Wind-On**: Only on H2 and on H3D and only with film magazine attached. Set to DIRECT (instant), winds the film immediately to frame 1 when the film magazine is attached to the camera in Active or Standby mode or when the film holder is inserted into a magazine attached to the camera. Setting to HALF PRESS, winds the film to frame 1 when the release is pressed halfway for the first picture.
- **Beeper**: When set to ON, enables the sound signal to be used in different situations.
- **Show Histogram**: When using a digital back that supports this feature, the YES setting displays a histogram of a digital exposure on the LCD screen after a picture is taken.
- **Interval and Self-Timer**: STAY leaves the Self-timer or Interval mode active after the exposure. Goes back to the standard setting in EXIT.
- **AE Lock and Quick Adjust**: SAVED setting retains an AE Lock setting and exposure adjustment made with the rear wheel. At EXP RESET, both the AE lock and the quick adjust are reset to the standard setting.
- **Show EV**: Displays EV values on the grip LCD display when set to YES.
- **Show ISO**: Shows the ISO setting on the grip LCD display, if set to YES.
- **Exp Adjust Increment**: Sets EV change made with the rear wheel at fixed exposure adjustments to increments of 1, $\frac{1}{2}$ or $\frac{1}{3}$.
- **Bracket Param. in Manual**: Selects the aperture or the shutter speed in a manual bracketing sequence.
- **Aperture Ctrl. in Manual**: Changes in the aperture are made either with the front wheel or the rear wheel. Using the front wheel is suggested.
- **Low Flash Warning**: ON shows Low Flash Warning on display.
- **Interval Timer Initial Delay**: Can be programmed from 0 to 60 seconds.
- **Aperture Indication**: The recommended NORMAL shows conventional display.
- **AE Lock Button Function**: Set to AE lock to set that function, can be re-assigned to many other functions shown at the bottom of the screen.
- **Stop Down Button Function**: Set to Stop Down for that function. Can be reassigned to many other functions shown at the bottom of the screen.
- **MUP Button Function**: Set to Mirror Up if you want to make exposures in the pre-released mode. Can be reassigned to many other functions shown on the screen.
- **Extra Mirror Delay**: Delay between mirror-up and actual exposure can be programmed and is described in more detail below under New Options on H3DII camera models.

NEW OPTIONS ON H3DII CAMERA MODELS

What used to be called the Drive control is now the ISO/WB (white balance) control. The Drive settings are now made by pressing the Menu control and turning the front control wheel to DRIVE. Press the ISO/WB button and turn the front wheel to SINGLE or CONTINUOUES MODE. (Multi Exposure is also available but only on H3D models with a film magazine attached.) Save by pressing the ISO/WB control.

ISO and White Balance Control

The ISO and White balance settings can be set and changed either on the sensor unit or on the power grip of the camera since the ISO/WB control on the latest H3DII cameras gives immediate access to the ISO and White Balance settings. Depress what used to be called the Drive control (this is marked on the new cameras as ISO/WB control). Set or change the ISO value with the front control wheel. The setting is from 50 to 400 ISO on the 22 and 39 Mpixel models, from 50 to 800 ISO on the 31 Mpixel models.

Set or change the White Balance setting by turning the rear wheel to Daylight, Shade, Cloudy Flash, Fluorescent, or Tungsten. You can also make your own color temperature setting from 2000 to 10,000 K by pressing the AF button and then turning the rear wheel to the desired color temperature values.

Press the ISO/WB button to save the settings. The settings appear on the sensor unit only after they have been saved. The set color temperature is used only for viewing. The raw format file contains all the information for correction with the software regardless of the color temperature at the time of exposure.

The H3DII Mirror Delay Option

Tests have shown that a slight delay between the moment the mirror settles in its lifted position and the time the exposure is actually made can improve image sharpness in many cases in handheld photography, especially when somewhat longer shutter speeds are used. The same applies at any shutter speed when working from a tripod. All H3DII cameras allow you to change and set this delay time to 25, 50, 100, and 200 milliseconds (Figure 4-26).

While these delays are very short (milliseconds), it is highly recommended you take advantage of this new option. It will help create the sharpest images in digital or film photography. This new option is not meant to eliminate the suggested approach of pre-releasing the camera. Pre-releasing is still the best approach for eliminating camera motion, but it is often not practical and, of course, completely impossible in handheld photography. Since possible camera motion in handheld or tripod work is determined by numerous factors, it is impossible to suggest a recommended delay time, but a 50 millisecond setting, which is the default setting, is a good starting point. Longer delay times should be considered with longer focal length lenses.

The extra mirror delay time is set either by loading the standard profile or by making a manual change in the custom options. The mirror delay option was added to the H3DII camera models even though the operation of these cameras is extremely smooth because the

Figure 4-26 Mirror delay. This new custom option on H3DII cameras allows you to program an extra mirror delay up to 200 milliseconds, which reduces the danger of mirror motion affecting the image.

shutter is in the lens. Lens shutters, where the shutter blades open and close around the optical axis of the lens, are recognized as creating less camera motion than the focal plane types where a shutter curtain moves vertically or horizontally across the image area. The mirror motion in the H camera models is also beautifully dampened.

Deleting the Last Image On H3DII cameras, the last digital image deletion has been implemented to the customizable button function list so the last image can be deleted conveniently either by pressing the User, the AE-L, the Stop Down or the M.UP button provided the regular procedure is used on the sensor unit without any special intervening action.

THE USER BUTTON FUNCTIONS

You can use the User button function for the following operations (most of them are obvious and need no further explanation): None, if not desired (the default setting); Standby; Stop Down (lens aperture); Flash Measure; Interval Timer; Multi Exposure; Self-Timer; Bracketing; AF Drive (drive lens in MF or AF); Mirror Up; B mode; T mode; Show Histogram (recall last histogram); Gray Balance Exposure; Delete Last Image (for digital work with digital backs that are equipped accordingly); Dig. Foc Check, which enlarges the image on a digital back with built-in monitor and is designed for this application; and Cycle LM mode, which allows you to switch instantly from Spot to CentreWeighted to Average metering by simply pressing the User button repeatedly.

Keep in mind that only one of these functions can be programmed for the User button. The functions Show Histogram, Delete Last Image, Dig. Foc Check, and Gray Balance Exposure work only with digital backs that are equipped accordingly. Keep in mind the shortcut for programming the User button: click the Menu button and then click the User button.

FLASH PHOTOGRAPHY

Using electronic flash with H camera models and operating the cameras in flash photography is described in the Chapter 18.

THE USE AND OPERATION OF PROFILES

The H camera profiles allow you to store and save a number of functions collectively in the camera and then allow rapid access to the stored combinations of camera settings and functions when needed. You do not have to program each function separately each time it is needed. Profiles also allow you to switch from one to the other instantly. For example, for outdoor people pictures, you may want to program the camera for Spot metering, A exposure mode, Fill Flash, and Auto Focus. For landscapes of moving elements, such as water, reflections, wind-blown trees, and flowers, you may select CentreSpot metering, S exposure mode, and Auto Focus. With the profiles in your camera you simply load the desired profile to set the camera accordingly.

These four profiles are factory-programmed into the camera. They become visible by clicking the Profiles/Esc button:

- STANDARD: Normal flash sync, auto focus single, single drive, aperture priority, (auto) exposure, and average metering, User button — None.
- FULL AUTO: Normal flash sync, auto focus single, single drive, P exposure, center-weighted metering, User button — None.
- STUDIO: Normal flash sync, manual focus, single drive, M exposure, spot metering User button — AF drive.
- FILL FLASH: Normal flash synch, flash exposure set to −1.7 EV, auto focus single, single drive, auto exposure, average metering.

If any of these four profiles and their names are satisfactory for your work, turn either the front or the rear wheel to the desired profile, press the Load (AF) button, and the camera is instantly set to the content of that profile.

Making Your Own Profile

You cannot change the camera settings stored in STANDARD, as this provides a fast and convenient way to return the camera to factory default settings. You can change the functions in the other three — FULL AUTO, STUDIO, and FILL FLASH — and make each one match your photographic approaches. To make your own Profile or Profiles, proceed as follows. Program each desired function, for example, the ones mentioned for "Outdoor people pictures" as is normally done. Save each function by clicking the ISO/WB (Drive) button. With the camera in the Active mode and the LCD screen showing aperture and shutter speed, click the Profiles/Esc. button(ON/OFF). Turn either the front or rear wheel to highlight the one of the three profiles that you want to change. Click the ISO/WB (Drive) button, which brings up the Profile name screen with the Profile name at the bottom. If you want to keep the Profile

name, click the ISO/WB (Drive) button again. If you want to change the name, proceed as described under IMPRINTING/TEXT.

To access any one of the existing or the changed Profiles when needed or desired with the camera in the Active mode, click the Profile (Esc) (ON/OFF) button. This brings up the Profiles names. Scroll to the desired Profile with the front or rear wheel. Depress the AF (Load) button.

THE GLOBAL POSITIONING SYSTEM

Photographers seem to like the possibility of imprinting data, lens used, aperture and shutter speed setting, date and time when the picture is taken, and other information on the edge of the film. This can be done with the imprinting system in H camera film magazines. Many photographers would also like to imprint the location where the picture is taken on the image. Satellites that were originally launched for military purposes have made this possible, and the Hasselblad H3D cameras can record these data as part of the digital image capture information. The very small accessory that is necessary for this purpose is attached to the service port on the front side of the camera. The camera can now record the GPS coordinates and the longitude and latitude of the camera's position as an invisible part of the image to the file together with the other data and will remain there until overwritten or deleted. The thumbnail of the image also shows the location, and you can download Google Earth and see a map showing the exact location of the camera.

Creating the Digital Image

■ ■ ■ ■

Creating a digital image involves many steps from recording the image in the camera to storing, filing, transferring, manipulating, and improving the image in the computer. The limited space in this book makes it impossible to cover in detail every step that is necessary or can be considered after the image is recorded in the camera. It is also unnecessary to do this because so much written material is available regarding storing, filing, retouching, and manipulating digital images in the computer. Even more helpful than any written material may be the lectures and workshops held constantly by recognized digital photographers.

Since the main purpose of this book is to suggest and explain the camera and lens operations that produce good quality digital images in the camera, it concentrates on the operation of the Hasselblad cameras for creating great digital images rather than discussing topics like the transfer, filing, storing, and manipulation of images that apply to digital imaging in general. More details about other aspects of digital imaging can be found in the Hasselblad instruction manuals on the Hasselblad Web sites.

ATTACHING AND DETACHING DIGITAL BACKS

On H3D and H3DII camera models the digital back should be considered a part of the camera to be removed only for cleaning the infrared filter in front of the sensor and for attaching a film magazine (not on H3DII). The procedure for attaching and detaching a back is described in Chapter 4.

The CFVII Digital Back

The CFVII back replaces the original CFV model. The CFVII has some improvements but is used in the same fashion as the CFV. The information in this chapter therefore applies to CFVII and CFV.

The CFV digital backs are supplied with a protective plate that covers the sensor and should be attached to the back whenever it is off the camera to protect the sensor from dust, dirt, and finger marks. The protective cover is removed by depressing the chrome button on top while pushing the magazine lock to the side. The cover is re-attached by depressing the chrome button.

The CFV backs attach directly to the camera body of V system cameras and are attached by depressing the chrome button and pushing the magazine lock button to the side. The CF backs have Databus connections that work with ELD and modified 202, 203, and 205 camera models. The CFV digital backs which are also a component of the 503 CWD digital camera, can

be used on most V system Hasselblad cameras without any special cable connections. They need a Flash sync input cable for use with ArcBody, FlexBody on 2000 and 2003, and 201, 203, and 205 cameras equipped with C type lenses. Computer control may aso require a cable.

The CF Digital Backs

The CF digital backs are attached to Hasselblad H or V system camera models or to other medium and large format cameras by means of an adapter that varies depending on the camera model. This design makes it possible to use the same digital back on different types of cameras.

There are four different adapters for Hasselblad cameras. The H adapter is for H camera models that accept this digital back. The EL, ELM, and ELX adapter is used in combination with ELX exposure cable on 500EL, 500ELM, and 500 and 553 ELX models. The 503CW adapter is used in combination with 503CW exposure cable on 503 cameras equipped with motor winders. The ELD adapter is for the 555ELD and in combination with a Flash sync cable for the FlexBody, ArcBody, 500, 501, and 503 camera models, all Superwide models, on 2000 and 2003 and 201, 203, and 205 models with C type lenses. Consult the Hasselblad Web site for the adapter type needed for other medium or large format cameras or for more details about attaching the digital back to different cameras.

The CF digital backs are also supplied with a protective cover that is attached with four screws and detached by removing the screws with the supplied screwdriver. After the plate is removed you must attach the adapter that is made for your particular camera model. Position the adapter on the digital back in the proper fashion and secure with the four supplied screws. The adapter is now part of the sensor unit. It must be removed and changed only when the same sensor unit is used on another camera that needs a different adapter. Attach the adapter/digital back combination to the camera. The CF backs have Databus connections for ELD and modified 202, 203, and 205 camera models. Always attach the cover plate to a detached back to protect the sensor from dust, dirt, and damage.

SENSOR UNITS ON DIFFERENT CAMERAS

When CF and CFV digital backs are used on any Hasselblad camera, the camera type must be programmed into the digital back. With CF sensor units, the cameras that appear on the screen depend on the adapter that is attached to the sensor unit. You only see the camera models that work with that particular adapter. Here are all the possible options.

- **500 Setting**: For use with 500C/CM, 501C/CM, and 503CX/CXi/CW models. If the 503 is equipped with a motor winder, set to Winder CW.
- **Winder CW**: For use with 503CW camera models equipped with winder. To control the camera from the computer and FlexColor or Phocus connect exposure cable 503 between the digital back and winder. Do not use the winder at the rapid sequence setting.
- **ELD**: For ELD cameras using the A or AS setting on the camera. No rapid sequences are possible. If battery power is necessary in location work, you need the adapter EL to bring the battery behind the motor compartment as described under Power Supply, later in this chapter.
- **ELX Setting**: For use with 500EL and ELM and 500/553 ELX models. Connect the exposure cable ELX between the motor housing and the digital back on all EL models.

- **Pinhole Setting**: For use with view cameras when used in complete darkness as there is no shutter control.
- **200 Setting**: Used in combination with 202, 203, and 205 camera models that have been modified for cable-free operation and are used together with F lenses or CF lenses used at the F setting. Do not use the motor drive at rapid sequence and do not use a Flash sync input cable.
- **H**: For H1 and H2 camera models.
- **Flash Sync Setting**: For use with the ArcBody, FlexBody with the Flash sync input cable, view cameras with the Hasselblad adapter, and 200 camera models that have not been modified with C lenses in the C mode. Do not use the motor drive at rapid setting.
- **SWC Setting**: Used with 903SWC and 905SWC cameras. You must depress the release button rapidly to avoid a faulty capture with a magenta cast. You can avoid this problem by using the Flash Sync setting and use the Flash sync cable to connect the lens to the digital back.

Programming the Camera Model

To program the camera type on the digital back, go to the main Menu and use the navigating control to go to Settings. Use the navigating control to select Camera. Depress the + or − buttons to select the camera model. Depress the Exit button to lock the setting. *Special Requirements for CF and CFV Sensor Units on Different Hasselblad Cameras*

A Flash sync input cable is necessary when using CF backs on Superwide, ArcBody, FlexBody, 2000, 2003, 201, 203, and 205 cameras with C type lenses and 500, 501, and 503 model cameras. This cable is also needed with CFV backs on ArcBody, FlexBody, 2000, 2003, 201, 203, and 205 models with C type lenses.

When a 503CW model with a power winder and a CF or CFV digital back is used with a computer, you must also use exposure cable 503CW. For computer control of EL, ELM, and ELX models with CF and CFV digital backs you need exposure cable ELX. The above mentioned cables are also necessary with CF backs even if used without a computer.

Consult the Hasselblad Web site or the Hasselblad agent in your country for exact details about using the CF digital back on other makes of medium-format or view cameras.

POWER SUPPLY

The digital sensor unit (digital back) on any Hasselblad camera model needs power even when used on manually operated camera models. Whether you work in the studio or on location, make certain that you have this power available for the entire shooting session.

On H3D Cameras

On H3D camera models, the batteries in the camera's power grip supply the necessary power to the digital back or, when attached to a computer with the FireWire cable, the power comes from the computer.

For CF and CFV Digital Backs

When the CF and CFV backs are connected to a computer via FireWire cable attached to the socket on the side of the digital back, the power comes from the computer eliminating the

need for a battery on the digital back. If all your digital photography with a CF or CFV digital back is done with a computer, you do not need a battery on the digital back. When not connected to a computer, the digital backs are powered from a 7.2 V Sony InfoLithium L type NP-F550 (or similar) battery available from Hasselblad and other sources.

On the CFV backs, the battery slides directly into the bottom of the digital back. Push the battery toward the camera where it depresses the battery-retaining catch. Push the battery in completely, which returns the safety catch to the original position. To remove the battery, depress the battery-retaining catch. Charge the battery before attaching it to the digital back.

With CF backs, you must remove the protective plate at the bottom of the camera before you can attach the battery. The battery is attached and removed as described above. If you want an EL camera model powered from a battery for portable use with any digital back, you must attach the supplied adapter EL to the digital back the same way you attach a battery. The battery is then attached to the adapter. This is necessary as the motor housing of the camera extends beyond the camera body.

Regardless whether any digital back is powered from a battery or from a computer, the power to the digital back is turned on and off with the ON/OFF button. The digital back goes to a power saving Standby mode after a certain time.

H3DII Battery Warning Signals

When battery power on H3DII cameras falls below a certain level, flashing yellow icons appear on the preview screen. The signal on the top right of the screen indicates that the power in the camera batteries is low. Audible signals can also be heard at that point. A signal on the top left indicates that the batteries in the Image Bank are low. Both signals change to red when the batteries are completely exhausted. The battery warning icons can only be red if the back is powered via FireWire.

Power Saving Options

Naturally you want to save as much battery power as possible so re-charging the battery is kept to a minimum, or just so you can take more pictures before re-charging becomes necessary. Reduce the length of time the camera stays in active state to the minimum that is practical for your operating method or the type of subject that you are photographing. In the User Interface menu you can set the Power Down, which is the same as depressing the ON/OFF switch on the camera. It can be set from 3–99 minutes. The default setting is NEVER and it is suggested to leave it there.

Since so much power is consumed by the preview screen, turn on the screen only when needed. The time of the display can be set with custom option Standby Timeout from 2–30 seconds. Set it to the minimum time that is practical for your photography. After the set time is reached the display turns off, but the back is still running and responds instantly by pressing a button. Never select None. In the Standby mode the camera consumes little power. When working with the digital sensor unit connected to a computer the screen is automatically turned off.

You can also reduce power consumption by reducing the brightness and/or contrast of the screen images. This is done with the same option in User Interface. Unless needed it is

recommended to leave the two on the default setting of 5. You can further save power with the Power Down option which is also part of the User Interface one step below the Language option. It can be set to times between 3 and 99 minutes. At the set time, the power in the sensor unit turns off, which is the same as turning off the power to the camera with the ON/OFF button on the H camera grip. You must turn on the camera before you can continue working.

SHUTTER DELAY, EXPOSURE TIME, AND CAPTURE SEQUENCE

The navigating control is also used to select Shutter Delay and Exposure Time.

Shutter Delay

The shutter delay varies between camera models, especially between SWC models and the SLR types where the mirror needs to be lifted before an exposure can be made. The digital backs are set for a default setting that should not be changed unless problems are encountered.

Exposure Time

Exposure Time does not have to be set if the exposure times are $\frac{1}{8}$ second or shorter. $\frac{1}{8}$ second is the default setting. For cable-free operation at longer shutter speeds set the exposure time to match the shutter speed set on the lens. The ELD also has a bulb setting usable for exposure times up to 32 seconds. As another option you can keep the default setting of $\frac{1}{8}$ second, but use longer shutter speeds and the B setting by connecting the Flash sync cable between the PC socket and the digital back.

Capture Sequence

The Capture Sequence setting works only in combination with motor-driven cameras with the Initial Delay, the time required to make the first exposure. Delay controls the time required between exposures, and Count controls the total number of exposures that are required.

To set the Capture Sequence, go to the Menu and with the navigation controls go to Settings. Open the Settings menu, select Camera, and open the Camera menu. Use the + or − buttons to select Pinhole. Use the up and down navigating control to select Exposure Time, and use the + or − control to select the exposure time. Depress the lower part of the Navigating button to select Capture Sequence then press the right navigating control part to open the Capture Sequence.

Press the + or − buttons to Initial Delay and set delay. Use the + or − buttons to select Delay and make the setting then use the + or − buttons again to select Count and set the number of exposures in the sequence.

Press OK to confirm all settings. The Menu/Exit button now displays Start. Press start to get the sequence running.

OPERATING CONTROLS ON DIGITAL BACKS

The Hasselblad H3D and H3DII cameras and the various digital backs have basically the same operating controls and are operated the same way, but the controls are arranged and operated in different fashion. The operating controls on the H3D camera are shown in Figure 5-1, on the H3DII in Figure 5-4, those of the CF backs in Figure 5-2, and the ones on the CFV backs in

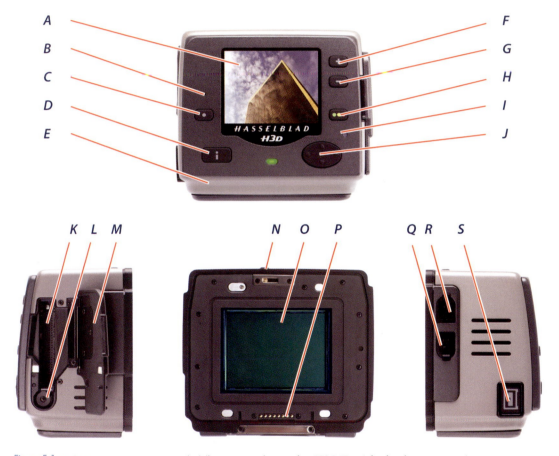

Figure 5-1 H3D operating controls. The controls on the H3DII with the larger preview screen are the same, but they are located in different locations (see Figure 5-4). (A) Preview screen, (B) function not used, (C) Menu (Exit button) opens and closes the menu system, (D) view mode button goes through the various view modes of the preview image, (E) ON light and busy light flashing green when digital back is performing an operation, (F) zoom in to make preview image larger, (G) zoom out to make image smaller or see several smaller images, (H) approval (OK) button for various functions, (I) busy light flashes red when a file is loading onto a card, (J) navigation button which is a rocker switch to step through preview images and navigate the menu system, (K) flash card slot, (L) flash card removal button, (M) flash card cover, (N) safety catch for removing sensor unit, (O) CCD and IR filter, (P) mounting plate fits on magazine retaining hooks, (Q): Flash sync input, Flash sync output (Q and R are used when sensor unit is used with a view camera), and (S) FireWire connector.

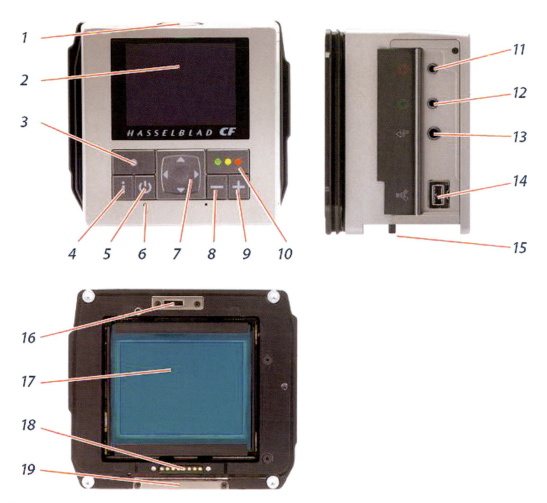

Figure 5-2 CF digital back operating controls. (1) Ventilator to keep unit cool, which must be kept open; (2) preview screen; (3) Menu (Exit button) used for various functions; (4) display button goes through various view modes; (5) ON/OFF button powers the digital back; (6) Ready Light indicator flashes green when digital back is performing a task; (7) Navigation button, a four-way rocker switch to step through preview images and navigate the Menu system; (8) Zoom out button also allows you to see several small images; (9) Zoom in button makes preview image larger; (10) Instant Approval (OK button); (11) Flash sync terminal; (12) Camera communication port used only with certain cameras and described in adapter user manual; (13) Flash out sync controls, 11 and 13 only used with studio flash; (14) FireWire connector; (15) digital back retaining hook slots; (16) CCD and IR filter; (17) Databus connectors; (18) digital back support slots; and (19) CF card slot cover.

Figure 5-3. All the information about creating the digital image applies to H3D and H3DII cameras and CF and CFV digital backs unless deviations and differences are specifically mentioned.

Before you proceed further you may want to check whether your back speaks your language and if not, change it. Press the Menu button. Press the navigating control up or down to

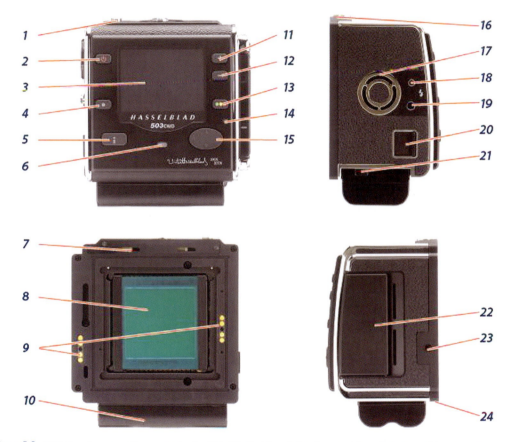

Figure 5-3 CFV back operating controls. (1) Digital back lock, must be depressed to remove or attach digital back; (2) ON/OFF control; (3) preview screen; (4). Menu (Exit) button, opens and closes Menu system and operates some other functions; (5) Display mode button for the various view modes on the preview screen; (6) Ready Light indicator flashes green when digital back is ready, flashes yellow when back is performing an operation; (7) retaining hooks; (8) CCD and IR filter; (9) Databus connectors; (10). battery. (not supplied); (11) Zoom in button to enlarge preview image; (12) Zoom out button used to also view several smaller images; (13) Instant Approval button (also confirmation button for some functions); (14) Ready Light Indicator; (15) Navigation button, a four-way rocker to step through preview images and navigate the Menu system; (16) retaining catch; (17) ventilator to keep back cool, must not be covered; (18) Flash sync in terminal; (19) Flash sync out terminal (controls 18 and 19 used with studio flash); (20) FireWire connector; (21) battery retaining catch; (22) CF card slot cover; (23) Winder EL terminal for connecting to an EL model or a CW winder; and (24) digital back support slots for magazine support hooks.

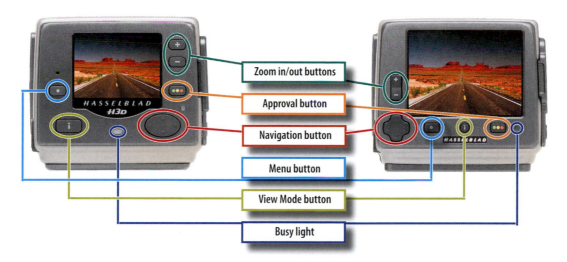

Figure 5-4 Operating controls on H3DII sensor units. The operating controls on the H3DII sensor unit with the larger preview screen shown on the right are in a different location than on the H3D unit shown on the left but serve the same functions.

Settings then to the right to User Interface. Press the + button which reveals the language. If necessary change language with + or − control and lock.

The Operating Controls in H3DII Cameras

The operating controls on the H3DII cameras perform the same functions as on the other sensor units, but some are operated differently. The navigating control has a new, easier to operate design but is used the same way. The two separate Zoom in (+) and Zoom out (−) buttons have been replaced with a single rocker switch with + at the top and − at the bottom.

The single busy light is green when the sensor unit is active, flashes green when the last capture is processing to the card but another capture can be made, and flashes yellow when the capture is processed and another capture cannot be made. Flashing red indicates a problem.

The Menu Control

After you depress the Menu button, the main menu appears with the blue frame highlighting where you are. You can scroll up and down by pressing the top or bottom of the navigation button. You will see + or − signs. These controls will change a setting or bring up another display. Arrows show where to go next on the Menu. When you see an arrow, depress the side of the navigating control indicated by the arrow, usually to the right. You can go back to the original setting by depressing the left side of the navigator control. Confirm the settings by depressing the OK button. You revert to the previous status or close the Menu by depressing the Exit/Menu button (Figures 5-5 and 5-6).

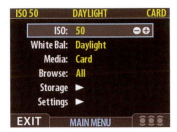

Figure 5-5 The main menu. The main menu set for selecting the ISO value with the + and − buttons.

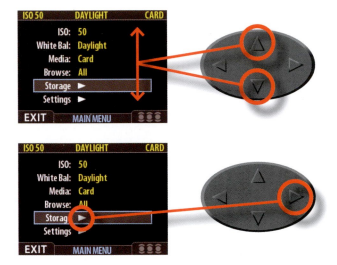

Figure 5-6 Using the Navigating control. Use the Up or Down symbols on the navigating control to move up or down the option list on the screen. Depress the right portion of the navigating control to reach a sub-menu.

On top of the Menu list you have the ISO, which is set by pressing the + or − button. The next line is the White Balance control which is also set to the desired value with the + and − controls.

The next line, Media, shows the recording media and may be predetermined; for example, when connected to a computer it always shows Computer. With a card only in the camera the Menu shows Card and cannot be changed. When connected to two media, card and Image Bank for example, you must set your choice.

Browse is explained under the section Viewing Images and Storage is explained later in this chapter under Organizing Images in Batches and Deleting Images.

The Settings Options

In the Settings option depressing the right of the navigator control brings you to User Interface with the options Camera, About, and Default. About brings up the specifications of

the camera. You can see the serial number and current firmware revisions of your digital back, which you need to know if you are looking for updates from the Hasselblad technical department. Default is used to change all the custom made settings to the factory default values. With the sensor unit attached to the H3D or H3DII, the camera setting is locked and cannot be changed. When the sensor unit is removed from the camera, you have the options Pinhole or Flash sync.

Flash Sync is used when the sensor unit is on a view camera with view camera adapter (not made by Hasselblad). Pinhole is used in a dark studio environment. Obtain complete details about view camera uses and possibilities from the Hasselblad Web sites, the instruction manuals, or the Hasselblad representative in your country.

The User Interface Options

The user Interface options allow you to program the digital sensor unit to suit your photographic style. You reach the Interface by opening the main menu, then using the up or down navigating controls to select Settings. Press the right navigating control to open the Settings Submenu. Press the right navigating control to select User Interface then the UP or DOWN navigating control to select the desired option. In some cases depress the + or − button to change or select a new entry or the right navigating control to access the Sound, Date and Time, and Display options. Press the Exit button to save the new settings.

The options in the Interface menu are seen in Figure 5-7.

- **Language**: Selected with the + or − controls.
- **Power Down**: Default setting is Never. You can set the time after which the power in the sensor unit should go off to save battery power. Once off, you must turn on the H3D or H3DII camera before you can continue working.
- **Mark Overexp**: This is an instant and easy way to see overexposed images. In the ON position and in the single image preview, overexposed pixels in a picture will be highlighted with a flashing signal that cannot possibly be overlooked. This is described in more detail in the section Evaluating the Tonal Range and Exposure later in this chapter.
- **Sound**: Exposure Warning turned ON gives you a warning sound of over or under exposure immediately after a picture is taken. The notes go up for an over exposed image and down an under exposed one. You can also adjust the volume of the signal to high or low in the Volume option. Select ON or OFF for the KeyClick and Exposure Warning.
- **Date and Time**: Used to mark each shot and label batches of images. The internal clock is set for the Date and Time but it can be changed with the + and − buttons. You can always bring back the original menu screen by repeatedly pressing the Exit button.
- **Display**: Brings you to Timeout, Contrast, and Brightness. After adjusting the Timeout time from 2 to 30 seconds, the display is turned off, but the sensor unit is still running and will respond immediately.
- **Contrast and Brightness**: On the screen this can be changed but it is recommended to leave them set at 5 or set to a lower value to save battery power.

Always depress the Exit button to lock the selected settings.

If you want to reset all of your custom settings back to the factory set Default setting, go to Menu, Settings, and Default entry. This brings up the text "Reset to default settings?" If Yes,

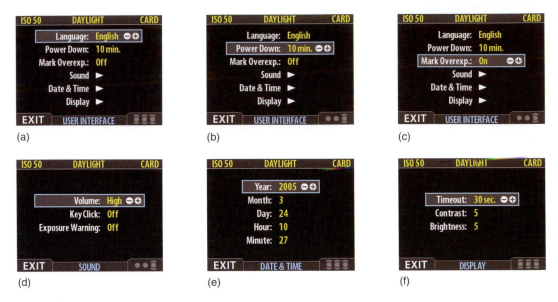

Figure 5-7 The main menu settings in the User Interface. By changing the User Interface you can control the way the digital back interacts to suit your working style. Main menu settings include Language (seven different languages to choose from); Power Down to power down the back after a certain time period to save battery power, which is set to Never, the default setting; Mark Overexp. to highlight overexposed pixels on the preview screen; Sound to let you know about the exposure by means of a sound signal; Date and Time to be marked on each shot and to label batches; and Display to set the display time out from 2–30 seconds and to set the contrast and brightness of the preview screen.

the digital back will reset all the custom settings that have been made to the default settings at the factory. Press the OK button and then the Exit button.

The H3DII Custom Options

These options can be seen in Figure 5-8.

The H3DII camera offers some new custom options: Copy to I Bank, I-B connection, Tilt Sensor, Menu Ctrl., and Display. These options are reached by going to Settings. The navigating control then brings up the options User Interface, Camera, About, Default, and the new Custom Options is reached with the navigating control.

1. **Copy to I-Bank**: Choose whether you want to copy only files from the active batch or all files from the card. 2. **I-B Connection**: Gives you the option of copying files into the present batch or creating a new one when copying to the Image Bank. 3. **Tilt Sensor**: Sets the viewing orientation of capture when they appear in Phocus or FlexColor avoiding unintentional changes in orientation when cameras are pointed straight up or down. The settings can be locked at Auto or locked at 0, 90, 180, or 270 degrees. 4. **Menu Ctrl.**: Can be set to make the front and rear control wheels active or inactive when navigating the sensor menu. If set to ACTIVE, a double click on the release button activates the sensor unit menu. Navigating up/down/sideways is made by using the control wheels. 5. **Display**: Provides three options: Display ON by Half Press, Display

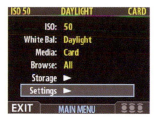 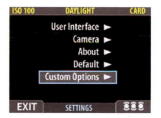 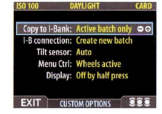

Figure 5-8 New H3DII Custom options. The new custom option section can be reached through Settings, User Interface Camera, About, and Default, with the new options reached with the navigating controls.

OFF by Half Press, and Toggle Display by Half Press. These allow you to turn the sensor unit display on when half pressing the shutter release.

In all of the above five options, the settings are made by depressing the + or − control. See Figure 5-9 for the standard preview display.

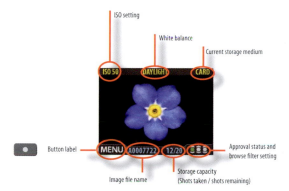

Figure 5-9 The standard preview display. The standard preview display shows, in addition to the image, some of the data that a photographer must be aware of, the ISO, White Balance, and storage medium on top, the image file name, storage capacity, as well as the information from the Instant Approval Architecture at the bottom.

The Miscellaneous Setting

On the main menu, you can go from Settings to Miscellaneous then to Interface by pressing the + or − buttons. This brings up the options Interface Camera or Interface Disc. Depending how you have configured your computer, when you connect the camera in the Interface Camera setting, the computer automatically launches Phocus or FlexColor. This may then start importing images and converting them to the 3F format. In the Interface Disc setting, the camera presents itself to the computer as a hard disc you can open, navigate, or read using the standard tools for your operating system support center.

MAKING THE SETTINGS ON THE CAMERA'S POWERGRIP

On newer H camera models the ISO and White Balance settings previously described can also be made on the LCD display on the powergrip instead of the digital back. Any settings that are made in this fashion will override the settings that have been made previously on the sensor unit and the new settings will show up on the display screen. Proceed as follows:

- Press the Menu button on the grip. Turn the front control wheel to Digital.
- Press the Drive/Enter button. Turn the front control wheel to either ISO setting or White Balance.
- In the ISO setting, turn the rear control wheel until the desired ISO value appears on the screen.
- In the White Balance setting turn the rear wheel to the desired value.
- Press the ISO/WB (Drive) button to lock either or both settings.

ISO AND WHITE BALANCE SETTINGS ON H3DII CAMERAS

On H3DII cameras the ISO and White Balance settings are made as described above. The only difference is that the Enter/Drive button is now known as the ISO/WB button. To make a Manual White Balance setting, press the Man (AF) button then turn the rear control wheel to select the color temperature between 2000 and 10,000 K.

ISO Settings

Digital images can be recorded at different ISO settings from ISO 50 to ISO 400 (to ISO 800 on H3D31 and H3DII-31). As in film photography it is best to select the lowest ISO that is suitable for a particular lighting situation and use the higher settings only when necessary. A lower value produces the best quality with the minimum amount of noise. To set the ISO on a digital sensor unit, press the Menu button. Set the ISO by depressing the + or − button. Lock the set value be pressing the Menu/Exit button. The set ISO value is seen on top of the preview screen and on the grip LCD display of H camera models.

White Balance

Color film photographers are very aware of color temperature since color transparency films are made as daylight film matched to a color temperature of 5600 K and as a Tungsten version for 3200 K. Furthermore, as described in Chapter 17, film photographers use light balance and conversion filters to match the color temperature of the light to that of the film.

In digital photography, White Balance is used to obtain images with the proper or desired color rendition. It is the digital way of telling the camera or the computer what type of light you are working with. You must set the white balance to produce images with proper colors eliminating or reducing the need for further adjustments — so called Neutralization in the Phocus or FlexColor software. Since the Hasselblad 3RF file is a raw file, further adjustments can, and in most cases should be made in Phocus or FlexColor and can be done without affecting the image quality.

Since the digital image with Hasselblad is recorded raw, the White Balance setting on the camera only affects the color on the preview screen and not the image recorded on the sensor. The White Balance setting, however, will be considered when the images are transferred with the FlexColor or Phocus software. The White Balance setting therefore should be made on the digital sensor unit (Figure 5-10).

(a) (b) (c)

(d) (e) (f)

Figure 5-10 White Balance settings. The options for the White Balance settings are Daylight, Shade, Cloudy, Tungsten, Flash, Fluorescent, and Manual.

The White Balance is set on the sensor unit by depressing the menu control then navigating to White Balance. Depressing the + or − controls brings up the options Fluorescent, Tungsten, Flash, Shade Cloudy, Daylight, or Manual. Select the setting that applies to your situation. The set White Balance is shown on top of the Preview screen and also on the grip LCD display of H3D camera models. For most of your photography, you want to set the White Balance for the known light source.

In the Manual setting the arrow points to the right navigation control which brings up the Manual White Balance window. You have two options, either Capture Neutral Object or using the + or − controls to set to the desired Color Temperature (Figure 5-11).

You may want to select the Color Temperature option when working with a precise color temperature value.

The Neutral Object Option

The Neutral Object option provides the most professional way for assuring proper colors in the digital image. In the Neutral Object version, you make a test exposure with a neutral

Figure 5-11 Manual White Balance control. With the Manual White Balance control you can either set the color temperature of the light source with the + or − buttons or make a test exposure in the Capture Neutral Object setting.

Figure 5-12 White balance test. Screen image that appears after test exposure shows the area chosen for the white balance calculation.

area of the subject filling the center area (the focusing area) on the screen. Rather than photographing a neutral area of the subject you may want to photograph a regular, gray card Greytagmacbeth card, a white balance reference card made by various companies, or the Qpcard supplied with the camera (Figure 5-12).

All these cards provide a fast way to obtain accurate color in digital photography. Any white balance adjustments you make to the raw image do not change the original raw file. They are just stored as instructions to tell the computer how you wish the final raw conversion to look.

Film photographers will remember that basically the same approach was recommended when working with negative color films in professional fields such as wedding photography. Photographers were advised to include a gray card in one of the images from a specific shooting session so the film developing lab would know what the colors on the prints should look like. Without such a reference, and especially for images without flesh tones, the lab really does not know what the actual subject colors were.

In digital Imaging you place this test object in front of the subject so it fills the center area of the focusing screen and make an exposure. If the exposure for the target area is correct, the preview screen shows a green frame around the focusing area. If the exposure is incorrect, the frame will be red and contain the words Underexposure or Overexposure. If so, change the lens settings and make new test exposures until the frame appears green. All pictures taken in the same light will then be neutralized. If the light changes or you change the lighting in a studio set-up, you must make a new test. Then view the image with the test target in the computer and, if necessary, make any desired adjustments. A new test is also recommended when you go to a new batch. When using the Neutral Object option, the camera does not need to be set to a specific white balance setting.

EVALUATING THE TONAL RANGE AND EXPOSURE

The methods for determining the lens settings that provide correct exposure in digital imaging are the same as in film photography and as described in detail in Chapter 15. A main

advantage of digital imaging compared to film photography is the possibility of seeing instantly whether the exposure is correct. You need not develop a film or make a test exposure on instant film. Evaluating the histogram that appears on the screen is an excellent way to determine exposure. There are other ways the camera can communicate with you and tell you whether the exposure is good, satisfactory, or unusable. Hasselblad offers various options to do that. They depend on the camera model or the type of digital back but the histogram evaluation works with all cameras and digital backs.

First you have the image that appears on the preview screen immediately after the exposure. While the larger preview screen on the H3DII cameras helps this evaluation, you must realize that the image on the preview screen gives you only some idea of the exposure and should never be a final answer as the brightness of the image can be changed and the image is difficult to evaluate in bright light. Never use the image on the screen to evaluate exposure. The H3D camera models can be programmed so you hear different sound signals immediately after the picture is made telling you whether exposure is good or whether the images are under or over exposed. This is done with the Sound Menu option.

The Histogram Evaluation

A Hasselblad digital imaging exposure can be evaluated from a histogram immediately after the image is recorded. With action shots the image you recorded may be the final image. In other cases you have the opportunity to make adjustments in the lens settings if the histogram does not look completely satisfactory and then see how the change affected the exposure on the new histogram. You can eliminate images with unsatisfactory histogram readings immediately. The histogram offers a much more precise image evaluation than the image you see on the display screen.

With Hasselblad digital cameras and digital backs, the histogram always appears on the Preview screen. On H camera models you can also see it on the grip LCD after you program custom option SHOW HISTOGRAM with Yes. At the YES (the default setting), the histogram appears on the LCD panel shortly after the exposure, and may be more convenient to evaluate especially in handheld photography. It works with various digital backs, but the histogram may look slightly different depending on the back attached to the camera.

A histogram shows the distribution of the tonal values within an image. Photographers familiar with the Zone System can think of a histogram as showing the tone values from Zone 0 black to Zone 10 white. On the histogram, the values vary from the black shadow areas shown at the far left to the pure white highlight areas shown at the far right, with the middle tones in between. The horizontal spread covers the full potential dynamic range of the digital camera system. When evaluating the histogram make certain that the graph is completely within the left and right margins, and that it stops before the margins and is not cut off on either the left or right side. If part of the graph is cut off on the left, the cut off part is pure black without any detail and a cut off part on the right is pure white, also without detail. If a very high contrast subject shows a histogram that goes beyond the margins on both sides, it is better to sacrifice shadow details (the curve going beyond the margin on the left) than blowing out the highlights.

The vertical height of the curve indicates the number of pixels for each tonal value. A high curve indicates a large number of pixels for that particular tonal value. As a result every

histogram looks different. The histogram for a high-key image with few or any dark areas has curves mainly or completely toward the right, whereas most of the curves for a low-key image with few or any bright areas are mostly to the left. An image with an average tonal range from white to black has curves all the way from left to right.

The histogram does not show the exact amount of under or over exposure, but the results of any corrections made in the aperture or shutter speed setting are clearly shown on the new Histogram. Overexposure in digital recording must be avoided because details in the overexposed areas are completely lost. This should be remembered especially by photographers accustomed to working with negative films and leaning toward overexposure to obtain sufficient detail in the shaded areas.

The MarkOverexp. Image Evaluation

While the histogram is a great tool to evaluate exposure and to show when some of your pixels are overexposed, it does not show you which ones are overexposed. In a shot that has many bright areas in different parts of the image, some of these areas may be important to the image while others may not if they are in an unimportant part of the image where they do not distract. It is therefore helpful to see these areas that are considered overexposed. This is possible with Hasselblad using the MarkOverexp. option. When activated, the overexposure control flashes the overexposed pixels so you can see precisely which pixels are without any details. The flashing pixels will help you determine whether the bright areas are in a part of the image where they are distracting, somewhere where they do not distract, or somewhere where they can easily be darkened in the computer. This signal is even more valuable because it allows you to eliminate distracting highlights before you take the final picture by changing the camera position or perhaps using a longer lens to reduce background coverage and eliminate the distracting areas.

The overexposure control is activated with the main menu control, going to Settings, then to User Interface and MarkOverexp. You also have a shortcut for this option, which is helpful especially if you want the overexposed pixels to flash only on desired images. With the single image on the screen, simply depress and hold the top of the navigating control and overexposed pixels, if existing in that particular image, will start to flash.

Instant Approval Architecture

The evaluation possibilities previously discussed are good methods for evaluating the exposure of a digital image. Hasselblad offers a third possibility with the Instant Approval Architecture option (Figure 5-13). This automatically functions in the H3D cameras. In the lower right hand of the Preview screen you see three small round signals. After an image is recorded, one of these signals lights up as green, yellow, or red based on the histogram that also appears as part of the screen. A green signal with a file name A indicates a good exposure, yellow with a file name B is an acceptable exposure, and a red one is unsatisfactory. The images are stored with the colored approval level.

Although these signals come on automatically, you can program the function to operate in different ways. In the menu screen, scroll down to Storage, press the right side of the navi-

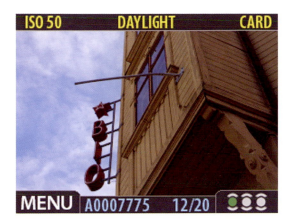

Figure 5-13 The Instant Approval Architecture. Instant Approval Architecture indications are shown on the lower right on the display screen. On the Image File Name, green images start with A, yellow images with B, and red images with C. You can change the status of a selected image by depressing the Approval button.

gating control to Default Appr. Level, then press the + or − buttons to set either for Auto, where the camera gives the exposure evaluation to all images, to Green or to Yellow where the camera only marks the images with those exposure values. Press the Exit button to move out of the Menu program. You can change the IAA color mark on any image by depressing and holding the OK button with the three colored dots. You see the dot on the Preview screen move from green to yellow to red. Lift your finger when the dot of the desired color is lit up; for instance, you can move yellow marked images to green or to red. When you make such a change you also change the file name. These markings can be helpful when you evaluate the images on the computer and also when deleting images as you can delete only the red or only the red and yellow. As a further benefit when working with a CF card, the red images are deleted automatically when the card is full, which allows you to record more images on the same card. See Figure 5-14 for some menu shortcuts.

The Importance of Perfect Exposures in Digital Images

These various exposure evaluations are helpful and very important in digital imaging since the tonal range that the sensor can record is limited, and no after image manipulations in the computer can fix poor tonal rendition or bring out details that do not exist in the original image. If your original digital image has no details in white or dark areas, nothing you do in the computer will bring them back. In principle that is no different from film photography. Regardless of what you do in the darkroom, you cannot produce a print with details in shaded or lighted areas if these details do not exist in the negative.

If you enter digital imaging from film photography, it is worth keeping in mind that recording images digitally is more like photographing with transparency, not negative film. There is less exposure latitude, the contrast range is more limited, and exposures need to be more critical — something to be remembered especially by photographers used to working

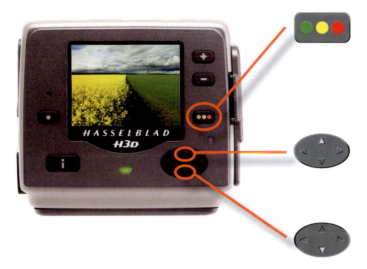

Figure 5-14 Menu shortcuts. (Top) Setting the Browse Filter. Press and hold the OK control until the desired filter for the Instant Approval Architecture is indicated. (Center) Overexposure Indicator. Depress the top of the navigating control until the display begins to flash in the overexposed areas. (Bottom). Deleting images. After selecting the image, press and hold the bottom of the navigating control until the Delete dialog box appears.

with negative color films that have a rather large exposure latitude. Make your exposure readings more carefully so the images are exposed to an accuracy that is within ½ f stop. To avoid overexposed digital images, expose them more like transparencies, that is exposing for the lighted, rather than the shaded areas. See details in Chapter 15.

In digital imaging you must try to obtain the best possible exposure in the camera in every image. Over exposure must be avoided. Some photographers seem to be under the impression that exposures in raw are not as critical because they can be corrected in the computer. That is incorrect. Even in raw, no computer manipulation can bring back details in the highlights or in the shadow areas if they do not exist on the original.

VIEWING IMAGES

The Viewing screen on the digital sensor unit is activated by pressing the View Mode button. With the navigating control, you can select the image that you want to preview. With the selected image on the screen, pressing the View Mode button repeatedly goes through the various viewing modes (Figure 5-15) such as Standard, which shows the image and a few important data such as ISO, White Balance Setting, and Media used. Full Screen shows the image on the full screen without any data. Histogram Overlay shows the histogram over part of the image. Full Details shows the histogram and all the data such as time and date and the camera and lens settings, and Battery Saver turns off the screen to save power still allowing you to use the menu and take pictures. In the Full Screen view, the Approval button has no effect.

Figure 5-15 Full Details Preview mode. In the Full Details Preview mode the screen image shows the Histogram, the camera settings, and a darkened preview of the image. The camera setting details are stored with the image.

The Zoom Control

You can zoom in or out in any one of the settings (except Battery Saver) by depressing the + or − buttons. The area you zoom in is shown on the preview image. You can zoom into any desired area of the image by moving the zoom area to the desired spot with the navigating control. At the end of the Zoom Out mode, you can view several of the last images taken. Move the + or − buttons to the standard setting before moving to the next image. With the Preview turned on, you can press the Menu button at any time to see or change sensor unit settings.

The zoom control also allows you to operate like the browse control. Starting with the single image view, depressing the zoom out control (−) repeatedly brings you from the single image view to the four thumbnail view, then the nine thumbnail view, then to the batch list, and finally to the Media list. Move the up/down navigating control to see images from different media.

Thumbnails

To see thumbnails, start with the standard preview display. Press the Zoom Out (−) button once to see four images (Figure 5-17), twice to see nine (Figure 5-16). The selected image has a blue border and you can zoom in on this image and use the Storage setting to work with the image. Use the navigating control to put the blue border on other images. You can get back to single image view by depressing the + button, repeatedly if necessary.

Browse Control

The Browse control on the main menu tells the sensor unit which images you would like to view. The options are All, Green, Red, Yellow, and Green and Yellow. The thumbnail view then

Figure 5-16 Thumbnails. The nine-image thumbnail display on the preview screen.

Figure 5-17 Sensor image display. The four-image display on the sensor unit with the selected image outlined in blue.

shows either all or only the selected images. An Empty Browse filter tells you that there are no images with that particular approval status on the storage media.

There is also a shortcut to get to the Browse option. Press and hold down the Approval button until the approval status color appears. Browsing then displays only the images with that classification.

Organizing Images in Batches

Just as you make folders on a computer, you may want to organize your images in batches. To create a new batch of images, press the Menu button and scroll down to Storage dialog. Depress the right of the navigator control and scroll down to Batch. Depress the right of the navigator control to get message "Create new Batch," which shows three numbers and five letters. You can now name your batch by changing the letters. Change the letters by depressing the + or − buttons to create your batch name. Save by depressing the OK button and take the pictures. Repeat the process for the next batch (Figures 5-18 and 5-19).

All the images that you take will automatically be filed in the latest batch programmed into the camera. You cannot file pictures in different batches.

To view the images on the different batches proceed as follows. Press the View mode button. Depress the + or − buttons until the Batch Menu appears. You now see all the batches listed from left to right, the ISO used, the batch name, the date, the number of images in each batch or the number of green, yellow, and red images in the batch if you used the Instant Approval Architecture.

Navigate to the desired batch with the navigator control. Press the + button to reveal the images in the batch either as single images or as thumbnails of four or nine by depressing the + or − button repeatedly. You can delete images from any batch as described later. You can only view the images from that particular batch. You must navigate to the other batch names to see those images.

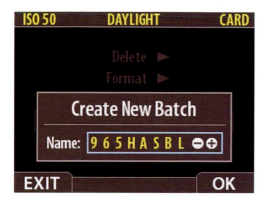

Figure 5-18 Changing the batch name. The batch name is changed by depressing the + or − button in combination with the navigating control which changes the number. Confirm the choice by depressing the OK button. Press the Exit/Menu control to go back to the previous menu.

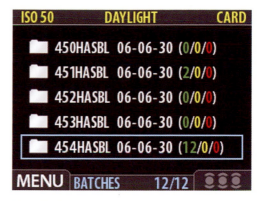

Figure 5-19 The batch list. Display shows the different batches, batch names with different numbers, the date the images were taken, and the number of green, yellow, and red images in each batch.

COPYING IMAGES

When working with CF cards handheld on location you probably want to copy images to the Image Bank whenever practical. This will free up space on the card and allow you to photograph without any cable connections. In other locations you may want to do the same, but copy the images directly on a computer.

In either case you start with the main menu and navigate down to Storage, then following the arrows navigate to Copy and to the Copy Dialog. If more than one disc is attached use the navigating control to go to From Card to and use the + or − buttons to select the medium you want to copy to. Confirm by answering Yes or No and press the Approval button. All images remain on the card even after they are copied. The stay there until deleted.

DELETING IMAGES

After recording your images, you will want to decide whether they should be stored or deleted. The basic approach for deleting images is as follows.

Deleting Single Images

There is a shortcut to delete just one image, which is especially practical for deleting the last image taken. With the selected image on the display screen, push and hold the bottom of the navigating control until the Delete This Image message appears. Depress the OK button. Make certain the message says This Image Only as you have other options of deleting other images

by depressing the + or − button. You can delete any single stored image after you bring that image on the screen with the navigating control.

Another way to delete images is from the thumbnail display. Depress the (−) button for the thumbnail display (4 or 9 images). Depress the navigating control to move the blue border over the selected image. Depress the Menu button. Scroll down to Storage. Depress the navigating button at the right to Delete and again to bring up the image with the Delete message. Pressing the + or − button brings up the option This Image, which will delete just the image on the screen. To delete just one image select This Image. Press OK.

Deleting Entire Batch

To delete all images in a batch, proceed as explained above using the Menu control. After you see the Delete message over the image press the + or − buttons until you see the message All In Batch. Click OK.

Deleting Selected Images From a Batch

You can also delete only selected images from a batch. Place the images on the viewing screen as described before. Select the image to be deleted with the navigator control and proceed as described under the section Deleting Single Images. *Deleting Images From the Instant Approval Architecture Menu*

In the Instant Approval Architecture (IAA) in a Hasselblad digital camera or digital back images are given a green, yellow, or red status based on the exposure. In the Menu/Storage/Delete setting, you have the option to delete only the red marked images, only the red and yellow marked images, or all images. Make your choice and the deleting process will follow your instructions.

Proceed as described above until you see the Delete message. Depress the + or − button until you see All Red In Batch or All Yellow and Red In Batch. Press OK. If the storage media is full, the IAA automatically deletes the red images to give you more storage space for well-exposed images.

CLEANING THE SENSOR UNIT

With digital cameras and digital backs, keeping the sensor unit clean is more important than worrying about the cleanliness of lenses, viewfinders, and focusing screens. Any dust particle in front of the sensor will be recorded in the image as dark or colored spots and possibly spoil or ruin an otherwise good digital image. If you see such marks it is definitely time to clean the filter.

Hasselblad completely covers the sensor with an infrared filter making it inaccessible. So your concern is really keeping the filter clean, not the sensor. Keeping things clean is easier than cleaning them. Leave the sensor unit attached to the camera where it is least likely exposed to dust. As mentioned earlier there are only two reason for removing a digital back from a Hasselblad camera body, one when attaching a film magazine and the other for cleaning the infrared filter. Whenever the digital sensor unit is off the camera, even for a short time,

cover it with the CCD filter cover. Never touch the CCD filter with your fingers, not even to remove a speck of dust.

When cleaning seems desirable remove the sensor unit as described earlier. As a reminder, on the H3D cameras you must remove the viewfinder to reach the special locking device that is located underneath the finder. It is rather easy to see dust spectacles, even small ones, by watching the reflections on the glass. If cleaning seems necessary, the suggested procedure is with E-wipes. Remove the tissue from the package minimizing manual handling to avoid contamination. You may want to fold the tissue to the height of the IR filter. Place the tissue on the filter and move it once over the filter with a firm pressure from two or three fingers covering the entire width of the filter. Do not use the same tissue to go over the filter a second time. Inspect the filter surface or make a test shot and inspect the image.

Lenses, focusing screens, and viewfinders are cleaned as discussed in Chapters 7 and 14.

THE PHOCUS AND FLEXCOLOR SOFTWARE PROGRAMS

THE IMAGE CREATING PROCESS

Recording a picture in the camera has always been only the first step in creating a photographic image. In film photography the photographic process continues with the development of the film, which offers the possibility of changing the contrast in black and white development followed perhaps by retouching the negative and eventually making a print which again could involve many options for darkroom manipulations especially dodging and burning sections of the image or changing the contrast in the entire image. These after-image manipulations also often involve cropping the image or changing the image shape.

All these elements are also true in digital imaging but the digital imaging process has possibilities for image retouching, image improvement and changing images way beyond anything a film photographer could visualize. All these manipulations and improvements can also be done on a computer in a more pleasurable and well-lit surrounding instead of a darkroom and can be done without the use of messy chemicals.

This after-image processing is an important part of creating any digital image but especially so when images are recorded in Raw as done with Hasselblad. While some raw images can be used as they come out of the camera if you are not looking for the best quality, you undoubtedly want to have a close look at every image and see in what ways you can improve its effectiveness and create the best possible image from a quality point of view as well as the visual effectiveness of the final image. This entire process from the moment the image is created in the camera to the printing of the final image is known as the workflow and is done with the help of a raw converter program which supports the photographic workflow process. In Hasselblad, this is now done with the Phocus software program introduced in 2008 and replacing the FlexColor software used by Hasselblad for a good number of years. One of these programs is supplied to every purchaser of a Hasselblad digital camera or Hasselblad digital sensor unit or can also be downloaded from the Hasselblad website by a registered Hasselblad owner. The program from the disc is transferred into the computer and becomes then the basic element of the workflow. While the discussion here refers to Phocus, you work basically the same way with FlexColor. Therefore, most points discussed in this chapter apply

to Phocus and FlexColor, but each has its own operating procedures so you must refer to the instruction manual for details.

ADVANTAGES OF PHOCUS

Photographers have been satisfied with the operation, the results, and the image quality that they achieved with FlexColor. Hasselblad felt however that it was time to support the photographer's workflow with the most modern and best conceivable raw conversion engine that reflects the way photographers work, or like to work today and gives the photographer more time to take pictures instead of processing them. The Phocus version delivers the ultimate quality and perfect colors in the Hasselblad digital process and gives you the flexibility and power necessary to enjoy the workflow solutions with several major advantages.

The Tool's software's palettes are neatly organized under four tabs representing the four basic steps Capture, Browse, Adjust, and Export in the workflow process where the actual Raw conversion takes place. Photographers familiar with Apple's Aperture or Adobe Lightroom programs will feel right at home in Phocus.

Phocus allows all three DAC levels of image correction to be controlled individually with level 1 dealing with chromatic aberration, level 2 with distortion, and level 3 with vignetting which is adjustable between 0 and 100%.

Moiré is practically never a problem in the multi-shot mode but the multi-shot mode is either not practical or impossible to use in many shooting situations and is possible only with the special Hasselblad multi-shot cameras or digital backs. Moiré is also not a serious problem in the Hasselblad single-shot mode except for high resolution images that can exhibit moiré under certain circumstances, Phocus implements a unique algorithm for moiré removal that identifies the areas within the image that are prone to moiré eliminating the need for making special masks or other manual manipulations. The other parts are masked automatically and thus unaffected by side effects of moiré removal. Moiré removal is performed directly on the raw data but within the potentially affected areas so that moiré is not really removed but avoided. This new "Deep Impact Moiré Filter," which can be used with any 3RF file, has 5 different settings or can be turned off completely. Set the moiré removal to the least aggressive setting that delivers a clean image without unwanted artifacts.

Pre-planning for a shoot makes all work with any DSLR camera more successful but Phocus makes this pre-planning easier and also allows making practically all camera controls such as metering and exposure mode, aperture, shutter speed, manual and auto focus, ISO, EV, and changes in the white balance settings from the computer. Such controls are also possible with a Hasselblad digital capture unit mounted on a view camera especially when the view camera is equipped with an electronic shutter lens.

The view section of Phocus also offers a wide selection of options such as full view, browse, and simultaneous viewing of two images for comparisons.

When using the Hasselblad Global Image Locater (GIL), Phocus allows you not only to see the coordinates of the geo-tagged images but provides a link to Google Earth to show exactly where each image was taken from a bird's eye view and even lets you fly right into the location.

Phocus may also allow you to work at higher ISO ratings, double the normal rate.

THE PHOCUS GRAPHICAL LAYOUT

The graphical layout in Phocus can be customized in regards to the various windows, item size, and positioning as well as the content in the various windows. Below is a description of the default graphical layout which is shown in Figure 5-20.

Figure 5-20 The Graphical layout of Phocus.

On the far left is the File Browser that contains information regarding Capture destination. Favorites, Collections, File systems, and devices. This window can be hidden or minimized after loading fresh captures or completing a search for folders but can only be placed on the left hand side of the layout.

The Menu includes File, Edit, Image, View, Window, and Help for specific choices.

The Viewer that normally contains the selected image is in the center of Figure 5-21. An optional viewer toolbar runs along the bottom of the viewer. The viewing area can also be minimized, and placed into a vertical column with a collection of thumbnails to the left. It can also be made to fill the entire screen as a Full Screen Viewer with Toolbar. Exit the Escape button to exit Full Screen mode.

The Tool Area on the far right shows sets of tools under four main tab headings, Capture, Browse, Adjust, and Export. These individual sets can be regrouped to include or delete certain tools or create duplicate tools. The four tabs can be hidden. Each tab can be customized for content.

Figure 5-21 Full Screen Viewer in Full Screen View, the viewer with the selected image fills the entire screen area and with the Viewer Toolbar with tools primarily used for viewing at the bottom.

Thumbnail images of the files in the selected folder can be seen in the Thumbnail Browser as a horizontal window below the Viewer or replacing the viewer (see Figure 5-22). Thumbnails can be moved within the browser, can be increased in size, or can be re-named. The display of the thumbnail browser can be increased or decreased in size, can be repositioned into a vertical window, and can also fill the entire screen with or without the File Browser or Tool Area by replacing the Viewer. Clicking on the top right hand corner icon brings up a menu that lets you sort images by IAA rating, by name, by date, or under a custom setting.

Figure 5-22 The Thumbnail Browser can be a horizontal window below the Viewer or replace the viewer to fill the entire center area.

The Toolbar seen in the main window contains buttons for a number of frequently used tools for general use such as Capture, Export, Import, Modify, Delete, Print, Preferences, and

Layout. More tools primarily for viewing are found on the Viewer Toolbar at the bottom of the viewer from the thumbnail browser.

WORKING WITH PHOCUS

The text here is limited to the description of the possibilities without giving step by step instructions for every procedure. This is done not only because it involves operating a computer rather than a camera but also because complete and detailed instructions would fill a book by itself and also because you can customize most functions to fit your desired working method. The software program does not follow a fixed workflow but gives you the opportunity to create a personalized working environment. For detailed instructions on the operation of the Phocus program consult the instruction manual. For detailed instruction on the practically unlimited image manipulation possibilities in the computer consult the many books that are on the market, read the articles in photographic magazines, and even better, attend workshops by known experts in the field of digital imaging, or purchase the educational discs produced by such photographers.

Importing Files

Before importing from a CF card or the Image Bank II, decide or check to see which folder has been selected as the destination folder. Then proceed as follows. Make the FireWire connection between the computer and the unit and go to the File Browser (number 1 in Figure 5-23). Go to Devices (number 2 in Figure 5-23) and click on the Icon's disclosure triangle to reveal the folder of capture (number 3 in Figure 5-23). Double click the folder (number 4 in Figure 5-23). The captures are now displayed in the Thumbnail Browser as compressed 3FR files with the 3FR Icon displayed (number 5 in Figure 5-23). Select the files required in the Thumbnail Browser and go to Import. You can now select a number of variables from the dialog box such as adjustment, Presets for a rapid workflow, etc. When affirmed, Phocus imports the selected files, processes them into FFF files (Flexible File Format), which is still a raw file, and stores them in the selected folder.

Tethered Capture

Hasselblad digital cameras and digital sensor units can be triggered and controlled to various degrees from the computer after the digital camera system is connected to the computer with a standard FireWire 800 cable. The camera operations that can be set and controlled from the computer depend on the camera model with the H cameras offering more controls. Since V system cameras are mechanical cameras, the lens controls cannot be operated from the computer and the remote control is pretty much limited to releasing the camera. A 503 CW camera also must be equipped with a motor winder with a cable connection between the winder and digital back. The more advanced data-controlled capabilities of H cameras allows operating also the aperture and shutter speed, as well as auto and manual focusing. When camera and computer are connected, an icon appears under Devices in the File Browser (number 1 in Figure 5-24) and a heading in the Camera Tool (number 2 in Figure 5-24)

Figure 5-23 The Operating steps for Importing files. The File Browser (top and center) the Thumbnail Browser (bottom).

Figure 5-24 Tethered Capture. After camera and computer are connected, an Icon appears in the File Browser (1) and a heading in the Camera Tool shows that the connection has been made (2). The camera can now possibly be triggered by the Capture Icon on the Toolbar (3).

notifies you that the connection has been made. The camera can now be triggered either by the Capture Icon in the Toolbar (number 3 in Figure 5-24), the shortcut, or the camera itself. The image becomes visible on the computer screen immediately after releasing the camera (this is the exact image as it was recorded on the sensor). This allows you to check all aspects of the image capture, make any desired changes and make another test.

The capture is then imported and stored directly as a lossless, compressed FFF file in the destination folder. Needless to repeat that it is necessary to select the correct folder beforehand.

Working with the File Browser

Clicking on the arrows on the header bar (number 1 in Figure 5-25) navigates through all folders with the folder name shown in the File Browser menu (number 2 Figure 5-25). The desired folders can now be selected in this menu or by double clicking on the icon in the main File Browser panel (number 3 in Figure 5-25).

When Phocus is first installed, a scratchpad folder is created and becomes the destination folder for all captures until you choose otherwise. The scratchpad can be accessed under the Capture Destination heading with its content appearing in the Thumbnail Browser. You can create other folders or select other folders as destination folders. The frequently used folders can be placed into Favorites or the images from various folders can be relocated in a new folder under Collections. Images selected for rapid browsing purposes from any folder can be dragged and dropped into Quick Collection where a number in brackets indicates the number of image files in the folder. Clicking on Quick Collection displays the images in the Thumbnail Browser. File System gives an overview of the location of your local or network connections for accessing capture/storage folders and Devices shows the connected image creating devices but only if these devices are connected.

The Thumbnail Browser

In the default setting, the Thumbnail Browser at the bottom of the screen displays all the images from a selected folder with the name and the number of images in the folder as well as the available free space on the hard drive shown on a bar above the images (Figure 5-26). The + or − signs (number 1 in Figure 5-27) are used to increase or decrease the size of all the captures in the thumbnails. A scroll bar runs along the bottom of the thumbnail images with the icon in the right corner altering all the thumbnails in the window globally (number 2 in Figure 5-27). A selected thumbnail can be opened in the viewer by double clicking or by pressing return/enter.

For viewing and sorting the images, click on the icon in the top right corner, which opens a pop-up menu (number 2 in Figure 5-28). You can view the IAA approval color rating by clicking on the arrow to ensure that it points upward. After selecting the desired IAA approval rating you will see only those images with that particular rating.

To sort images, click on the arrow making certain that it points downward and click on the menu to sort the images based on name, date, or a custom setting. There is also a check-box (number 3 in Figure 5-28) to display crops. To retain the crop in thumbnails, check the box, make the crop and go Menu>Adjustments>Save.

Figure 5-25 The File Browser. Clicking on the arrows (1) navigates through the folders with the folder name appearing in the File Browser Menu (2). Folders can also be selected by double clicking on the selected icon (3).

An extra tabbed folder can be created in the Thumbnail Browser by holding down the Command (Apple) key while selecting a folder in File Browser>File System. This creates an extra tabbed folder (number 4 in Figure 5-29) which appears in the Thumbnail Browser. Click on the X in the tab to delete it.

Thumbnails that have been assigned to the Quick Collection receive a quick collection icon (number 5 in Figure 5-29) in whichever folder they are stored in. Images in the Quick Collection can be deleted any time.

Figure 5-26 The Thumbnail Browser at the bottom of the screen display.

Figure 5-27 Changing size of image. The size of the image is changed by clicking the + or – signs (1). Dragging the modifying icon (2) alters all images globally.

Figure 5-28 Viewing the thumbnails. Clicking on the icon (1) opens a pop up menu to view and sort the displayed captures in different ways. Clicking on the arrow (2) when it points upward allows you to see the images based on the IAA approval rating. To sort, click on the arrow when it points downward. Checkbox (3) displays crops.

The Viewer

Any image selected from the Thumbnail Browser can be enlarged and viewed on the Viewer for detailed examination. The current size of the image is always shown in the top right corner of the Viewer. A bar above the image carries the name of the image, its approval level and its size in percent as well as a + and – sign for changing the size. You can change the size of the image with the Zoom Tool in the Toolbar and you can view two images, even from

Figure 5-29 Extra Tabbed folder and Quick Collection. The extra tabbed folder appears in the Thumbnail Browser (4). Thumbnails assigned to a Quick Collection acquire a Quick Collection icon (5).

different folders, side by side on the viewer for comparison by selecting an image in the Thumbnail Browser and then selecting Compare view in the viewer toolbar below the image, then go to Menu > View > and to Compare Image. Adjustments that you might make affect only the right hand image. The two images can be switched left to right or vice versa with the Switch Compare Images key on the far right of the toolbar.

The Viewer Toolbar

The viewer Toolbar that is below the image with the Normal View symbol on the far left, allows you to work with the image in the viewer. The window next to it is Compare View and allows you to view two images side by side,. You press the S key to open the selected thumbnail which then appears on the left hand side of the viewer. Double click another thumbnail for the second image.

The activated crop tool includes a placement/centering grid which can be customized in the Crop tab in the Tools window to match the desired proportional ratios. It is then dragged into position. Crop dimensions appear immediately beneath cropped area while the mouse is pressed. You can determine the number of lines in the grid while pressing a numerical key.

The Neutralizing Tool allows making a rapid neutral color balance in any part of the image. After clicking the icon, position the tool over an area that you judge to be neutral and click again. The RGB readout at the bottom right of frame can give you more information.

The Zoom Tool can be placed over any area within the image that you want to zoom in and will then provide a 100% view of that particular area. Clicking Alt reverts the image to the original size.

To Mark Underexposed and Mark Overexposed, click to mark areas of the image which are underexposed indicated as light magenta in the default setting or overexposed and marked as light cyan. Cover the affected areas then go to Menu > View > Warning Options to change threshold settings and the warning color.

Figure 5-30 Viewer Toolbar. The viewer Toolbar has from top to bottom the following tools encircled in the illustration: Normal View; Compare View; Crop Tool; Neutralizing Tool; Zoom Tool; Mark Underexposed; Mark Overexposed; Grid; Previous Image; Next Image; and switch compare images.

The Grid button adds a grid over the Viewer image to help in re-composing the image and assuring perfectly straight verticals and horizontals. Go to Menu > View > Grid Options to change the number and color of lines. The Grid Option menu will access the Grip Options Dialog.

The Previous Image or the Next Image can always be viewed by pressing the left or right arrow key. The new image replaces the previous one on the viewer.

Switch Compare Images switches the position of the two images in Compare View.

The Tool Area

In The Tool Area you have four tool collections called tabs — Capture, Browse, Adjust, and Export with a pop-up menu in each list showing the available tools. All tools can be removed or added to any list in any tab so you can customize each tab for your way of working. The Capture tab lists all the information about the camera and capture information. The amount of information, however, is somewhat dependent on the camera or digital back used for the digital capture.

Besides seeing all the information about the existing image, the Tool Area allows you to make the desired changes in the image to create a new preset. Tools are opened in the easiest fashion by clicking the main disclosure triangle in each tool header which drops down a dialog that allows setting changes. Some tools use slider controls combined with a window for numerical input so you can either key in a specific value or use the up/down controls to raise or lower the values.

Tool List

Camera Camera reflects the settings from a tethered camera with the amount of information depending on the camera model.

Capture information The amount of capture information also depends on the camera model.

Color Correction The color correction is a sophisticated control for selective and subtle color shifts. Controls saturation and vibrancy of selected areas (Figure 5-31). You can also check the box Reproduction Mode to produce a colormetric representation which utilizes other imaging techniques including the use of a linear film response curve. The steps for accomplishing a color correction are shown in Figure 5-32.

Figure 5-31 The Color Correction Tool window. The box for Reproduction Mode is at the bottom.

Color Information Color Information provides an RGB readout of the area beneath a cursor located on an image in the Viewer window.

Crop Tool A tool to set the format and the orientation of the Crop Tool for an artistic change in the image. Clicking on the Mask icon brings up a window to select color and opacity of the mask.

Curves Curve adjustments can be made as a combined RGB setting or by selected individual channels (Figure 5-33). To adjust the curve, click and drag on the graph. Check box on the tool header bar to see whether preview image reflects the updated changes. To sample an area of the viewer image, click the eyedropper icon and mouse over the area. The value is automatically represented on the curve.

Exposure EV, contrast and brightness can be set numerically with sliders.

White Balance Has standard presets and other preset possibilities and allows color temperature adjustments and Tint compensation to assure consistent colors within a batch.

Figure 5-32 Color correction. After clicking on the color picker icon (1) in the tool tab you click on the desired tone on the color wheel where a point (2) will appear. You can now adjust hue, saturation and lightness either by moving the slides (3) or clicking on the point on the wheel and dragging it to form an arrow (4) that can be extended shortened or rotated to alter the settings. You can also create a new point (5) to rotate the whole segment within the circle. Saturation and vibrancy are altered with sliders (6).

Figure 5-33 Curves. Clicking on a new point creates a gravity point which pulls the curve towards itself. You need not click on the actual curve.

Histogram The Histogram can display graphs of combined or separate channels (Figure 5-34). Highlight, shadow and gamma settings can be entered with a slider control numerically. You can see when clipping occurs in the shadow or highlight areas.

Sharpness The four sharpness controls, are Amount, Radius, Threshold and Dark Limit (Figure 5-35). Apply checkbox to turn effect on or off. Presets Default, Medium, and High are also available.

Figure 5-34 The Histogram showing separate RGB channels.

Figure 5-35 The four sharpness controls: Amount, Radius, Threshold, and Dark Limit.

Amount controls the strength of the sharpening effect with a value between 80 and 200 a recommended starting point depending on the type of image.

The Radius setting depends on the nature of the image and the resolution with a large radius generally used with high resolution images.

Threshold controls the point above or below which pixels are affected. Low settings will sharpen most pixels but may create noise in soft texture. Higher settings restrict the changes to detailed areas.

Dark Limit sets the brightness level below which the filter has no effect. A setting between 0 and 20 is recommended for most images with a higher number producing a less extensive sharpening effect.

IPTC Core and IPTC Keywords You can select whether to see a long, medium, or small list displayed in the window and edit the information in each preset list. This allows keywork inclusion in the Metadata.

Job Information You can chose the desired destination folder, enter a new file name, enter the desired numerals as part of the next sequence number, and see the information at the time of capture which is part of the metadata.

Lens correction Chromatic Aberration, Distortion, and Vignetting are the available tools with Chromatic Aberration and Distortion working in the background while Vignetting is set by a slider control.

Noise Filter A filtering tool consisting of Color to neutralize the coloration of colored noisy pixels which may occur in areas with very fine detail; the Luminance control which is helpful to reduce "noise" in dark areas especially when long exposures or high ISO values are used; and Moiré reducing the moiré effect which may originate from patterned materials showing interference with the frequencies of the pixel structure on the sensor.
Queue Displays the files currently being processed in the background.

Menu

The Menu at the very top of the screen contains several Phocus specific items like Image, File, Edit, View, and Window with helpful hints and various keyboard shortcuts.

The Toolbar

The Toolbar above the Viewer offers in the default setting a number of options from Capture to Import, Export, Modifying, Deleting, and Printing, and Preferences and Layout. You can customize the layout with the Customize Toolbar control (Figure 5-36).

Figure 5-36 The Toolbar with the frequently used tools in the default setting.

In the Capture mode, shots from a tethered camera are stored directly as FFF files in the selected folder. An exposure can also be initiated remotely from the keyboard.

In Import, Phocus imports the selected files and converts them into FFF files.

The Export setting allows you to select the file format, resolution, profile, etc. of the exported files which includes an Output Preset and a Name Preset menu.

Modify opens a dialog box that lists the choices for batch modification.

Delete sends selected images directly to Trash You can also open a dialog box for approval before trashing. Print offers the standard printer choice as well as PDF and Preview opportunities.

Preferances with the dialog of the following:

- Units which allow measuring images in centimeters, inches, or pixels
- Initial Approval Level which sets the approval rating of the incoming files

- Save Adjustments which sets whether adjustments are saved "manually" where you need to save each time you find it necessary, "Ask before saving" where you can check before a save is attempted or "Always save" that saves the current adjustments automatically
- Flash Delay to allow time for older flash system to regenerate
- Image Editor allows choosing the software that you want to work with for further editing
- Background Brightness to control the brightness of the graphical interface

Layout switches the layout of the Viewer and and Thumbnail Browser windows.

Adjustments

The original raw image goes through a range of transformations before it becomes the visible image on the screen. The image that first appears on the screen reflects the default Imbedded Adjustment Preset. From this point on, a new set of transformations can be imposed to create the final image. In Phocus, these transformations are called adjustments and can include, for example, color temperature settings, exposure and curve modifications, and sharpness enhancement. A set of adjustments for an image at a given time is referred to as an Adjustment

Figure 5-37 Adjustment example. Import sign (1) on the adjustment section, Save Changes button (2) with the preset name (3). The new preset name after two additional corrections is shown as (4) with the dimed Save button (5) and the five tools used for the corrections shown as (6) after clicking on the latest save.

Preset. After making all the fine tuning modifications which you see in the image in the viewer you can save the changes by pressing the Save Changes button in the adjustment section of the toolbar

You have now created a new embedded Adjustment Preset. By pressing the Reload button in the adjustment section you can reload and see the image with the previously made adjustments.

As an example, you might select a specific thumbnail and import it into the viewer, indicated by Import (1) appearing in the adjustment section of the toolbar (Figure 5-37). After using three tools, White balance, Histogram, and Exposure click the Save Changes button (2) in the adjustment section. An edit preset name appears (3) in this case showing the time of the save. The save button dims to indicate that the save was made. You may want to use two more tools like Color Correction and Noise Filter. Save the changes as before which is indicated and confirmed by the new time (4) and the dimming of the Save button (5). In the Adjustment Browser, the two adjustment preset saves appear on the list and clicking on the latest save reveals the five tools used to make the changes (6)

The 503 and Other V System Cameras and Components

■ ■ ■ ■

DIGITAL IMAGING WITH V SYSTEM CAMERAS

You can produce film images in the square or rectangular format with all V system camera models. Digital imaging has not outdated theses cameras originally made for film photography. By simply replacing the film magazine with a Hasselblad digital back the V system cameras, at least the more recent models, make excellent tools for digital imaging. You can also produce digital images in the square or rectangular format depending on which digital back you attach to the camera. You can produce square images in the 36.7×36.7 mm size with the Hasselblad CFV and CFVII 16 Mpixel CFV sensor units. They fit directly to the rear of the cameras like a film magazine. See Chapter 12 for different digital backs used on 200 camera models. You can produce larger rectangular images in the 36.7×49.0 mm size with Hasselblad digital sensor units CF 22 with 22 Mpixels or the CF 39 unit with 39 Mpixels. The CF digital sensor units go on all the different cameras in combination with an adapter that varies with the camera model. Some cameras also require an exposure cable or a Flash sync input cable, and the 200 and 2000 camera models need a slight camera modification if used with F lenses. The 503CW must be operated with the CW motor winder. Consult Hasselblad for exact details. The sensor units are described in further detail in Chapter 3. Hasselblad also has a complete digital V system camera package consisting of the 503CWD camera with CFVII 16 Mpixel digital back, 80 mm Planar lens, focusing screen with digital image format markings, and accessories for digital imaging.

HASSELBLAD 500 CAMERA MODELS

All Hasselblad cameras in the 500 series are identical in the interchangeability of their components and in the use and operation of lenses and magazines (Figure 6-1). All are completely mechanical, battery-independent, SLR cameras with shutter lenses. A rear curtain protects the image plane from light before and after an exposure is made. The 500C and 500EL cameras made prior to 1970 do not have interchangeable focusing screens. The Classic is basically a 500CM without a removable winding crank and an 80 mm Planar lens engraved C that does not have the F setting and the interlock between the aperture and the shutter speed ring.

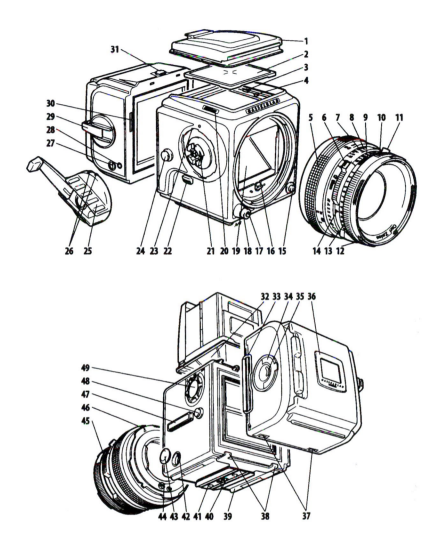

Figure 6-1 500/501/503 components. (1) focusing hood, (2) focusing screen, (3) screen retaining clip, (4) Flash ready signal*, (5) focusing ring and scale, (6) shutter speed and aperture interlock button (7) central lens index (8) depth-of-field scale, (9) aperture ring and scale, (10) shutter speed selector ring, (11) PC flash terminal, (12) lens accessory mount, (13) exposure value scale, (14) exposure value index, (15) lens lock and release button, (16) drive shaft, (17) cable release socket, (18) shutter release button, (19) mirror, (20) nameplate, (21) winding crank bayonet*, (22) pre-release button, (23) winder bayonet mount*, (24) strap lug, (25) winding crank, (26) winding crank index*, (27) frame counter, (28) magazine status indicator, (29) film winding crank, (30) magazine driving gear, (31) magazine catch, (32) focusing hood magnifier, (33) magazine slide, (34) film insert key, (35) film consumption indicator, (36) film tab holder, (37) magazine support slots, (38) magazine supports, (39) camera support, (40) tripod socket, (41) quick coupling plate, (42) dedicated flash connection*, (43) connection cover*, (44) lens coupling shaft, (45) manual stop down control, (46) lens location index, (47) accessory rail, (48) strap lug, (49) film speed selector*. *Not on 500/501 models.

The 501C and 501CM camera models have the Acute Matte focusing screen. The 501CM also has the gliding mirror system (GMS), which shows the entire image on the focusing screen with all lenses and all accessories. The original 500 and 501 models do not have a dedicated flash system.

Camera Finishes

Most camera models have been available in chrome or black finish. The 501CM and 503CW cameras have also been on the market in the ruby red, cobalt blue, forest green, and sun yellow finishes.

HASSELBLAD 503 CAMERA MODELS

The 503CX camera has the automatic dedicated flash system and a new Palpas coating on the interior surfaces reducing the possibility for stray light reaching the image plane and creating flare. The 503CW model also has the gliding mirror system. All 503 models have the new Acute Matte focusing screen that provides an even brighter and sharper image than before. This new screen makes the image fall in and out of focus in a clear and definite fashion for the most accurate focusing with any lens. The screen also has a new Fresnel lens that provides even brightness over the entire screen surface. The 503CXi and the 503CW can be used with an accessory motor winder.

Working with 503 Cameras

Whether you work with film or digitally, everything you need to know about the component interchangeability on 503 and other V system cameras, including the latest 503CW types, is described in this chapter. More details about the camera operations that will help produce technically great pictures with 503 cameras and lenses can be found in Chapter 9, with details about the viewing system in Chapter 7, and the selection and use of film magazines in Chapter 8.

THE MOTOR-DRIVEN EL CAMERA MODELS

The 500ELX and later models have the automatic dedicated flash system and a gliding mirror arrangement. Like those of the earlier EL and ELM models, the 500ELX motor is powered by rechargeable NiCad batteries.

The 553ELX motor, like the motor in all future models, is powered by five standard AA batteries instead of the NiCads.

Hasselblad 555ELD for Digital Imaging

The 555ELD has a new heavy-duty motor powered by five AA batteries and a gliding mirror system with a mirror suspension and a camera release mechanism that was in the space camera design. This camera is ideal for photography with film or for electronic imaging with a

digital camera back. The rear of the 555ELD has integrated connectors to interface with some digital backs, eliminating cable connections between camera and magazine. An accessory IR release unit can be attached to the front of the 555ELD camera for wireless remote operation up to 33 feet (10 m). It is powered by the camera batteries.

THE HASSELBLAD 200 CAMERA MODELS

The Hasselblad 200 camera models have electronically controlled focal plane shutters synchronized for flash up to $\frac{1}{90}$ second, the gliding mirror system with an instant return mirror, the dedicated flash system, and a built-in self-timer. You can make double or multiple exposures without removing the film magazine.

The winding crank is removable for operation with a motor winder specifically made for these camera models. The cameras can be used with all non-shutter lenses (FE, TCC, and F) as well as the CF, CFi, and CFE types with shutter. With the latter, exposures can be made with the shutter in the lens synchronized for flash up to $\frac{1}{500}$ second or the focal plane shutter (except the 202FA, where the focal plane shutter must be used).

The camera models with built-in metering systems have the electronic Databus connection in the bayonet lens mount to transfer the data from FE, CFE, and TCC lenses into the camera and the same electronic connections at the rear of the camera body to transfer the data from E, ECC, or TCC film magazines into the camera's metering system. With lenses that do not have the electronic coupling, you must manually stop down the lens aperture for the meter reading. With A-type film magazines, the film sensitivity is programmed manually into the camera body's metering system.

All cameras need a 6 V battery for timing the focal plane shutter speed and for operating the metering system. All cameras (except the 202FA) can be operated without a battery if the shutter in CF, CFE, or CFi lenses is used to make the exposure.

The 201, 202, 203, and 205 Camera Models

The original 205TCC came with TCC film magazines that have an adjustment to change the exposure so that shorter or longer film developing times can be used in black and white photography to change the contrast in the negative, based on Ansel Adams's principles. The camera designation was changed to 205FCC, (F standing for focal plane shutter) with a change in the dedicated flash operation described in Chapter 18.

All 205 cameras have a built-in spot meter with automatic bracketing programmable in $\frac{1}{4}$ f stop values. The shutter speeds, set electronically to an accuracy of $\frac{1}{12}$ f stop increments, range from 90 seconds to $\frac{1}{2000}$ second (from 34 minutes to $\frac{1}{2000}$ second in Manual mode). The built-in self-timer can be programmed for delays from 2 to 60 seconds.

The 203FE camera is identical to the 205FCC but has a center metering system (not a spot meter) and automatic bracketing in $\frac{1}{3}$ f stop increments.

The 202FA model has the features of the 203FE but no automatic bracketing and a shutter speed range up to $\frac{1}{1000}$ second only. With CFi and CFE shutter lenses the exposure must be made with the focal plane shutter, limiting flash exposures to $\frac{1}{90}$ second or longer.

The 201F, like the other 200 models, has no metering system and shutter speeds up to $\frac{1}{1000}$ second adjustable in ½ f stop increments.

THE HASSELBLAD 2000/2003 CAMERA MODELS

Hasselblad introduced these focal plane shutter models mainly to allow using larger aperture lenses such as the 80mm $f/2$ Planar. These models offer electronically controlled shutter speeds from $\frac{1}{2000}$ to 1 second with a focal plane curtain made from very thin titanium. To prevent accidental damage to the shutter, the later 2000 FCM/FCW and 2003 models include a safeguard device that retracts the shutter curtain when the magazine is removed. A motor winder can be attached to 2000 FCW and the 2003 models. Double or multiple exposures can be made without removing the magazine. The mirror can be made to return instantly after the exposure or when the film is advanced, or it can be locked up permanently.

THE HASSELBLAD SUPERWIDE CAMERAS

All Superwides, from the earliest models to the latest 905SWC, are built around the Biogon 38 mm $f4.5$ lens and its 90-degree diagonal angle of view when used for the 2¼ square format (Figure 6-2).

The Biogon, permanently mounted on a short camera body without reflex viewing, is an optically true wide angle design, practically distortion-free with superb corner-to-corner image quality at close and far distances even with the lens aperture wide open. The Biogon focuses down to 12 in. (0.3 m), making the Superwide an excellent camera for copying. The rear of the camera takes the same film magazines as other Hassselblad V system camera models. Older camera models, however, do not accept the Polaroid film magazine. The Superwide cameras are not recommended for digital imaging, at least not at larger apertures and/or with the large 36.7 × 49 mm sensor. The reasons are described in detail in Chapter 11.

An optical viewfinder attaches to the top of the camera. Because the lens has great depth-of-field — for example, from 26 in. (66 cm) to infinity at $f/22$ — you can usually achieve sufficiently accurate focusing by visually estimating the distance. However, you can view and focus the image by attaching a focusing screen adapter in place of the film magazine.

The original camera was called Hasselblad Supreme Wide Angle with film advance and shutter cocking as two separate operations. The next version, the Hasselblad Superwide C, was equipped with a Biogon C lens design with film advance and shutter cocking in one operation. A spirit level built into the top of the camera body with a prism attached to the viewfinder lets you see the level setting from the viewing position. On the Hasselblad 903SWC the spirit level, on top of the removable viewfinder, is visible in the viewfinder together with the image area covered on the film, which is especially helpful in handheld photography. The viewfinder also has a magnifier at the bottom that allows you to see the distance setting on the CF lens in the viewfinder. The Superwide SWC/M models allow attaching the Hasselblad instant film magazine.

Figure 6-2 Square format. A subject composed beautifully in the square format including the door on the right as an important part of the image. (Photo by Ernst Wildi.)

THE HASSELBLAD FLEXBODY AND ARCBODY CAMERAS

The Hasselblad V system also includes the FlexBody and the ArcBody cameras with swing and tilt control. While the FlexBody is used with Hasselblad shutter lenses, the ArcBody requires special Rodenstock type lenses with larger covering power.

RECORDING THE IMAGE IN 503 AND OTHER V SYSTEM CAMERAS

The Auxiliary Shutter

The auxiliary shutter at the rear of the camera body in lens shutter SLR cameras protects the film or digital sensor from light before and after an exposure is made. When the release is pressed, the baffle plates open and stay in the open position until the pressure is taken off the release. You must keep the finger on the release until the shutter in the lens completes

the exposure. This is something to keep in mind when using longer shutter speeds. Check the proper operation of the auxiliare shutter occasionally as described below.

The Focal Plane Shutter

In the focal plane shutter cameras, the shutter curtain controls the exposure time and also protects the film or digital sensor from light before and after the exposure. When the shutter in a lens is used to make the exposure (with the focal plane shutter set to C), the focal plane curtain works like the auxiliary shutter. It opens when you press the release and closes when you remove your finger from the release. Again, this is something to keep in mind at longer shutter speeds.

CHECKING THE CAMERA FUNCTIONS IN 503 AND OTHER V SYSTEM CAMERAS

Because all Hasselblad cameras can be operated without a film magazine or a digital sensor unit you can easily check the camera and lens functions. Remove the magazine or digital sensor and point the camera with lens toward a bright area. Look through the camera body/lens combination and press the release.

Make certain that the two rear baffle plates are completely out of the light path when the release is pressed and that they close completely and tightly when the button is released. Set the lens at a smaller aperture and check whether the diaphragm closes down to the preset value.

With focal plane shutter cameras set to C, make certain that the curtain is fully open when you press the release and that it closes when you remove your finger from the release. With shutter lenses, the rear curtains of the focal plane shutter must be fully open when the lens shutter opens and closes. On either camera type, you can also check whether the long shutter speeds ($\frac{1}{2}$, $\frac{1}{4}$, 1 second) in the lens or focal plane shutter are approximately correct. Also check the flash synchronization after attaching a flash unit to the camera or lens. You must see the flash firing while the lens or focal plane shutter is fully open.

COMPONENT INTERCHANGEABILITY IN THE V SYSTEM

Many features and operations are identical on all Hasselblad V system cameras. Film magazines and most digital sensor units can be switched from one camera to any of the other models at the end or the middle of a roll of film. The very early magazines with serial numbers below 20000, however, are usable only on 1000F and 1600F cameras. All cameras, except the Superwide models made before 1980, can also be combined with the Hasselblad instant film (Polaroid) magazine.

All V system cameras made since 1957, except the ArcBody, have the same lens mount so all V system lenses fit on all cameras (except the ArcBody).

HASSELBLAD SHUTTER LENSES ON 503 AND OTHER V SYSTEM CAMERAS

Hasselblad lenses with shutters are indicated with a C (C, CF, CB, CFi, and CFE). The lenses that have a designation F and an F setting on the shutter speed ring can also be used on focal plane shutter cameras.

The original Carl Zeiss C lenses made until 1981 had a unique lens barrel design with interlocked aperture and shutter speed rings with automatic depth-of-field scales, M and X flash synchronization (sync), and the built-in self-timer. It is not recommended to use these lenses on newer camera models therefore they are not discussed in further detail.

On CF lenses, introduced in 1982, aperture and shutter speed rings are no longer interlocked but can be locked together when desired. Figure 6-3 shows how to distinguish C from the newer types.

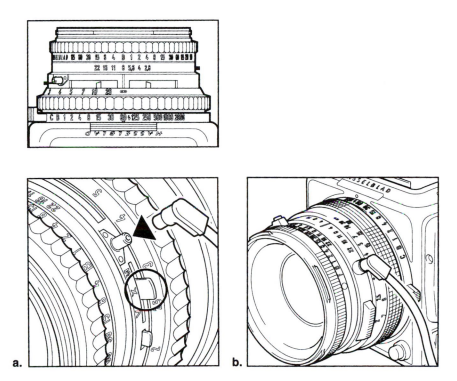

Figure 6-3 C lenses (a) can be distinguished from CF, CFi, CB, and CFE types (b) mainly by the VXM lever on the left side. This control is only on C types.

On CFi lenses, the flash connector is equipped with a cable locking device. CFE lenses are identical to CFi types but also have the electronic Databus connections for the light-metering system in the 200 camera models.

In the limited line of CB lenses, Carl Zeiss eliminated some features like the F setting. CB lenses can be used on focal plane shutter cameras (except the 202FA), but the exposure must be made with the shutter in the lens.

Lenses Without Shutters

The Carl Zeiss F lenses were originally designed for the 2000 camera models and did not have the electronic coupling to the camera body. F lenses became TCC types with electronic

Databus connections when the 205TCC camera was introduced and were changed later, in name only, to the FE types.

WORKING WITH THE V SYSTEM COMPONENTS ON 503 AND OTHER V SYSTEM CAMERAS

Removing and Attaching Lenses

Lenses can be removed and attached only when the shutter in the lens and/or camera is cocked and the camera is ready to be released but is not pre-released. If not, turn the winding crank, with film magazine removed to avoid wasting a frame, before you try to remove the lens. On 200 and 2000 cameras, simply turn the winding crank while pressing the center chrome button.

To remove any lens from a camera body, press the lens lock lever, turn the lens about 35 degrees counterclockwise (preferably by holding the lens on a non-movable part), and lift it out (Figure 6-4).

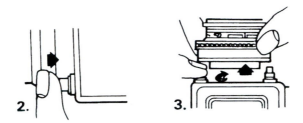

Figure 6-4 (2) To remove a lens press the lens lock button. (3) Turn the lens counterclockwise as seen from the front. Before removing a lens, check that the winding crank has been turned.

To attach a lens to any camera body simply place the lens into the mount and turn it clockwise until you hear a definite click. It is not necessary to press the lens lock lever (Figures 6-5 and 6-6). Lenses can be attached only if the shutter in the lens is cocked and the ridge on the camera's connecting shaft points to the dot. If not, turn the winding crank. If the shutter in the lens is uncocked, cock by inserting a coin in the slot and turn clockwise.

Figure 6-5 (4) To attach a lens, insert the lens in the bayonet mount so that the marking on the lens mount is aligned with the mark on the camera. (5) Rotate the lens clockwise until it clicks into place.

Figure 6-6 (6) Lenses can be attached only if the slot or ridge on the coupling shaft (A) is lined up with the dots (B) on the camera body and lens. If the camera slot is not lined up, turn the winding knob, or, on the EL models, change from the pre-released to the normal position. (7) If the slot in the lens is not lined up, insert a coin in the slot and make one full turn clockwise.

The Hasselblad shutter lenses should be stored with the shutter in the cocked position. There are no parts in the shutter that wear out if the shutter is left in this position.

These suggestions for mounting and removing lenses also apply to bellows, teleconverters, and extension tubes with or without electronic coupling. But with these accessories, you must also remove the components from the camera in the proper sequence. Always remove the lens first from the converter, tube, or bellows. Then remove the accessory from the camera body. You can remove lens and accessory together from the camera, but never remove a lens from the accessory without the components attached to the camera. It may uncock the shutter and jam the lens and accessory together.

Removing and Attaching Film Magazines and Digital Sensor Units

Hasselblad film magazines, with or without electronic contacts, can be removed from all camera bodies, whether they are loaded with film or not and whether the film has been advanced or not. They can be removed, however, only when the darkslide is inserted completely. A darkslide in the magazine also prevents accidental releasing of the camera (Figure 6-7). Digital sensor units are attached and removed in the same fashion.

Remove and attach film magazines as described in Figure 6-8. Before attaching a magazine, try to turn the winding crank. Turn it, if possible, to ascertain that the camera is in the ready position. Before you attach a magazine with loaded film check whether or not the film has been advanced. If the round window on the frame counter side is white, the film has been advanced; if it is red, the film has not been advanced. If so, attach the magazine to a camera body that also has not been cocked. Turn the winding crank with the darkslide in the magazine, then remove the darkslide. You can check whether there is film in the magazine by looking at the film consumption window on the other side of the magazine. If it is all or partially red, it contains film. If it is all chrome, it is empty.

Attaching and removing magazines with PM 90 viewfinders on the camera requires a special operation (Figure 6-9).

Operating the Instant Film Magazine

The newer instant film magazines can be used on all newer camera models; the older, discontinued type 80 can be used only on 500C and 500ELs models. Neither type can be used on

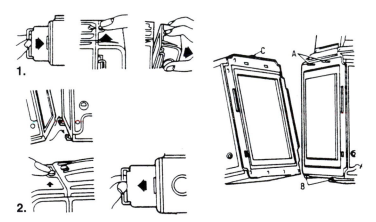

Figure 6-7 The camera/magazine connection. (1) A gear (A) on the magazine connects to the winding mechanism (B) of the camera. The opening (C) is for the pin (D) that comes out of the camera when the darkslide is out and the release is pressed. The 2000FCM and 2003 models also have a shutter retraction control (G). (2) When the darkslide is inserted, a piece of white metal (B) covers half the opening so that the pin cannot penetrate and the release cannot be pressed. The magazine lock button (A) can be pressed only when the darkslide is fully inserted. (3) The handle of the magazine slide (A) is moved to one side to clear the film insert. (4) It is best to insert the magazine slide with the handle toward the camera front. E, ECC, and TCC magazines and camera models with a built-in metering system also have the four electronic connectors.

Figure 6-8 (1) To remove a magazine, insert the darkslide. Press the magazine lock (C) on top of the magazine to the right, move the top of the magazine away from the camera, and lift the magazine off the two lower support catches. (2) When attaching a magazine with the darkslide inserted, hook the bottom of the magazine onto the lower two support catches of the camera body (B). Pivot the top of the magazine toward the camera latches (A) while pressing the magazine lock (C) to the right. Remove the darkslide.

Figure 6-9 With PM 90 and PME 90 viewfinders attach or remove a magazine by pressing the magazine catch slide (1). This can be done only if the locking lever is pushed forward simultaneously (2).

Superwide cameras made before 1980. With instant film (Polaroid) magazines, you can turn the camera's winding crank at any time.

Attaching and Removing Viewfinders

All viewfinders were interchangeable among all SLR models until the introduction of the 200 models with a metering system in 1991. These camera models with built-in metering systems require the newer finders with a cut out front for the viewfinder display panel. The newer types can be used on other camera models. The older types cannot be modified.

All viewfinders, old or new, are mounted and removed from a camera in the same fashion (Figure 6-10) After detaching the film magazine, slide the viewfinder on the camera toward the rear. Slide in the new viewfinder from the rear and replace the magazine.

Figure 6-10 Changing a viewfinder. Viewfinders can be removed only with the film magazine detached. (8) Slide the finder toward the rear and off the camera. (9) Slide in the new viewfinder from the rear, making certain that it is properly placed in the guiding grooves.

Changing Focusing Screens

On all Hasselblad V system SLR camera models made since 1970, you can remove the focusing screen as described in Figure 6-11 after removing the film magazine and the viewfinder.

Figure 6-11 Changing a focusing screen. (1) After removing the film magazine and viewfinder, push both screen retainers (A) into the camera body, and turn the camera upside down. The screen will drop out easily (if it does not, push gently from inside the camera body). (2) Drop the new screen into the square opening, with the finished side up. (3) Make certain that the screen rests on all four supports (A). The screen retaining clips will close automatically when the viewfinder is attached to the camera.

All screens must be inserted so that the finished side with the metal frame over the screen surface faces up. Screens with a split image rangefinder can be inserted so that the dividing line in the rangefinder is either horizontal or vertical.

Changing the Winding Cranks or Knobs

On all camera models with removable winding cranks, the crank (or knob) is best removed and attached with the camera in the cocked position when the winding mechanism does not rotate (Figures 6-12 and 6-13).

Figure 6-12 Changing winding cranks on newer models. To remove the winding crank, push the locking lever downward while turning the crank counterclockwise (left). To attach the crank or motor winder, place the winder or motor with the small black triangle opposite the dot on the camera. Turn it clockwise until it locks into position (right).

Figure 6-13 Changing the winding crank or knob on older cameras. (4) The dot (or the large triangular mark) on the crank or knob is usually opposite the red triangle on the camera body. (5) To change the knob or crank, put the camera in the ready position and push the locking device on the knob or crank away from the camera body. On the newer cranks, press the center button while turning the knob or crank counterclockwise. (6) Attach the knob or crank by pressing it against the camera body with its engraved circle (or the small triangular mark) opposite the triangular index on the camera body. (7) Turn it clockwise, and it will lock into position as soon as the red dot and the triangle match.

Bottom Plate and Tripod Socket

Although the newer camera models have a more solid and more professional-looking bottom plate, the tripod coupling plate design has been maintained, and all camera models including the H models can be used with the tripod coupling. The latest models come with two spirit levels for vertical or horizontal alignment of H cameras or V cameras with a 6 × 4.5 mm film magazine.

Viewfinders and Focusing Screens

■ ■ ■ ■

VIEWFINDERS FOR DIGITAL IMAGING

Selecting the right viewfinder and using it properly is as important in digital imaging as it is in film photography. While the image can be seen on the preview screen of the digital camera or digital back, you are more likely to evaluate the image in the viewfinder more carefully than you do on the screen especially in handheld photography. I therefore recommend using the viewfinder for evaluating and focusing the digital image, especially since the Acute Matte screen on current Hasselblad models provides an extremely sharp image of the subject and the viewfinder magnifies the image for precise focusing. The very sharp and magnified image on the bright Acute Matte focusing screen is a good reason for selecting Hasselblad for digital imaging. Viewing through a viewfinder also assures a steadier camera in handheld work. Viewfinders are interchangeable on the 503 and other more recent V system Hasselblad camera models, so you can select a type that is most satisfactory for your digital imaging or your film photography.

Viewfinders for Digital Imaging with H Camera Models

All H camera models come with an eye-level viewfinder that provides convenient viewing when photographing in the horizontal or vertical format. The original HV 90× finder has a 2.7× magnification and shows the full screen area for the 6 × 4.5 film format. The eye-level finder HVD 90× on the H3D and H3D-II cameras have a higher 3.1× magnification that covers only the smaller area of the 36.7 × 49 mm sensor. It has some vignetting at the bottom of the film format. If you like to see the full area of the film format, you need the HV 90×. The eye-level finders have a diopter correction and have a built-in metering system.

Since viewing from the top has advantages in some situations when the H3D camera models are used on a tripod, a waist-level finder with a 3.25× magnification without a metering system is available as an accessory. The operation of the finders is described in detail in Chapter 4.

Viewfinders for Digital Imaging with V System Cameras and Digital Backs

All viewfinders for waist- or eye-level viewing available for the V system cameras can be used for digital imaging as well as film photography.

FOCUSING SCREENS

Focusing Screens for Digital Imaging with H Camera Models

The original H camera models and the H2F model are equipped with a standard Acute Matte focusing screen HS standard that shows the area of the 6 × 4.5 film format. This screen is also available as an HS grid accessory screen with a grid pattern.

The Hasselblad digital backs that can be attached to these cameras for digital imaging come with a mask that can be placed over the focusing screen to show the area coverage of the digital sensor.

The H3D and H3DII digital cameras have an Acute Matte focusing screen that shows the image area of the digital sensor unit on the camera. The H3D-22/39 and H3D-31 screens are also available as accessories with grid lines (see Figure 7-1). If you use the H3D cameras for film photography and like to see the full area coverage of the 6 × 4.5 film format, you need to purchase an Acute Matte screen for this film format. Also read Chapter 4 for more details.

Focusing Screens for Digital Imaging with V System Hasselblad and Other Cameras

The Hasselblad 503CWD camera equipped with a CFV or CFVII digital back comes with an Acute Matte screen that shows the 2¼ square film area but has engraved lines for the 36.7 × 36.7 area of the digital sensor.

The Hasselblad CFV digital sensor units that can be attached to all V system camera bodies come with a mask that can be placed over the focusing screen to show the digital sensor area.

The CF 39 and CF 22 digital sensor units that attach to Hasselblad medium-format and large view cameras in combination with an adapter are supplied with a mask for the viewing screen that corresponds to the adapter purchased with the digital back. You use the regular focusing screen in the camera for viewing and focusing. More details about the digital sensor units are found in Chapter 3.

The Acute Matte Focusing Screen

All Hasselblad cameras made since 1998 are supplied with an Acute Matte screen. The very latest 500 models are also equipped with a split-image rangefinder and a microprism version. The Acute Matte design consists of an acrylic focusing screen with a fine Fresnel pattern and microlenses. These provide remarkably high brightness over the entire surface and a high resolution that helps to achieve accurate focusing in any type of photography in any lighting situation (Figure 7-2).

HS Standard HS Grid

H3D-22/39 H3D-22/39 Grid

H3D-31 H3D-31 Grid

Figure 7-1 H3D screens. Top illustration shows the two screens for the 6 × 4.5 film format. All screens in H3D and H3DII cameras show the area covered on the 36.7 × 49.0 sensor (center and bottom). The screens in the H3D-31 model also have the area of the 33.1 × 44.2 sensor engraved (bottom). The screens in the left column without grid come with the cameras. All screens with grid lines are available as accessories.

The H camera models and the 503 models in the V system have a new type of Acute Matte D screen that provides a brighter and sharper image than before. This makes focusing easier and more accurate. The new screen also has a redesigned Fresnel lens for completely even light distribution.

Screens with microprism areas used to be popular, but the Acute Matte screen offers practically the same benefits over the entire screen surface.

Figure 7-2 The Acute Matte screen. The superb image brightness and contrast of the Acute Matte focusing screen (left) are achieved with a fine Fresnel pattern (A) and a focusing screen plate composed of microscopic lenses (B). The lenses direct more light toward the eye than an ordinary focusing screen (right), which diffuses the light in all directions.

Other Focusing Screens

Throughout the Hasselblad history other types of screens have been made for V system cameras some of the more recent ones are shown in Figure 7-3. The screens with grid lines can be used for 6×4.5 photography as the outer horizontal and vertical lines correspond to this rectangular format and also to 8×10 paper proportions.

Focusing with Split-Image Rangefinder

On the Acute Matte screens with split-image rangefinder the image can be focused either in the clear rangefinder center circle or in the surrounding screen area. In the rangefinder area, the subject is in focus when a straight line crossing the rangefinder area appears unbroken across the dividing center line (see Figure 7-4). Rangefinder focusing is a good method for photographers who might have a problem seeing a sharp image in the viewfinder. Keep in mind that the image in the rangefinder area always looks sharp. You must focus on a straight line crossing the split area and your eye must be in the optical center otherwise one rangefinder field is blacked out.

Split-image rangefinder focusing has limitations regarding lens aperture. With lens apertures smaller than $f/4$ or $f/5.6$, one side of the split-image rangefinder field blacks out so the rangefinder is no longer usable. This is not a serious limitation, because the lens aperture is normally wide open when you focus and is $f/5.6$ or larger on the mostly used lenses.

Cleaning Focusing Screens

Never use lens cleaning fluids, other chemicals, or water on any focusing screen. Instead, clean it with a soft cloth, and if necessary, by breathing on it. Never dry it with hot air. Handle the acrylic screens carefully.

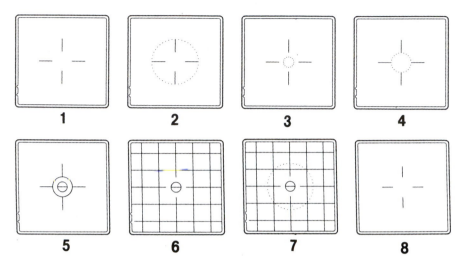

Figure 7-3 Different focusing screens. In addition to the standard Acute Matte focusing screen (1) are the screens with the 202/203 center metering area (2), the 205 spot metering area (3), and a screen showing the metering area of the PME 90 and PME 45 meter prism finder (4). There are screens with a microprism/split-image rangefinder area (5), and screens with grid lines (6 and 7), and a plain glass screen (8) The grid lines can also be used for composing in the rectangular 6 × 4.5 format.

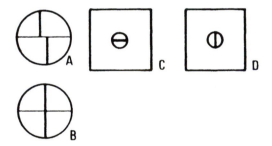

Figure 7-4 Rangefinder focusing. Accurate focusing with the split-image rangefinder screen is obtained when a straight line of the subject crossing the split is not broken (A) but continuous (B). The screen can be placed in the V system cameras so that the split is horizontal (C) or vertical (D).

AREA COVERAGE ON THE FOCUSING SCREEN

The focusing screen on Hasselblad H cameras shows 100% of the image area covered on film or on the digital sensor. Screens on V system cameras show about 98% (horizontally and vertically) of the film image recorded in the camera. This reduction was originally done on purpose to match the area more closely to a projected transparency (which is cut off by the slide mount).

For all practical purposes, the area you see in the finder is the area recorded in the camera. Focusing screens or masks with the correct area engraved for the various digital sensor sizes are supplied with the digital backs.

All V system Hasselblad cameras with a gliding mirror system show the recorded image area from top to bottom with any lens or accessory. Older cameras have vignetting along the upper edge when extension tubes, bellows, or lenses with focal length lenses longer than 100 mm are used. This image cut-off is only on the focusing screen, not in the image, so allow for it.

VIEWFINDERS

The Hasselblad eye-level finder for the H cameras and the interchangeable viewfinders in the V system magnify the image on the screen for accurate focusing. They also shield the screen from extraneous light for convenient image evaluation even in bright sunlight. Each viewfinder has its own advantage, so select the type that appears to be most satisfactory for your type of photography and for the way you operate the camera. All finders are beautifully suited for handheld photography, both film and digital.

Viewfinder Magnification

The magnification of Hasselblad viewfinders varies and is indicated in Table 7-1. Although the magnification varies, with the standard hood having the highest value, the image in all finders is sufficiently magnified for precise focusing on the Acute Matte screen. Your choice of finder is therefore best determined by the viewing convenience for your approach to photography. A higher magnification, however, enlarges the display of viewfinder information in H system and 200V system cameras making the figures and symbols easier to read. Some photographers like to add a view magnifier over the viewfinder eyepiece to magnify the center portion of the screen 2×. I do not feel that this is really necessary if you use the finders properly.

Viewfinders to Improve Camera Steadiness

Camera motion is reduced when two forces work against each other. With a handheld camera, the two forces are the hands pressing the camera in one direction and the photographer's head, with the eye pressed against the viewfinder, pushing the opposite way (see Figure 1-4 in Chapter 1). A firm contact between eye and viewfinder is necessary and is encouraged by the rubber eyepieces on the prism finders.

The latest viewfinders have a high eyepoint so you can wear eyeglasses for viewing. The firm contact between eye and eyepiece is, however, somewhat lost as it is difficult to press a finder eyepiece as firmly toward eyeglasses as you can toward your eye and forehead. Eyeglasses also leave an open space on the sides where light can enter making the screen image appear darker than it actually is. For these reasons, and because I do so much handheld photography, my personal choice is to view without glasses and leave my eyeglasses, which I need for reading the figures on lenses or magazines, on a chain around my neck so I can simply drop them when I take a picture. Whether to work with or without eyeglasses must

be your decision. The standard focusing hood cannot be used in any practical way with eyeglasses. Some finders with the older eyepiece can be changed to the newer type. Check with the Hasselblad service center or on their Web site.

Viewfinders for Exposure Measurement

The eyelevel finder on all H camera models includes the metering system for the camera discussed in detail in Chapter 4.

Equipping a V camera model with a meter prism viewfinder adds a built-in light-metering system to any V system Hasselblad camera. The light is measured through the lens (TTL) and through filters, extension tubes, and bellows. You see the measured area while composing the image on the focusing screen. These viewfinders offer a good solution for fast, convenient TTL exposure metering in digital or film photography. Chapter 15 discusses how to obtain perfect exposures with these finders.

SUGGESTIONS FOR ACCURATE FOCUSING

Viewfinders are necessary and recommended for viewing and focusing in film and digital photography because they magnify the finder image as shown in Table 7-1. While viewfinders magnify the image, any viewfinder can provide you with a sharp image only if your eyes can focus for the viewing distance of the finder, just as you can read a newspaper only if your eyes can focus at the reading distance. Test your camera and finder by focusing at a subject with very fine detail and do so with or without your glasses depending on whether you plan to wear them for photography or not. Turn the focusing ring. See whether you can easily see the details going in and out of focus when you turn the focusing ring slightly beyond the correct distance setting. Focus a few times to see if you always end up at exactly the same distance setting on the focusing ring. Test with different lenses if you have them, especially with wide angles, and also at lower light levels where focusing is more problematic.

Matching the Viewfinder to your Eyesight

Except for the HVM waist-level finder for the H models and the HM2 and RMfx finders, all newer Hasselblad V system viewfinders have an adjustable eyepiece, as shown in Table 7-1, to match to your eyesight. The built-in correction ranges shown in Table 7-1 seem to be sufficient for most photographers. Check whether this is the case with your viewfinder. If not, consider changing the eyepiece or magnifying lens if possible.

Adjusting the Built-In Diopter Correction

You must adjust the diopter correction on an adjustable eyepiece to your eyesight before you start using it.

Because the viewfinder must provide a sharp image of the focusing screen and not necessarily of the subject, it is best to make the adjustment without a lens on the camera so that you see nothing but the focusing screen. Adjust the diopter correction until the lines on the

Table 7-1 Viewfinders and Focusing Hoods and their Diopter Values

Viewfinder type	Built-in diopter adjustment	Potential diopter range with correction lenses or eyepieces	Magnification
Viewfinders for H cameras			
Eye-level finder HV 90×	−5 to +3.5	From optician	2.7×
Eye-level finder HVD 90×	−5 to +3.5	From optician	3.1×
HVM waist-level finder		From optician	3.25×
V System finders			
Standard focusing hood		−4 to +3	4.5×
PME 90	−2 to +0.5	−4 to +3	2×
PM 45 and PME 45	−2 to +1	−4.5 to +3.5	2.5×
Magnifying hood	−2.5 to +3.5		3×
View magnifier	−3 to +4.5		2×
Magnifying hood DPS	−2.5 to +0.5		5.5×

screen are absolutely sharp. After the first adjustment, remove your eye from the finder for a few seconds and look at a distant subject to relax your eye. Look at the focusing screen a second time to see whether the image is still sharp with the relaxed eye. The procedure for operating the diopter correction on PM 90 finders is illustrated in Figure 7-5.

Diopter Correction Lenses

The standard focusing hoods made for all SLR Hasselblad models since 1986 can be equipped with diopter correction lenses ranging from +3 to − 4. These accessory lenses, mounted in a square frame like the one that is in the hood, are not added to the existing magnifier but inserted in place of the present lens (see Figure 7-6). The focusing hoods made up to 1985 offer no practical diopter correction method.

Diopter correction lenses can also be installed in newer viewfinders if the built-in correction is insufficient. Unfortunately, there is no simple way to determine what diopter correction you need except to try the various correction pieces or lenses.

The HVM waist-level finder for the H camera models can be equipped with custom-made diopter correction lenses. Such correction lenses should be made to fit into the holder available from Hasselblad.

SELECTING A VIEWFINDER

Selecting a viewfinder is a personal choice based on your type of photography, your desired exposure measuring mode, or your preferred type of viewing and holding the camera.

Viewfinders for the H Camera Models

The H camera models come equipped with the 90 degree eye-level finders mentioned earlier. These finders also have a high eyepoint so they can be comfortably used with or without

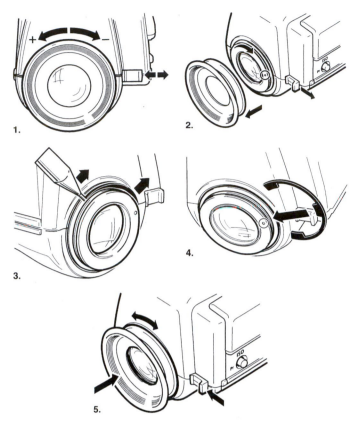

Figure 7-5 Eyepiece correction in PM and PME finders. (1) To set the diopter correction built into the PME finders, pull out the eyepiece lock. Then turn the eyepiece to the proper setting and push the lock lever back into the finder. (2) To change the eyepiece in the finder, remove the eyecup, release the diopter lock, and rotate the diopter all the way to the right. (3) With a pointed tool, remove the red "C" lock ring and remove the diopter. (4) Insert the corrective diopter eyepiece and the red "C" lock ring. (5) Re-install the rubber eyecup, rotate the eyepiece to the correct setting, and lock it by inserting the locking lever into finder.

Figure 7-6 Changing the magnifying lens on the standard focusing hood. To change the magnifying lens, remove the hood from the camera and open it. Hold the plate with the lens at an angle, pull it downward, and remove it through the bottom. To insert the new plate, reverse the process.

eyeglasses. A shorter eyecup for viewing with eyeglasses is available. This finder is beautifully designed for handheld operation in the horizontal and vertical format.

The Standard Focusing Hood and Magnifying Hoods

The standard focusing hood (Figure 7-7) has definite and unique advantages such as a high magnification and foldable, which keeps the camera lightweight and compact. You can also view the image from a distance and with both eyes open as you view the image on a view camera. You can view the image on the focusing screen from many camera angles — from waist level, from low angles or ground level — and from high levels by holding the camera upside down above your head.

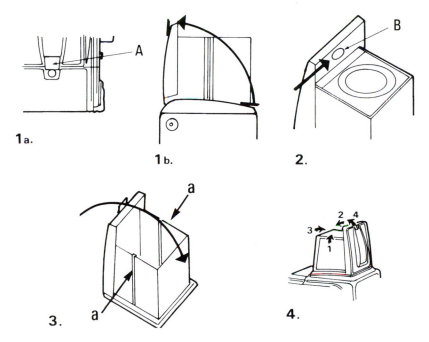

Figure 7-7 Opening and closing the focusing hood. (1) You open the new focusing hood with the tab (A) and lifting the hood upward (1a, 1b). (2) To bring the magnifying lens into viewing position, slide the tab (B) in the direction of the arrow. (3) To fold the new focusing hood, pinch the sides at the hinge (a) and press down the cover. (4) To close the older focusing hood, flip down the top plate and fold down the sides and rear panel. The front panel locks when folded down.

The standard hood is not practical for viewing with eyeglasses, so make certain that it has a magnifying lens that provides a sharp image of the focusing screen without eyeglasses. Also, the hood is not very comfortable when pressed against the eye, as it should be for handheld work. A magnifying hood with a rubber eyecup is a better choice. With the standard finder and the magnifying hood, the image is right side up but reversed sideways. You can get accustomed to this, at least with stationary subjects. You are likely to move the camera in the

wrong direction when following moving subjects. On the Magnifying hood 4×4 DPS the designation 4×4. refers to the 40 mm area coverage. This magnifying hood is optimized for use with digital backs with CCD sizes smaller than 40 mm. The magnifying hood enlarges this area $5.5\times$.

Viewing From the Top

Viewing from the top lets you photograph from almost any camera angle and holding the camera in many different ways, as shown in Figure 7-8. On the other hand, a focusing or magnifying hood is not practical with a tripod-mounted camera at eye level. With the waist-level finders, you can view with the magnifying lens or the lens can be flipped away so the image can be viewed with both eyes open. Viewing from the top is also possible on the H cameras in combination with the HVM waist-level finder, but is practical only when photographing in the horizontal format.

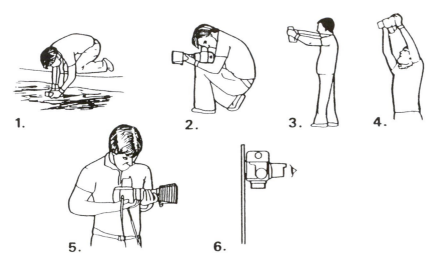

Figure 7-8 Viewing from the top has great advantages when you are photographing, for example, from low angles (1), from the knee (2), straight down (3), from over the head (4), sideways (5), or from a vertically mounted camera (6).

90-Degree Eye-Level Viewing

Since H cameras need to be turned for vertical pictures, all H camera models are designed for eye-level viewing with the 90-degree eye-level finder, which has Databus connections at the bottom to the camera's electronic circuit. The viewfinder is removable so the cameras can also be used with a waist-level type.

The 90-degree viewfinders for the V system may have a special appeal to 35 mm photographers who are accustomed to this type of viewing and focusing, which are practical and convenient, whether the camera is held in the normal fashion or turned sideways for

shooting verticals. A 90-degree finder is necessary when you are photographing verticals handheld. All prism finders show an image that is right side up and unreversed. These viewfinders also have a shoe on top for attaching a small flash unit or other accessory. The PM 90 finders cannot be used with the instant film or the 70 mm film magazines.

45-Degree Eye-Level Viewing

The prism viewfinders with 45-degree viewing in the V camera system are a good compromise between the standard hood and the 90-degree eye-level finders. Viewing can be considered eye-level since the lens is only about two inches lower than with a 90-degree prism finder. These finders can be used with all film magazines, including the instant film types, but are practical only when photographing in the square or horizontal format.

Reflex Viewfinder RMfx

The RMfx is designed for use with the focusing screen adapter on the Superwide cameras, the FlexBody, and the ArcBody. Its built-in mirror gives an image that is right side up and magnified $3.3\times$.

Some Older Hasselblad Viewfinders

- Reflex Viewfinder RM2, originally called HC 3/70, for 90-degree viewing with a viewing tube long enough to go to the rear of the 70 mm film magazine.
- HC-4 viewfinder for 90-degree eye-level viewing but with a shorter tube for use with rollfilm magazines only.
- HC-1 was the original 90-degree finder.
- PME 5 and PM 51 are two 45-degree prism finders with built-in exposure meter.
- PM 3 and PME 3 are like PME 5 and PM 51 but without the cut out front.
- Frame and sports viewfinders are mounted either on the side or the top of a camera or on top of some lenses.

Cleaning Viewfinders

Clean the eyepiece lenses and the lens in the standard and magnifying hood the same way you clean a lens. Blow or brush away all dust particles before wiping with lens tissue. Wipe the lens gently with the tissue, if necessary. Use the same approach on the bottom prism surface. Protect the bottom surface of the prism finder with its cover when the finder is off the camera.

The bottom surface of older prism finders was covered by a plastic sheet. This should never be cleaned with cleaning fluids or any other chemicals.

Heidi Niemala
Editorial photograph made with a 50 mm lens in the basement of a pre-Civil War building.

Heidi Niemala
Photographed for clothing designer with a 150 mm lens.

Heidi Niemala
Editorial portrait with a 150 mm lens.

Heidi Niemala
Photographed with a 50 mm lens during a sand storm at White Sands.

Selection and Use of Film Magazines

■ ■ ■ ■

THE H SYSTEM FILM MAGAZINES

The use and operation of the film magazine in the H camera system is described in detail in Chapter 4.

V SYSTEM MAGAZINES

All Hasselblad rollfilm magazines in the V system are designed with three parts — the shell, the darkslide, and the insert that holds the spools — and they are used in the same way (Figure 8-1).

Magazine shells have serial numbers on the plate that attaches to the camera; film inserts have a three-digit number engraved between the two film spools. These three numbers should correspond to the last three digits on the magazine shell as they were matched in the factory to produce maximum film flatness. For example, if the magazine number is VC482232, the insert with the number 232 belongs to it. If inserts are switched, the magazine still works, but spacing between images may not be as even. Magazines made before 1969 were not automatic and had an opening to see the frame numbers on the paper backing of the film.

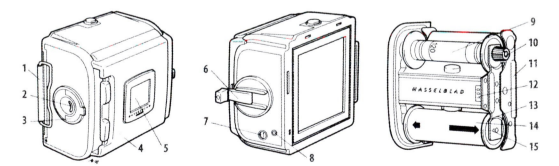

Figure 8-1 The rollfilm magazine components. (1) darkslide, (2) film load indicator, (3) film holder key, (4) darkslide holder, (5) film tab holder, (6) film winding crank, (7) frame counter, (8) film advance indicator, (9) take-up spool, (10) take-up knob, (11) film clamp, (12) film insert number, (13) spool clamp bar, (14) supply spool, and (15) film load index.

V SYSTEM ROLLFILM MAGAZINE TYPES

E-Type Magazines

E-types have an ISO dial and electronic contacts to transfer the ISO sensitivity to the 200 cameras that have a built-in exposure meter.

ECC Magazines

ECC magazines (formerly called TCC) have the ISO dial and electronic contacts and also a dial for programming image contrast adjustments based on the Zone System theory. E and ECC magazines can be used on cameras without a metering system (Figure 8-2).

A-Type Magazines

The standard magazine for cameras without metering systems. They can be used on cameras with a metering system. The ISO value is then programmed into the camera.

A12, E12, and E12CC are made for 12 images in the 2¼ in. (6 × 6 cm) size on 120 rollfilm. Some magazine types also come in the "16" version, A16 and E16, made for 16 images in the 6 × 4.5 cm format on 120 rollfilm. These magazines are supplied with a transparent mask to show the rectangular area on the focusing screen.

A24 and A32 magazines are made for 220 rollfilm producing 24 square images or 32 rectangular ones on a roll of film (Figure 8-3).

Some special magazines that have been made include:

- Film magazine 16S, made for the Superslide format
- Magazine A12V for 12 images in the vertical format without the need for turning the camera
- Magazine producing 24 × 56 mm panoramic images on 35 mm film
- Magazine 70 shown in Figure 10-6 for 70 mm film with type 2 perforations in cassettes providing
 To copy editor. 10-6 is the 10-6 figure from present book.
 Change number This is now fig 8-3 about 70 pictures in the square format
 Magazine 70/100–200 For long rolls of 70 mm perforated film for up to 200 pictures depending on the thickness of the film
- Sheet film holder and adapter for 4 × 5 sheetfilm cut down to the proper size to fit the holder

USING V SYSTEM MAGAZINES

Loading and Unloading the Rollfilm Magazines

Before you drop the loaded holder into the magazine, look inside the shell to ascertain that there are no leftover pieces of paper from a previous roll. Completely remove the paper from the new roll of film without leaving any loose paper on the a roll. It can easily come off and possibly lodge itself in the film gate.

All rollfilm magazines are loaded in identical fashion (Figure 8-4). Although the paper protects the film from light, I suggest that you load the magazine in subdued light. The magazines

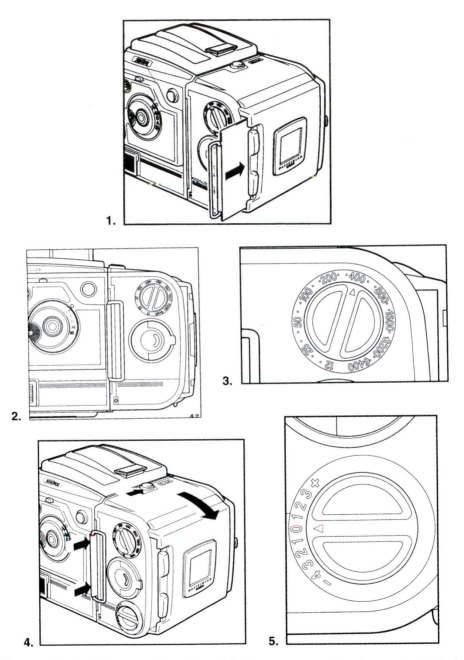

Figure 8-2 Hasselblad rollfilm magazines. (1 and 4) All newer magazines have a darkslide holder at the rear. (2) E and ECC magazines have an ISO adjustment dial at the top. (3) It can be set for ISO 12 to 6400. (4) ECC magazines also have a contrast adjustment control at the bottom. (5) The adjustments are from −4 to +3 based on Ansel Adams's recommendations.

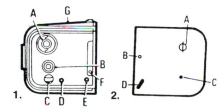

Figure 8-3 Film magazine 70. (1) On the side of the magazine are the film transport key (A); the film counter setting button (B); the film counter (C); the signal indicating whether the magazine is loaded (white), not loaded, or at the end of film (red) (D); the operating signal (E); the film plane mark (F); and a panel for notes (G). (2) Without a cassette holder, the inside of the magazine can be seen with the film winding shaft (A); the slotted pin (B), which locks the cassette holder to the magazine; the pin (C) connecting to the exposure counter; and the feeler lever (D), which connects to the film load indicator. The camera can operate only when the lever is pushed down by the film or manually.

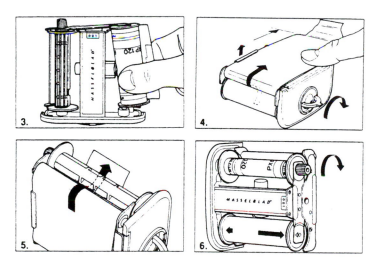

Figure 8-4 Important film loading steps for the automatic magazines. (3) The take-up spool is identified by the knurled knob. Place the film on the other side. (4) Make certain the film unwinds the opposite way from the way it is wound on the spool, with the black side outermost, and that it is placed underneath the side guide. (5) Attach it in the same way on the take-up spool. (6) Use the knurled knob on the take-up spool to move the film until the black arrow on the film is opposite the triangular index.

can be loaded while attached to the camera or off the camera in which case the darkslide must be in the magazine. I find it easier to load the film with the magazine on the camera.

The most important points to keep in mind when loading film include:

1. The take-up side on the insert is easily distinguished by the knurled knob.
2. Make certain the film comes off the spool so that the black side is outermost; the emulsion faces the lens. The film needs to curl the opposite way from the way it is wound on the spool.

3. Make certain the film rides under the side guide, not over it. I press my thumb against the paper next to the guide to keep it under the guide. It eliminates the need for using the insert lock.

4. For proper spacing, the black arrow on the paper must be placed opposite the red triangle. Most film has only one arrow going across the paper backing. Some 220 film has a black dotted line followed by an unbroken black arrow a few inches later. Advance the film to the line with an arrow.

5. Before placing the insert into the magazine, ascertain once more that the edge of the film is underneath the side guide.

6. Make certain to turn the magazine's winding crank until it stops and the number 1 is in the frame counter window before you start to take pictures. At this point, the crank is locked and cannot be turned again until after the first exposure. Do not turn the film winding crank until the end of the film.

With the film properly loaded, all Hasselblad magazines should space images evenly from the first to the last picture with the space between images never exceeding 6 mm yet wide enough to make a cut.

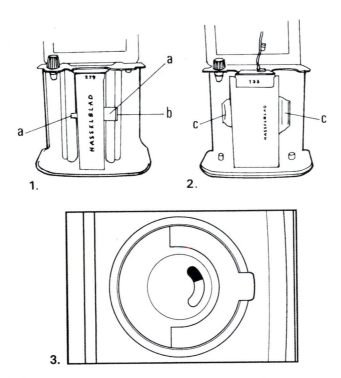

Figure 8-5 The film holder–film insert. The newer film inserts (1) have a spring-loaded device (a) that keeps the film tight on both the feed and the take-up spools. The roller (b) on the feed side rests against the film to actuate the film consumption signal. Two chrome strips (c) served the same purpose on the older film inserts (2). A film consumption signal (3) that is partially red and chrome indicates that a partially exposed roll of film is in the magazine.

After the last picture on a roll has been taken, the camera's winding crank or knob can be turned as usual, so you really do not know that you have reached the end of the roll until you try to take the next picture. At the end of a roll, turn the film winding crank to pull the paper trailer through the magazine and around the exposed roll of film as a light protection. It becomes easier to turn the crank at that point. I suggest winding the paper through as soon as you have taken the last picture even if the magazine is not going to be reloaded immediately.

Operating Signals

Whenever the insert is removed from the magazine shell, the frame counter jumps back, and the operating signal in the magazine becomes black. The spring-loaded device that keeps the film tight on the loaded spool also activates the film consumption indicator, which shows all white with a new roll of film. As the film is used, more and more red shows in the circular window (Figure 8-5).

If you want to know what type of film is in the magazine place the top from the film box underneath the black cover disc.

USE AND APPLICATION OF THE INSTANT FILM MAGAZINES

The instant film magazine did in the film age what the digital back does today — allows you to see the image that will be recorded in the camera before you shoot the final picture. This

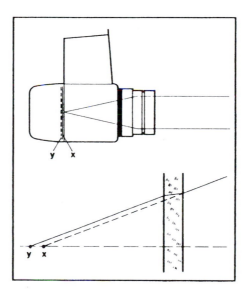

Figure 8-6 The purpose of the glass plate. The instant film pack design makes it impossible to bring the film plane at the same distance as in other Hasselblad magazines so that the image formed by the lens falls at x, slightly in front of the instant film plane (y). The glass plate lengthens the distance and moves the image from x to y so that it is formed where it produces the sharpest possible image

gives you the opportunity to make changes in the camera or lighting setup. The Hasselblad instant film magazine made for professional films in the 100 and 600 series can be used on all V system cameras, except early Superwide models, and is attached and detached as other magazines.

The Hasselblad instant film magazines have glass plates in front of the film to move the image to the exact film plane distance which is slightly farther back (see Figure 8-6). Keep it clean. When used on cameras with a built-in metering system, program the ISO into the camera. Clean the rollers of the developer spreader in the magazine, preferably after every film pack. Do not touch the face of the instant print immediately after separation. Let it dry to a hard gloss.

Lois Greenfield

A beautiful image of the Australian dancers Paul Zivkovitch and Craig Bary. The use of mirrors in the photograph allows the viewer to see multiple perspectives of the body and the dancer's face at the same time. This image, which has no image manipulations of any kind, has been exhibited in museums, galleries, and collections. (© Lois Greenfield.)

Lois Greenfield
An image of two dance students, Brandon White and Dale Harris, made during a lecture/demonstration at Randolph Community College in North Carolina. While Lois usually likes to use fabric to suggest movement and the passage of time, it was used in this case in a restrictive fashion to restrain the dancers' movement. There was no image manipulation. (© Lois Greenfield.)

Operating 503 and Other V System Cameras

■ ■ ■ ■

OPERATING THE 503 AND OTHER V SYSTEM CAMERAS FOR DIGITAL IMAGING

The Hasselblad 503CW, other 503, and V system cameras are good tools for digital imaging by simply attaching a digital back instead of the film magazine to the camera body. The cameras are operated the same way in digital imaging as they are in film photography. The V system cameras that do not have a built-in metering system can be equipped with a meterprism viewfinder for determining exposure with a built-in TTL metering system that can be used in both film and digital imaging. Whatever is discussed in this chapter applies also with digital backs on the cameras except that you need not worry about advancing or not advancing the film accidentally and protecting the film with a darkslide. Any special instructions for digital backs are discussed in Chapters 3 and 5.

THE BASIC CAMERA/MAGAZINE OPERATION

On all Hasselblad V system cameras without a built-in motor or a motor drive accessory, the shutter is recocked and the film advanced by a full turn of the winding crank or knob. On the motor-driven EL models set to the normal 0 operating position — or on any of the other 500, 200, and 2000 camera models equipped with a motor winder — these operations are done automatically after the picture has been taken.

Hasselblad cameras can be released only when they are properly interlocked with lenses and film magazines. The operating signals between camera and magazine are shown in Figure 9-1.

OPERATING THE 503CW WINDER

The CW motor winder (see Figure 9-2), which makes the 503 camera models motor driven with a speed of about 1.3 frames per second, is held to the camera not only by the winding shaft but also by the carrying strap lug and can be used as a grip for convenient handheld photography. The motor is powered by six 1.5 V AA Alkaline or rechargeable NiCad battery types. Alkaline batteries should provide at least 3000 exposures in normal conditions.

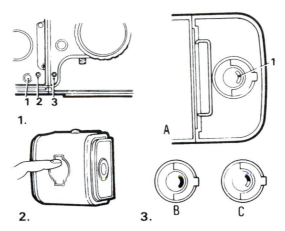

Figure 9-1 The operating signals. (1) The film counter in the magazine (1) shows how far the film has been advanced. The operating signal in the magazine (2) is white when the film has been advanced, and red when the film has not been advanced. Older cameras also had a signal in the camera body (3), which showed white when the shutter was cocked, red when uncocked. (3) When an automatic magazine (A) is newly loaded, the film consumption indicator is all chrome (1). When there is no film in the magazine or the roll of film is at the end, the indicator is all red (B). A partially exposed film is indicated by an intermediate red/chrome position (C). (2) On original magazines, the Flap opened to see the frame number on the paper backing.

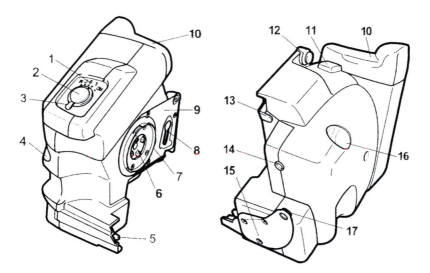

Figure 9-2 The CW motor winder. (1) Mode selector dial, (2) release button, (3) mode selector, (4) front IR sensor, (5) camera release lever, (6) winder coupling, (7) bayonet mount, (8) winder retaining slot, (9) camera interface plate, (10) battery holder, (11) battery holder catch, (12) upper strap lug, (13) winder catch, (14) remote cord connector, (15) strap mounting screws, (16) rear IR sensor, and (17) lower strap lug.

Attaching and Removing the 503 Winder

After removing the winding crank, lens, and carrying strap, place the winder over the winding mechanism with the strap lug in the winder's mounting plate. Rotate it clockwise until it clicks into position (see Figure 9-3). A faint sound after the motor is attached indicates that the motor senses the camera status. The motor winds an uncocked camera automatically so

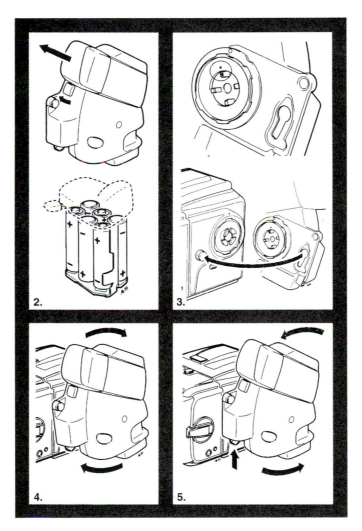

Figure 9-3 **503CW motor operation.** (2) Open the battery compartment by moving the lever clockwise, insert the six batteries as shown in the battery holder. (3) After removing the lens, attach the motor over the winding mechanism, with the strap lug in the motor's mounting plate. (4) Turn the motor clockwise. (5) To remove the motor, press the detaching lever and turn the winder counterclockwise.

you may lose a frame on the film unless you make sure that the shutter is cocked before you attach the motor winder. To remove the winder, remove the lens. Holding the winder firmly, press the detaching lever and keep it pressed while turning the winder counterclockwise. The lens must be removed for attaching and detaching the winder.

Motor Operation

The motor winder can be used for single exposures (S) at any shutter speed but at shutter speeds of 1/8 second and longer, keep the release depressed until you hear the lens shutter closing. In sequence photography (C), the shutter speed must be 1/8 second or shorter (1/15 second or shorter in cold temperatures). For multiple exposures set the mode selector to M. The motor makes the exposure but does not advance the film. Insert the darkslide, remove the magazine, and switch the mode selector from M to S (or C) to recock the shutter. Re-attach the film magazine and remove the darkslide. Set the mode selector to L (lock) to prevent accidental exposures when not in use (see Figure 9-4). Double and multiple exposures in digital imaging are made the same way but you need not worry about advancing the film accidentally.

Figure 9-4 The winder operating controls. The release and mode selector have these settings: RC (remote), L (lock), S (single pictures), C (sequences), and M (multiple exposures).

If the motor does not operate the camera, check whether a darkslide might be inserted and whether the frame counter in the film magazine indicates that you are at the end of the film. Also check that the mode selector is not set to L or RC, and, of course, check the condition of the batteries and be sure that they have been inserted properly.

Remote Operation

A camera equipped with a motor winder can be remote-released in the S (single), C (continuous), and M (multi) mode by using a 10-foot (3 m) accessory release cable connected to the motor winder or by using the wireless infrared remote control. With the mode selector set to RC, the compact IR remote release (see Figure 9-5) can operate the camera from up to 33 feet (10 m) from any direction because the motor winder has IR sensors at the front and rear.

Figure 9-5 The IR remote release. (1) Release button, (2) IR windows, (3) mode selector, and (4) battery compartment.

The remote control uses one CR2 battery. To save battery power, the mode selector should be set back to L or to S, C, or M as soon as the remote release is no longer used.

The IR remote must be coded to the specific motor winder on the camera. Set the mode selector to RC, aim the IR windows in the remote control at one of the IR sensors in the motor, and press both the release in the remote control and the release in the motor at the same time for three or four seconds. If you want to operate more than one camera from one release, code each motor with the remote release in the same fashion.

SETTING APERTURE AND SHUTTER SPEEDS

CFi and CFE Lenses

On CF, CFi, and CFE shutter lenses shown in Figure 9-6 you set and change the aperture, the shutter speed, or the EV value by turning either the aperture and/or the shutter speed ring. The aperture can be set at the engraved figures or between for ½ stop settings. The shutter speed ring must be set at the engraved figures. To interlock the two rings, you press the aperture/shutter speed interlock control. The shutter speed ring stops at B. To move the ring to F for using the focal plane shutter or out of F, press the locking button, which is green on CF lenses and orange on the CFi and CFE types. The aperture can be manually closed down as shown in Figure 9-7 so you can evaluate the image on the focusing screen at different aperture settings. Figure 9-7 also shows the flash cable lock on the latest lenses.

When any type of shutter lens is set to shutter speeds 1, 2, and 4 (corresponding to 1-second, ½-second, and ¼-second shutter speeds), you must keep the camera release pressed until you hear the sound of the shutter closing; otherwise, the rear curtain closes before the exposure cycle is finished. This also applies to focal plane shutter camera models when the exposure is made with the shutter in the lens. The focal plane curtain functions like the auxiliary shutter. The release cycle illustrated in Figure 9-8 shows why this is necessary.

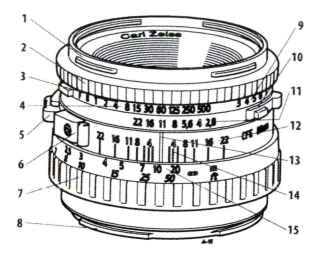

Figure 9-6 CFi, CFE, and CB lens controls. (1) external and internal bayonet mount, (2) shutter speed ring, (3) warning mark, (4) shutter speed scale, (5) manual stop down control, (6) flash terminal with lock, (7) focusing ring, (8) lens bayonet plate, (9) EV scale, (10) aperture/shutter speed interlock, (11) aperture ring and scale, (12) depth-of-field scale, (13) index, (14) infrared focusing index, and (15) distance scale.

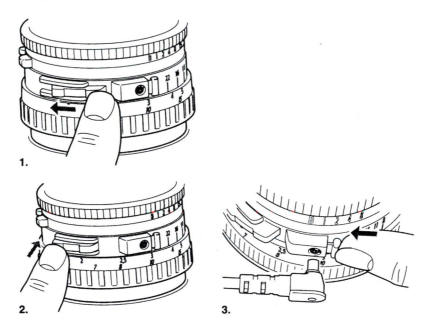

Figure 9-7 Operating CF/CB lens controls. (1) To close the aperture down manually, slide the knob in the direction of the arrow until it clicks into position. (2) To return the aperture to the fully open position, press the lower part of the control. (3) To attach a flash cord, press the locking button. When the button is released, the cord will be locked in the flash socket. To remove the cord, press the lock button again.

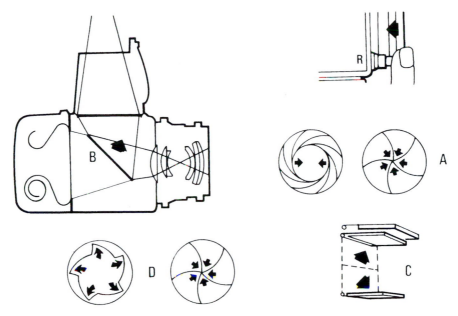

Figure 9-8 The release cycle on all V system SLR camera models when the shutter in the lens is used. When the camera release is pressed, the lens shutter closes and the diaphragm stops down to the preset aperture (A), the mirror moves up (B), and the auxiliary shutter or focal plane shutter opens (C). The lens shutter opens and closes at the set shutter speed, or, in the B setting, the shutter closes when the finger is removed from the release (D). Depending on the camera model or the set operating mode on some models, the mirror returns either instantly after the exposure or when the film is advanced.

Since the original C lenses are not recommended for use on newer cameras, they are not discussed in this book.

FE, TCC, and F Non-Shutter Lenses

The shutter speed ring, which is part of the camera body, can be set at any of the engraved shutter speeds or halfway between them. The shortest flash sync speed of 1/90 second is indicated by X. You set the aperture by turning the ring at the rear of the lens at the engraved figures or between for ½ stop settings. On 2000/2003 cameras, you can couple the aperture and the shutter speed ring with the cross coupling control on the aperture ring. Figure 9-9 shows the operating controls on non shutter lenses.

Time Exposures

For shutter speeds longer than 1 second you set shutter lenses to B, where the shutter stays open as long as the release on the camera or the cable release is pressed. Cameras or lenses set at B are still flash synchronized.

Figure 9-9 FE, TCC, and F lens controls. (1) Flash outlet in camera body for focal plane shutter, (2) aperture scale, (3) shutter speed ring and scale on camera (not on 202FA), (4) bayonet mount for lens shade, (5) EV scale, (6) depth-of-field indicator, (7) distance scale, (8) focusing ring, (9) lock for bayonet lens mount, (10) index for EV scale, (11) manual stop down control, (12) inside bayonet mount for filters, (13) Grip ring for removing lenses, (14) index for aperture, (15) index for shutter speed, (16) shutter speed lock (only on 2000/2003), (17) cross coupling button (does not work on 2000), and (18) grip for aperture and EV setting.

On 200 model cameras, electronically controlled long exposures up to 90 seconds can be made with the focal plane shutter. For even longer exposures, up to 34 minutes, you can use the focal plane shutter in the Manual Exposure mode.

DISTANCE SETTING

Lenses in the V system have large rubberized focusing rings that are far enough away from the camera body so they can easily be reached and operated.

The focusing ring on apochromatic lenses can be turned a few millimeters beyond the infinity point because the fluorite elements in these lenses are more sensitive to changes in temperature than glass elements. The distance settings therefore may vary slightly depending on the temperature. Always visually focus the image on the focusing screen; do not guess the distance or simply set the scale at infinity if the subject is far away.

RELEASING THE 503 AND OTHER V SYSTEM CAMERA MODELS

Camera steadiness is greatly determined by the way you operate the release. Push it slowly and gradually so that you hardly know when the exposure is made. For the smoothest operation, move the release to the halfway position so that only a slight additional pressure makes the shutter click. On 200 camera models with built-in metering systems, pressing the release halfway also turns on the metering system.

The Superwide cameras have a release lock shown in Figure 9-10. Set to T, the release stays in even when you remove your finger and could be used for time exposures. It is not a recommended operating procedure because it can create camera shake. For time exposures with any camera, attach a cable release and pre-release SLR cameras. The lock does not work

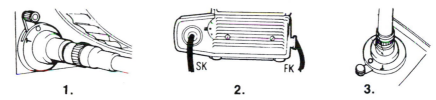

Figure 9-10 The release lock. (1) Set to T; the release lock in earlier 500 models keeps the auxiliary shutter open until the lever is moved back to 0. (2) EL models have a release lock on the side of the battery compartment with the operating position 0 in the center, a release lock L to prevent accidental releasing at the top, and a lock T for time exposures at the bottom. (3) Superwide cameras have the release lock next to the release.

when a cable release is used. Older SLR Hasselblad types also have a release lock, to be used as described above for the Superwide.

The EL Camera Release

All ELmodels are released by electrical contact, not by mechanical means, with a release button or an FK release cable that can be inserted in either one of the two openings at the front. Some EL models come equipped with the large square release button that has been used by astronauts in the past. It is removable, and when removed, the camera has the same two release openings. On the 555ELD, the release button must be inserted in the lower opening for photography with film.

All EL models can also be released through the side socket at the rear of the camera using an SK release cord. EL cameras have a release lock lever on the battery compartment that is operated as explained in Figure 9-10. Do not use the lock for time exposures. Pre-release the camera and use release cables.

Operating the 201F Camera

On the 201F focal plane shutter camera without metering system shown in Figure 9-11 you can lock the shutter speed setting by pushing forward the locking knob above the battery compartment. The built-in self-timer can be programmed for a 2-second delay by pushing the Mirror Lock-Up control twice or pushing it once for a 10-second delay. The ASA dial on the side is used with dedicated flash and is used like the control on the 500 models. The battery is checked by turning the shutter speed ring to the battery symbol position as shown in Figure 9-12. The ready light of the dedicated flash system in the viewfinder lights up, or gets brighter if already lit, if the battery is in good condition.

Special Operating Controls on 2000/2003 Camera Models

The 2000/2003 cameras have a few unique operating controls. The mirror motion is adjustable so that the mirror returns instantly, returns when the film is advanced, or remains locked in the upper position; a permanent mirror lock up (see Figure 9-13). Moving the lever above the battery compartment from O to L locks the shutter speed setting as shown in Figure 9-14.

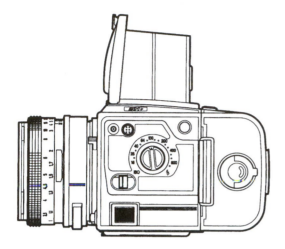

Figure 9-11 201 camera model. The 201 camera is distinguished mainly by the ASA dial for dedicated flash. Above the battery compartment is the lock for the shutter speed ring.

Figure 9-12 201 battery check. The condition of the 201 battery is checked by placing the battery symbol on the shutter speed ring opposite the index.

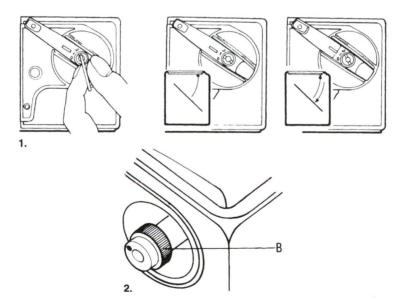

Figure 9-13 Mirror motion on 2000/2003 cameras. (1) Change the mirror motion by turning the slotted disc with a coin. Turn the disc to 1 if the mirror is to return when the shutter is recocked, to 2 for instant return operation, or to 0 if the mirror is to be permanently locked up. (2) To change the mirror motion on 2003FCW models, remove the crank or motor, pull out the ring (B), and turn the shaft to 1, 2, or 3.

Figure 9-14 Shutter speed lock on 2000/2003 models. Lock the shutter speed ring by pushing the locking lever above the battery compartment downward so that the indicator points toward L. The battery compartment on all focal plane shutter cameras is identical. Remove and insert the battery compartment only with the camera in the ready position with the shutter cocked and the mirror down.

On 2000FCM, 2000FCW, and 2003FCW models the focal plane shutter automatically retracts when a film magazine is removed. Recock the shutter before you attach the magazine to avoid fogging film. With a motor winder on the camera, the shutter is automatically recocked when the film magazine is re-attached. You can disconnect the shutter safeguard feature by pushing the lever on the rear of the camera body to the side.

PRE-RELEASING THE CAMERAS

I recommend pre-releasing tripod-mounted cameras used at longer shutter speeds or with longer focal length lenses to reduce the danger of mirror or shutter created vibrations. Pre-releasing also eliminates the slight delay of about $\frac{1}{25}$ second caused by the operating procedure in SLR camera models. In the pre-released mode, the shutter opens instantly like a rangefinder or twin lens reflex camera. Pre-releasing serves no purpose and is impractical in handheld photography. The pre-release procedure for the various V system models is shown and described in Figures 9-15 to 9-18. Since Hasselblad cameras can be pre-released so easily, I recommend doing so whenever practical with a mounted camera, even the lens shutter models where the shutter operation is extremely smooth.

As pre-releasing lifts up the mirror, the image on the focusing screen disappears. If you want to see the image again before you take the picture, turn the winding knob or crank with the film magazine removed or turn the winding crank with the center button depressed on focal plane shutter models.

PRODUCING DOUBLE OR MULTIPLE EXPOSURES

Computer Produced Double and Multiple Exposures

Digital imaging has greatly reduced, or completely eliminated, the need for producing any type of double or multiple exposures in the camera. The computer offers greater possibilities for

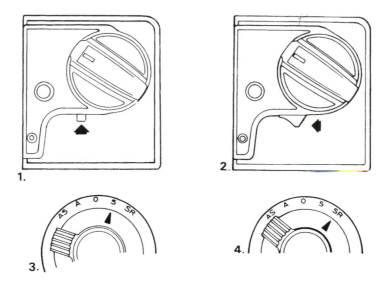

Figure 9-15 Pre-releasing cameras. The 500/503 cameras (1) and all focal-plane shutter models (2) are pre-released by pressing the lever below the winding crank or knob upward (on 500 models) or toward the rear (on 200 models). Pre-release EL cameras by setting the selector dial to S (3) where the camera returns to its normal viewing position after exposure or to SR (4) where the camera remains in the pre-released.

Figure 9-16 Pre-releasing the 500/503 and EL models. Pre-releasing (A) causes the lens shutter to close (B), the lens diaphragm to stop down to the present aperture (C), the mirror to lift up (D), and the auxiliary shutter to open (E). When the release is pressed (F), only the lens shutter opens and closes (G) to make the exposure.

producing more amazing images than the camera ever did even in the hands of the most creative photographers. On the computer you can combine brand new digital or film images with images that you, or someone else, may have made years ago, and you can combine images made in different cameras and in different image formats. When creating these images in the computer you can constantly and immediately see the changes in the image as you work and do not have to wait until the film is processed. Even if your images are on film, you can still use the computer for combining them after you scan the film images.

Figure 9-17 Pre-releasing the 200 and 2000 focal plane shutter cameras. When the lens shutter is used, the pre-release cycle is identical to that of the 500 and EL models, except that the focal plane shutter replaces the auxiliary shutter. When the focal plane shutter is used with non-shutter lenses, pre-releasing lifts only the mirror and closes the diaphragm to the preset aperture (A). When the camera release is pressed (B), the focal plane shutter opens and closes to make the exposure (C), the mirror then flips down, and the diaphragm opens fully (E). An image at full brightness is therefore visible on the focusing screen immediately after the exposure has been made (on 2000/2003 cameras only with the mirror set at 2). Advance the film and cock the shutter by turning the crank (F).

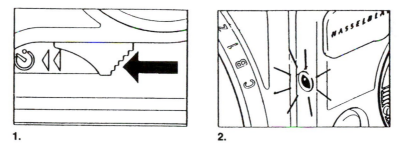

1. **2.**

Figure 9-18 Pre-release function. (1) On 200 cameras, pressing the pre-release one time pre-releases the camera, and pressing it a second time starts the self-timer (except on 201 models), with the self-timer delay time programmed into the camera. Stop the self-timer by pressing the pre-release a third time. (2) Self-timer operation is indicated by a red light at the front of the camera. On 201 models, pressing the pre-release control a second time starts the self-timer for a 10-second delay, and pressing it twice starts a 2-second delay.

Producing Multiple Exposures in the Camera

The process and camera operation used to produce double exposures in the camera is discussed below. To produce a double exposure on Superwide and 500 model cameras, you must remove the film magazine after the first exposure as shown in Figure 9-19 .and in Figure 9-20 for EL cameras.

Removing the magazine is unnecessary on 200 and 2000 camera models. After the first exposure, turn the winding crank with the center disc pressed, thereby cocking the shutter without advancing the film.

Most double exposures have two images recorded on the same film area resulting in an overexposed image. Exposure for each image must be reduced; the amount depends somewhat on the type of image. A good suggestion is to reduce the exposure for each by 1½ EV

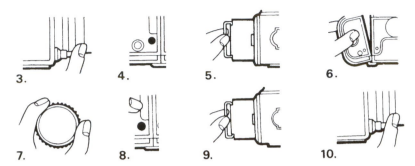

Figure 9-19 Producing double exposures on 500/503 and Superwide camera models. Make the first exposure as usual (3); the operating signal in the magazine will then be red (4). Insert the darkslide (5), and lift the magazine off the camera (6). Turn the camera winding crank (7). Re-attach the magazine (8). Remove the darkslide (9), and make the second exposure (10). Set the 503 motor winder to M for multiple exposures.

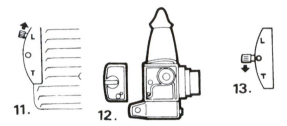

Figure 9-20 Producing a double exposure on EL models. Release the camera for the first exposure, but keep your finger on the release so that the film does not advance. With the release pressed, move the time lever to the L position (11), which locks the mechanism. Insert the darkslide, and remove the magazine (12) from the camera. Move the time lever back to 0 (13) to recock the shutter. Replace the magazine and make the second exposure.

values. But you may want to experiment. The exposure compensations do not have to be considered in images that may be used in computer-produced double or multiple exposures. Expose them normally.

Figure 9-21 Two portraits taken with V system cameras and a 120 mm telephoto lens. The portrait taken on a sunny day with fill flash creates a completely different mood and feeling than the one taken in the soft light of a foggy morning. The model's outfit and the setting on the dock with the white bench and with the lake in the background enhances the mood. The model was composed to one side to leave more room in the viewing direction. (Photos by Ernst Wildi).

Operating EL Cameras for Digital and Film Photography

The text here is limited to the operations that apply to EL models only. The operations that apply to all V system cameras are discussed in other chapters. The newer 500ELX, 553ELX, and 555ELD models with a dedicated flash system are recognized by the film sensitivity dial above the accessory rail (see Figure 10-1). The flash operation is discussed in Chapter 18.

BATTERIES

Starting with the ELX in 1988, EL cameras use five standard 1.5 V alkaline or lithium batteries that provide up to 4,000 exposures. You can also use rechargeable 1.2 AA NiCad batteries for 1,000 exposures to be recharged in standard AA type recharge units. Insert batteries as shown in Figure 10-2, which also shows how to check the battery condition.

The NiCad Batteries in Earlier Models

Earlier EL models are powered by rechargeable NiCad batteries. Only one battery is necessary to drive the camera, and it can be inserted in either opening in the battery compartment. A fully charged battery should last for about 1,000 exposures at normal temperature. NiCad batteries must be used properly as follows:

1. Insert only one battery into the motor compartment, but keep a second, fully charged battery readily available.
2. Operate the camera until the mechanism slows down (indicating that the battery is close to being discharged).
3. Change to a fully charged spare battery, and use this battery as in step 2.
4. Recharge the first battery whenever practical for 14 hours, and keep it as a spare.

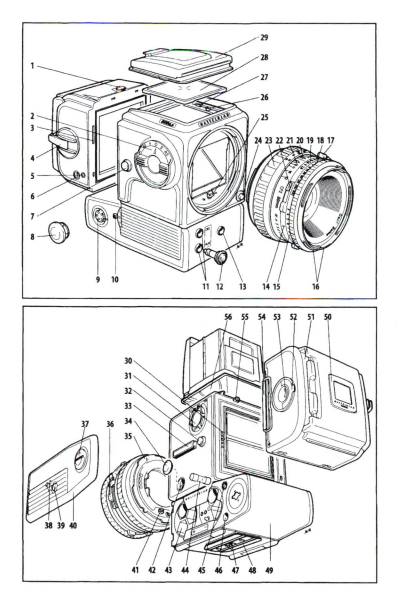

Figure 10-1 The important operating controls on the 555ELD. (2) mode selector, (8) remote socket cover, (9) remote release socket, (10) time exposure and locking lever, (11) release socket (digital and film on 555ELD), (12) release button, (13) IR release unit mount (on 555ELD only), (24) lens release button, (25) drive shaft, (26) flash function indicator, (27) screen retaining clip, (28) focusing screen, (29) focusing hood, (30) electronic connection (on 555ELD only), (31) ISO setting for dedicated flash, (32) strap lug, (33) accessory rail, (34) flash connector cover, (37) cover lock, (38) battery check lights, (39) battery check button, (40) battery compartment cover, (41) lens drive coupling, (42) dedicated flash connector, (43) battery compartment, (44) fuse, (45) fuse holder, (46) spare fuse holder, (47) tripod socket, (48) quick coupling plate, and (49) motor housing. Items 50 to 56 are described in chapter 8.

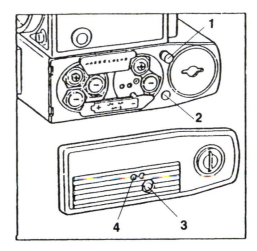

Figure 10-2 Open the battery compartment cover by a full clockwise turn of a coin inserted in the cover lock. Removing the cover reveals the compartments for five AA batteries and for the fuse above the motor drive (1), and an empty compartment to store a spare fuse (2). Check the condition of the alkaline or lithium batteries by pressing the battery check button (3). When both lights (4) come on, more than 40% of the power remains. One light indicates that about 20% is left. If neither light comes on, the batteries need to be changed.

OPERATING EL CAMERAS

Releasing 555ELD

In the FILM setting, the front release on the 555ELD operates the camera the same way as the front release on other EL models (see Figure 10-3). For longer exposures, you must keep your finger on the release until the lens shutter closes. In the DIG position, in addition to operating the camera cycle, a signal goes to some digital backs via the pins at the rear of the camera telling the digital back when the exposure starts and ends. This signal works only with a few digital backs designed for this operation, and, with such a back attached, the FILM release does not work. The regular FILM release is used with other digital backs. Obtain up-to-date details from the manufacturer of the digital back or from Hasselblad.

The Operating Selector Dial

EL cameras have a release lock as shown in Figure 10-3 and an operating selector dial that operates the camera in different modes as shown in Figure 10-4. When the camera is operated with the selector dial set to SR or AS, the camera stops in the pre-released mode. To put a camera in the normal viewing position, move the operating dial to 0, and press the release to take a picture (see Figure 10-4). Remove the film magazine before pressing the release to avoid wasting a frame of film.

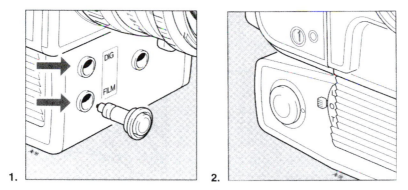

Figure 10-3 Releasing the camera. (1) All EL models have two release openings at the front that serve the same purpose on all models except the 555ELD. On the 555ELD the top opening is for digital work with some digital backs made for this type of operation and the bottom opening is for film. (2) The time exposure and locking lever can be set to L to lock the release, 0 for normal operation, or T for time exposures. Moving the lever from 0 to T is like releasing the camera and making an exposure.

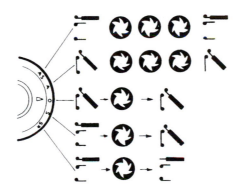

Figure 10-4 The operating selector dial. At the normal (0) setting, one picture is taken, and the camera stops in the normal position with the mirror down. At S, the camera is pre-released but returns to the normal position after the picture is made. At SR, the camera is also pre-released and remains that way after the picture is taken. A is the automatic mode, where the camera takes pictures at the rate of one frame per second as long as the release is pressed or as long as film is in the camera and returns to the normal mode. The AS setting is for automatic operation, starting and ending in the pre-released mode; the camera operates somewhat faster than in the A position at about 12 pictures in 9 seconds.

If nothing happens when the release is pressed, check that the locking lever is at 0 position. Then check that the magazine slide has been removed and the exposure counter in the magazine has not reached the end of the roll. If none of these checks helps, check the batteries and perhaps the fuse. A blown fuse usually indicates that something is wrong in the electrical circuit.

Releasing with Cables

All EL models can be released with an FK cable (F stands for "front") attached to one of the release sockets at the front of the camera. You can also release all EL cameras through the side socket at the rear of the motor compartment by using the SK cable (S stands for "side") or the longer LK types.

Wireless Remote Releasing of the 555ELD

An accessory remote control for wireless remote camera operation up to 33 feet (10 m) for film or digital photography can be attached to the front of 555ELD cameras (see Figure 10-5). The release unit is the same as that available for the H camera and is supplied with the 503CW motor winder described in Chapter 8. The power for the camera unit comes from the batteries in the camera, but the remote release needs a CR2 battery.

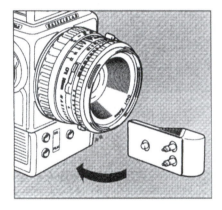

Figure 10-5 Attaching the wireless IR release accessory. After removing the release button, match the respective release sockets, push the release unit to the front of the camera, and attach. The ON/OFF switch operates the unit. Set the Pr control for digital or film.

Jonathan Exley
An attention-creating image of mult-time Indianapolis 500 winner Helio Castroneves.

Jonathan Exley
Personal portrait of close friends Jason and Naomi Priestley taken with a 150 mm lens and a short extension tube.

Jonathan Exley
Lifestyle Designer, Kathy Ireland. (Courtesy of kathyireland.com.)

Jonathan Exley

Team Penske photographed with multiple strobes and a 120 mm lens at sunset at the Phoenix International Raceway.

The Superwide Cameras

Information in this chapter is limited to the operations that apply specifically to Superwide models. Basic camera operations that apply to all V system cameras are discussed in other chapters.

BASIC CAMERA OPERATION

Cameras made since 1980 advance the film either with a ratchet-type motion (necessary when the instant film magazine is attached) or with a full turn on the crank. When you press the release, the shutter in the lens simply opens and closes for the set exposure time. It is not necessary to keep the release pressed when you use the longer shutter speeds. For time exposures use a cable release and use the release lock on the cable if it exists. The T position on the camera's release lock is helpful when you evaluate the image on a focusing screen adapter. You do not have to keep your finger on the release.

THE SUPERWIDE FOR DIGITAL IMAGING

Since the Superwide camera model was introduced in 1954 it was recognized as a superb tool for high quality wide angle photography because of the extreme 90-degree angle of view, the superb image quality, and extremely low distortion value of the Carl Zeiss Biogon lens. The Superwide is still a great camera for critical, high quality wide angle photography but only in film photography. The latest 905SWC model has a Biogon lens with a slightly different lens and barrel design to reduce the possibility of flare to the highest degree, but otherwise it is identical to the 903SWC (see Figure 11-1).

As discussed in Chapter 14, the Biogon is an optically true wide angle lens design that must be positioned very close to the image plane (see Figure 11-4). The rear element of the Biogon is only about an inch from the image plane. This does not create a problem in film photography but it does in digital imaging because of the IR filter and sensor cover glass that is in front of the sensor (the image plane).

The light rays that go to the corner of the image enter the filter and the glass at an oblique angle. As a result they have to travel a different distance than without the glasses in film photography (Figure 11-2). The spherical aberration introduced by the cover glass and the IR filter

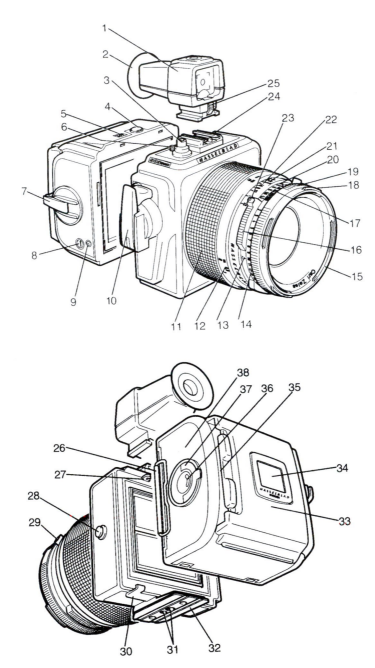

Figure 11-1 The important operating controls on the 903SWC camera. (1) Viewfinder with built-in spirit; (2) rubber eyecup; (3) camera release; (4) magazine lock button; (6) time exposure lock; (10) winding crank; (24) accessory/viewfinder mount; (25) viewfinder release catch; (27) magazine hooks; (28) strap lug; (30) magazine supports; (31) tripod sockets; and (32) quick coupling plate.

Figure 11-2 Path of light rays to the digital sensor. Light rays at the edges hit the glass surface at an oblique angle and need to travel a different distance than they do in film photography without the glass.

Figure 11-3 Plane of sharpness. The curvature in the plane of sharpness of the Biogon 38 mm due to the spherical aberration introduced by the IR filter and cover glass in front of the digital sensor.

results in a curved image plane (Figure 11-3) that creates the unsharpness on the edges of the image. Stopping down the lens aperture improves the quality but not to the point where it can be considered good enough for the high quality images demanded in architectural and aerial photography. The loss of quality is most noticeable on the large 36.7 × 49 mm sensor where the large angle of view of the Biogon 38 mm is most beneficial. On smaller sensors, the angle of view, and thus the benefits of the 38 mm focal length are reduced.

Consider the HCD 28 mm lens for high quality digital work on H3D and H3DII cameras. This lens has a diagonal angle of view that is even larger than the 38 mm Biogon, and the cover glass and IR filter in front of the sensor were taken into account in the lens design.

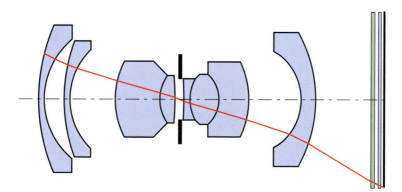

Figure 11-4 The Biogon in digital recording. The Biogon 38 mm shown with the 36.7 × 49 mm sensor and the cover glass and IR filter in front of the sensor.

HOLDING THE CAMERA

Photographers operate the Superwide (Figure 11-5) either by holding it between two hands with the index finger on the release, or by holding it with the left hand placed underneath the camera and lens and the right hand placed flat against the right side of the camera, again with the index finger on the release. In both methods, press your elbows into your body and press the Superwide hard against your cheek for best camera steadiness.

Figure 11-5 Holding the Superwide. Rest the camera in your left hand and release it with the index finger of your right hand (left). Because the camera is small, you can also place both hands around the camera body, with your middle finger on the release (right).

Figure 11-6 Attaching the Superwide viewfinder. The Superwide viewfinder slides from the rear into the shoe mount on top of the camera.

VIEWING WITH THE SUPERWIDE

The optical viewfinder of the Superwide is a separate, removable component that slides from the rear into the shoe mount on top of the camera. Slide it forward until it rests against the pin (Figures 11-6, 11-7, and 11-8).

You may find it disturbing that the lens cuts off a bottom portion of the view. Although this may be objectionable, it does not have to interfere with precise camera alignment because the bottom edge of the field can be seen on both sides of the lens, even with the professional lens shade on the Biogon.

The barrel distortion seen in the finder is only in the finder, not in the recorded image since the Biogon is practically distortion free. To frame the area horizontally, make certain you see the desired area at the widest point across the center of the viewfinder field. Align the top at the highest point, if necessary, allowing for parallax difference at closer distances. Use the focusing screen adapter for precise work.

LEVELING THE CAMERA

In architecture, product shots, or in copying, the camera needs to be perfectly level to keep vertical lines parallel to each other and have the image plane parallel to the subject. Any degree of

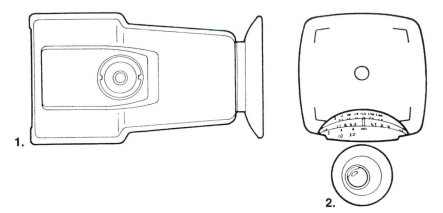

Figure 11-7 The Superwide viewfinder. (1) The finder has a built-in spirit level on top. The spirit level is also visible in the viewfinder. (2) You can see the leveling of the camera without removing your eye from the finder. A magnifying lens at the bottom lets you read the focusing distance, the depth-of-field, and the set shutter speed while viewing through the finder. The four lines inside the finder show the area coverage vertically and horizontally for the 6 × 4.5 format.

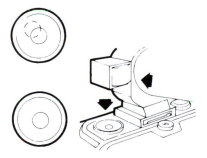

Figure 11-8 The old Superwide viewfinder. On earlier Superwide models, the spirit level is on top of the camera body and is reflected in the viewfinder prism so it can be seen from the normal viewing position behind the camera. Masks are used for the 6 × 4.5 format.

camera tilt with an extreme wide angle lens like the Biogon records the verticals as slanted lines and does not maintain ultimate sharpness over the entire area in close-up work such as copying. Check the built-in spirit level carefully when doing this type of photography. Based on my point of view that we should always try to record a perfect image in the camera, I recommend this approach even today when it is possible to straighten verticals in the computer.

FOCUSING THE SUPERWIDE CAMERAS

At longer distances, focusing the Biogon lens by estimating the distance is sufficiently accurate because the short 38mm focal length provides considerable depth-of-field. At the maximum aperture of $f/4.5$, depth-of-field extends from 3 m (10 feet) to infinity. With the aperture closed down to $f/22$, the depth-of-field range is from 26 in. (0.6 m) to infinity.

Close-Up Photography with the Superwide

The Biogon lens focuses down to 12 in. (0.3 m) with the superb corner-to-corner image sharpness maintained down to this minimum focusing distance. This makes the Superwide an excellent tool for distortion-free close-up work, such as copying in film photography. In close-up work, estimating the distance is not good enough. At the minimum distance, the depth-of-field is less than one inch; with the aperture wide open, it is increased to about two inches at $f/22$. You can measure the distance from the subject to the film plane mark on the magazine or, better yet, focus the image visually by using the focusing screen adapter accessory, which also shows the exact area coverage with view camera precision.

Focusing with the Focusing Screen Adapter

Precise visual focusing with the lens set at any distance is possible by attaching the focusing screen adapter in place of a film magazine.

The latest focusing screen adapters with the Acute Matte focusing screen provide a bright image over the entire area. Set the shutter at B and keep it open by placing the release lock to T. Open the lens aperture fully for most accurate focusing or set it at the selected aperture to evaluate the final image. You can view the image on the screen through any of the Hasselblad viewfinders, which also provide a magnified view of the entire image and at the same time shield the focusing screen from all extraneous light.

The RMfx finder, with its $3.3\times$ magnification, is especially recommended because it shows the image right side up. The finders slide into the grooves on the adapter and are held in place by a pin on the upper left. To remove the finder, push the pin to the left and slide out the finder.

Determining Exposure

A Hasselblad meter prism finder attached to the focusing screen adapter can be used to determine exposure as you normally do on the camera's focusing screen. I suggest, however, that you make an exposure test on your Superwide camera to see whether it gives the same results as on the standard focusing screen. An instant film magazine can also be used.

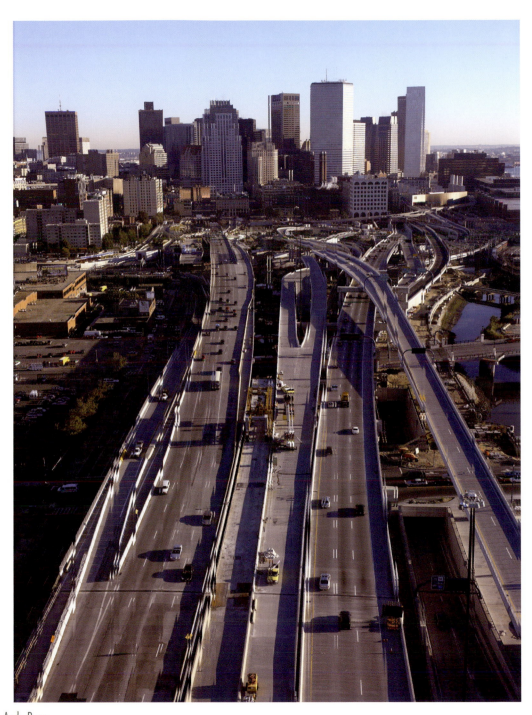

Andy Ryan
An aerial made with the help of a gyroscope to illustrate the enormity of the project and the volume of concrete used in the Central Artery Project of the South Bay Interchange in Boston.

Andy Ryan
A long exposure in the existing light made at and for MIT in Cambridge, MA. The verticals were straightened in the computer together with minor curve adjustments to add saturation and contrast.

Andy Ryan
An architectural image without manipulation made at and for MIT in Cambridge, MA with very effective lighting that existed only on sunny days between June and September on this side of the building.

Andy Ryan
An interior made at a long exposure in Qingpu, China. The photographer's assistant dressed in black added an interesting element and a compositional balance to the image. The verticals were straightened in the computer together with minor curve adjustments to add contrast.

Operating the 200 Cameras for Digital Imaging and Film Photography

Hasselblad 203 or 205 cameras interlocked with E, ECC, or TCC magazines and with FE or TCC lenses provide a simple and automated operation that requires little instruction for eliminating mistakes. The text here, although limited to operations that apply to 200 cameras specifically, is somewhat long only to give you complete details about all the operating possibilities especially regarding the built-in exposure and flash metering system. The metering approach that produces perfect exposures with these built-in metering systems is described in Chapter 15. Figure 12-1 shows all the camera operating controls. The exposure mode selector shown in Figure 12-2 is a distinguishing feature of the different 200 camera models.

DIGITAL IMAGING WITH 200 CAMERA MODELS

Hasselblad 200 camera models are beautiful tools for digital imaging mainly because the excellent built-in metering system can simplify the metering process and produce beautifully exposed digital images. The cameras can be used with Hasselblad digital backs CFV with the square 16 megapixel 36.7 × 36.7 mm sensor, but they require a minor modification if used with F lenses. Consult Hasselblad regarding this modification. A modified camera works in the cable free mode with F lenses or CF lenses set to F. ISO settings on a modified camera must be made with any magazine, film or digital. With a CFV digital back, the ISO setting must be made on the camera and on the digital back. Rapid exposure sequences should be avoided.

200 model cameras can also be used with the large 36.7 × 49.0 sensor in Hasselblad CF 22 (22 megapixels) and CF 39 (39 megapixels) digital backs described in Chapter 3. They are used in Single-shot mode together with Hasselblad ELD adapter and Flash sync input cable, but only with C type lenses. F lenses cannot be used with these digital backs.

RELEASING THE CAMERA

All camera models in the 200 series have electronically controlled focal plane shutters. Protect the curtain by storing the camera body with a magazine attached.

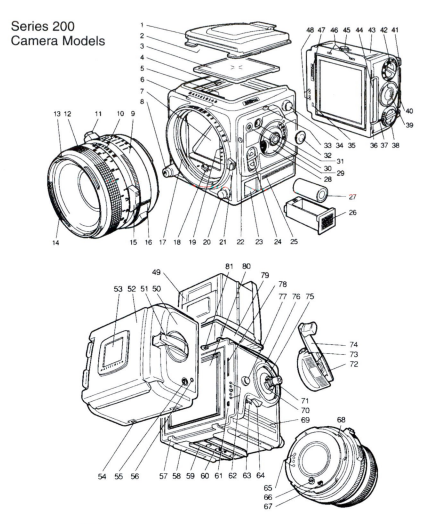

Series 200 Camera Models

Figure 12-1 Main components and operating controls of 200 cameras with built-in metering system: (1) focusing hood cover, (2) cut-out in viewfinder for finder display, (3) focusing screen, (4) focusing screen catch, (5) liquid crystal display, (6) illumination window, (7) mirror, (8) shutter release, (16) system mark, (17) lens mount, (18) drive shaft, (19) electronic connections, (20) lens lock, (21) shutter speed ring (not on 202 model), (22) self-timer indicator, (23) battery compartment, (24) adjustment controls, (25) grip cushion, (26) battery case, (27) battery, (28) mode selector dial, (29) PC socket, (30_ AE lock, (31) dedicated flash connection, (32) flash socket cover, (33) display illumination button, (34) strap lug, (58) camera support, (59) quick coupling slide, (60) tripod thread, (61) magazine indicator trigger, (62) electronic connections, (63) self-timer symbol, (64) pre-release/self-timer control, (65) electronic connections, (66) drive shaft, (67) drive shaft catch, (68) lens bayonet, (69) grip cushion, (70) winder coupling, (71) double-exposure control, (72) winding crank hub, (73) crank catch, (74) winding crank, (75) winder bayonet mount, (76) winding crank index, (77) strap lug, (78) magazine driving gear, and (80) shutter curtain.

Figure 12-2 The exposure mode selector: 203 model (1), 202 model (2), 205 model (3).The original 205TCC had A instead of Ab (no automatic bracketing), and the Pr and A settings were reversed, with A on top.

Batteries

The basic camera operations are mechanical, but the shutter speeds are controlled electronically from the power of a 6 V PX28 battery, preferably lithium, stored in a battery compartment. In 202, 203, and 205 camera models, the battery also powers the metering system. Its life span depends mainly on the use of the meter and the display light. At normal temperatures, a battery should last for more than 4000 metering cycles of 15 seconds each.To save battery power, the electronic circuit turns off automatically after about 15 seconds. A battery symbol in the viewfinder shows when the battery needs to be replaced.

Before inserting or changing a battery, turn the winding crank with the center disc depressed so the camera is in the ready state. Insert the battery with the minus (−) and plus (+) ends positioned as engraved on the compartment. Whenever you remove the battery compartment, all values programmed into the electronic circuit change to the standard values mentioned in the later section Programming Camera Functions. Using the lens shutter with the shutter speed ring in 203 or 205 cameras set to C, you can make an exposure without a battery in the camera.

Pre-Releasing and Use of Self-Timer

Lock the mirror up and pre-release the camera by pressing the release under the winding crank one time toward the rear (see Figure 12-3).To see the image again before making the exposure, simply turn the crank with the center disc pressed.

The pre-release control also operates the self-timer as described in Figure 12-3. Pressing the pre-release a second time starts the self-timer. The desired self-timer delay (from 2 to 60 seconds) is programmed into the camera. When it is in operation, the self-timer symbol appears on the display, and a red light at the front of the camera flashes — twice per second — at the beginning then changes to a continuous light during the last ½ second. The self-timer function is inoperative when the shutter speed ring is set in position B or C.

Figure 12-3 The pre-release control. The lever underneath the winding crank pre-releases the camera when pushed once toward the rear. It starts the self-timer when pushed a second time. The self-timer exposure can be stopped with a third push on the lever. On the 201 camera, the self-timer delay is set for a 10-second delay and set for a 2-second delay with a second push.

FILM ADVANCE AND SHUTTER COCKING

Turning the winding crank advances the film and cocks the shutter. You can recock the shutter without advancing the film by pressing the program disc in the center of the crank when you start turning the crank. The disc needs to be pressed only when you start turning the crank, not for the complete turn.

Motor Operation

All 200 camera models can be operated with a motor winder specifically made for these cameras. It is powered by five AA cells (alkaline or rechargeable) that should provide about 3000 exposures at normal temperatures or 1000 exposures with the rechargeable type. If only one picture is desired, press the release for just a moment. When you keep the release pressed, sequences of images are recorded at the rate of 1.3 images per second until you remove your finger from the release or the roll of film is finished.

While the motor is held to the camera with a solid stainless steel coupling and is shaped to serve as a second support for handheld photography, do not use the motor winder for carrying the camera. It is not designed for remote camera operation, and you must remove it from the camera to produce double exposures. The electrical contacts on the camera and motor must be kept clean using a soft cloth.

OPERATION OF FILM MAGAZINES

E, ECC, and TCC Magazines

With film you probably want to take advantage of the built-in automation and metering system so consider using E, ECC, or TCC magazines where the ISO film sensitivity is set on the magazine and is electronically transferred to the camera body and its built-in metering system. When switching from one of these magazines to another with a different ISO setting, the change is made automatically when you change the magazine.

Working with Other Magazine Types and Digital Backs

With digital backs, A type magazines, or instant film magazines you manually program the ISO film sensitivity into the camera using the camera's Programming (Pr) mode. You must do so whenever you change to another A type magazine or the instant film magazine with a different ISO, but not when changing to an E, ECC, or TCC type where the ISO setting on the magazine overrides the ISO value programmed into the camera.

SETTING THE SHUTTER TYPE AND SHUTTER SPEED

The shutter speed ring on 202, 203, and 205 cameras has engraved shutter speeds from $\frac{1}{2000}$ to 1 second ($\frac{1}{1000}$ second on 201 and 202 models) that can be set manually either at the engraved speeds or between them for ½ stops. It is set to C when a lens shutter is used for the exposure. The B setting is for longer time exposures. You can turn the shutter speed ring to C and B, and out of it, only after pressing the lens lock button.

While the shutter speeds can be set manually, you are not likely to do so since you probably will do most or all of your photography with the built-in aperture priority metering system where the camera sets the shutter speed automatically after you set the lens aperture. The 202FA camera does not have the manual shutter speed ring at the front of the camera. The electronic circuit in the camera always sets the shutter speed even in the Manual mode.

Long Exposure Times

The electronic shutter speed range is up to 90 seconds. On the 203 and 205 cameras, set to M (Manual mode), you can have electronically controlled exposure times up to 34 minutes. At the M setting, press both the + and the − adjustment buttons simultaneously and the electronic circuit changes into the Long Exposure mode (LE), indicated on the viewfinder display. (see Figure 12-4). In the LE mode, every manually set shutter speed is reversed: ½ second becomes 2 seconds, $\frac{1}{30}$ second will be 30 seconds, and $\frac{1}{2000}$ second will be 2000 seconds, which is almost 34 minutes. To go back to the normal shutter speed range, press both adjustment buttons again simultaneously.

Figure 12-4 The Long Exposure mode. The Long Exposure mode is indicated on the viewfinder display by LE. Exposure time here is 1 minute 30 seconds, or 90 seconds. The shutter speed ring was set at $\frac{1}{90}$ second.

SELECTING AND OPERATING LENSES

Working with FE, CFE, and TCC Lenses

The FE, CFE, and earlier TCC lenses without shutter have the electronic contact pins to transmit the electronic data between the lens and the camera body. The contact surfaces of these pins are sensitive to contamination and should not be touched with your fingers. Attach the protective rear cover after removing the lens from the camera.

The operating procedure using the built-in metering system is as follows. Set the lens manually to the desired aperture value either at one of the engraved figures or between two figures for ½ stops. Take a meter reading with the lens aperture either fully open, as it usually is for maximum screen brightness, or manually closed down. The shutter speed sets itself automatically (except in M), and changes automatically when you change the lens aperture setting. I suggest that you look at the display to check the set shutter speed before you take the picture to ascertain that it is usable for your photographic approach; for example, that it is short enough for handheld photography. Take the picture.

Working with Shutter Lenses

You can use shutter lenses (not the original C types) on these cameras and you can then take pictures either with the shutter in the camera or the shutter in the lens (except on 202 model). The camera operation is the same as described previously with shutter lenses set at F for use of the focal plane shutter. The shutter speeds are automatically set and are indicated in the viewfinder. The lens shutter is inoperative, and the viewfinder image returns instantly after the picture is made. On all models except the 202, the exposure can also be made with the shutter in the lens, in which case the camera's shutter speed ring is set to C and the lens shutter operates normally. Except on CFE lenses, the aperture must be closed down manually for the reading and the exposure. The shutter speed is indicated on the display, together with the letters SET, reminding you that you must set this shutter speed manually on the lens. The finder image does not return until the winding crank is turned manually or by the motor winder. The original C lenses should not be considered for use on any focal plane shutter camera.

Manually Closing Down the Aperture

With shutter lenses (except the CFE type), you must manually close down the lens aperture for the exposure meter reading, regardless of whether you use the lens or the camera shutter

for the exposure. This is also necessary when you use any accessories such as extension tubes without the electronic connection, with any lens, even the FE, CFE, and TCC types.

Selecting the Shutter Type

Except for flash photography, you are likely to use the focal plane shutter for most of your photography. For flash photography, especially outdoors, the lens shutter gives you the possibility of shooting flash at all shutter speeds up to $\frac{1}{500}$ second, an option that is extremely helpful when fill flash is used outdoors on sunny days.

THE METERING SYSTEM

The 202 and 203 camera models have a center area metering system with the exposure based on the light reflected from a large center area. The 205 models have a Spot meter, where 100% of the meter reading is based on a center area that is approximately 1% of the total image area (Figure 12-5). Since the light is measured through the lens, the measuring angle depends on the focal length of the lens on the camera and is about 4½ degrees with the Spot meter and the standard 80mm lens. It becomes a 1-degree Spot meter when the reading is made through a 350mm focal length lens. Regardless of the lens, the measured area is always seen on the Acute Matte focusing screen, which is the main advantage for using a camera metering system. The entire metering system is within the camera body (Figure 12-6) eliminating electronic contacts between camera and finder and allowing to use any viewfinder on the camera without losing the benefits of the built-in light metering system.

Turning On the Metering System

The easiest way to turn on the metering system is by pressing the AE lock on the side of the camera (Figure 12-7), but you can also do this by pressing the front release halfway or by pressing the pre-release control, after the darkslide is removed.

When using the AE lock to turn on the system, the light value stored in the camera from the preceding shot is erased and metering starts from scratch. This is the logical approach when you start taking pictures in a different light situation.

With the mode selector at D or Z the light value from the previous shot is maintained in the camera when you depress the front release halfway, an ideal approach when you are continuing to take pictures in the same lighting situation. It eliminates the need to take a new reading. The EV value stays locked in the camera. You can change the aperture for the new picture, and the shutter speed automatically adjusts to give the same exposure but only with lenses with the electronic connection. With such lenses, you can also change lenses and use the new lens at any aperture without the need to take a new meter reading. Keep in mind that this applies only in the D and Z settings, a good reason to consider either one of these modes for your photography. And it only applies if you turn on the meter with the front release. In the A or Ab setting, the system always starts from scratch, even when turned on with the front release. Pre-releasing the camera always locks and stores the exposure value

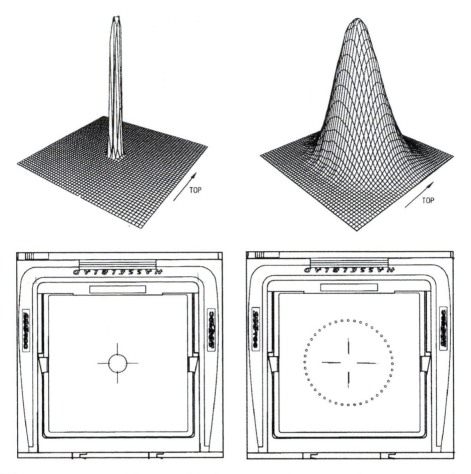

Figure 12-5 The metering area. The 205 (left) has a precise Spot meter that measures only a small center area. In the 202 and 203 models (right), approximately 75% of the light is measured within a 28 mm center area. The measured areas are indicated on the focusing screens (bottom).

Figure 12-6 The metering system. The metering cell is at the bottom of the camera and is completely protected from extraneous light.

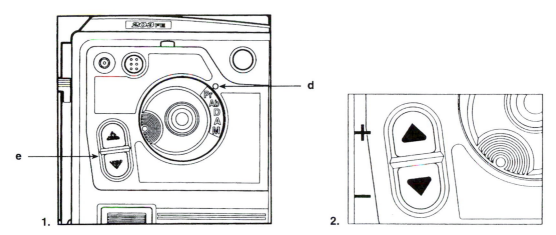

Figure 12-7 The operating controls. (1) The desired mode is set opposite the index (d). In the center of the selector is the AE lock button used to activate the metering system or to lock the shutter speed or light value. (2) The two adjustment buttons (e) are used to increase (top button) or decrease values (bottom button).

that is present at the moment when the mirror was lifted, but the adjustment buttons can still be used to adjust that value.

The system and the viewfinder display turn on only when the shutter is cocked. To save the battery, the metering system turns off automatically after about 15 seconds. If the AE lock has been kept depressed for more than 16 seconds, the camera can be activated only by means of the release button or the pre-release lever.

THE VIEWFINDER DISPLAY

The viewfinder display information is shown in Figure 12-8. The finder display in the camera, which can be illuminated as shown in Figure 12-9, shows the shutter speed on the right side. If the figure has a small "s", the shutter speed is in seconds; for example, 4 s means 4 seconds. It is a fraction, such as ¼ second, without the "s". With the shutter set to C, the letters SET also appear, but not with the original TCC model. On newer 200 cameras the exposure is made at the speed shown on the display regardless of the physical shutter speed ring setting. On the original 205TCC you must keep the shutter speed ring at 1 second.

With FE, CFE, or TCC lenses on the camera, you can see the set lens aperture on the left by pressing the release halfway. The mode selector settings are shown as on the selector dial, except for Ab, which is indicated as A. On 202, 203, and 205FCC models in the A or Ab mode, the letter L comes on when the AE lock or the front release is pressed.

An incorrect camera setting that you should be aware of appears on the display as some kind of warning as illustrated in Figure 12-10.

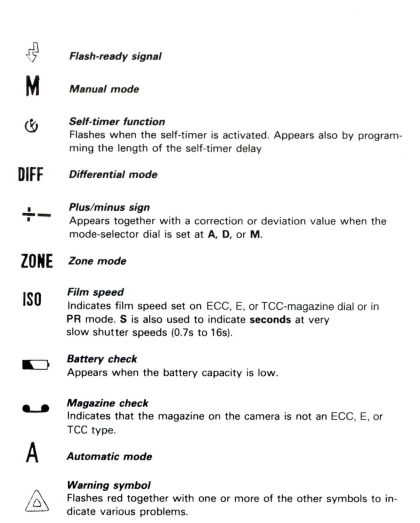

⚡ *Flash-ready signal*

M *Manual mode*

🕐 *Self-timer function*
Flashes when the self-timer is activated. Appears also by programming the length of the self-timer delay

DIFF *Differential mode*

÷− *Plus/minus sign*
Appears together with a correction or deviation value when the mode-selector dial is set at **A**, **D**, or **M**.

ZONE *Zone mode*

ISO *Film speed*
Indicates film speed set on ECC, E, or TCC-magazine dial or in PR mode. **S** is also used to indicate **seconds** at very slow shutter speeds (0.7s to 16s).

🔋 *Battery check*
Appears when the battery capacity is low.

Magazine check
Indicates that the magazine on the camera is not an ECC, E, or TCC type.

A *Automatic mode*

⚠ *Warning symbol*
Flashes red together with one or more of the other symbols to indicate various problems.

Figure 12-8 Viewfinder display information. The information that appears on the viewfinder display.

Figure 12-9 Illuminating the display. The viewfinder display is illuminated by daylight coming through the window below the Hasselblad engraving at the front of the camera. In dim light, you can illuminate the display by pressing the button above the flash connectors. It turns off automatically after about 15 seconds.

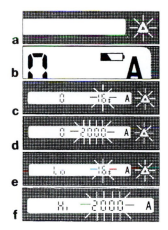

Figure 12-10 Warning signals in finder display. The major warning signals that appear on the display are as follows: (a) flashing red triangle indicates an improper camera setting, (b) low battery power, (c) shutter speed should be longer than is possible on camera, (d) shutter speed should be shorter than is possible on camera, (e) light value is below meter range, (f) light value is above meter range, (g) flash was too bright for correct exposure (displayed in dedicated flash mode only), (h) flash was too low for correct exposure (displayed in dedicated flash mode only), (i) measured area falls below zone 0, (j) measured subject area falls above zone 10, and (k) measured area is beyond set contrast range.

PROGRAMMING THE CAMERA FUNCTIONS.

The Pr setting on the mode selector is used to program certain values into the electronic circuit of the camera. Three values can be programmed into any 200 camera model (see Figure 12-11):

1. The ISO film sensitivity (works only with digital backs or film magazines that do not have the electronic coupling)
2. The self-timer delay
3. A reduction (or increase) in the flash exposure of the dedicated flash system

On camera models with automatic bracketing, you can program the Ab value, which is the difference in exposure between the first and subsequent pictures. On 205 models, you can also program a desired contrast range, and on the 203, a desired reference value.

To program any value into any camera model, set the mode selector to PR then repeatedly press the AE lock until your desired programming function appears on the display. Set or change the programming values by pressing the plus or minus adjusting buttons. Flash and automatic bracketing values are shown as fractions (Figure 12-12). After programming the desired values, set the mode selector to the exposure mode that you want to use. Should you forget to do so, the picture will be made in the automatic mode and will probably still be usable.

The programmed values can be changed at any time. All programmed values remain stored in the camera as long as the camera's battery is in good condition. When you remove the battery, all programmed functions return to the normal (default) values such as 100 ISO

Figure 12-11 The programming display. The major programmed values are the film sensitivity (a), the self-timer delay (b), the flash adjustment (c), and the bracketing value (d).

Figure 12-12 Fractional indications on viewfinder display. (1) On the 202 and 203 models, fractional indications on the display are in $\frac{1}{3}$ stop increments: $\frac{1}{3}$ (a) and $\frac{2}{3}$ (b). (2) On the 205 camera, the indications are in $\frac{1}{4}$ stop increments: $\frac{2}{4}$ or $\frac{1}{2}$ (a) and $\frac{3}{4}$ (b).

for the film sensitivity, 10 sec for the self-timer, 0 for the flash, the bracketing and reference values, and −9 to +9 for the contrast range.

THE METERING OPERATION

You must first decide which exposure mode to use and set the desired value on the selector knob. Decide on the lens aperture and set it manually no matter what type of lens or which shutter you use. With lenses without the electronic connection, manually close the aperture to the preset value for the meter reading.

Exposure Modes

The different exposure modes on the mode selector dial (Figure 12-2) do not change the metering area but give you different choices for light measuring and for making the lens settings. The selected exposure mode is set opposite the index and is shown on the display (Figure 12-13). The dial stays in a set position.

Automatic Exposure Mode

In the A or Ab mode you take one picture at the automatically set shutter speed. Set to A or Ab, the meter always starts with a new reading for the new subject or lighting situation unless you locked the previous setting with the AE lock. When the camera is moved to brighter or darker subject areas, the shutter speed adjusts itself automatically and continuously, giving

Figure 12-13 Display of shutter speed and aperture. In the A, D, and Z modes, the display shows the selected mode, the shutter speed, and a 0 (zero) indicating the correct exposure for that area (b). The aperture is visible when you press the release halfway (a). When you change shutter speed by pressing an adjustment button the display shows the new shutter speed and the deviation (c), or the new zone.

you the point-and-shoot approach when there is no time for more careful meter readings. It works well with 203 cameras where the built-in meter measures a rather large center area. I do not suggest the automatic mode on the 205 camera because the small spot metering area may point at a subject area that gives wrong readings. Although the shutter speed is set automatically, I suggest having a quick look at the shutter speed indicated in the viewfinder to ascertain that it is usable for your photographic approach. You can lock the set value by pressing the AE lock. This is automatically done in the D and Z modes, which is the main advantage for considering these two modes for all photography.

Automatic Bracketing Mode

With the motor winder attached and the 203 or 205 FCC camera set to PR, program the desired bracketing value — $\frac{1}{3} f$ stops on the 203 and $\frac{1}{4} f$ stops on the 205 — into the camera with the adjustment buttons (see Figure 12-14). The numeral 0 changes to horizontal fraction lines, and the maximum value is 1 stop. Set the mode control to AB. If you want only three images, remove your finger from the release after the third take.

Differential and Zone Modes

The differential D mode and the zone Z mode work the same way but the viewfinder display is different. You see 0 on the right in the D mode, and zone 5 at Z with the shutter speed displayed on the right in both modes. Figure 12-15 shows the finder display in the D mode; Figure 12-16 does the same for the Z setting. With the lens aperture preset, point the metering area at a desired part of the subject and turn on the metering system using the AE lock. The shutter speed sets itself and also locks itself instantly.

This automatic locking is the real benefit of working in the Z or D mode. These are the modes that I recommend for most subjects and applications, except perhaps flash. They offer a wonderful, logical, fast, and convenient method of taking accurate meter readings no

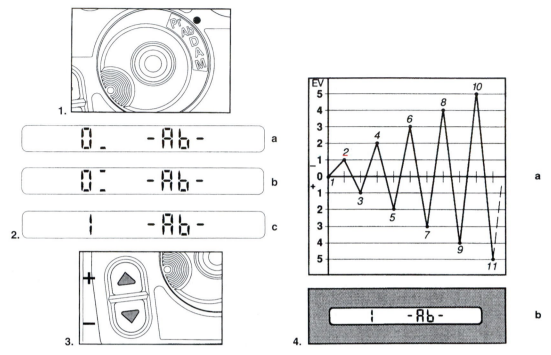

Figure 12-14 Programming the Ab value. In the automatic bracketing (Ab) mode (1), the Ab values shown as $\frac{1}{3}$ (a), $\frac{2}{3}$ (b), and 1 *f* stop (c) on the 203 camera (2) are programmed into the camera by pressing the + adjustment control with the mode selector set to PR (3). With the automatic bracketing function programmed for 1 stop (4b), the first exposure is made at the set exposure value, the second at 1 EV lower (1 stop brighter), the third at 1 EV higher (1 stop darker), and so on as shown on (4a).

matter what the subject or the lighting might be. The viewfinder shows the area that is measured and locks the value so you can re-compose and take the picture at the locked exposure value. At the same time you can see the difference in the values on the display without a change in the lens settings.

My suggested metering approach is to point the metering area at any part within the subject area that has average brightness (18% reflectance), as explained in the chapter on exposure. Depress the AE lock which turns on the meter and sets and locks the shutter speed. Now you can re-compose the image if desired and take the picture. When moving the camera set to D or Z into brighter or darker subject areas, the shutter speed does not change but the 0 on the left will change to show the difference in brightness between the first and second area; for example, +1 means that the new area is 1 stop brighter. In the Z mode, zone 5 changes to a higher or lower zone number. These differences are indicated in $\frac{1}{3}$ *f* stop values on the 202 and 203 and in ¼ values on the 205. In D and Z you can change the aperture setting at any time, the shutter speed adjusts automatically. Use the adjustment buttons for bracketing.

Figure 12-15 Display in D mode. In the D mode, the display shows 0 and the calculated shutter speed (a). When you move the camera to brighter or darker areas, the shutter speed does not change. The 0 changes to a deviation figure, indicating how much brighter or darker the new area is; in this case −1½ on the 205 model (b). Shutter speed changes are made with the adjustment buttons (c).

Figure 12-16 Display in Z mode. In the Zone mode, the display shows zone 5 and the selected shutter speed (a). When the metering spot is moved to other areas, the shutter speed does not change, but the display shows the new zone as 6½ (b). You change the shutter speed and zone using the adjustment buttons (c).

Manual Exposure Mode

Although the manual M mode works beautifully, I see little advantage in using this setting because the D or Z setting works the same way without having to adjust the shutter speed manually. In the Manual mode, however, you can pre-select the shutter speed, an option that can be desirable in flash work. You can preset the shutter speed and then change the aperture until you see 0 on the display or vice versa.

The ML Exposure Mode on the 202 Camera

The mode selector on the 202 camera has an ML setting, which is the Manual mode but with the possibility of locking the shutter speed. This is an ideal setting for using the camera in the shutter priority mode, an approach that can work beautifully in flash location photography.

Figure 12-17 Color harmony. A photograph made visually effective by the combination of blue and yellow and the completely different lines and textures in the sharp outlines in the boat and the delicate tree branches on the right. Exposure determined with the D mode of the built-in meter. (Photo by Ernst Wildi.)

THE ZONE SYSTEM THEORY

The Zone mode, in combination with the precise spot meter in the 205 camera, is the ideal metering system for black and white photographers working with Ansel Adams's Zone System.

An important aspect of Adams' Zone System theory is the concept of adjusting exposure and film development so that all the resulting black and white negatives can be printed on standard-grade paper no matter what the contrast range of the scene might have been. Adams referred to these adjustments as expansion (increasing contrast) and contraction (lowering contrast), and he defined the adjustments with the so-called N− (for contraction) and N+ (for expansion). For details, consult Adams' or other Zone System books.

Figure 12-18 Colors. The red door surrounded by the green frame and the bright overall color on the building made me photograph this building. The pillars with the different color and texture added further visual effectiveness to this picture. Photographed with a short TCC tele lens with the lens aperture set for depth-of-field from the pillars to the door.

The Zone System Compensation Dial

The ECC (TCC) film magazines have a dial to program these compensations, from −4 to +3, directly into the camera. The exposure is changed automatically based on these adjustments. To eliminate mistakes the contrast dial functions only in the Zone mode. The adjustment does not show in the viewfinder display, so check the setting on the magazine.

Keeping Track of the Contrast Range

In the D mode setting on the 205 you can program a desired maximum contrast range into the camera. The normal value in the camera is −9 to +9 f stops, and I suggest you leave it at

that range. To program a narrower range, press the minus adjustment button until you see the desired minus value. To set the + value, do the same with the + adjustment button. If the range exceeds the programmed values when you evaluate the scene, the DIFF display flickers.

With the 203 set to the Manual mode, you can program a reference value into the camera that will warn you when the light or the subject brightness changes beyond a desirable level. You must turn on the meter using the front release, not the AE lock button.

ELECTRONIC FLASH

Dedicated flash, described in more general detail in Chapter 18, works like other cameras by measuring the light from a 40 mm center area of the image plane. With Hasselblad digital backs an adjustment is necessary since the digital sensor reflects a different amount of light than film does. This is described in Chapter 4.

With the camera's focal plane shutter set at shutter speeds shorter than $\frac{1}{90}$ second either the flash does not fire, the exposure is made automatically at $\frac{1}{90}$ second, or you receive a warning, depending on the camera model. When using the shutter in a lens, all shutter speeds up to $\frac{1}{500}$ second can be used, a recommended approach when using fill flash in bright light.

The Flash Connections

For dedicated flash with the focal plane shutter, you only need to connect the six-pin cable from the flash unit or dedicated flash accessory to the six-pin socket on the side of the camera (Figure 12-9). When using non-dedicated units with the focal plane shutter, the sync cable goes into the PC socket next to it. When dedicated or non-dedicated units are used with the shutter in a lens, the sync cable goes into the PC socket on the lens.

Flash and Exposure Modes

Any type of flash can be used in all the exposure modes (A, Ab, D, Z, and M). I do not suggest using the A or Ab mode in dark situations as the camera will set itself for a long shutter speed that overexposes the background areas. In the D, Z, and M modes you can photograph at the shutter speed that exposes the surrounding area properly. Chapter 18 describes the technique of combining flash and existing light.

Flash Exposure

On all 200 camera models, the desired exposure for the flash is adjustable completely independent of the lens settings (see Figure 12-20). On the 201 model, make the adjustment using the ISO dial on the side of the camera, as on the 500 models. On cameras with built-in metering systems, the desired value for the flash exposure is programmed into the camera in the P mode. Press the AE lock repeatedly until FLASH appears on the display. The desired + or − values based on the suggestions in Chapter 18 are then programmed with the adjustment buttons.

Figure 12-19 Many images captured on black and white film need an adjustment in the exposure and the developing time to bring the contrast range to the perfect level based on Ansel Adams' Zone System theory. (Photographs taken with a 100mm lens by Ernst Wildi.)

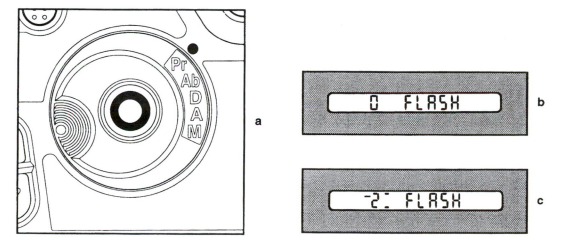

Figure 12-20 Flash exposure adjustments. The desired flash exposure is programmed into the camera at the Pr setting (a) and indicated on the viewfinder display with 0 indicating that the flash exposure is normal (b). The display in (c) indicates a flash exposure reduction of $2\frac{2}{3} f$ stops on the 202 or 203 camera.

On the original 205TCC the dedicated flash exposure is made at the shutter speed physically set on the shutter speed ring, not the speed shown on the viewfinder display. Use the Manual exposure mode and set the shutter speed manually at a figure up to $\frac{1}{90}$ second.

FlexBody, ArcBody, and PC Mutar for Digital Imaging and Film Photography

FLEXBODY, ARCBODY, AND PC MUTAR FOR DIGITAL PHOTOGRAPHY

By attaching a digital sensor unit to the Hasselblad FlexBody or ArcBody you have updated digital cameras with swing and tilt control that otherwise exists only in large view cameras. You have these image controls, which are necessary in many professional applications, in a compact camera that can easily be carried and used on location. These camera/digital back combinations are also updated so you can record the digital images on the largest size sensor with the highest Mpixel rating available. This can be an additional benefit because many subjects that require these image controls, like architecture, also require the ultimate image sharpness.

The PC Mutar shift converter also provides shift control for digital imaging when mounted on any V system SLR camera equipped with a digital sensor unit.

Shift and Tilt Control in the Age of Digital Imaging

The digital age has reduced the need for shift and tilt controls in the camera. You can straighten slanted verticals which are the result of tilting the camera in the computer instead of the camera (Figure 13-1). You can also increase the range of sharpness, the main benefit of the tilt control, in the computer by superimposing two identical images with one focused for the foreground subjects and the other for whatever needs to be sharp in the background. While these corrections are possible in the computer you must be aware that they can be very time-consuming while they are done easily and quickly with the FlexBody, ArcBody, or PC Mutar.

Techical Considerations for Digital Imaging

While the ArcBody, Flexbody, and PC Mutar are good tools for Digital Imaging, you must be aware of some facts that apply only in digital imaging. As described and illustrated in Chapter 11 on the Superwide camera, the infrared filter and protective glass in front of the digital sensor can affect the image quality taken with wide angle lenses that are not designed for digital imaging but are often used when photographing with these cameras or used in combination with the PC Mutar.

Figure 13-1 Straightening verticals in the computer. The vertical lines in this picturesque entrance were beautifully straightened in the computer. Original image was made with a Distagon 50mm lens on a V system camera equipped with CFV digital back. (Photo by Bob Gallagher.)

The light rays from wide angle lenses that go to the corners of the image enter the filter and the glass at an oblique angle and have to travel a different distances. As a result, the focus point is moved out producing a curved image plan that results in unsharpness at the edges of the image. The effect is most notable with extreme wide angle lenses and/or with extreme tiling or shifting of the image plan and on the large 36.7×49.0 sensor. The problem hardly

exists with the smaller sensors. The possible unsharpness also becomes most objectionable when photographing flat, rather than three dimension subjects where the effect is hardly noticeable and certainly not objectionable. For photographing flat object with the ArcBody on the large sensor, only the 75 mm Rodenstock lens should be considered.

APPLICATIONS FOR THE FLEXBODY, ARCBODY, AND PC MUTAR

Hasselblad FlexBody and ArcBody cameras are designed around a flexible bellows for shift and tilt control in medium-format photography. Tilting the image plane increases the range of sharpness beyond anything that is possible with the depth-of-field range of any lens and can therefore be helpful for many types of subjects from a landscape to interior architecturals and food or other tabletop illustrations.

Shifting the image plane up or down, as is possible in both the FlexBody and the ArcBody, covers more of the top or bottom of a subject, the top of a building for example, without tilting the camera thus avoiding slanted verticals. The shift and tilt control on both cameras only works up and down. If you need to tilt or shift along the horizontal plane, turn the entire camera sideways. The image is evaluated on both cameras on the focusing screen adapter specifically made for these cameras and is included in the camera package.

The PC Mutar Teleconverter also can include more at the bottom or top of a subject without tilting the camera but does so by shifting the lens plane up or down instead of the image plane. The PC Mutar lens has a shutter and can therefore be used for film photography or digital imaging on all Hasselblad cameras that use shutter lenses. The image can be evaluated on the focusing screen of the camera with the standard or any of the prism viewfinders.

FlexBody Characteristics

Since you tilt the image plane on the FlexBody (not the lens plane), the image plane remains in the center of the optical axis so you do not need special lenses with large covering power. All V system Hasselblad lenses can be used in combination with the tilt control on the FlexBody.

The image plane on the FlexBody can also be shifted up or down to include more of the bottom or top of a subject, but the range is limited because of the limited covering power of Hasselblad lenses. These lenses were designed to cover the 6×6 ($2\frac{1}{4} \times 2\frac{1}{4}$) image format and nothing larger which is necessary when the lens is shifted out of its image center. Figure 13-2 shows the main FlexBody operating controls.

ArcBody Characteristics

Extensive shifting of the image plane is possible on the ArcBody because this camera must be used with special Rodenstock lenses with a large covering power designed for large format photography. The image plane on the ArcBody can also be tilted to increase the sharpness range. Figure 13-3 shows the ArcBody camera controls.

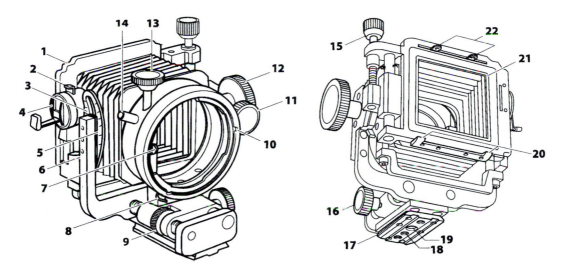

Figure 13-2 The important FlexBody operating controls: (1) rear standard, (2) winding crank lock, (3) tilt scale, (4) winding crank, (5) tilt index, (6) front standard, (7) drive shaft, (8) lens release lever, (9) close-up extension wheel, (10) lens marking, (11) tilt control lock, (12) tilt control, (13) shutter cocking knob, (14) cable release socket, (15) shift control knob, (16) locking knob for close-up extension, (17) quick coupling plate with ¼-inch and ⅜-inch tripod thread (18, 19), (20) magazine support, (21) rear frame, and (22) magazine hooks.

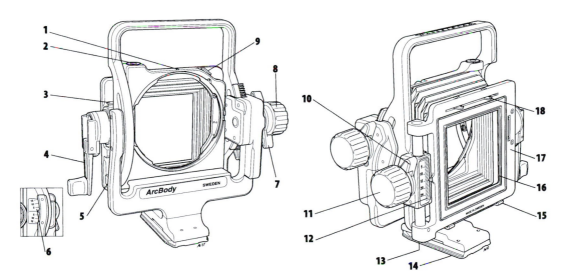

Figure 13-3 The ArcBody operating controls: (1) lens alignment index, (2) spirit level, (3) lock for film winding crank, (4) film winding crank, (5) spirit level, (6) tilt scale, (7) lock for tilt control, (8) tilt control, (9) lens release catch, (10) lock for shift control, (11) shift control, (12) shift scale, (13) spirit level, (14) quick coupling plate, (15) magazine supports, (16) stray light mask, (17) rear standard, and (18) magazine hooks.

USING THE TILT CONTROL

When you are photographing a flat plane from an oblique angle — as in a tabletop setting, a food illustration, or a landscape photograph of a flat area such as a water surface or a flat field — (Figure 13-4) you can control the sharpness range independently from the depth-of-field by tilting the image plane.

Figure 13-4 Applications for tilt control. The tilt control on the FlexBody provides sharpness from top to bottom in the tabletop setting with old *Hasselblad Forum* magazines and of the fall leaves floating on the water. (Photos by Ernst Wildi.)

You can have almost unlimited sharpness, far beyond the depth-of-field range of any lens even when the lenses are used at larger apertures. This allows short shutter speeds (see Figure 13-5). This tilt control principle is known to large-format photographers under the name Scheimpflug (the name of the photographer who came up with the principle). It is based on the following (see Figure 13-6):

> "When photographing a flat plane from an oblique angle, you have the maximum possible sharpness range when a line extended from the lens plane and a line extended from the image plane meet at a common point on a line extended from the subject plane."

Although the Scheimpflug principle could be used to predetermine or calculate the amount of tilt, you will probably find that you can more easily determine the necessary degree of tilt and the correct focus setting by evaluating the image on the focusing screen. Start perhaps by focusing the lens at a point approximately one-third beyond the closest and two-thirds in front of the farthest subject distance — at 14 feet (4.3 m) when the closest subject is 6 feet (1.9 m) and the farthest is 30 feet (9.1 m). Tilt the image plane in one direction

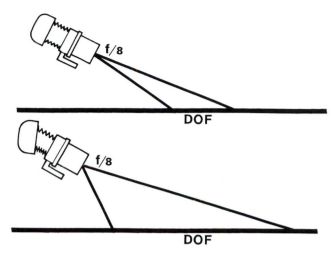

Figure 13-5 Depth-of-field and sharpness range. With the aperture set at *f*/8 the lens produces a specific amount of depth-of-field (top). You can extend the range of sharpness at the same aperture by tilting the image plane in relation to the lens plane (bottom).

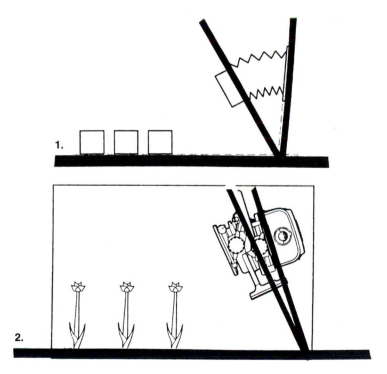

Figure 13-6 Maximum sharpness range. The maximum sharpness range on the FlexBody or ArcBody is obtained when lines extended from the lens plane and image plane meet at a common point on a line extended from the subject plane.

and check whether the sharpness range increases. If not, tilt the plane in the other direction. Check the sharpness at the top and bottom and see whether both become critically sharp at some point. If they do not, change the focus setting on the lens. You will quickly find a point where you have sharpness over the entire plane. Lock the tilt control.

Limitations of Sharpness Controls

With the tilt control you can accomplish sharpness over the entire area even with the lens aperture wide open, but only if you have a flat subject plane, such as the surface of a table or a flat field in the landscape. If there are any three-dimensional subjects on the table — a vase with flowers, a bottle of wine — or a building or tree in a landscape, the various subjects are no longer on a flat plane. We have at least two different image planes: one is the flat surface, the other a plane going from the surface to the top of the subject (see Figure 13-7). You can adjust the tilt for either, but not for both. The difference must be corrected with the lens aperture and its resulting depth-of-field.

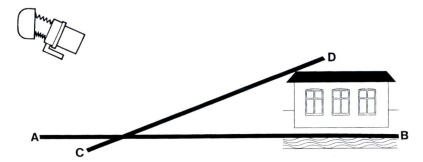

Figure 13-7 Sharpness in different subject planes. The image plane can be tilted for sharpness in one subject plane only, either plane A to B or plane C to D. The depth-of-field control must be used to achieve sharpness in both planes.

The tilt control also allows you to do the opposite — to limit the sharpness to one particular plane. Be careful when doing this as it is a special effect that can easily look artificial and attract unnecessary attention.

THE SHIFT CONTROL

On the FlexBody and the ArcBody, the image plane can also be shifted — moved up or down while remaining parallel to the lens plane. The main applications are in product and architectural photography. Instead of tilting the camera upward to cover a building to the top, resulting in slanted verticals, you can shift the image plane downward (see Figure 13-8). By doing this you can keep the image plane parallel to the subject plane; the wall of the building perhaps.

Figure 13-8 Use of the shift control. A tilted camera results in slanted lines (top). Instead of tilting the camera, you can shift the image plane downward until the top of the building is included in the composition, keeping the image plane parallel to the building (bottom).

Limitations of the Shift Control

When using the shift control you are moving the image area out of the optical axis and out of the 78 mm covering power circle of the Hasselblad V system lenses used on the FlexBody. Soon, two corners of the image darken, or even vignette, and lose image sharpness. Shifting with the Hasselblad lenses on the FlexBody is therefore limited, as indicated on the first line in Table 13-1 for various lenses. You can extend the shift capability to the values shown on the bottom line of the table when covering the subject in a horizontal 6 × 4.5 format. A mask for this format comes with the FlexBody.

The ArcBody eliminates this problem. The Rodenstock lenses that must be used on this camera have a much larger covering power, so you can shift 28 mm with all three lenses of 35, 45, and 75 mm focal length without losing image quality at lease in film photography. All three lenses have maximum apertures of $f/4.5$ which should never be used to create the image in the camera. The quality will not be up Hasselblad's standards. The lenses, like other lenses made for view cameras, were made with this large aperture only to provide a

Table 13-1 Maximum Shift in Millimeters on the FlexBody with Various Lenses

Focal length of lens	40	50	60	80	100	120	250
Maximum without mask	0	5	10	10	14	14	10
Maximum with mask	7	12	14	14	14	14	14

bright image on the focusing screen for focusing and image evaluation. For photography, use apertures *f*/11 or smaller.

CLOSE-UP PHOTOGRAPHY WITH THE FLEXBODY

The front frame that holds the lens on the FlexBody can be moved forward as much as 22 mm for close-up photography. Moved to 22 mm, it produces the same results as a 22 mm extension tube would with the same lens on other Hasselblad V system cameras. I suggest using this close-up extension only for close-up photography. For photography at normal distances, move the front frame all the way to the rear and focus the lens with its focusing ring.

VIEWING, FOCUSING, AND EVALUATING THE IMAGE

On both cameras, the image is evaluated on the focusing screen adapter, in combination with either any Hasselblad V system camera viewfinder or the special RMfx Reflex finder, which shows the 3.3× magnified image right side up. When you tilt or shift, the image on the top or bottom of the screen darkens because your eye is no longer aligned in the optical axis. The Fresnel slides supplied with both cameras solve this problem. The slides are inserted into the adapter either from the left or right. The darkening does not happen on the film or digital back.

TAKING A PICTURE WITH THE FLEXBODY AND ARCBODY

After the image plane is adjusted, the lens focused, and the aperture and shutter speeds set on the lens, remove the focusing screen adapter, and attach the digital back or film magazine but do not remove the darkslide (see Figure 13-9).

Then proceed as follows:

1. Attach the supplied cable release, and press the release halfway. You will hear the lens shutter closing.
2. Remove the darkslide in a film magazine.
3. Press the release completely. The shutter opens and closes to make the exposure.
4. Insert the darkslide in a film magazine before you do anything else. Make certain you do not cock the shutter before the darkslide is in the magazine. That would expose the film to light.
5. Recock the shutter.
6. Advance the film in a film magazine (using the film winding crank on the FlexBody).

The ArcBody operation is identical, but you must also operate the open/close lever for the shutter on the lens. Use the central neutral density filter with the 35 mm and 45 mm lenses to achieve even brightness over the entire image area (discussed in Chapter 14).

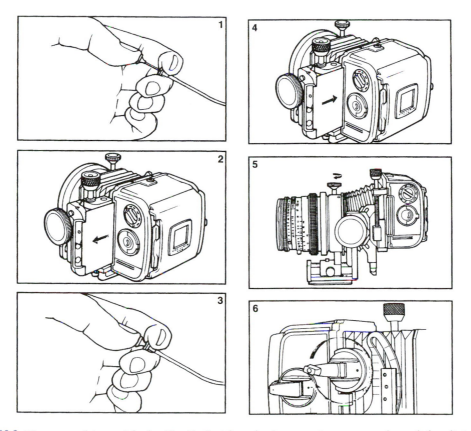

Figure 13-9 Photographing with the FlexBody. After the lens settings are made and the digital back or magazine is attached, press the cable release halfway (1) to close the lens shutter. Remove the darkslide (2), and press the release completely (3) to make the picture. Then insert the darkslide on a film magazine (4), recock the shutter (5), and advance the film (6).

Since there is no darkslide in digital backs, some of the above mentioned procedures do not have to be considered in digital imaging.

THE PC MUTAR TELECONVERTER

The five-element PC Mutar is a 1.4× teleconverter that can be used with lenses from 40 to 80mm focal length increasing the focal length of the lens 1.4 × so the 40mm lens becomes a 56mm focal length. The PC Mutar also increases the covering power from an 80-mm diameter circle to a 106-mm diameter circle so you can shift the lenses on V system cameras 16mm up or down for perspective control without loss of image quality or darkening of the corners. The PC Mutar eliminates or reduces the need for tilting the camera in architectural and product photography. It provides a good solution for such work especially when used on 200 model cameras with 40 or 50mm lenses. Image quality is excellent.

Camera Operation with the PC Mutar

There is no mechanical connection between the camera and the lens/PC Mutar combination. The camera and lens shutter must be operated with the supplied cable release. The two cable release ends must be adjusted so that camera and lens operate in the proper sequence as follows:

1. The shutter in the lens closes.
2. The mirror lifts up, and the auxiliary shutter opens while the shutter in the lens remains closed.
3. The shutter in the lens opens and closes to make the exposure. After it is adjusted and locked, the sequence remains intact at least for that particular lens and camera. Do not use the pre-release because the lens shutter does not close down.

Although the operation with the double cable release works, you can simplify the operation by attaching the PC Mutar to a 200 model camera and use the focal plane shutter for the exposure. The 200 camera can be operated two ways:

1. Attach only one cable release to the camera release thread of the PC Mutar to release the camera. (The release button is covered by the PC Mutar.)
2. Make the exposure with the self-timer built into the camera set for a short two-second delay. This approach can be used with shutter and non-shutter lenses and does not require recocking the shutter in the lens after the exposure. You must remember, however, to close the lens aperture manually for metering and for the exposure (see Figure 13-10).

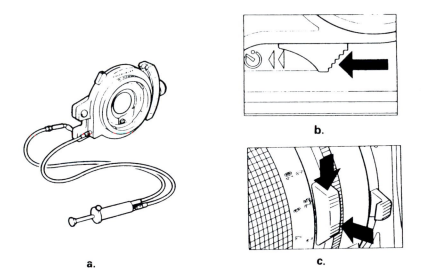

Figure 13-10 PC Mutar on focal plane shutter cameras. The supplied cable release (a) does not have to be used with any lens used on 200 V system cameras. Use the focal plane shutter for the exposure, and release the camera with the self-timer. The aperture (b) on all lenses must be manually closed down (c).

Exposure with the PC Mutar

Because the PC Muter is a 1.4 × converter; exposure needs a one-stop increase unless the exposure determination is made through the lens and converter. You will also notice a darkening on the focusing screen when the PC Mutar/lens combination is shifted away from the 0 position. This darkening is only on the screen and not in the image. But you must take a meter reading with a meter in the camera or prism viewfinder at the neutral 0 position before you shift.

Photographing with the PC Mutar

Vertical lines are recorded straight and parallel when the image plane is parallel to the subject. Start the photography by leveling the camera. Loosen the PC Mutar shift control lock and shift the PC Mutar up or down until you see the desired image area on the focusing screen (Figure 13-11).

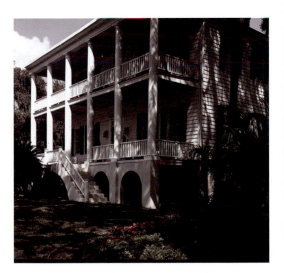

Figure 13-11 PC Mutar and ArcBody applications. The PC Mutar combined with a 50 mm lens produced a good architectural photograph with perfectly straight and parallel verticals (left). The ArcBody produced the same results in a street scene in Germany (right). (Photos by Ernst Wildi.)

Marco Grob
Singer Alvin Chea from the Take 6 band photographed with an HC 2.8/80 mm lens on an H camera.

Marco Grob
A make-up test shot made with an HC Macro 4/120 mm lens on an H camera.

Marco Grob
This photograph was shot for a campaign for Zenith watches on the Atlantic Dunes near Cape Town with an HC 2.8/80 mm lens on an H camera.

Marco Grob
This photograph was shot for *GQ* magazine with the model, Daniel, illuminated with all the light comming from a real TV set. Made with an HC 3.5/50 mm lens on an H camera.

Marco Grob
"The Stairs" photographed in Cape Town for *Glamour* magazine with an HC 3.5/50 mm lens on an H camera.

Lens Characteristics and Specifications

■ ■ ■ ■

THE TECHNICAL PART THAT YOU MUST KNOW ABOUT LENSES

Lenses create the image on the film or the sensor of the digital camera or digital back, therefore, they are a major element that determines how the image is recorded in the camera. Understanding the characteristics of lenses and how they can be used to create the desired results and make the images visually effective must be part of the photographer's photographic education regardless of whether you work with film or digitally. This knowledge helps you to determine which lens should be used for a specific job and how to use it to produce the desired image. That is the reason this chapter covers the technical aspects and the use of lenses in great detail.

Lenses produce the image on a sensor in a digital camera in exactly the same way they do on film except that the filter in front of the digital sensor needs some technical consideration. For photographic purposes, everything in this chapter applies to film and digital photography except the figures for angle of view and covering power vary somewhat because of the size difference between the film format and the sensors sizes in the digital backs or digital cameras.

FOCAL LENGTH

Lenses are distinguished mainly by their focal length, which is an optical characteristic built into the lens that can be changed only by adding or removing optical components, such as a teleconverter or by moving some of the lens elements as done on zoom and some macro lenses. Focal length is unchanged when you add extension tubes, switch a lens from one camera to another, or use a lens for different film formats or for different sensor sizes.

To classify lenses into standard, wide angle, and telephoto, consider the focal length in relation to the format. A lens is considered standard when its focal length is about equal to the diagonal of the picture format for which it is used. That comes out to about 62 mm for the 36.7 × 49.0 sensor, 56 mm for the 33.1 × 44.2 size, 52 mm for the 36.7 × 36.7 size, 70 mm for the 6 × 4.5 film format, and 78 mm for the 2¼ square making 80 mm the standard focal length for this format. An 80 mm focal length can also be considered a good standard lens for the 36.7 × 49.0 sensor size and the 6 × 4.5 film format. The term "standard" is somewhat

theoretical as your personal preference may be part of this decision. For example, 110 mm, not 80 mm, was always my standard lens for 2¼ square photography.

Lenses with longer focal lengths are classified as long focal length lenses, telephotos, or tele lenses and those with shorter focal lengths as wide angles.

Zoom Lenses

On zoom lenses, the focal length can be changed by moving some of the lens elements with the zoom control. The ratio between the shortest and longest focal length is known as the zoom range and is 2.2× for the 50–110 HC 3,5–4.5 lens in the H camera system. Zoom lenses can reduce the number of lenses you need to carry and reduce or eliminate the need for changing lenses and focusing each lens after the change. They are also helpful for making minor adjustments in the area coverage while composing (Figure 14-1).

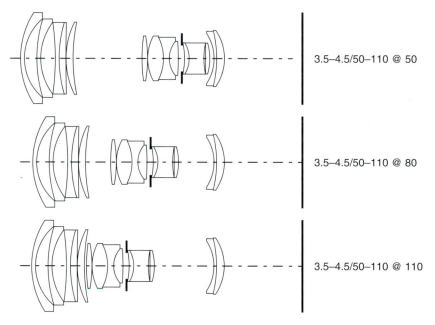

3.5–4.5/50–110 @ 50

3.5–4.5/50–110 @ 80

3.5–4.5/50–110 @ 110

Figure 14-1 Zoom lens design. The 14-element HC 3.5 −4.5 50 mm–110 mm zoom lens with front focusing in the 50 mm position (top), set at 80 mm (center), and set at 110 mm (bottom). This zoom lens can be used with extension tubes. See Chapter 19 for detail.

The aperture of a zoom lens remains the same over the entire zoom range; however, many zoom lenses have a somewhat smaller maximum aperture at the telephoto setting than at the shorter focal length. This is the case with the HC 50–110 mm zoom for the H camera, which explains why the aperture figure is $f/3.5–4.5$. The slightly smaller aperture of $f/4.5$ is at the 110 mm setting. Reducing the aperture allows for a more compact lens with smaller front lens elements.

When focusing a zoom lens manually, focus with the lens set to the longest focal length regardless of the focal length setting that you plan to use. At the longer focal length, the image on the focusing screen has the highest magnification and the minimum depth-of-field, and focusing is likely more accurate. This suggestion does not have to be considered with automatic focusing.

Optical and Digital Zoom

In the specifications for digital amateur cameras, you find terms like optical zoom and digital zoom. An optical zoom is the type described in the previous paragraph where the image on the sensor is magnified more or less by moving some of the lens elements in the lens. You always use the entire image that is recorded on the sensor. Image quality is the same at all focal length settings, except perhaps for minor, usually unrecognizable differences in the lens quality at different settings.

In a digital zoom, nothing changes in the lens. The lens records one specific area like a fixed focal length lens. The "zoom" is done by magnifying a part of the image recorded on the sensor. This is the same approach that we have used for years in film photography by printing just a segment of the entire negative. Enlarging just a part of the negative results in a loss of sharpness, and exactly the same is true for a digital zoom where the image sharpness in the smaller image area is greatly reduced. That is the main reason why digital zooms are never used in a camera for serious photography.

Angle of View

The angle of view is the angle of the area that the lens covers on a specific image format (see Figure 14-2). The angle of view can be related either to the diagonal or to the horizontal or vertical dimension of the picture. If you care to study such figures, make certain you know what they represent (Figure 14-2). A lens that has a diagonal angle of approximately 50 degrees is considered standard on any image format in film or digital photography. The angle of view and thus the area coverage is directly proportional to the focal length. The angle of view of a lens that has a focal length twice as long is half as large, and the lens covers a horizontal and vertical area that is half as wide and high at the same distance and on the same size sensor or film area. Vice versa, a 35 mm wide angle has an angle of view twice as large as a 70 mm lens and covers an area twice as large horizontally or vertically on the same image format.

Area Coverage

The angle of view of a lens determines the area coverage and the magnification. The area coverage for any lens is directly proportional to the subject distance. At twice the distance, a lens covers an area twice as wide. If a lens covers a larger area, subjects are recorded smaller because the magnification is lower.

Lens Factor

In literature and specification sheets for digital cameras, especially the DSLR types, you come across a relatively new term — "lens factor." It has to do with the fact that digital sensors in

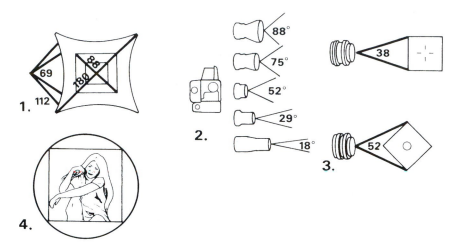

Figure 14-2 Angle of view. (2) The diagonal angle of view of different lenses for the 2¼ film format from top to bottom: 40, 50, 80, 150, and 250 mm focal length. (3) The angle of view can be expressed in relation either to the picture diagonal or to the horizontal or vertical side. The three are different in a rectangular format. (1) On the 30 mm full-frame fish-eye lens, the 180-degree diagonal angle of view is completely out of proportion to the 112-degree horizontal or vertical angle. (4) The covering power of a lens is the diameter of the circle within which satisfactory image quality and illumination are obtained.

most of these cameras are smaller than the 35 mm film format that is familiar to most photographers. Most of these cameras have a sensor in the APS size of about 15 × 23 mm, (some are even smaller), and therefore cover a smaller area that would be the case on 35 mm film. In other words, a lens of a specific focal length becomes equivalent to a lens of longer focal length. The lens factor for the APS size is about 1.5×, which means that a 50 mm lens in the 35 mm film format becomes the equivalent of a 75 mm lens when used with the APS size digital sensor. I consider the term lens factor an unfortunate choice and misleading as it may give the impression to the photographer that the focal length of the lens is changed. This is not the case as focal length can be changed only by adding optical elements or moving elements within the lens. A 100 mm lens on a Hasselblad keeps its 100 mm focal length and records the image as a 100 mm focal length whether it is used for the 2¼ film format or any one of the smaller sensors in a digital back. The change is only in the angle of view and the area coverage, which is smaller on a digital sensor than it is on the 120 film format. As a result the so-called lens factors also must be considered in digital imaging with Hasselblad and are as follows:

36.7 × 49.0 sensor: 1.1× compared to 6 × 4.5 film format
33.1 × 44.0 sensor: 1.25× compared to 6 × 4.5 film format
36.7 × 36.7 sensor: 1.5× compared to 2¼ square format

With Hasselblad in some cases you may compare a rectangular format to a square or vice versa, so you also must take the format shape in consideration. For example, the lens factor

when comparing the diagonal coverage of the square 36.7×36.7 sensor to the rectangular 6×4.5 film size is only $1.3\times$ not $1.5\times$ as mentioned above for the 2¼ square.

Rather than determining the equivalent focal length as done above, it may be more valuable to determine the equivalent area coverage for the digital sensor. This can be helpful, for example, when reading the V system close-up charts in Chapter 19. These charts apply to the $2\frac{1}{4}$ film format. You can determine the area coverage along the longer dimension of the image format for the smaller digital sensors as follows:

> For the 36.7×49.0 sensor multiply the indicated coverage by $0.9\times$
> For the 33.1×44.0 sensor multiply the indicated coverage by $0.8\times$
> For the 36.7×36.7 sensor multiply the indicated coverage by $0.7\times$

Such conversions are not necessary for close-up photography with H cameras. The Manual includes charts for both the film format and for the different digital sensor sizes in Chapter 19.

COVERING POWER

Lenses are optically designed to produce satisfactory image quality and illumination for a specific image format. This lens design characteristic is called covering power and is sometimes called image circle (see Figure 14-1). The Hasselblad H system lenses, with one exception, are designed to produce this quality and illumination on the 6×4.5 image format in film photography. These lenses produce superb corner-to-corner quality with all digital backs or digital Hasselblad camera models since the sensors are smaller than the 6×4.5 film size. The exception is the HCD 28 mm $f/4$ lens which is designed specifically for digital imaging with the H3D and H3DII camera and is designed to cover only the area of the 36.7×49.0 digital sensor. Designing the lens for the smaller digital format resulted in a compact lens with an extremely large 95 diagonal angle of view, larger than the angle of view of the Superwide camera for film photography. The Hasselblad V system lenses are designed to produce the promised quality and illumination in the 2¼-in. (6×6 cm) square format.

The covering power of a lens depends on the lens design not the focal length. Lenses with a 100 mm focal length, for instance, can be made to cover the 35 mm format, the medium format, or the larger area of a 4×5-in. view camera.

Because lenses produce a circular image, the covering power of a lens is indicated by the diameter of the circle within which definition and illumination are satisfactory (Figure 14-1). Beyond that circle, the illumination or the sharpness or both are unacceptable. Lenses designed for a larger format can be used for a smaller format.

LENS QUALITY

A single lens element produces an image affected by all kinds of faults, called aberrations, that include spherical and chromatic aberration, coma, astigmatism, field curvature, and distortion. The aberrations can be reduced by combining various lens elements of different curvatures and thicknesses made from different types of glass and arranged in different ways within the lens

mount. It is the lens designer's job to find a combination that reduces all aberrations to a point where they are not visible or objectionable in the applications for which the lens is made.

Number of Lens Elements

Although large aperture, extreme wide angle and zoom lenses require more elements, the number of elements does not indicate the quality — a larger number of lens elements do not mean a better lens. The quality is determined by the designer's skill in combining a number of elements to produce the maximum in quality using the latest types of glass and design techniques. The quality of the finished lens is further determined, perhaps even more, by the accuracy with which each lens element is ground and polished, the accuracy and workmanship that goes into each mechanical component of the lens mount, the precision that is used in assembling the components, and the time and care taken in testing the finished lens.

Aspheric Lens Elements

Some lens designers have found easier ways to correct some of the lens aberrations by making some lens elements with aspherical surfaces rather than the "ordinary" spherical type. Such lenses are usually promoted by the companies as more modern and producing better image quality than competitive lenses designed with the "old fashioned" spherical lens elements only. A lens with aspherical lens elements certainly may produce excellent image quality but not necessarily because it has aspherical lens elements. Another lens designer may come up with a lens design with spherical elements only that may have equal or even better quality. In other words, it is not the aspherical lens design that makes a better lens, it is the skill of the lens designer and the precision in the manufacturing process. Manufacturers try to stay away from aspherical lens elements as they are very difficult to produce and include them only if the lens designer finds no other way to come up with a high quality lens design.

Lens Quality Information

Lens quality used to be expressed by the number of lines per millimeter a lens is capable of reproducing as separate lines (see Figure 14-3). Lens and photo technicians have, however, found that the sharpness in a photograph is not determined so much by the resolution of fine detail as by the edge sharpness of lines within the image. This is known as acutance. Acutance values correlate very well with the observer's impression of sharpness.

Image-forming qualities are expressed with modulation transfer function (MTF) diagrams, which are published in identical fashion for all the lenses in the V and the H systems and are available from Hasselblad. These diagrams can be helpful for comparing the performance of different Hasselblad lenses, to see whether the sharpness varies between close and far distances, or to what degree image sharpness changes when the aperture is closed down.

On the MTF diagrams (Figure 14-3), the center of the image is on the left. Each vertical line represents 10 mm, so the far right is 40 mm from the center. The corners of the 2¼-in. (6 × 6 cm) square are at 39 mm, at 35 mm for the 6 × 4.5 format, at 31 mm for the large 36.7 × 49.0 sensor, at 28 mm for the 33.1 × 44.2 size, and at 26 mm for the 36.7 × 36.7 version.

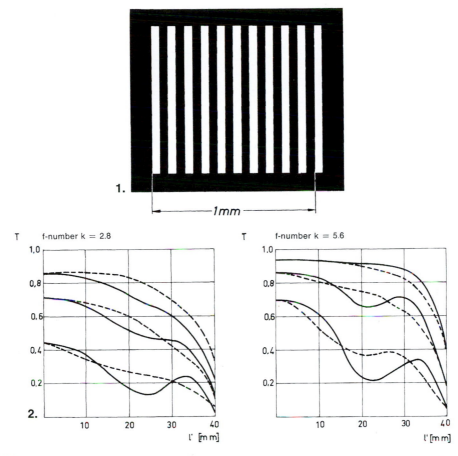

Figure 14-3 MTF diagrams. (1) The quality of a photographic image is not determined by the number of lines that are resolved but by the edge sharpness, which is called acutance. (2) On the MTF diagrams, the image height is on the horizontal axis with the center at the left. The diagrams are shown with the aperture wide open (left) and stopped down about two aperture values (right).

The performance is illustrated with three sets of lines for different resolution figures with the top line (or the two top lines) the most important for general photography. The higher the lines, the better the lens. The dotted curve is for tangential lines and the solid curve for sagittal lines. Figure 14-4 shows MTF diagrams for the HC 3.2/150 mm and the HC4/120 mm lens.

The Hasselblad MTF diagrams cannot be used to compare the Hasselblad lenses to those made by other companies because there are no standards within the industry. Most companies publish these diagrams based solely on computer printouts not taking into account the manufacturing precision. The charts for the Hasselblad lenses show the actual performance of the lens that is on your camera or the camera that you plan to purchase.

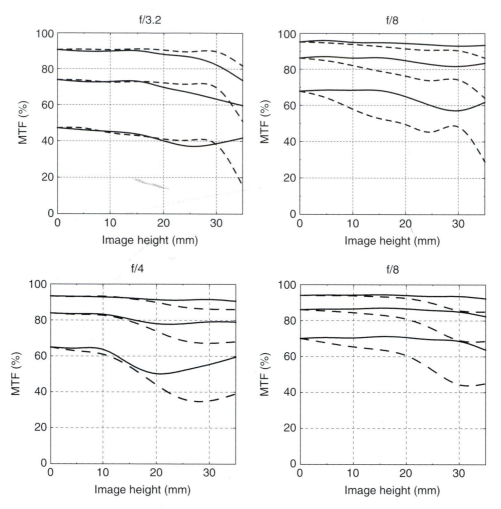

Figure 14-4 MTF diagram. MTF diagrams for the HC 3.2/150 mm wide open at *f*/3.2 and closed down to *f*/8 (top) and for the HC 4/210 mm wide open at *f*/4 and at *f*/8 (bottom).

Image Quality with Zoom Lenses

When designing a fixed focal length lens, the lens designer only needs to be concerned about the lens performance at one specific focal length. In a zoom lens, the optical technician needs to worry about the quality at every focal length and there has to be a compromise. Having identical quality at every setting within the zoom range can only be a dream. The best that a lens designer can do is come up with a lens design that produces completely acceptable sharpness at all focal lengths, and the Hasselblad lens designers accomplished this beautifully. MTF diagrams for zoom lenses usually show the curves at two or three different focal length settings. The MTF diagrams for the HC 50–110 zoom lens are shown in Figure 14-5

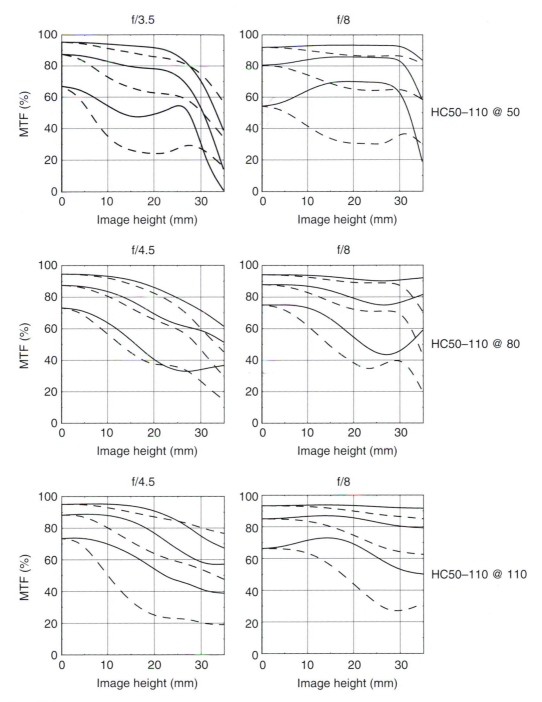

Figure 14-5 Zoom lens quality. MTF diagrams for the HC 3.5–4.5/50–110 mm zoom lens set at 50 mm (top), at 80 mm (center), and at 110 mm (bottom) all with the aperture wide open and closed down to f/8.

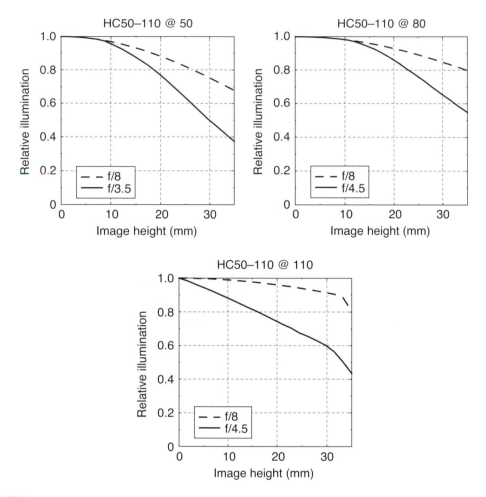

Figure 14-6 Illumination. Illumination diagrams for the HC 50–110 mm zoom lens at 50 mm (top left), at 80 mm (top right), and at 110 mm (center).

at the 50, 80, and 110 mm focal length. Figure 14-6 shows the illumination at different focal length settings.

Image Quality at Different Lens Apertures

Every lens in the Hasselblad line produces excellent image sharpness when used at the maximum lens aperture. Image sharpness, however, further improves especially in the corners as the aperture is stopped down with maximum corner-to-corner sharpness usually when the aperture is two or three *f* stops below the maximum. The MTF diagrams for all Hasselblad lenses show the performance at maximum aperture and with the aperture closed down,

usually two *f* stops (Figure 14-4). This allows you to judge to what extent image sharpness improves in the center and at the corners of the image when stopping down the aperture.

Image Quality at Small Apertures

When lens apertures become very small, a loss of sharpness may be caused by the nature of light, not the lens or lens design. Light going through a small opening spreads slightly at the edges, an effect known as diffraction, possibly affecting image sharpness at small apertures. To reduce this problem, manufacturers of high quality lenses, like Hasselblad, limit the minimum aperture to a point where the quality loss is not objectionable or even noticeable. This explains why some of the lenses may stop down only to *f*/16 or *f*/22 so you do not have to be concerned about closing the aperture too far. Stop it down completely if the depth-of-field requires it. However, use a somewhat larger aperture setting with any lens if the smallest aperture is not needed for depth-of-field.

Your Own Quality Tests

There are probably occasions when you want to test a lens yourself. You can use the readily available lens test charts for that purpose, but other objects with fine detail and sharp outlines, such as good quality printed material, are even better. Brick walls are often suggested for outdoor tests, but they are not exceptionally good because they do not have sharp outlines or much contrast. An old building made from stone or weathered wood is a better choice.

Here are a few other points that you must consider:

- The test target must be absolutely flat so that you do not have to worry about depth-of-field.
- The image plane must be parallel to the test target.
- If you compare different focal length lenses, each lens must cover the same size area.
- Eliminate any possibility of camera motion.
- Make the test with the aperture wide open and closed down about two stops.
- Keep specific lens designs in mind. Macro lenses are designed to produce best quality at closer distances. Retrofocus types perform better at long distances.
- Evaluate the center and the corner of the image.
- If done on film, each negative or transparency must have the same exposure and must be developed identically. Evaluate the original negative or transparency, not a print or a projected transparency.

Color Correction and Apochromatic Lenses

Most photographic lenses are corrected so that mainly the red and blue light rays form the image at the same point. Such achromatic lenses can produce images of superb sharpness, at least within the wide angle, standard, and short telephoto range, but long telephotos may produce images with color fringes. As a result, some long telephoto lenses are of the apochromatic design. They are corrected not only for red and blue but also the colors in between and may carry the letters "apo" or the word "apochromatic" as part of their name.

Apochromatic lenses may have elements made from special optical materials (not glass) that are sensitive to changes in temperature and affect the focus setting. As a result, the focusing ring goes beyond the infinity setting. Such a lens must always be focused visually on the

focusing screen. Do not just set it at infinity if the subject is far away. The Carl Zeiss 250 mm Sonnar Super Achromat, the 350 mm Tele Super Achromat and the 300 mm Zeiss Telephoto Powerpack (TPP) in the V system are three such types. The latter consists of an FE Zeiss 300mm Tele Superachromat, which is an apochromatic lens with some elements made from very special types of glass. It comes with an apochromatic Apo-Mutar 1.7× Teleconverter specially designed for this lens making it a 500 mm apochromatic lens. It is called a powerpack because of the close focusing distance of 23 feet (7 m) and the large *f*/2.8 aperture, which is unusual for such a long focal length especially in the medium format. Combined with the Teleconverter is a 500 mm *f*/4.8 apochromatic lens. The lens is finished in a special type of silver gray anodizing with a high reflectivity to reduce changes in temperature inside this lens which, in wildlife and bird photography, can be exposed to bright sunlight over long periods of time.

Relative Illuminance

The corners of the image recorded by any lens receive somewhat less light than the center. This loss of illumination can be caused by the lens design that limits the lens diameter to keep lenses compact and lightweight. On wide angle lenses the cause is often found in the lens barrel design where light rays that enter the lens at steep angles are cut off by components in the lens barrel. Also on extreme wide angle lenses, the diaphragm opening that is circular when seen from the front and allows a large amount of light to enter but becomes elliptical and smaller when viewed from the side letting less light through the opening. Lens designers try to keep the difference in illumination within acceptable levels. If this is not possible, you can obtain a more even light distribution by reducing the illumination that goes to the center of the image with a neutral density center filter placed over the lens. In the Hasselblad line, this is necessary or recommended only with the Rodenstock lenses for the ArcBody and the 30 and 45 mm lenses of the XPan camera (for the 45 mm lens only when used at apertures *f*/8 or larger). On all other Hasselblad lenses, the corner illumination is within acceptable levels so a darkening is never objectionable or even visible in the final image.

The data for relative illuminance are published for all Hasselblad V and H system lenses and are available from Hasselblad. Corner illumination improves when stopping down a lens as can be seen by the diagram in Figure 14-7, in Figure 14.8 for the HC 150 mm lens with the aperture stopped down to *f*/8 and, in Figure 14-6 for the HC 50–110 mm zoom lens wide open and at *f*/8 at three different focal length settings.

Color Rendition

Color rendition in an image is determined mainly by the glass used in the lens. Individual multicoating of the different lens surfaces can also help to reduce variations between lenses.

Because sequences of images are frequently taken in the same location but with different focal length lenses, matched color rendition in all lenses is important although variations in a digital image can be corrected in after image manipulations. All lenses in the Hasselblad system produce images with virtually identical color rendition even when comparing the V system and the H system lenses.

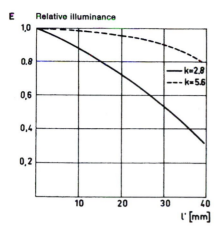

Figure 14-7 Relative illuminance. The relative illuminance shown with the aperture wide open (bottom line) and closed down two *f* stops (top line). The image height is again on the horizontal axis with the center at the left and the corner at the right.

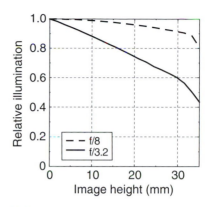

Figure 14-8 Illumination at different apertures. Illumination diagram for the HC 3.2/150 mm lens shows that corner illumination improves when the aperture is stopped down to *f*/8.

Coating and Multicoating

Lens coating, invented by Zeiss in 1935, reduces light reflections off a glass surface from about 5 to 1%. In multicoating, invented later, each lens surface receives several layers of coating, each of a different thickness, to reduce reflections from the different wavelengths of light. This process reduces reflections down to about 0.3%.

All Hasselblad H lenses are multicoated. All newer Hasselblad system lenses that carry a red T engraving are multicoated with six or seven layers on each glass air surface. The 250 mm Sonnar Super-Achromat is not engraved T because it has a one-layer coating as it was originally designed also for IR photography in the space program,

Coating and multicoating reduce the light that otherwise would be reflected between lens surfaces and eventually reach the image plane where it would cause flare and reduce the image contrast and color saturation. Disturbing light reflections can also be created by the interior of the camera body or the lens barrel. The interior of the H camera bodies and the 503 model in the V system have a Palpas coating to reduce or eliminate reflections. The rear of the lens barrel in the latest lenses is also designed to reduce the risk of stray light reaching the film or digital sensor — a major difference between the CFi/CFE and earlier types in the V system.

Lens Shades

Multicoating of lenses has not reduced or eliminated the need for lens shades. Shades serve a different purpose than multicoating. Multicoating and coating the interior camera body reduces reflections from the light that actually goes through the lens to form the image in the

camera. Lens shades must be used to eliminate all the light that falls on the lens from outside areas and is not needed for the image. Lens shades are especially important when you are photographing toward light sources and against white backgrounds or bright outside areas such as overcast skies, water, and snow. A lens shade is also a good protection for the lens when it rains or snows. I suggest keeping a lens shade on the lens at all times.

Regular square or round shades are compact and provide good shading in most cases. They are made in different lengths to provide maximum shading for different focal length lenses. Shades for zoom lenses must be a compromise because they can be only as long as needed for the shortest focal length. On the Proshade in the V system and the Proshade V/H 60–95 the bellows can be extended to match the focal length of the lens. These Proshades are highly recommended when you are photographing against white backgrounds. They can also be used for holding gelatin or glass filters.

DISTORTIONS

Lens Distortion

Distortion in relation to lens design refers to the inability of the lens to record straight subject lines as straight lines over the entire image area. Straight lines near the edges appear curved, either inward (referred to as pincushion distortion) or outward (called barrel distortion; Figure 14-9). In some photography such as portraiture, the degree of distortion correction is less critical than in architectural, product, and scientific photography. Lens distortion does not change with the lens aperture. The distortion corrections for the lenses made for Hasselblad are also published sometimes for different distance settings. Figure 14-10 shows the distortion diagrams for the HC 3.2/150 mm lens at infinity and about 7 feet and Figure 14-11 shows the distortion for the HC Macro 4/120 mm lens set at infinity and at a distance that produces a 1:2 magnification. For zoom lenses, the distortion is usually shown at different focal length settings.

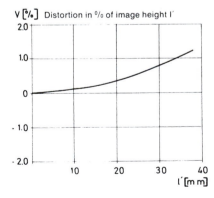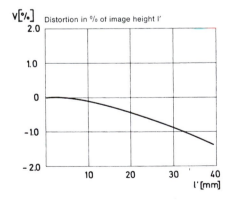

Figure 14-9 Barrel or pincushion distortion. If the distortion curve has a positive value and goes upward (left), the lens has pincushion distortion. A curve with a negative value goes downward (right), indicating barrel distortion.

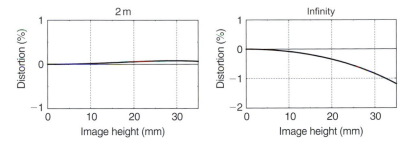

Figure 14-10 Distortion for HC 150. The distortion for the HC 150 is shown at infinity at the right and for a distance of about 7 feet at the left.

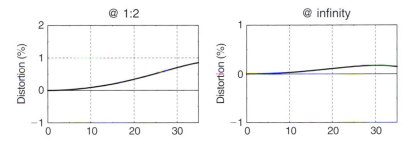

Figure 14-11 Distortion of macro lens. Distortion of HC Macro 4/120 mm at infinity (right) and at a 1:2 magnification distance.

The ability or inability to record straight lines properly over the entire image area is the only distortion caused by the lens design. Do not blame the lens for any other distortions that might appear in your images, especially with wide angle lenses.

Foreshortening

When a subject or part of a subject close to the camera, such as the nose in a portrait or an arm stretched out toward the lens, appears excessively large in relation to the rest of the subject or scene we have foreshortening, not distortion. Foreshortening is caused when the lens is too close to the subject or part of the subject. To avoid foreshortening, photograph at a longer focal length from further away. Excessively large noses can be avoided if the camera is at least 3 feet (1 m) away from the person.

Slanted Lines

Slanted vertical lines are frequently referred to as distortion, but again are not created by the lens but by a tilted camera. Since slanted lines can be straightened by computer manipulations, the need for considering this point when taking the picture is reduced. Trying to

straighten the lines in the camera while taking the picture is still a good and certainly much faster solution. Slanted lines can often be avoided easily without any special equipment by simply photographing the subject with a longer lens from a longer distance, if that is possible, as discussed in Chapter 15.

Wide Angle Distortion

Another type of distortion occurs when three-dimensional subjects are photographed with wide angle lenses. You see this distortion in many news pictures of people because wide angle lenses are popular tools in news photography. The objects near the edge of the picture appear wider than those in the center. A perfectly round chandelier, for example, appears egg-shaped in the corner of the picture and a person's face is elongated and/or curved. This effect is called wide angle distortion as it becomes obvious and objectionable only in pictures taken with wide angle lenses. In spite of its name, wide angle distortion is not the fault of the lens or its design. It happens even in pictures taken with the best designed wide angle lenses.

The first reason for this effect is the flat image plane in the camera. (see Figure 14-12). A second reason can be found in the fact that the lens sees objects on the sides from a different angle than those in the center. In a group of people the lens sees those in the center from the front, but looks at the side of the head of those at the sides. In group or product pictures, the distortion can be reduced by turning the people or products so that they all face toward the center of the lens (see Figures 14-12 and 14-13). In cases with immovable objects, try to compose the shot so objects that easily look distorted do not appear on the edges or corners of the frame.

LENS DESIGN AND LENS NAMES

Most modern lenses, like the HC types for the Hasselblad H cameras, do not have specific names based on the type of lens or its design. The names on the Carl Zeiss lenses in the V system differ depending on the lens design, which does not mean that one design is better than another, but simply that a specific design was selected as the most suitable for that particular focal length (see Figure 14-14).

Planar lenses are symmetrical with five to seven elements grouped into similar front and rear sections. The name is based on their ability to produce an exceptionally flat field. Makro-Planars, originally called S-Planars, are corrected to produce the sharpest images at close distances, but they also produce good quality at longer distances.

Sonnar lenses, consisting of four or five elements, are a compact design, with the main components in the front section. The Tessar is a classic four-element lens design that produces lightweight compact lenses. Tele-Tessar lenses are optically true telephoto types with a positive front section and a negative rear section separated by a large air space. Mutar is the name for teleconverters made by Zeiss. When the name is combined with "Apo," it indicates a Zeiss teleconverter with apochromatic correction. The PC Mutar is a $1.4\times$ teleconverter with shift capability.

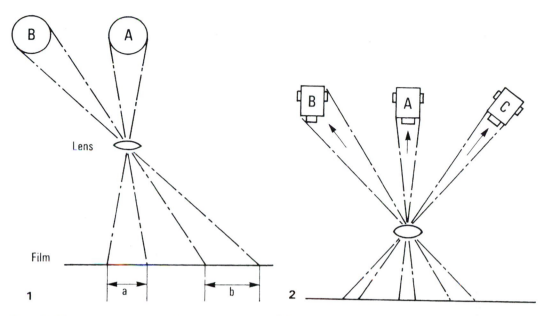

Figure 14-12 Wide angle distortion. (1) A round subject at the edges (B) becomes elongated when traced onto the flat image plane. Distance (b) is greater than distance (a) for the round subject in the center. (2) When you photograph groups of people or products, wide angle distortion is further emphasized because the lens sees the subjects at the edges from the side (B), but it sees those in the center from the front (A). You can greatly reduce the distortion by turning the people or the products on the sides so that the lens also sees them from the front (C).

Distagons are retrofocus-type wide angle lenses with a long back focus for use on SLR cameras. The Biogon is an optically true wide angle design. Variogon is the trade name for the zoom lens made by Schneider. The 60–120 mm zoom lens is designed by Hasselblad and manufactured to Hasselblad's specifications and tolerances.

Lenses for the H Camera System

All lenses for the H camera system are made by Fuji in Japan in cooperation with the Hasselblad lens designers. The lenses are manufactured to the highest standards specified by Hasselblad with all the glass and air surfaces multicoated to produce the most satisfactory image quality in digital and film photography. Some of the lens designs are shown in Figure 14-15.

All lenses for the H camera system have shutters designed by Hasselblad with shutter speeds up to 1/800 second. These shutters are designed in two different sizes in order to produce most accurate shutter speeds over the entire shutter speed range with any focal length lens regardless of the physical diameter of the lens elements. Shutters with a 20 mm diameter are built into lenses up to and including 80 mm focal length. The larger shutter with a 28 mm diameter is in the longer focal length lenses.

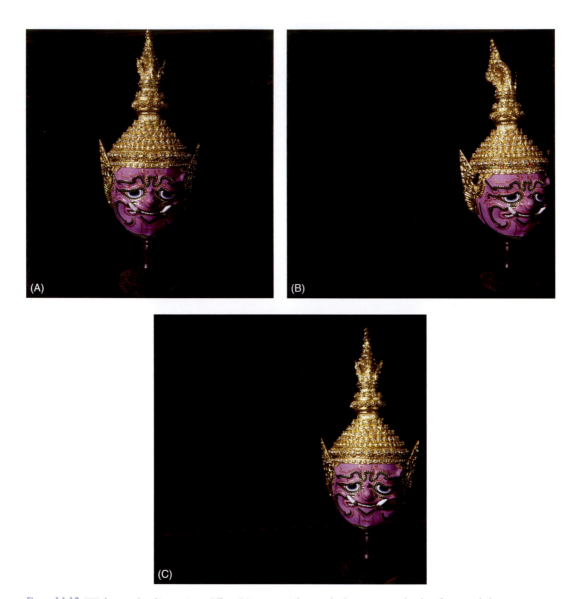

Figure 14-13 Wide angle distortion. The 50 mm wide angle lens records the front of the face of the mask from Thailand when the mask is straight in front of the lens and faces the lens. (A) Placed at the side, the same lens photographs the mask from the side. (B) With the mask in the same position at the side but turned to face the center of the lens, the image is practically identical to the one photographed from the front. (Photo by Ernst Wildi.)

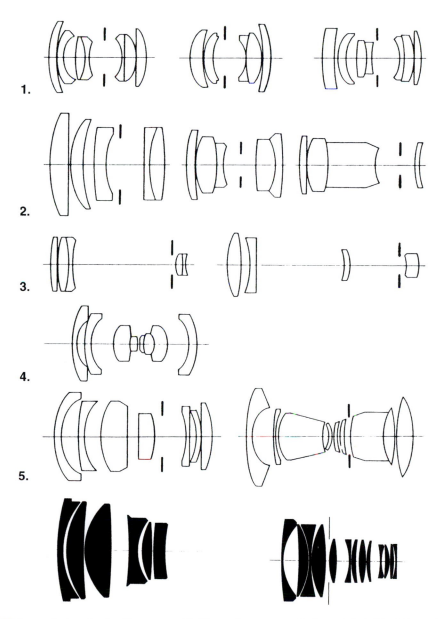

Figure 14-14 Lens design in the V system. (1) Planar lenses are (left to right) 80, 100, and 135 mm. Makro-Planar. (2) Sonnars are (left to right) 150 mm *f*/2.8, 150 mm *f*/4, and 250 mm *f*/5.6. (3) Tele-Tessars are (left) 500 mm Tele-Apotessar and (right) 350 mm *f*/5.6 Tele-Tessar. (4) The Biogon 38 mm optically true wide angle design. (5). The Distagon retrofocus wide angle design: 60 mm (left) and 30 mm fish-eye (right). An apochromatic design, the 350 mm Super Achromat, is shown at the bottom left. The 60 to 120 mm zoom design is shown at the bottom right.

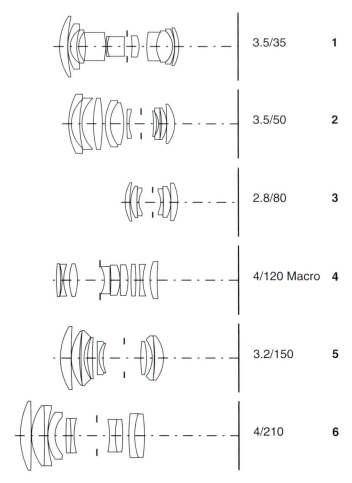

3.5/35	1
3.5/50	2
2.8/80	3
4/120 Macro	4
3.2/150	5
4/210	6

Figure 14-15 Lens designs of H system lenses. (1) The HC 3.5/35 mm retrofocus wide angle with 11 lens elements and rear focusing. (2) The HC 3.5/50 mm retrofocus wide angle with 10 lens elements and rear focusing. (3) The symmetrical design of the 6-element HC 2.8/80 mm standard lens with full focusing. (4) The 9-element HC 4/120 mm Macro lens with focusing from infinity to life-size magnification. (5) The HC 3.2/150 mm telephoto with 9 elements and internal focusing. (6) The HC 4/210 mm telephoto with 10 lens elements and rear focusing.

New Lens Designs for Digital Imaging

The Carl Zeiss and HC lenses are designed to produce the utmost image quality in film photography and are equally excellent high quality lenses for digital imaging. In digital imaging some of the lens aberrations, such as chromatic aberration and distortion, can be corrected further in the computer software but to a satisfactory degree only if the lens is optically designed to produce good corner to corner image quality without the help of the computer. This topic, Digital Auto Correction (DAC), is further discussed in Chapter 3 in the section

entitled "Lenses for Digital Imaging." DAC can only provide great image quality on a lens that is optically designed to produce that quality. It cannot produce good image quality from an inferior lens. The quality improvement that DAC can make is shown in Figure 14-16. The MTF diagrams show clearly that the HC 35 has excellent quality even without DAC.

The diagram shows that the basic optical design produces excellent image quality even without DAC. MTF diagrams are discussed in detail in this chapter in the section entitled "Lens Quality Information."

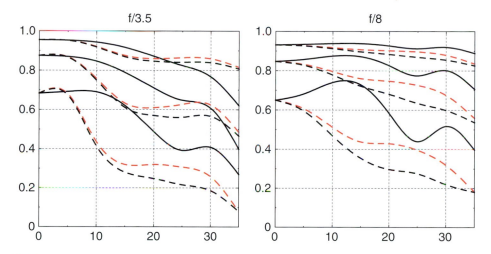

Figure 14-16 Digital APO correction. The red dotted lines in the MTF diagrams for the HC 35 mm show the improvements made by the DAC correction at *f*/3.5 (left) and at *f*/8 on the right.

The HCD 4/28 mm Lens

The designation D indicates that this retrofocus wide angle lens can only be used for digital imaging not for film photography and only on H3D and H3DII camera models. There are two reasons for this limitation: as part of the design brief, the lens has been designed with software correction that works only with the H3 cameras which transmit the lens data to the computer and the lens is optically designed to cover the diagonal of the 36.7 × 49.0 sensor only, not the larger film format. This allowed producing a lens with an exceptionally large, practically unknown 95-degree angle of view for digital recording. The 28 mm lens also cannot be used with the Converter H1.7x. The lens design of the HCD 28 mm lens is shown in Figure 3-7 in Chapter 3. DAC improves the distortion correction on this lens.

WIDE ANGLE LENS DESIGNS

Biogon and Distagon are wide angle lens designs with two completely different optical configurations. The Biogon is an optically true wide angle lens (the classic design that is still used for wide-angle lenses on large-format cameras) known for its superb corner-to-corner quality

and low distortion values. This is the main reason the Superwide camera was produced and is extensively used for architectural photography.

Because the nodal point from which the focal length is measured is within the physical dimension of this lens design, these wide angle lenses must be close to the image plane, something that is possible on the Superwide cameras but not on SLR models.

The Biogon focuses down to 12 in. (0.3 m) and maintains the superb sharpness down to 12 in., making the Superwide also a superb tool for copying and other critical close-up photography.

Distagons and the wide angle lenses for the 503 and other V system cameras are retrofocus wide angle designs, sometimes also called inverted telephotos. The nodal point is behind the physical dimension of the lens, bringing the rear element of the lens far away from the image plane. Wide angle lenses on SLR cameras must have the retrofocus design as the mirror must have room to move up and down. As it is somewhat more difficult to design retrofocus lenses for maximum sharpness over a wide range of distances, they are designed to provide best image quality at long distances. Such lenses are mostly used for long distance photography. Distortion values may also be somewhat higher.

Floating Lens Elements

The floating element (FLE) lens design improves image quality with retrofocus-type lenses at closer distances. In an FLE lens, some of the lens elements can be or are moved separately from the rest. In the 40 and 50 mm shutter lenses, you manually move the floating elements using an adjustment ring at the front of the lens (see Figure 14-17). Do not forget to set it before you take a picture, and always set the front calibration ring first to one of the click stops based on the subject distance; then focus the image in the normal fashion by turning

Figure 14-17 Operating the FLE. On the 40 and 50 mm CFi (CF) lenses, the FLEs are moved with the front ring to three or four click stops, which are engraved in meters only. The four settings on the 50 mm lens are infinity to 12 feet (4 m); 12 feet (4 m) to 4 feet (1.2 m); 4 feet (1.2 m) to 32 inches (0.8 m); and 32 in. (0.8 m) to 19 in. (0.5 m).

the regular focusing ring. Do not focus the image first and set the calibration ring afterward. The image will be out of focus. If you want sharpness from foreground to background, set the calibration ring to the longest or second longest distance setting.

On the Distagon FE 50 mm *f*/2.8 non-shutter lenses, the floating portion of the lens elements moves automatically to the proper position when you turn the regular focusing ring.

The 30 mm Distagon Fish-Eye Lens

The 30 mm Distagon for the 503 and other V system cameras is a completely different wide angle design known as fish-eye. The diagonal angle of view is 180 degrees for the 2¼ × 2¼ image format producing a curvature in all straight lines that do not pass exactly through the center of the image. The effect is one of greatly exaggerated barrel distortion resulting in strangely beautiful images. The 30 mm Distagon covers the entire 2¼ V system format without any visible light falloff in the corners and with excellent sharpness from corner to corner even with the lens wide open. I must point out the full frame coverage specially because some fish-eye lenses made for other cameras produce a circular image that covers only the central area of the image. The effect can be striking but it is largely the circular image that attracts attention not the subject within the circle. The effect wears off quickly as all pictures start to look alike. Such fisheye lenses therefore have limited application in serious photography.

The 30 mm Distagon can also be used with digital backs on the 503 or other V system cameras, but the fish-eye effect will not be as striking since the smaller sensors do not show the full 180-degree diagonal coverage.

The 180-degree diagonal angle of view of the 30 mm Distagon does not allow placing filters or shades in front of the lens because they would cut into the field of view. The Distagon design and the multicoating have reduced flare to a degree that makes it possible to photograph directly into a light source without a shade and without any noticeable loss of contrast. The filter problem has been solved with a removable front section that allows you to attach small, 26 mm filters inside the lens. The lens comes from the factory with a clear glass in place. This clear glass, or filter, must always be there because it is part of the lens design. Image quality suffers without the glass. Four of the most common filters are supplied with the lens.

TELEPHOTO DESIGNS

True Telephoto Lenses

An optically true telephoto lens is an optical design where the principal plane, from which the focal length is measured, is not within the physical dimension of the lens but is somewhere in front of it. This lens design allows the lenses to be made physically more compact — shorter than the focal length of the lens.

Telephoto Lenses for Close-Up Work

As the focal length of a lens increases, so usually does the minimum focusing distance, and this may give some photographers the impression that telephoto lenses are meant for long

distance photography only. This is not so. The focusing distances are limited for mechanical design reasons. All tele lenses can be used at closer distances in combination with close-up accessories. Extension tubes are perfect for this purpose.

The close-up charts in Chapter 19 show the area coverage with different extension tubes for focal lengths up to 255 mm (150 mm lens plus 1,7 converter) for the H system and up to 250 mm in the V system.

INTERNAL FOCUSING

Focusing a lens to closer distances usually means moving the entire lens farther from the image plane thereby making the lens physically longer. This is still the case with many lenses. On many modern lenses, especially telephotos, focusing is accomplished optically by moving some of the lens elements within the lens design. This method, which does not change the physical length of the lens at all or only to a minor degree and does not result in a rotating lens barrel, is known as internal focusing. Internal focusing can result in smoother, easier focusing than the mechanical type, especially in long telephotos. Since internal focusing does not move the entire lens, the focusing range can be and has been extended all the way where it can produce life-size magnification on the HC 4/120 macro for the H system cameras while maintaining the automatic focusing capability over the entire focusing range. Figure 14-18 shows how the lens elements are moved in the 120 mm HC macro lens when focusing from infinity to the minimum focusing distance where the lens produces life-size magnification on the film format. This was partially made possible as the focusing mechanism does not need to turn or move the entire lens. Many Hasselblad H system lenses have internal focusing indicated as rear or front focusing, depending on whether the front or rear elements are used for this purpose. The image quality of the 120 mm HC Macro lens is shown in the MTF diagrams for different distances in Figure 14-19 (see also Figure 14-20).

H SYSTEM CF LENS ADAPTER

The CF lens adapter allows using all the Carl Zeiss lenses from the V camera system on all H camera models for digital imaging or for film photography (Figure 14-21). You can photograph with H system lenses that you may already have and also extend the range of lenses with those from the V system such as the 30 mm fish-eye or the very long 500 mm telephoto type which are not available in the H system. The use of the adapter is indicated on the LCD screen and shown as either "My lenses" or "All lenses." After you program the My lens setting with the lenses that you consider using on the H camera, the lens selection is faster when you actually use the lens. You must program the proper lens into the camera to assure that the light metering system gives the correct figures.

All exposure metering modes in the camera can be used and the metering is done with the lens aperture wide open as it usually is with C type lenses. The aperture and shutter speed settings are read on the LCD display and are manually transferred to the lens. With CFE lenses a preset aperture is electronically transferred to the camera. All V system lenses

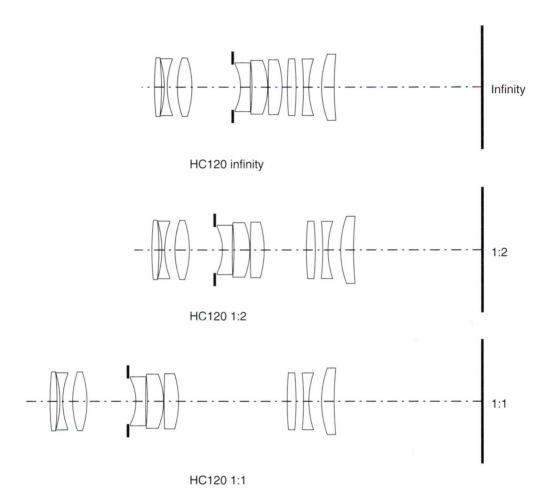

Infinity

HC120 infinity

1:2

HC120 1:2

1:1

HC120 1:1

Figure 14-18 Focusing the macro lens. On the HC Macro 4/120 mm the focusing is accomplished internally by moving some of the lens elements. At infinity (top) at a 1:2 magnification, covering an area twice as large as the image recorded in the camera (center) and at 1:1 life-size magnification (bottom).

must be focused manually but correct focus is confirmed by the focus confirmation signal in the viewfinder for lenses faster than $f/6.7$. After the exposure the shutter in the lens must be recocked with the cocking lever on the side of the adapter. This operation also brings the image back on the focusing screen.

The adapter is attached to the camera body first and the lens is then attached to the front of the adapter. Remove a lens from the adapter after cocking the shutter, then pressing the lens adapter catch and turning the lens counter-clockwise. Extension tubes and tele-converters can be used and must be removed as described in Chapter 19.

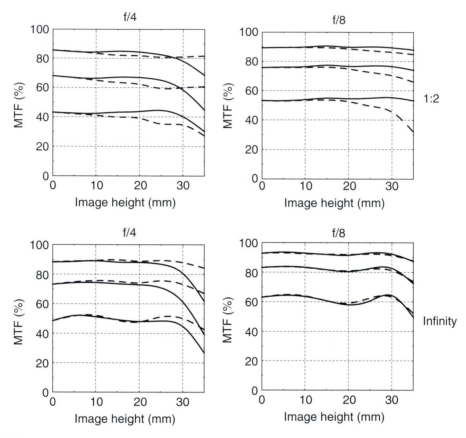

Figure 14-19 Macro lens quality. The quality of the HC Macro 4/120 mm lens is shown in MTF diagrams with the lens set at infinity (bottom) and at a distance where it produces a 1:2 magnification (top). Both are shown at *f/4* and *f/8*.

CHARACTERISTICS AND USE OF TELECONVERTERS

Teleconverters, also called tele extenders, are optical components that are mounted between the camera and lens to increase the focal length of the lens used in front of them. A 2× converter doubles the focal length of the lens so a 250 mm lens becomes a 500 mm type. A 1.4× converter increases the focal length 1.4 times, so the focal length of a 100 mm lens is increased to 140 mm. The 1.7× converter, for the H system (shown in Figure 14-22) changes the 150 mm focal length to 255 mm. The XE designation in the V system converters means that it has the electronic Databus connection for the metering system in 200 cameras. The XE converters shown in Figure 14-23 can be used on other V system camera models. Teleconverters provide you with a longer focal length without ending up with a much larger and heavier lens. You can have a 360 mm focal length with a lens/converter combination that is only about

Figure 14-20　HC Macro lens. Two images taken with the HC Macro 4/120 mm lens at *f*/8. The one with the stamp was photographed at the minimum distance setting where it produced life-size magnification. (Photos by Ernst Wildi.)

200 mm (8 in.) long. A converter can also be used with different lenses, thus giving you twice as many focal length lenses than you actually have; for example, six with three lenses.

The teleconverters are attached to the cameras like other lenses. When removing a teleconverter from a 503 or other V system camera, remove the lens first from the converter and

Figure 14-21 CF lens adapter. Two pictures taken with 150 mm Sonnar lens and CF lens adapter on a Hasselblad H camera. (Photos by Ernst Wildi.)

Converter 1.7X

Figure 14-22 H system converter design. The 1.7× teleconverter in the H camera system is a six-element lens design.

Figure 14-23 Teleconverter design. A quality teleconverter, like the Hasselblad 2 XE, may have as many or more lens elements than basic lenses.

then remove the converter from the camera. Never remove a lens from a converter that is not attached to the camera.

Hasselblad Teleconverters

The Hasselblad 1.7× teleconverter in the H system can be used with all H system lenses except the 28 and 35 mm wide angles and the 50–110 mm zoom lens.

The teleconverter can be used with the 300 mm $f/4.5$ lens but you must focus manually. The auto focus cannot be used as it functions only with an effective lens aperture of $f/6.8$ or larger. When the 1.7× teleconverter is used with the $f/4.5$ aperutre of the 300 mm lens, the effective aperture value is $f/7.65$ as explained later in the chapter entitled "Exposure with Teleconverters."

The Hasselblad 2 XE teleconverter for 503 and other V system cameras can be used with all fixed focal length V system lenses except the Makro-Planar 135 mm and zoom lenses. The Apo 1.4 XE converter was designed and optically optimized for the Tele-Superachromat CFE 350 mm but can also be used together with the Sonnar CFi 250 mm, the 350 mm Tele-Tessars, and the 500 mm Tele-Apotessar. For physical reasons, the Hasselblad teleconverter 1.4 XE can be used only with lenses from 100–500 mm focal length (except the 135 mm Makro-Planar). It also produces satisfactory quality with the Variogon 140–280 mm at all focal lengths and the Hasselblad 60–120 mm zoom lens at longer focal lengths.

Focusing Range and Area Coverage with Teleconverters

The focusing range of the prime lens is maintained when combined with a teleconverter. Combined with a 180 mm lens, we have a 250 mm (with 1.4×) or a 360 mm (with 2×) lens that focuses as close as 5 feet, much closer than a telephoto lens of the same focal length. A converter can therefore serve as a close-up accessory instead of an extension tube. The 120 mm Makro-Planar, which focuses down to somewhat less than 3 feet (0.8 m) and covers an 8-in.-wide area, covers an area as small as 4 in. (100 mm) when combined with the 2 XE converter.

Image Quality with Teleconverters

Because teleconverters magnify the image, they also emphasize quality faults in the basic lens. They can produce good quality images only if combined with a high quality lens, which is no problem with the lenses in the Hasselblad H or V camera systems. The image quality of a converter also varies depending on the lens and lens design with which it is combined, but all teleconverters made for Hasselblad and used with the recommended lenses produce a sharpness that comes close, or even matches, that of an equivalent longer focal length lens.

Exposure with Teleconverters

With any 2× converter, the light that reaches the image plan is reduced by two f stops. A 1.4× converter causes a loss of 1 f stop, a 1.7× converter, 1½ f stops. You must compensate

for this loss of light when taking a meter reading with a separate exposure meter. With a metering system in the camera or a meter prism finder, whatever the built-in meter shows is correct. The aperture on a meter prism finder is set for the maximum aperture of the lens as usual.

PROTECTING YOUR LENSES

Lenses are expensive components of all Hasselblad camera systems. It therefore makes good sense to keep them clean and in perfect operating condition. Protect them as much as possible, on and off the camera, with covers whenever they are not used.

This applies especially to the rear of the lens when the lens is off the camera, as it is often more difficult to clean. Protecting the rear of the lens is also recommended to maintain the proper functioning of the connecting mechanism.

If cleaning the lens surfaces seems to be desirable, always start by blowing off any possible dust and dirt to prevent scratches on the lens surface. Do any further cleaning only if deemed necessary. To do so, wipe the surfaces gently with a clean chamois or eyeglass or lens-cleaning tissue, breathing on the surface if necessary. Lens-cleaning fluid can be used, but never put the fluid directly on the lens. Instead, put it on the cleaning cloth or tissue. Do not over clean lenses. A little dust does not affect image quality, but fingerprints do. Never touch lens surfaces with your fingers. Never touch the electronic contacts on Fe, CFE, and the HC lenses with your fingers.

THE CREATIVE PART THAT HELPS YOU PRODUCE BETTER PHOTOGRAPHS

Since lenses are the main element in determining how the image is recorded on the digital sensor or on film you must carefully and thoroughly decide which focal length produces the desired composition and records the elements within the composition in the most effective fashion. Then you must decide which aperture setting produces the correct exposure and also records the elements from foreground to background in the desired fashion. In addition you also have chances to record images in a very special fashion or add special effects to an otherwise ordinary image. Lenses can be major tools for creating effective, beautiful, unusual, and interesting images.

LENSES FOR AREA COVERAGE

Wide angle lenses, with their larger angle of view, cover larger areas and record subjects smaller than the standard lenses. Telephoto lenses have a smaller angle of view, and they cover smaller areas and make subjects appear larger. Using various focal length lenses, or focal length settings on a zoom lens, for nothing more than covering a specific area is a good reason for selecting wide angle, standard, or tele lenses or using zoom lenses at different focal length settings. However, before you make the final decision and before you press the release, try to remember that you can often cover the same selected area with different focal length

lenses by photographing from longer or shorter distances, and that these images will be recorded on the sensor or on film in a different fashion.

CHANGING PERSPECTIVE

Perspective is defined as the size relationship between foreground and background and different focal length lenses can be used to do just that (see Figures 14-24, 14-25, and 14-26).

Visualize a scene with a birch tree in the foreground and a mountain range in the background in a location where you can photograph the scene from different distances. You have now different options: with a wide angle lens of perhaps a 50 mm focal length from a close distance of 10 feet (3 m) or with a telephoto lens perhaps of 250 mm focal length, from a longer distance of 50 feet (15 m). The size of the birch tree is identical in both images, but the background subjects are not. In the wide angle scene, the mountains appear small, even smaller than we see them with our eyes. In the telephoto shot, the distant mountains are five times larger and appear more majestic and much larger than seen with our eyes. The same picture taken with a standard 80 mm lens would show the scene more or less as seen with our eyes and that is why it is called a normal or standard lens.

There are situations when, for good reason, you want to see the image in the "standard" fashion. Many news and legal pictures must show a scene as seen by the naked eye and must therefore be made with a standard lens. Be aware that these standard images may likely look ordinary because it is the image that everybody sees with the naked eye. But by changing perspective with shorter or longer focal length lenses you frequently create more fascinating images. It pays to consider this possibility before you press the release, especially since it is the simplest approach to record any three-dimensional scene in a different fashion.

Since different focal length lenses are necessary for this approach, it is usually assumed that the focal length of the lens determines perspective. Strictly speaking that is incorrect. Perspective is really determined by the subject distance. The different focal length lenses are

A B C

Figure 14-24 Image perspective. With a telephoto lens used at a longer distance (A), the pieces of fruit appear close to each other, with the banana in the back practically as large as the apple in the front. With the standard lens (B), the relative positions are as seen by our eyes. With the wide angle lens used at a close distance (C), the banana is much smaller than the apple and appears to be much farther away.

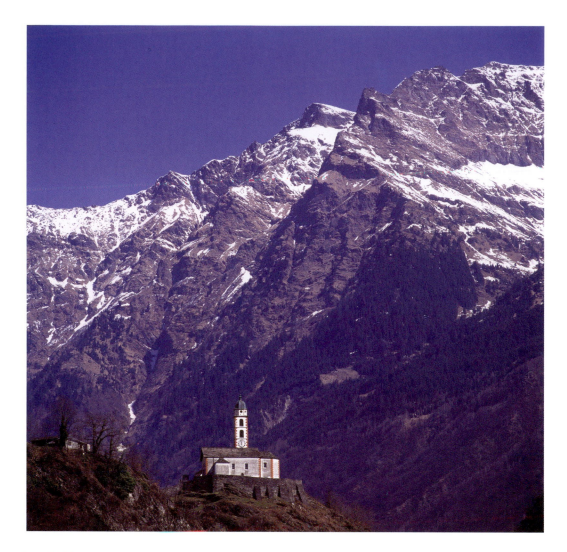

Figure 14-25 Telephoto perspective. A long telephoto lens with polarizing filter enlarged the mountains dramatically so they became a dominant part of the picture and produce a majestic size relationship to the sunlit church in the southern part of Switzerland. Since the mountains are a dominant part of the image, the lens was set to keep them within the depth of field range. (Photo by Ernst Wildi.)

necessary only to change the foreground and background area coverage. You need a wide angle lens to cover a large foreground subject from a close distance, and you need the telephoto to cover the same foreground subject in the same size from farther away. It is the different distances that determine the perspective.

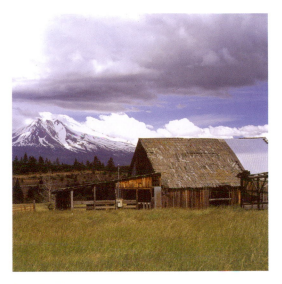

Figure 14-26 Perspective. A barn photographed with Mount Shasta in the background at a 110 mm focal length (top) and 250 mm (bottom). The barn in the foreground could have been recorded in the same size in both images by either photographing with the 110 mm lens from a closer distance or with the 250 mm lens from a longer distance. (Photo by Ernst Wildi.)

SELECTIVE BACKGROUNDS

Different focal length lenses can also be used to change the background area without changing the size of the foreground subject (see Figure 14-27). Long lenses permit us to cut down background areas and eliminate distracting background elements such as billboards, cars, people, direct light sources, or bright white sky areas. In the studio, a longer lens makes it possible to use smaller backdrops. In outdoor people pictures, longer lenses are usually preferable because they produce a blurred, undisturbing and undistracting background for a portrait. In candid people pictures a larger background area may be desirable to identify a location.

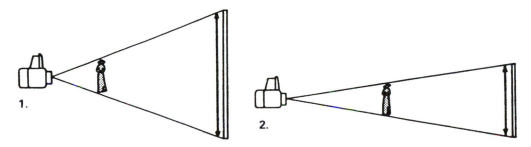

Figure 14-27 Background area coverage. A short focal length lens (1) covers a large background area, whereas a longer focal length lens used from a longer distance (2) covers a smaller background area. The size of the main subject is the same with both lenses.

Background Sharpness

The section on depth-of-field in Chapter 16 mentions that depth of field is determined by the subject distance not the lens. That is still correct regarding the depth-of-field range but not the degree of sharpness in subjects that are beyond the depth-of-field.

When backgrounds are beyond the depth-of-field and therefore not sharp, the focal length of the lens determines the degree of blur. As longer lenses magnify backgrounds, they also magnify the blur making backgrounds more diffused and less disturbing. With a short focal length lens, the same backgrounds may be just slightly out of focus at the same diaphragm opening.

You may want to select a specific focal length to record the background with the desired amount of blur and then photograph from the necessary distance. The sharpness of the background areas can be seen in the viewfinder but only after stopping the lens aperture to the selected aperture setting. You can use the manual stop down control on Hasselblad cameras or lenses to evaluate the degree of blur in the background and foreground by viewing through the finder while manually setting the aperture to different values.

Foreground Sharpness

Whatever has been said in the previously about background sharpness also applies to foreground subjects that are closer than the minimum distance on the depth–of-field scale. While subjects with sharp outlines — fences, rocks, and tree trunks — usually look better when they are within the depth-of-field range and therefore sharp, blurred foregrounds with grasses, leaves, and patches of flowers or other subjects with flowing lines can make effective foregrounds at least in color pictures where they can add a touch of color. You must be selective, however. Foreground subjects can often be used as part of the composition to frame the subject or scene. Blurred foregrounds are generally best when blurred completely so that the subjects are hardly recognizable. When the foreground is blurred just a little, the effect might look like a mistake. If the standard lens does not provide enough blur, go to a longer lens. Blurred foregrounds are seldom successful in black and white.

EFFECTIVE WIDE ANGLE PHOTOGRAPHY

Consider wide angle lenses not only for covering larger areas but for enhancing the three-dimensional aspect of a scene, especially outdoors. The three-dimensional aspect is enhanced simply by including effective foreground elements such as a rock or rock formation, a flower bed, a field, an area of water, a boat, a tree stump, or a fence, in the composition enhancing the three-dimensional feeling to the image. This approach is especially effective with wide angle lenses because they emphasize the size relationship between foreground and background, which makes the background subjects appear to be farther away than they actually are (Figure 14-28). The large depth-of-field range also often allows you to maintain sharpness from foreground to background, if desired.

Figure 14-28 Wide angle photography. Two examples where short focal length lenses were used not just to cover a larger area but to add depth and a three-dimensional feeling to outdoor scenes. Both images composed with the boat about 1/3 from the top and 1/3 from the left border of the image. (Photos by Ernst Wildi.)

CORRECTING VERTICALS

The vertical lines of a building or other object appear in the finished picture vertical and parallel to each other only if the camera is level, with the image plane parallel to the building. When the camera is tilted upward or downward, the verticals slant toward each other, and the building seems to be falling over (see Figure 14-29).

Figure 14-29 Slanted verticals. Tilting the camera to cover a building from bottom to top results in slanted verticals (1). To record straight verticals (2), the image plane must be parallel to the building.

While this effect can be corrected in the computer or by using special equipment like the FlexBody, ArcBody or PC Mutar, it is worthwhile realizing that there is often a much simpler approach for recording a perfect image in the camera. Consider photographing the subject with a longer focal length from a longer distance if that is possible. The longer distance may eliminate or at least reduce the need for tilting the camera (see Figures 14-30 and 14-31) thus recording the subject in a completely professional manner.

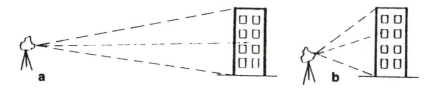

Figure 14-30 Photographing buildings from different distances. Photographing a building from a longer distance with a longer lens (a) may produce straight verticals since it reduces or eliminates the need for tilting the camera, which is necessary from a shorter distance with a shorter lens (b).

EFFECTIVE FISH-EYE IMAGES.

Everything you photograph with a 30 mm Distagon fish-eye lens on a 503 or other V system camera looks different from the way we see the world. This occurs because of its 180-degree diagonal angle of view, which is completely out of proportion to the 112-degree horizontal or vertical angle of view that would be normal for a 30 mm lens on the 2¼ square film format (see Figure 14-1). Be aware that the angle of view mentioned above applies only when recording the image on the 2¼ square film format. On the somewhat smaller 36.7 × 49 mm sensor, the fish-eye effect can still be striking but is greatly reduced on smaller sensor sizes.

The curved lines on the outside areas of the image create this visual difference and are the first good reason for considering this lens for some of your images. The effect can be very striking, but can also become objectionable and a distraction in many compositions. You must be careful how you compose the scene; evaluate the entire image area carefully in the viewfinder.

The curvature in the horizontal and vertical lines becomes more exaggerated further away from the center of the image. A horizon line composed close to the center of the image will have just a slight curvature and may look more like a mistake. The same line composed close to the top or bottom of the image will be recorded with a strong curvature and is more likely to look like an artistic component of the image. A tree with a curved tree trunk on one side of the image may look strange, perhaps because the viewer may not know whether the tree looked that way or was just recorded in this curved fashion. Composed with a second and similar tree in the same location but on the other side, the image may look like a beautifully framed composition.

Fish-Eye Images Without the Fish-Eye Look

While fish-eye images are best recognized by the curved lines, images produced with the full-frame Distagon lens need not have the typical fish-eye look. Straight horizontal, vertical, and diagonal lines that intersect the center of the field are recorded as straight lines. You can avoid, or at least reduce, the fish-eye look by composing the image so that important vertical, horizontal, and diagonal lines cross the center of the field. A horizon composed in the center is perfectly straight. A big redwood tree photographed with a tilted camera so its tree trunk runs diagonally from a corner to the center is perfectly straight (Figure 14-32). Circular

Figure 14-31 Correcting verticals. A building in the Bodie ghost town in California, produced with perfectly straight and parallel verticals in the camera by photographing them with a 250 mm telephoto from a long distance. (Photo by Ernst Wildi.)

Figure 14-32 Effective fish-eye photography. (Left) The tree trunk appears perfectly straight in this fish-eye picture because it is composed to go from the corner to the center of the image. (Right) Only the 180-degree diagonal angle of the 30 mm Distagon covered the entire range of the two arches. (Photos by Ernst Wildi.)

subjects, such as the face of a clock, remain perfectly circular if centered in the composition. The fish-eye lens just covers a much larger background area diagonally than a wide angle lens would. Such a lens can even lend a unique touch to wedding pictures (see Figure 14-33).

USING THE ZOOM LENS FOR CREATIVE PURPOSES

Zoom lenses offer unique possibilities for creating fascinating images by zooming while the image is recorded in the camera using a shutter speed long enough to give you time to operate the zoom control. One second is usually a good choice. Zooming changes the size of the subject recorded in the camera and converts highlights into streaks radiating either from the center to the outside when you zoom to longer focal lengths or from the outside to the center when you zoom from the long to the shorter focal lengths (Figure 14-34).

If you zoom for the entire exposure time, the image consists of streaks only. Most zoom images are more effective when the subject can be recognized and is surrounded by streaks. For such results, keep the focal length at a fixed setting for about half the exposure time (½ second when the total time is 1 second), and zoom only during the second half. To produce effective zoom shots with bright streaks, you must photograph subjects with bright areas. The streaks produced by the highlights are also more visible if they cross darker image areas. You can make the streaks longer by zooming over the entire focal length range or shorter by using only part of the zoom range.

Figure 14-33 Composing the wedding photograph. A wedding photograph with style, beauty, and technical perfection. Beautifully composed with the bride in the perfect center with the circular ceiling remaining circular and the pillars on the two sides equally spaced from the center to give this image a perfect symmetry. (Photo by Andy Marcus.)

Figure 14-34 Zoom lens photography. A 1 second exposure while zooming from the shorter focal lengths to the telephoto settings while the shutter was open. (Photo by Ernst Wildi.)

Achieving Perfect Exposures in Digital and Film Photography

DETERMINING EXPOSURE IN DIGITAL IMAGING

The lens settings that provide correct exposure in digital imaging are determined in the same way as in film photography by using the same metering methods, modes, and approaches suggested in this chapter. You must especially beware of overexposing digital images as this is difficult to improve in the computer. When you work with lighted and shaded subject areas, where the exposure must be based on one or the other, you are usually more successful exposing for the lighted areas like you would for transparencies.

Digital imaging with Hasselblad cameras, however, offers valuable advantages over film photography. You have the opportunity to evaluate the exposure in various ways immediately after a picture is made and then you have the opportunity to make exposure adjustments before you take the final picture. While the same possibility of checking exposure is offered on any Hasselblad camera with instant film, the process is time-consuming and involves changing the magazine and waiting for the instant film to be processed. With Hasselblad digital cameras or digital sensor units, you have various, simple ways to check exposure.

First you have the image that you can see on the preview screen immediately after the exposure is made. This image, however, should only be used as a rough guide, never for evaluating the accuracy of the exposure. The image is too small for this purpose and it is often difficult to see a good image in the surrounding light situations. The histogram that also appears immediately after the exposure is more helpful and accurately shows how the different tones and brightness values are recorded in the camera and how the values change when exposure adjustments are made. Being able to see a histogram immediately after every exposure is a major advantage of digital imaging over film photography. The camera operations necessary to see the histograms on the display screen and the evaluation of the histogram are described in detail in Chapter 5 and also later in this chapter.

Hasselblad, H3D, H3DII cameras, and CF and CFV digital sensor units also offer the Instant Approval Architecture (IAA). This analyzes the shot to see whether it is over- or underexposed and gives a green signal when the exposure looks satisfactory, a yellow signal when images need a closer examination, and red for images that are unsatisfactory. These values are stored

with the image. They can also be changed if desired. It is also possible to program cameras or backs to give different audio signals for the three different exposure values. IAA is described in more detail in Chapter 5.

Furthermore, it is possible to see which areas or pixels are overexposed in a picture. When programmed into the digital sensor unit, the overexposed pixels flash so you can clearly see whether these areas are important and might be objectionable in the final picture and if so, you can change exposure or re-compose the image. Further details are also available in Chapter 5.

DECIDING ON THE METERING METHOD

The lens settings that provide correct exposure in digital or film photography are determined with an exposure meter, which can be either a separate handheld meter or a metering system built into the camera or prism viewfinder. Modern handheld exposure meters are very sophisticated with many different possibilities for evaluating the scene and its dynamic range in addition to the possibility of metering the scene either in the incident or reflective metering mode. You may want to consider such a meter if the additional information is helpful in your work. However, if your main or only concern is obtaining perfect exposures in your digital or film images, a well-designed metering system in a camera can give you just as accurate results in an easier, more convenient, and definitely much faster fashion.

Using camera meters is still considered an amateur approach in some quarters, but the metering systems in Hasselblad H cameras — the 203 and 205 models or in a meter prism equipped 503 or other V system camera model — offer excellent professional metering approaches. The advantages of Hasselblad's built-in metering systems are so numerous that I consider this feature another good reason for selecting Hasselblad for digital imaging or film photography especially for work outside the electronic flash studio.

The Advantages of a Built-In Metering System

A built-in metering system offers a number of advantages.

1. You can make the meter readings from the camera position while evaluating the scene or subject in the viewfinder.
2. The focusing screen shows the exact area that is measured by the meter. With the measured area visible on the screen, you know what area is measured and you can easily select the area or areas that you want to measure.
3. The meter reading is fast because the metering system reduces the number of lens settings, if any, that need to be made manually.
4. Determining and making the lens settings is fast and you can take the meter reading while you compose.
5. The possibility of making mistakes is reduced as few, if any, values have to be transferred manually. Even with PME finders on 503 or other V system cameras, you only need to read the EV value and set it on the lens.
6. As the light is measured through the lens you can always measure an area that is actually covered by that particular lens, which is especially helpful with long telephotos.

7. When you change lenses, the measuring area adjusts automatically to the area coverage of the new lens.
8. All the information you need to know about exposure and lens settings is visible in the viewfinder while you are evaluating the image.
9. Warning signals may appear if a problem exists.
10. The light is measured through accessories placed in front of the lens such as filters, or accessories that are between the lens and camera, such as extension tubes, bellows, and teleconverters so you do not have to consider filter or exposure factors.
11. In H cameras and 200 models lenses and film magazines are or can be electronically coupled to the camera body, which offers the ultimate solution for speed, convenience, and accuracy.
12. A metering system in the camera or viewfinder eliminates the need to carry and worry about a separate meter.

METERING MODES

Any exposure meter, handheld or built-in, can provide correct exposures only if you understand how the meter measures the light and how it must measure the subject or scene. All the exposure approaches discussed here apply in digital and film photography.

There are two methods of metering. You can measure the light that falls on the subject, known as incident light metering, or you can measure the light that is reflected off the subject or scene, known as reflected light metering.

The Incident Light-Metering Approach

As the name indicates, in an incident meter reading you measure the light that falls on the subject through a diffusion disc on the meter that measures the light falling on the subject from all directions. You take incident meter readings by holding the meter in front of the subject to be photographed (or in another location with the same amount of light) with the metering cell facing the camera lens so that all the light that falls on the subject also falls on the metering cell. Since incident meter readings usually have to be made where the subject is, the photographer must move away from the camera position. This is a time-consuming process and impractical in handheld photography.

Incident meter readings are unaffected by the color and brightness of the subject. They give the same reading whether held in front of a white, gray, or black subject, and the reading is correct regardless of the color or brightness of the subject (see Figures 15-1 and 15-2).

Incident meter readings can be made with handheld meters but not with metering systems in cameras. There is one exception: the PME 90 and PME 45 viewfinders, which have a domelike disc on top for incident meter readings. While incident metering with these viewfinders works, it is impractical. You must either remove the finder from the camera to take a reading at the subject location or take the entire camera there for the reading. The reading on the prism finder can be locked.

Many professional photographers are confirmed users of handheld incident meters and often feel that it is the only professional metering mode, especially when compared to built-in meters. There is nothing wrong with this approach and feeling, especially as it is not the

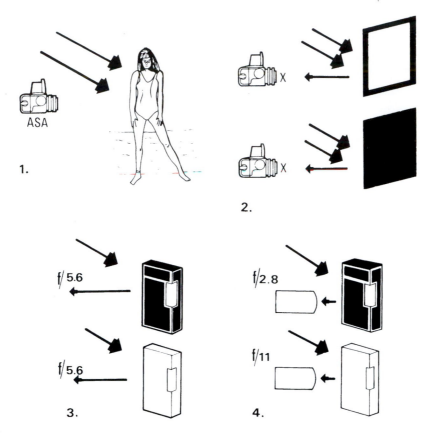

Figure 15-1 Basics of incident and reflected metering. (1) Correct lens settings are determined by the sensitivity of the film and the amount of light that falls on the subject. (2) If an incident exposure meter reading indicates that the subject requires a lens setting of X, this same setting is correct whether the subject is light or dark. (3) The same aperture and shutter speed is used whether you photograph a black or a white lighter under the same lighting. (4) Reflected light meters give higher readings (smaller apertures) for light subjects than for dark ones, even though the same amount of light falls on both.

meter that determines the accuracy of the exposure but the way a meter is used. I feel very strongly that built-in meters can provide equally accurate results, but only if you understand how they measure the light or subject and then use them properly. You might then appreciate the speed and simplicity of using such meters, especially when you work with a handheld camera.

Reflected Meter Readings

Reflected meter readings, whether made with a handheld or built-in meter, are more practical and much faster especially in location and handheld photography because the meter reading

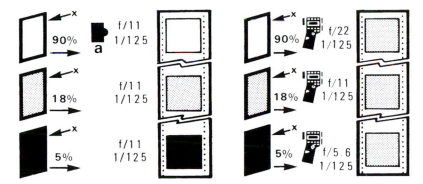

Figure 15-2 Incident and reflected meter readings. An incident exposure meter gives the same aperture and shutter speeds for white, gray, and black subjects, and these settings record white as white, gray as gray, and black as black (left). Reflected meter readings differ for white, gray, or black, even though the same amount of light falls on all three. If you set the lens for the white reading (f/22, $\frac{1}{125}$ second), white is recorded as gray, not white. A lens set for the black reading (f/5.6, $\frac{1}{125}$ second) also records black as gray, not black, and so does a reading of gray at f/11 and $\frac{1}{125}$ second (right).

can be made from the camera position. You must have a clear understanding of how these meters measure the light.

In a reflected meter reading, you measure the light reflected off the subject. The meter reading, with the meter pointed at the subject, is now determined not only by the amount of light falling on the subject but also by the amount of light reflected from the subject. With any reflected meter, built-in or handheld, a bright subject gives a higher reading than a dark subject even if the same amount of light falls on both. The difference can amount to as much as four or five EV values or f stops (see Figures 15-1, 15-2, 15-3, and 15-4). The photographer now

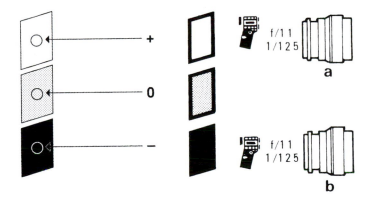

Figure 15-3 Reflected meter readings. A reflected light meter reading is correct only when taken off a subject area of average brightness reflecting about 18% of the light. Exposure must be increased for brighter subjects and decreased for darker ones (left). An incident meter reading gives the same exposure (f/11 and $\frac{1}{125}$), whether held in front of a white, gray, or black subject (right).

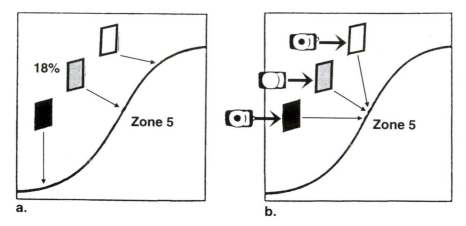

Figure 15-4 The Zone System exposure principle. Lens settings, based on a reflected meter reading of 18% gray, record this middle gray tone as zone 5. A reflected meter pointed at white records white also as a zone 5 middle gray and does the same for black (b). For correct exposure, only middle gray should be recorded as zone 5. To place white and black at the ends of the curve (for example, as zones 1 and 9), you must make adjustments in the reflected meter readings (a).

must decide which color or brightness value is correct and point the meter at this particular area or make an adjustment in the lens setting when measuring a brighter or darker area.

Light Reflectance and Gray Tones

The measuring cell in all reflected meters, handheld or built-in, is adjusted at the factory for an 18% reflectance value. The meter reading is perfect only if the meter is pointed at a subject area that reflects 18% of the light, such as a graycard or a green field. A brighter subject area reflects more light and if this reading is used on the camera, the image will be underexposed. We need to increase exposure by setting the EV to a lower value (to EV 9 or 10 instead of 11), or open the lens aperture (to $f/5.6$ or $f/8$ instead of $f/11$). When measuring darker subjects, do the opposite. Make the same adjustments in the Zone mode of the 205 camera, setting it to zone 3 or 4 for darker subjects and to zone 6 or 7 for brighter ones.

The color chart (Figure 15-5) shows the colors that have 18% reflectance values or zone 5 values, in the center column marked as 0 on top and zone 5 at the bottom. The colors that require a one stop increase in exposure are in column $+1$. The colors where you need to increase exposure by two f stops are in column $+2$. The colors that need a -1 reduction are in column 1 (see Figures 15-6 and 15-7).

METERING APPROACHES WITH BUILT-IN AND REFLECTED EXPOSURE METERS

Setting the exposure meter or camera for the proper ISO value is naturally the first step in using any exposure metering system for film or digital work. Whether you make a meter reading with a reflected or built-in meter, start by evaluating the subject or scene and see whether

Figure 15-5 The chart shows reflectance values of different shades of color. The color shades in column 0 reflect 18% of the light and therefore need no adjustments of a reflected or built-in meter reading. The color shades in column +1 need a 1 stop increase, those in column +2, a 2 stop increase in a reflected reflected meter reading. Decrease exposure 1 stop for the darker color shades in column −1. The figures 4 to 7 at the bottom indicated in which zone the different color shades should be placed in a reflected meter reading.

Figure 15-6 Reflected meter readings. Four illustrations showing 18% reflectance areas for a spot meter reading with a built-in exposure metering system for film or digital photography. Areas with the same reflectance should be selected for a center area or center spot area reading whenever available.

there are any areas that have an 18% reflectance value. While doing so, also evaluate whether the selected 18% area receives the same amount of light as most other areas that need to be properly exposed within the composed picture (Figures 15-7).

For example, if most of the scene is in sunlight, select an 18% area in sunlight, not the shade or vice versa. Select a shaded 18% subject area if most of the other areas are also in

Figure 15-7 18% reflectance scene. Since practically all colors and shades within the scene are of average brightness, a reading with any built-in CentreWeighted or CentreSpot metering system should provide perfect exposures. (Photo by Ernst Wildi.)

the shade. You have to compromise in some cases. For example, if an 18% green grass area in sunlight is a relatively small part of a composition where most other areas, and perhaps more important areas, are somewhat shaded, you may want to increase exposure to have more details in the darker areas even though the green grass area may by somewhat overexposed.

This may sound rather complicated, but let me point out that this subject and light evaluation is not a characteristic of a reflective or built-in metering mode. The same evaluation must be made with an incident meter. With an incident meter you must also evaluate what amount of light that falls on different areas within the composition and then decide whether shaded or lighted areas are more important and then make the meter reading accordingly.

In this subject evaluation, camera metering systems have a definite advantage because the metered area is accurately outlined on the focusing screen and you can see the measured

Figure15-8 Use of a graycard. Instead of measuring the light reflected off the subject, you can measure the light reflected off the graycard. The reading is then the same whether the card is held in front of the white or the black lighter (left). A graycard reading should provide the correct exposure in a portrait regardless of the color of the skin (right).

area from your camera position while you compose the photograph. You can also easily move the camera to measure any other area within the composition without moving away from the camera position.

Practical Camera Metering Approaches

There are three approaches for determining the proper lens settings with a reflected light meter.

1. Evaluate the area covered by the lens and look for subject areas that have an 18% reflectance value. Subjects with green, brown, blue, or red colors are very close to this value. Also check that the selected areas receive the same light as most other important areas within the scene. Take the meter reading by pointing the handheld meter or the metering area in the camera view-finder at that part of the subject. Take the reading and lock it on a camera meter, re-compose, and take the picture. I find this is usually the best approach in outdoor work, especially with built-in meters. It is an especially good approach with a spot meter. The Differential and Zone modes in 203 and 205 cameras are wonderful for this approach since they lock a setting automati-cally. The H cameras offer different but simple ways of locking an exposure setting. The simplest, which I usually use, is programming the AE lock for this purpose. I simply need to press the AE lock button while pointing the camera at the desired area and before I move the camera away to re-compose. The AE lock button locks the setting. I can change a locked aperture and shutter speed setting without changing the EV value with the front wheel. Since I usually use the spot meter, I have also used the custom option Spot Mode for locking the spot meter reading on the H camera. These options are described in detail in Chapter 4.
2. Point a handheld meter or the metering area of a built-in meter at a part of the subject that is practical for metering. Evaluate the subject's color and brightness within the metered area. If the area is not 18%, make the adjustment based on the color chart. This is a necessary approach when there are no subject areas with an 18% reflectance, as might be the case in a winter scene where everything is covered with snow.
3. Instead of measuring an actual subject area, take the meter reading of a graycard that has 18% reflectance. Hold the graycard in front of the subject more or less parallel to the image plane so that the same light falls on the card that falls on the subject. Also make certain that the meter

measures only the graycard area. The reading off the graycard is correct, regardless of the color or brightness of the subject (see Figure 15-8). This may not be too practical on location, but it can be an excellent approach for indoor work, close-up photography, and copying.

Whenever you take a reflected meter reading, make certain that the reading is not affected by large dark or bright areas such as a white sky or large white clouds.

LIGHTED AND SHADED AREAS

Many subjects have areas that are brightly lit and other areas that are in the shade. Regardless of what metering approach and what type of meter is used, always decide whether to expose for the lighted areas or the shaded areas or somewhere in between. There is no metering system in the world that will do this automatically. Setting the lens between the two readings works in some cases but usually does not provide the best exposure.

Exposing Negatives versus Transparencies

Negative and transparency films need different exposures with subjects or scenes that have important details in shaded and lighted areas. To produce high quality prints, black and white and color negatives must be exposed for good shadow density. You want to base the lens settings on the meter reading of the important shadow areas or close to it. You may also want to check whether the shadow and the highlight areas are within the acceptable contrast range.

Transparencies, almost invariably, must be exposed for the lighted areas; otherwise, the lighted areas look overexposed, become washed out, and lose color saturation Take the meter reading of a lighted part of the scene or subject preferably with 18% reflectance, or if not, make the adjustment as described before. Since you cannot be too concerned about shadow detail, you may want to avoid large shaded areas in the composition.

EXPOSING DIGITAL IMAGES

Exposing for an 18% reflectance value also applies in digital imaging, perhaps even more so as exposures are more critical. You must especially beware of overexposing digital images as they are difficult to improve with computer manipulations. When working with lighted and shaded subject areas, where the exposure must be based on one or the other, you are usually more successful exposing for the lighted areas as would be done for transparencies.

Digital imaging also offers the possibility of covering contrast ranges that are impossible to record with highlight and shadow details in film photography. This is accomplished by photographing a subject or scene with two identical images with one exposed for highlight detail and the other for details in the shaded areas and combining them afterwards in the computer.

Evaluating the Tonal Range and Exposure in Electronic Imaging

Digital imaging with Hasselblad H cameras offers a valuable advantage over film photography by giving you the opportunity to evaluate exposure on a histogram, which allows you to

make adjustments before you take the picture. This is somewhat similar to but much simpler and faster than making test exposures on instant film.

The histogram appears on the preview screen immediately after the picture is taken (unless the camera or digital back is programmed for Full Screen Mode). To make the histogram appear on the LCD panel on the H camera grip, you program custom option 17, SHOW HISTOGRAM, into the camera, as described in Chapter 4 and programmed to YES (the default setting), and the histogram appears on the LCD panel shortly after the exposure. It works with various digital backs, but the histogram may look slightly different depending on the back attached to the camera.

The Histogram

A histogram shows the distribution of the tonal values within an image. The values vary from the black shadow areas (shown at the far left) to the pure white highlight areas (shown at the far right), with the middle tones in between. The horizontal spread covers the full potential dynamic range of the camera system. Photographers familiar with the Zone System can think of a histogram as showing the tone values from zone 0 (black) on the left to zone 10 (white) on the right.

The vertical height of the curve indicates the number of pixels for each tonal value. A high curve indicates a large number of pixels for that particular tonal value. The histogram for a high-key image with few or any dark areas has curves mainly or completely toward the right, whereas most of the curves for a low-key image with few or any bright areas are mostly to the left. An image with an average tonal range from white to black has curves all the way from left to right.

Determining Exposure from a Histogram

The interpretation of the histogram is somewhat different for different digital backs because different backs may report ISO values to the camera in different ways. In principle, however, regardless of the contrast range of the image, all the vertical curves must be within the left and right margin of the histogram; that is, within the maximum potential dynamic range. They should never go beyond the left or right margin. If the curves go beyond the right margin, areas in the image will be totally white without any information, and the lens settings must be changed to make them fall within the left and right margin. If the curves go beyond the left margin, the black zone, parts of the image will be totally black, and you must change aperture or shutter speed (or both) accordingly.

The histogram does not show the exact amount of under- or overexposure, but the results of any corrections made in the aperture or shutter speed setting are clearly shown on the new histogram. Overexposure in digital recording must be avoided because details in the overexposed areas are completely lost. This should be remembered especially by photographers accustomed to working with negative film and leaning toward overexposure to obtain sufficient detail in the shaded areas.

The Hasselblad digital systems also let you see which areas in a picture might have overexposure. You can program the system so that overexposed pixels flash on the preview screen. Details are discussed in Chapter 5.

White Balance

White balance is closely associated with exposure and in some cases it is even more important than exposure in digital imaging. It assures that digital images are not only properly exposed but also have the correct tonal rendition. See Chapter 5 for details.

USING DIFFERENT METERING SYSTEMS

Metering Systems Built into Cameras

Metering systems built into cameras are of different designs, offering different metering modes, different ways of showing and transferring the metering information, and different degrees of automation. But they all measure the light reflected off the subject and must be used as described previously.

Average Metering

Average metering means measuring the entire, or almost the entire, image area seen in the viewfinder equally from side to side and top to bottom. The original H cameras offered the averaging metering option with the meter reading based on a 45×37 mm center area, or about 70% of the total image area. Average metering can be a good choice for fast shooting and compositions without large dark or bright areas such as a white sky. But it is not a first choice for more critical work.

CentreWeighted Metering

The built-in meter measures a large part of the area seen in the viewfinder but not equally. The meter reading is based mainly on the subject brightness in the center portion of the composition where the main subject is usually placed. The original Hasselblad H cameras have a CentreWeighted mode that measures a 23×20 mm center area, about 25% of the total area. Some Hasselblad meter prism finders used to have this system, but it has been replaced by the more precise center area or Spot metering type in newer cameras and prism finders.

Center Area Metering

In center area metering, the meter measures only the center area and allows a more accurate metering approach. With this approach you know exactly what area of the subject is measured. Center metering is in the XPan cameras, an option in H cameras; in the 202 and 203 camera models, with approximately 75% of the light measured in the indicated center area; and on the PME meter prism finders, where most of the light is measured within a 40 mm center area. The latest H camera models offer two center metering modes both measuring a center area of about 20×23 mm which is about 25% of the total image area. The centre

Weighted mode measures this center area equally from side to side while the CentreSpot mode measures mainly the center area.

Since a center area metering system measures the most important area of the composition without being influenced by dark or bright outside areas, the readings are mostly accurate enough to allow the use of the 200, the H model, and XPan cameras in the automatic mode with excellent results.

Spot Meters

A Spot meter measures a small center area outlined on the focusing screen virtually unaffected by any light from outside areas, no matter how bright it might be (Figures 15-9 and

Figure 15-9 Advantage of TTL metering. Since this winter scene in Southern Germany was made with a long telephoto lens, the built-in metering system measuring the light through the telephoto lens allowed a reading of the center area without the bright snow and foggy background affecting the meter reading. (Photo by Ernst Wildi.)

15-10). A Spot meter offers a very precise method for metering small, specific areas or various areas within the composition to determine the brightness difference such as between shaded and lighted areas, between the main subject and the background, and between the main and fill light.

Figure 15-10 Spot meter reading. The sunlit tree against the dark sky might appear to present an exposure problem. The green grass area below the tree, however, was perfect for a Spot meter reading and gave perfect exposure. The Spot meter reading could also have been made of a sky area that looked like a graycard. (Photo by Ernst Wildi.)

The Spot meter in the H cameras measures about 2.5% of the total area within the 7.5 mm spot circle in the center, the Spot meter in 205 cameras measures about 1%, and PME finders on 503 and other V system cameras set for Spot metering measure a 12 mm center area. The measuring angle of a built-in spot meter depends on the focal length of the lens on the camera and is unimportant since the focusing screen always shows the exact measured area regardless of what lens is on the camera.

BRACKETING

Using the Hasselblad metering systems as described should give you very satisfactory exposures. Bracketing, taking images of the same subject or scene at two or more different exposure settings, should not be necessary in most cases or only after evaluating the histogram in digital work. It is still recommended whenever you have any doubts about the result, when you cannot find subject areas of a known reflectance value for metering, and especially when you photograph subjects that have a high contrast range. Sometimes you may also want to bracket to produce the most effective image, not necessarily the best exposure. The two are not always the same. You may sometimes prefer a darker image because it is more dramatic and has more color saturation. An early morning picture or a picture taken in the fog may be more beautiful when colors are more on the pastel side, creating a high-key effect.

For critical work, especially in digital imaging, you probably want to bracket in $\frac{1}{3}$ or $\frac{1}{2}$ f stop increments. For other work, bracketing in full f stops makes more sense. Manual bracketing is the best approach in most cases.

On the H and XPan cameras, and on most 200 models equipped with a motor winder, you can bracket automatically. This is a wonderful feature when you must work fast. A sequence of three bracketed shots can be made in almost the same time as a single picture and without moving the camera from the eye. The camera operation for automatic bracketing is described in Chapter 4 for the H cameras, in Chapter 12 for the 200 models and in Chapter 20 for the XPan camera.

EXPOSURE WITH FILTERS AND CLOSE-UP ACCESSORIES

When filters, extension tubes, teleconverters, or other accessories are placed in front of the lens or between the lens and the image plane, the light reaching the image plane is reduced. You must compensate if the meter reading is made with a handheld meter. The necessary compensation for Hasselblad accessories is in the corresponding sections in this book. You do not have to make any adjustments when using a built-in meter since the meter reading is not only made through the lens but also through the accessory. With teleconverters or extension tubes without Databus connections on 200 cameras, you must manually close down the aperture for the meter reading.

On meter prism finders, set MAX at the maximum aperture engraved on the lens, as you normally do. A meter reading with a meter prism finder attached to the focusing screen adapter on the FlexBody or ArcBody should be taken before shifting or tilting, and exposure tests are recommended.

THE HASSELBLAD METERING SYSTEMS

The metering system in the original H cameras can be set for average, CentreWeighted, or Spot metering with many different light-measuring approaches and programmable functions to match the metering approach to your photography. The latest H models offer CentreWeighted, CentreSpot and Spot. (see Chapter 4 for details). The operation of the 203 center metering system and the 205 Spot metering systems are discussed in Chapter 12.

The PME viewfinders on the 503 and other V system camera models make excellent built-in metering systems. The same finders can also be used on any 500, 200, or 2000 camera model as well as the focusing screen adapter on the Superwide cameras, the FlexBody, and the ArcBody by providing TTL metering in all cases. The readings in the finder must be transferred manually to the lenses. The finders can be set for incident metering and for reflected metering in Center metering mode or as a Spot meter (see Figures 15-11 and 15-12).

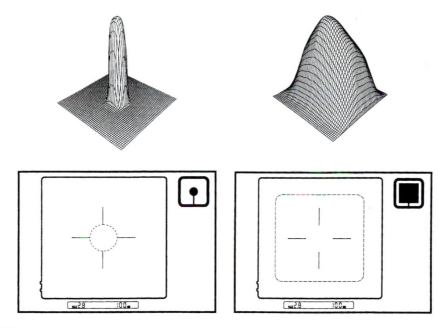

Figure 15-11 Metering patterns in PME meter prism finders. In addition to incident metering, the PME 90 and PME 45 meter prism finders offer the option of a spot meter measuring a 12 mm center area within the four black lines (left) or center area metering where most of the light is measured within a 40 mm center area (right).

The PME 90 and PME 45 Meter Prism Viewfinders

The metering areas, the metering options, and the operation of the metering system are identical in both finders. The two finders (see Figures 15-13 and 15-14) differ in the following ways. The metering system in the PME 90 is operated from a lithium CR-123A, and the PME 45 from

Figure 15-12 Selecting the metering mode. On the PME 90 and PME 45 meter prism finders, you set the desired metering mode by pressing the metering mode button marked Pr (1) and then pressing the UP or DOWN adjustment button until the desired mode symbol, spot meter (2), center area metering (3), incident metering (4), appears on the viewfinder display. The ISO button sets the film sensitivity. The Fmax button is for setting the maximum aperture of the lens on the camera.

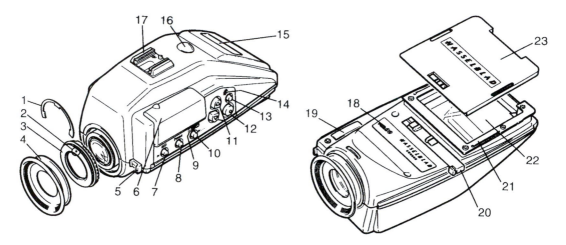

Figure 15-13 The PME 90 operating controls: (1) locking clip, (2) indication mark, (3) eyepiece diopter adjustment, (4) removable rubber eyecup, (5) eyepiece diopter lock, (6) battery compartment cover, (7) ISO setting button, (8) MAX aperture setting button, (9) metering mode symbols, (10) metering mode selector, (11) upper and lower adjustment buttons, (12) metering button, (13) display illumination button, (14) display illumination symbol, (15) display illumination window, (16) incident metering dome, (17) accessory shoe, (18) viewfinder type emblem, (19) cover for service use, (20) magazine catch operating slide, (21) viewfinder retaining plate, (22) prism, and (23) protective cover.

a lithium CR-2 (see Figure 15-15). They have somewhat different magnifications and diopter correction options as shown in Table 7-1. The PME 90 has an illumination window for the viewfinder display, and the PME 45 does not. When the PME 45 is turned on, the display is illuminated via LEDs powered by the battery. The PME 45 can be used with the instant film magazine

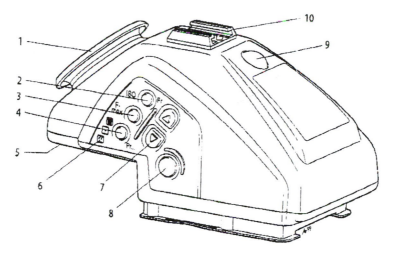

Figure 15-14 Operating controls on the PME 45: (1) rubber eyecup, (2) ISO selector knob, (3) MAX aperture selector, (4) metering mode selector, (5) eyepiece diopter adjustment lock, (6) metering mode symbols, (7) up and down adjustment buttons, (8) metering button, (9) incident light dome, and (10) accessory shoe.

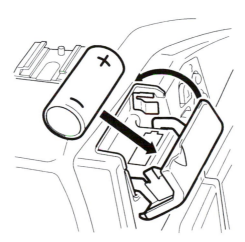

Figure 15-15 Inserting the battery in PME 90 and PME 45. Insert the 3 V lithium battery as shown, after opening the battery compartment cover. A battery symbol appears on the viewfinder display indicating when the battery needs to be replaced.

attached to the camera, and the PME 90 cannot. All newer PME meters are properly adjusted for the Acute Matte screens but the spot meter reading is affected by the bright center area of the microprism and/or split-image rangefinder area. Use the center area metering with such screens or change the screen to a type without the microprism/rangefinder area.

Basic Meter Prism Operation

Set the correct ISO rating on all meter prism finders by pressing the ISO button and then using the adjustment controls to set the proper ISO value. Set the meter prism finder for the maximum aperture of the lens on the camera by pressing the Fmax button and then using the adjustment controls (Figure 15-16). Change this setting when you change to a lens with a different maximum aperture. As a precaution, I suggest that you make certain that the lens is not manually closed down when the meter reading is taken.

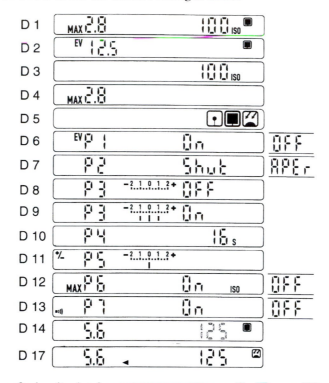

Figure 15-16 PME viewfinder display for various operating modes. The set ISO value and the MAX lens aperture (D 1) appear when the meter is turned on. After 1.5 seconds, the display changes (D 2). The ISO value seen after the ISO button is pressed (D 3). Set maximum aperture shows after pressing the Fmax button (D 4). The metering mode symbols (D 5) spot meter, center metering, and incident metering mode. In Pr 1 mode you see EV values (D 6). In Pr 2, the meter is set for either aperture priority or shutter speed priority (D 7). In Pr 3, a reference value can be programmed into the meter. It is turned off (D 8) and turned on with a +1 and −1 value programmed into the finder (D 9). The metering duration is programmed in Pr 4 and is set to 16 seconds in A permanently (D 10). An exposure correction from +2 to −2 can be programmed into the meter in Pr 5 (D 11). With Pr 6 turned on, the set ISO and maximum aperture values appear on the display for 1.5 seconds before the meter reading comes on (D 12). A sound warning can be added to the reference mode in Pr 7 (D 13). Display with center area metering and aperture priority (aperture figure solid) is shown (D 14). A stored value is indicated by an arrowhead pointing toward the stored value, in this case the aperture (D 17). All values programmed into the PME finders remain memorized in the finder until they are changed. Removing or replacing the battery does not affect the settings.

On the PME 90, the display is illuminated from a window on top of the viewfinder. Do not cover it up with your hand. You can illuminate it in low-light levels by pressing the illumination button.

Operating the PME 90 and PME 45 Meters

When the meter is turned on, the display shows the maximum aperture and the ISO set on the finder. After 1.5 seconds, the display changes to show the meter reading, which can be in EV values or as aperture priority showing the correct shutter speed for the set aperture or shutter priority where you see the necessary aperture for the set shutter speed. Selecting EV values is usually the most practical, fastest, and least mistake-prone solution with Hasselblad shutter lenses.

The programming functions that work in all metering modes are obtained by simultaneously pressing the ISO and meter mode selection buttons. These two buttons have a small Pr engraving next to them. You obtain the different programming possibilities (from Pr 1 to Pr 7) by pressing the metering mode button repeatedly. The functions are shown and described in Figure 15-16.

Some Older Hasselblad Metering Items

> The PME 51 meter prism viewfinder with a moving needle cannot be recommended for today's photography.
> The PME/VC 6 is a 45-degree prism finder similar to the later PME versions but adjusted for the old focusing screens.
> The Planar 80 and 100 mm and the Sonnar 150 and 250 mm lenses with an attached servo motor for automatic exposure control.

Raya
This photograph was shot digitally for Club Med in the daylight with flash on an H camera and with an HC 2.8/80 mm lens.

Raya
Model Lisa Forsberg photographed with an H camera, an HC 3.2/150 mm lens, and a short
extension tube. (Raya Photographer.)

Raya
This photograph was shot just before a storm in Normandy, France for Prisma Press.
Daylight plus flash on model Jitka Ogurekova using an HC 2.8/80 mm lens on an H camera.
(Raya Photographer.)

Raya
High jewlery photograph produced with an HC 3.2/150 mm lens on an H camera.
(Raya Photographer.)

Raya
This photograph was shot at a restaurant at Disneyland Paris using four flashes and an HC
2.8/80 mm lens on an H camera. (Raya Photographer.)

Controls for Creating Effective Images on Film or Digitally

The image in the camera, whether produced on a digital sensor or on film, is created by the lens and its effectiveness is determined by the focal length of the lens, the distance setting, and the settings of the aperture and shutter speed controls. The last two also determine the exposure, but we must be aware that the same exposure can be obtained with many different combinations of aperture and shutter speeds. These controls therefore must be determined not only for producing correct exposure but also for creating visually effective images.

APERTURE CONTROL

Lenses are distinguished by their maximum aperture, usually engraved on the lens, and are often referred to as the "speed" of the lens. Large aperture lenses are frequently known as "fast" lenses. The aperture number is determined by the size of the diaphragm opening which can be set to different numbers with a low number, such as $f/2.8$, indicating a larger opening than $f/5.6$. The amount of light reaching the image plane is reduced by setting the aperture to a higher number, such as $f/11$. A change in aperture from one setting to the next either doubles or halves the amount of light reaching the image plane.

Because aperture and shutter speed together determine the total amount of light that reaches the image plane, you must change the shutter speed when changing the aperture. Because aperture numbers double or halve the amount of light, it is easy to adjust the shutter speed to compensate for a change in aperture. Change it from $\frac{1}{60}$ to $\frac{1}{125}$ when you open the aperture one f stop and do the opposite when changing from $\frac{1}{60}$ to $\frac{1}{30}$.

Distance Setting and Exposure

On many modern lenses, focusing is accomplished optically by moving some of the lens components (internal focusing) or rear or front focusing on the H camera lenses depending on whether the focusing is accomplished with the rear or front elements. One is not better than the other, just different in design. Such lenses can be used at any distance without the need for adjusting exposure.

Other lenses are focused to closer distances by physically moving the entire lens further from the image plane. This reduces the amount of light reaching the image plane. The amount is negligible for all practical purposes within the normal focusing range of a lens because it practically never exceeds ½ *f* stop. Furthermore the loss is compensated for when exposure is determined with a metering system in the camera.

Exposure Values

Exposure values (EVs) are seldom used, but it is worthwhile knowing that EVs are single numbers that indicate how much light exists in a certain location or is reflected from a subject for a specific film sensitivity. A camera or lens set to a specific EV number produces the same exposure at any aperture and shutter speed combination. (see Figure 16-1).

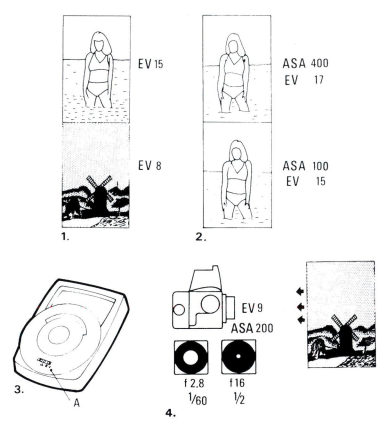

Figure 16-1 Exposure values. (1) A lower EV number indicates a smaller amount of light or a darker subject. (2) If the EV is 17 for 400 ISO it will be 15 for ISO 100. (3) Most professional exposure meters have an EV scale. (4) For every EV value you have a choice of various aperture and shutter speed combinations, such as *f*/2.8 and $\frac{1}{60}$ second or *f*/16 and ½ second. Both give the same exposure because they have the same EV value.

On V system cameras without a metering system, you can set the lens for the desired EV number and then interlock the aperture and shutter speed ring and take pictures at any of the interlocked settings. They all produce the same exposure (see Figures 16-2, 16-3, and 16-4).

CONTROLS FOR CREATING IMAGES

Aperture for Depth-of-Field Control

When a camera lens is focused at a specific distance, only the subject at the focused distance is recorded critically sharp in the image. Sharpness gradually falls off in front and beyond the

Figure 16-2 Aperture and shutter speed settings. Once the EV value is set on any V system lens (1), you can see all the possible aperture and shutter speed combinations as well as the depth-of-field on the lens (2).

set distance. In the photographic image, however, some degree of blur is acceptable because it still appears sharp to our eyes especially when it is not enlarged drastically. This range of acceptable sharpness is called depth-of-field (see Figure 16-5). The amount of depth-of-field is determined by the lens aperture and increases as the aperture is closed down (Figure 16-5). This is clearly shown by the depth-of-field scales on the lenses (see Figure 16-6).

At normal distances, about one-third of the total depth-of-field is in front and two-thirds is behind the set distance. The depth-of-field scales on the lenses confirm this fact. At close distances, the range is more equally divided between the areas in front of and behind the set distance.

The depth-of-field range is best determined from the scales on the lenses. Focus the lens manually or automatically on H cameras at the farthest distance to be sharp and read the distance on the focusing ring. Focus at the closest subject that needs sharpness and read the distance. Set the lens so that the two distances are within the depth-of-field for the set aperture, or set the aperture to a value that brings both distances within the depth-of-field range.

Figure 16-3 Aperture/shutter speed lock. On CF, CFE, CB, and CFi lenses the shutter speed and EV values are set by turning the shutter speed ring. The aperture is set by turning the aperture ring (1). Interlock aperture and shutter speed rings by pressing the interlock button (2).

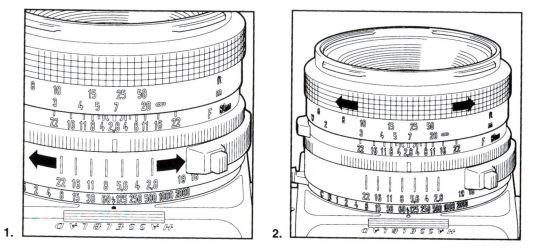

Figure 16-4 Aperture/shutter speed lock on lenses without shutters. On FE, TCC, and F lenses the shutter speed ($\frac{1}{90}$ in this illustration) is set on the camera (except on 202FA). The aperture is set using the rear ring, which has grip sections (1). The focusing ring is at the front (2).

DEPTH-OF-FIELD

Depth-of-Field and Focal Length of the Lens

"Wide-angle lenses have more depth-of-field than telephotos" is a common statement in the photographic field. The statement is correct, but only if the different focal length lenses are

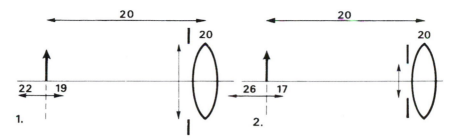

Figure 16-5 Depth-of-field at different apertures. (1) With the lens focused on the subject at 20 feet and the aperture wide open, the depth-of-field may extend from 19 to 22 feet with one-third in front and two-thirds behind the focused distance. (2) With the lens closed down, the depth-of-field increases; for instance, to a range from 17 to 26 feet still with one-third in front and two-thirds behind the focused distance.

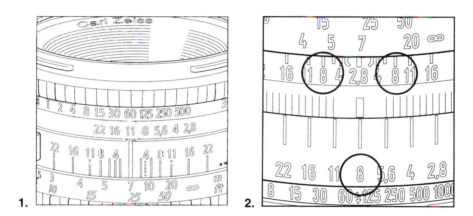

Figure 16-6 Depth-of-field scales. (1) The depth-of-field is the distance range on the focusing ring between the aperture figures on the left and right that corresponds to the aperture (here, *f*/11) on the lens. (2) The same scales, here set for *f*/8, are on FE, TCC, and F lenses.

used from the same distance. In such a case, the wide angle lens has more depth-of-field but also covers a much larger area than the standard or telephoto lens. The three lenses create three completely different images (see Figure 16-8).

If you use different focal length lenses to cover the same size area by taking the pictures from different distances, the depth-of-field is exactly the same with every lens. It can be changed only by opening or closing the aperture (see Figure 16-9).

Keep this fact in mind especially in close-up work where you usually need or want to cover a specific area. Regardless at what focal length you take the picture, the depth-of-field is the same. Depth-of-field is really determined by the magnification, not the focal length of the lens.

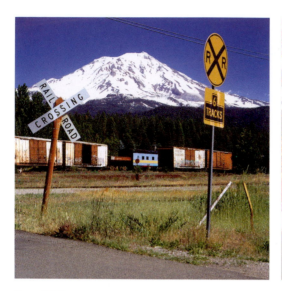

Figure 16-7 Depth-of-field range. Two images that required depth-of-field from foreground to background and were taken with the lens aperture completely closed down. This was necessary to record both Mt. Shasta in the background and the railroad crossing signs in the foreground with maximum sharpness. Including the railroad signs and the railroad cars added a different touch and color to an otherwise ordinary postcard view. Maximum depth-of-field was also considered essential in the harbor scene in Italy because of the sharp outlines of the boats. (Photos by Ernst Wildi.)

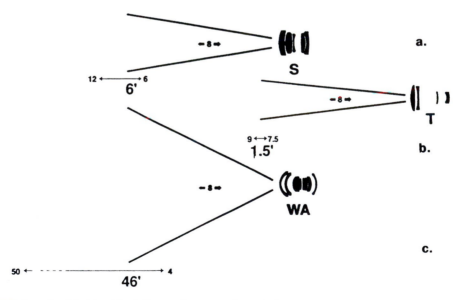

Figure 16-8 Depth-of-field with different lenses. When different focal length lenses are used from the same distance (here, 8 feet), the wide angle lens (c) has more depth-of-field (46 feet) than the standard lens (a), with 6 feet, or the telephoto lens (b), with 1.5 feet.

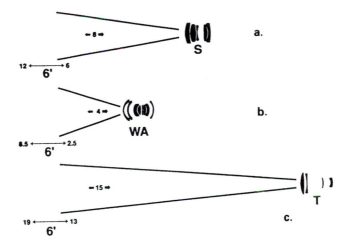

Figure 16-9 Depth-of-field and area coverage. To cover the same size area, the wide-angle lens (b) must be used from a closer distance than the standard lens (a) or the telephoto (c), where you must move farther away. In this situation, all three lenses have the same depth-of-field (6 feet) at the same aperture.

Medium-Format Depth-of-Field

If you work in the medium-format with film or with the large sensors in Hasselblad digital backs or digital cameras be aware that the depth-of-field is shallower than on the 35 mm film format or a digital camera with the smaller full frame or the even smaller APS size sensor. This difference is based on the longer focal length of the lens that is necessary to cover the same area on the larger formats. This means a different magnification for the same area of coverage and, as mentioned before, magnification determines the depth of field. For example, covering an area 49 mm wide with the large 36.7×49 mm sensor means a $1\times$ (life-size) magnification, whereas it is only $0.7 \times$ on 35 mm film or a full frame sensor and $0.5\times$ on smaller APS size sensor. A higher magnification always has less depth-of-field at the same aperture.

Depth-of-Field Scales and Charts

The figures on depth-of-field scales and charts are calculated based on the acceptable blur known as the "circle of confusion." They are not related to the lens design or the type or quality of a lens. However, a critically sharp lens may appear to have less depth-of-field than one of lower quality, which may bring you to the conclusion that your sharp lens does not produce enough depth-of-field. If that should be the case, it is only because the falloff in sharpness becomes more visible on the critically sharp type, not because of the lens design.

You must realize, however, that the depth-of-field is a range of acceptable, not critical, sharpness (see Figure 16-10). Subjects toward the end of the depth-of-field range are not as sharp as those at the focused distance. This is obvious on a large print or when you evaluate negatives or transparencies under an $8\times$ or $10\times$ magnifying glass, the type I recommend for

Figure 16-10 Sharpness within the depth-of-field range. Depth-of-field is not a range of critical sharpness (in the example, from 8 to 50 feet) with an abrupt falloff to blur. Instead, it is a gradual decrease in sharpness on both sides of the set distance (15 feet in the example) even within the depth-of-field range.

such evaluation. This sharpness difference may be more obvious with very sharp lenses, but again do not blame the lens. Blame the incredibly sharp film available or the fabulous sharpness created in a digital image by the large Hasselblad sensors. These are the elements that make these differences in the sharpness range more obvious. You can also blame the age of the depth-of-field scales and tables which were calculated years ago when film was not very sharp. Although the scales are still usable for general work, you may want to make your own adjustments for critical work, either by not using the entire depth-of-field range shown on the charts or lenses or by closing the aperture one or two stops more than necessary for the desired depth-of-field range. Whenever a specific subject is to be critically sharp, focus the lens on that subject. Do not rely on depth-of-field.

Depth-of-Field on the Focusing Screen of SLR Cameras

The ability to see depth-of-field on the focusing screen of SLR cameras made for digital imaging or film photography such as all Hasselblad models except the Superwide, is often described as a main benefit of working with such cameras for serious photography. In principle this is true since you view the image through the lens and you can stop down the aperture manually to see the image as it will be recorded in the camera at the set aperture. Unfortunately this is incorrect. The focusing screen on SLR cameras, or the Preview screen on digital sensor units even on Hasselblad cameras made for larger film and sensor sizes, is simply too small to see where the sharpness is acceptable or where the sharpness starts falling below the acceptable limit when the image is enlarged. Furthermore the image on a focusing screen, even the Acute Matte types, cannot show a razor sharp image to see how depth-of-field changes when closing down the lens aperture. The problem is increased when you try to evaluate the dark image at smaller lens apertures.

The focusing screens on SLR cameras, especially the large screens on Hasselblads, are wonderful for focusing and evaluating the image to see what is really sharp and how much blur you have in background and foreground areas.

For determining depth-of-field or to determine the minimum and maximum distances where images are acceptably sharp, use the charts or scales on the lenses.

Depth-of-Field on the Preview Screen of Digital Sensor Units

Everything that has been said above for focusing screens applies to preview screens on the Hasselblad sensor units and to an even higher degree because the images on these screens are usually viewed without daylight completely shielded from the screen which viewfinders do on focusing screens.

Hyperfocal Distance

Hyperfocal distance is often referred to as the distance setting that produces the maximum depth-of-field at a specific aperture. Although this is correct, I suggest looking at Hyperfocal distance as the distance setting that produces depth-of-field to infinity at the set aperture. Because Hasselblad lenses have depth-of-field scales, there is no need for hyperfocal distance charts. Simply set the distance ring so that the infinity mark is opposite the corresponding aperture on the depth-of-field scale on the right. The hyperfocal distance, if you want to know it, is the distance opposite the index. You will also find that the depth-of-field extends on the other side to half the hyperfocal distance; for example, to 8 feet (2.6 m) if the hyperfocal distance is 16 feet (5.2 m) (see Figure 16-11).

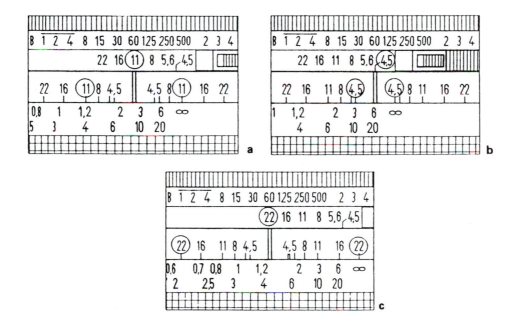

Figure 16-11 Hyperfocal distance. A lens is set to the hyperfocal distance when the infinity mark is placed opposite the set aperture on the depth-of-field scale: at *f*/11 (a), *f*/4.5 (b), and *f*/22 (c). The depth-of-field then extends from infinity down to half the distance that is opposite the index (to 10 feet at *f*/4.5, to 2 feet at *f*/22, and to 4 feet at *f*/11).

Manual Diaphragm Stop Down

On single-lens reflex cameras, the diaphragm is normally wide open to provide the brightest view of the focusing screen. The image on the screen shows the image as it will be recorded at the maximum aperture. The manual diaphragm stop down on the H cameras and the other focal plane shutter cameras, and on all Hasselblad shutter lenses allows you to see how the image is recorded at different apertures (see Figure 16-12).

Because the lens diaphragm closes to the preset aperture, the focusing screen becomes darker. But you can now see the image as it will be recorded in the camera at the set aperture, or you can see how the image changes as you open or close the aperture. You can take the picture with the aperture manually closed down, or you can reopen the aperture before you take the picture.

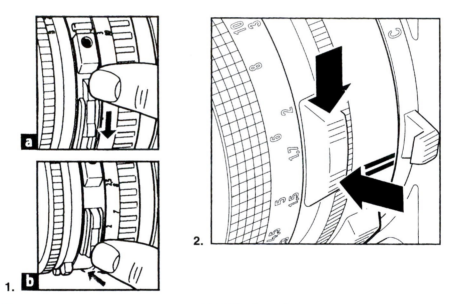

Figure 16-12 Manual aperture stop down. (1) You can close down the aperture on the latest V system lenses to any preset aperture by pushing the stop down lever downward (a). It remains in the stopped down position until you move the stop down lever back to the original position by pressing the bottom part of the lever (b). (2) The stop down control on the CF lenses looks somewhat different but is operated in the same way. Manually close down the aperture on all H system lenses by clicking the stop down lever at the front of the camera.

PHOTOGRAPHING GROUPS

I have often heard and even read that the people in a group picture must be arranged in a curved line to be sharp from side to side in the picture. This statement is backed up by the explanation that in a straight arrangement the people on the outside are farther away from the center of the lens than those in the center and will be out of focus. If the group is

arranged in a curved line, everybody from center to the edges can be at the same distance (see Figure 16-13).

This is not, however, the way lenses are designed nor how they record a subject. Every lens is designed to record a sharp image on the flat image plane from a flat subject in front of the lens, whether the subject is a building, a flat document, or a group of people. If this were not the case, the walls of a building and a document would also have to be curved to ensure sharpness from left to right and top to bottom. For good overall sharpness, arrange the group in a straight line. If you prefer a curved arrangement for artistic reasons or for better flash illumination, feel free to do so, but be aware that you need more depth-of-field. For this you need to close down the lens aperture because the people on the outside are now closer to the camera than those in the center.

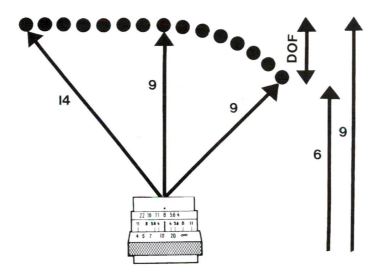

Figure 16-13 Photographing groups. When people are arranged in a straight line, the people at the edges are farther away (here, 14 feet) than the people in the center (9 feet) when measured from the center of the lens. Arranged in a curve, they all can be at the same 9-foot distance. Lenses, however, are designed to produce a sharp image from a flat, not a curved, subject plane. If the group of people is arranged in a curved line for other reasons, the lens aperture must be closed down because you need more depth-of-field — from 6 feet to 9 feet in this example.

BACKGROUND SHARPNESS

The lens aperture not only determines the actual depth-of-field range but also the degree of blur in subjects in front of and beyond the depth of-field range (how sharp or how blurred backgrounds appear in the photograph). Because backgrounds are a dominant part of many pictures, the degree of sharpness or unsharpness in the background often determines the effectiveness of the final picture. Check the degree of sharpness or blur in the background and possible foreground subjects before you take the picture. To do so view the image with the aperture closed down to the value that you plan to use for the picture. Blur in backgrounds

is enhanced not only by opening the aperture but also with longer focal length lenses. If you want to keep backgrounds reasonably sharp, use a shorter focal length; if you want to blur backgrounds more, change to a telephoto. Everything that has been discussed about background sharpness also applies to foreground subjects, which can often visually enhance an image by adding a touch of color to a photograph (Figure 16-14).

Figure 16-14 Background and foreground sharpness. A 120 mm lens at the maximum lens aperture blurred the background sufficiently to be undistracting but still recognizable to establish the location. Exposure based on the background area. Fill flash left). The completely blurred leaves in the foreground added a touch of color to this scene and created a nice contrast to the blue color on the water surface in the background (right). (Photos by Ernst Wildi.)

CREATIVE USE OF THE LENS APERTURE

Before you press the release, you must decide whether everything from foreground to background should be sharp or whether one or both should be blurred, and if so how much (Figures 16-15 and 16-16).

Our eyes focus constantly and instantly so we see everything sharp. To present the scene or subject as seen with your eyes, try to have sharpness from foreground to background. A maximum range of sharpness is usually necessary with subjects that we are accustomed to see sharp such as buildings, room interiors, product displays, and food illustrations. Generally, subjects with sharp outlines such as fences, rocks, and railings look best when they are sharp, especially when they are in the foreground.

Limiting the range of sharpness lets us create images that look different from the way we see the world and create images as only the camera can. By narrowing the plane of focus to a specific subject, or specific subject area, you create a strong attention-creating element,

Figure 16-15 Foreground sharpness. A romantic wedding photograph visually enhanced with the soft, undistracting background and the completely blurred red flowers in the foreground created by using a large aperture on a long 250 mm telephoto lens. (Photo by Andy Marcus.)

forcing the audience to look at that part of your image. The lens aperture is therefore a powerful tool for creating effective, unique images.

The maximum amount of depth-of-field is always limited and depends on the focal length of the lens, the distance setting, and the aperture. If a wide angle lens can produce a desirable

Figure 16-16 Lens setting for depth-of-field. Photographed at the smallest lens aperture with the focusing ring set to provide depth-of-field from the front of the picnic table to the trees in the background. The trees on the left, especially the bare trunk with the same color as the table, add a wonderful compositional balance to the image.

image in a specific location it will offer more depth-of-field than the longer focal length lens. The sharpness range can be increased by tilting the image or lens plane on a camera as discussed in Chapter 13.

With digital imaging you practically can have an unlimited sharpness range by taking two or three identical images with one focused for the foreground and the second for the background. Perhaps you might take a third image for the middle areas and then combine the images in the computer.

SELECTION OF SHUTTER SPEED

The shutter speed may be predetermined for exposure reasons or for allowing handheld camera operation. With moving subjects, the shutter speed must be chosen from the image-creating point

of view as different shutter speeds record moving subjects differently in the camera. You must decide whether the motion is to be frozen, recorded with a slight blur, or completely blurred.

A moving subject recorded at a high shutter speed appears to be standing still, producing interesting and sometimes strange pictures. The shutter speed that stops action depends on the speed of the moving subject, the size of the subject as recorded in the camera, and its direction of movement in relation to the image plane (see Figure 16-17). To stop continuous motion, — such as skiing; diving; motorcycle, car, and horse races; or roller coasters — $\frac{1}{800}$ or $\frac{1}{2000}$ second is frequently necessary, especially with longer focal length lenses.

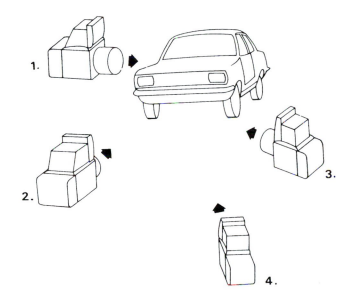

Figure 16-17 Shooting direction. Using the same shutter speed, blur is greatest when the subject is moving at right angles to the camera view (1). A subject moving at the same speed straight (2) or at an angle (3) toward the camera view is less blurred. There will be less blur even at the same shutter speed when the subject is photographed from a greater distance (4).

You can also stop motion at slower shutter speeds by photographing at the peak of the action in actions and sports that have a beginning and an end or are repeated. There is a peak of action on many amusement park rides, jumping on a trampoline, in ballet dancing, and in other stage and circus performances (see Figure 16-18).

Blurred Motion Effects

Blurring subjects with a slow shutter speed is not limited to sports actions. Interesting and fascinating images can be created with anything that moves: water in any form, reflections on water, clouds moving in the sky traffic at night, amusement park rides, smoke, rain, snow, trees, or flowers or grass blown by the wind,. Because we cannot see blurred motion with our

Figure 16-18 Photographing the peak of the action. Blur in moving subjects is reduced when the shutter is released when the subject is momentarily still, as at the end of a swing, or at the top of the bounce from a trampoline. Another method is to follow the moving subject with the camera and make the exposure while the camera moves.

eyes, images with blurred motion are different from our way of seeing, which is a main reason blurred motion effects are fascinating and attract attention (Figures 16-19 and 16-20).

Because the desired effect in the image is usually based on personal taste, it is difficult to give recommended shutter speeds. For moving trees, grass, and reflections shutter speeds around 1 second can be used as a starting point. For moving water and waves $\frac{1}{8}$ to 1 second can produce good results, but you can also go to speeds of several seconds for a different effect.

Following Moving Subjects

Another approach with moving subjects is to follow the subject with the camera and snap the shutter while the camera moves. You see this approach often used in car, motorcycle, and horse races. If you move the camera at the same speed as the subject, only the background is blurred. If moved slower or faster, you create a blur in the background and in the subject. With many subjects, some elements are moving in different directions at different speeds — for instance, the spokes of a wheel, the legs of a bicycle rider or a horse, the wings of a bird, and the arms of a ballet dancer or ice skater — thereby creating different amounts of blur within the image. The feeling of motion is enhanced when you photograph the moving subject against a contrasting background with dark and bright and different colored areas that create noticeable streaks. Spectators and trees are good examples.

Figure 16-19 Blurred snow and water. Water is the most popular subject for blurred motion, which in this case is emphasized by the sharp outlines of the tree in the foreground and the rock formations in the back. A slow shutter speed of ¼ second made the falling snow the important part of the image. The diagonal streaks of the snowflakes framed against a dark background area enhance the feeling of a blizzard. (Photos by Ernst Wildi.)

Figure 16-20 Blurred motion. Slow shutter speeds can enhance pictures of ordinary subjects such as leaves moving in the wind (left) and the steam coming from the geysers in Yellowstone (right). Such images are usually most effective if they include sharp elements such as the tree trunks of the trees or the rocks in Yellowstone. (Photos by Ernst Wildi.)

Many photographers find it best to follow a moving subject with a handheld camera, especially when the subject changes speed or direction, as birds or ice hockey players might. If the subject moves along a straight line, such as a racing car or an athlete in a 100-meter sprint, a tripod-mounted camera is more likely to produce successful results.

APERTURE AND SHUTTER SPEED OPERATION

Setting and changing apertures and shutter speeds for creating visually effective images on film or digitally can be done fast and easily when both the aperture and the shutter speed can be changed without altering the exposure; that is maintaining the EV value. This is possible on all Hasselblad cameras used both in film or digital photography.

On the H cameras you simply turn the front control wheel on the LCD grip (see Chapter 4 for details). On all shutter lenses, interlock the aperture and shutter speed rings (see details in this chapter under "Exposure Values").

Understanding Light and Filters

∎ ∎ ∎ ∎

FILTERS IN DIGITAL IMAGING

With all the image manipulation possibilities in digital imaging, the need for using filters on the camera has been reduced. This is true especially regarding filters used for changing colors or producing special effects. The correct or desired colors in any type of light are achieved with the white balance control in digital cameras or digital sensor units (discussed in detail in Chapter 5). Regarding special effects, the computer offers practically unlimited creative possibilities that you could only dream about a few years ago. You can create these new images from a comfortable chair in your studio or home without destroying the original image. However, as with everything in digital photography, some filters still offer a simple solution for changing or improving images while they are produced in the camera and in some cases provide the only simple solution to create the desired results. I therefore suggest that you still consider using some filters on the camera whenever you feel that they can produce a more effective image. This approach can eliminate time-consuming and difficult work on the computer. If the results from the filter on the camera are not to your complete satisfaction, you can always add additional improvements in the computer.

Filters Worth Considering in Digital Photography

Polarizing filters still offer a simple solution for improving the rendition of distant areas in an outdoor photograph; to eliminate reflections from glass, water, and other surfaces, and to improve the color saturation and/or contrast in sidelighted subjects or scenes and in copying.

You may also run into situations where you want to reduce the amount of light reaching the sensor to use a longer shutter speed or to take a picture on a sunny day with the aperture wide open. Neutral density filters on the lens can do this without changing the colors when you take the picture. I still like Softars filters as they produce a beautiful soft touch while maintaining the sharpness in the image.

Partial filtering when taking the picture is still a good approach for darkening specific areas within the composition, and is most often used for darkening bright sky areas without darkening the rest of the image. In digital imaging you can darken a bright sky area and increase the contrast range in the computer or by taking two pictures, one exposed for the darker and one for the brighter areas within the composition and then combine the two.

Some digital photographers like to use Digital Filters or Red Enhancing filters. Such filters apparently block the infrared and ultraviolet (UV) rays and seem to enrich the red and orange colors to brighten up flat scenes.

The filters used in black and white film photography to change gray tones can also improve the rendition of different colored areas in digital black and white images if black and white images can be produced in the camera. With Hasselblad, black and white images are produced in the computer.

White Balance in Digital Photography

If you work exclusively in digital photography, you do not have to read the paragraphs about the color balance and conversion filters as the color rendition in digital photography is controlled by the White Balance control (discussed in detail in Chapter 5). This allows you to obtain the desired colors when photographing in any light source of known or unknown color temperature instead of placing filters in front of the lens. It should nevertheless be helpful to the digital photographer to know something about the color temperature of light.

REASONS FOR USING FILTERS

In film photography there are five basic reasons for using filters on the camera: (1) to obtain correct color rendition or enhance color images in color photography, (2) change gray tones in black and white, (3) create special effects and moods, (4) to reduce the amount of light reaching the film, and (5) to protect the lens.

Filters as Lens Protection

Lenses are expensive components in any camera system. It is a good practice to protect the front element with an optically plain piece of glass such as an UV or haze filter. Such filters protect the lens from dust and dirt, reduce the need for cleaning, and if cleaning is necessary, it is reduced to cleaning the filter without touching the lens surfaces. Good quality haze and skylight filters do not change the colors or gray tones to any noticeable degree. To avoid possible differences in color, it is best to use identical filters made by the same company on all lenses.

Equip each lens with its own filter. It is too time-consuming to switch filters every time lenses are changed. Since these filters become a permanent part of the lens, they must be of the very highest quality. A lens shade offers further protection for the lens and prevents snow or raindrops from falling on the front element of the lens.

Haze and UV Filters

Haze and UV filters absorb UV rays without changing colors to a noticeable degree. Besides protecting the lens, they can be helpful when photographing in places that have large amounts of UV light, such as at high altitudes. In most modern lenses, however, some lens elements are made from glass that absorbs UV rays to a greater extent than a UV filter. In a way, such lenses have a built-in UV filter. Consequently, haze and UV filters have little value

for improving pictures, and in most cases do not penetrate haze and do not improve distant shots. Consider polarizing filters for this purpose as explained later in this chapter.

Neutral Density Filters

Neutral density filters, also called gray filters, are made from neutral gray colored glass that does not change colors or the tonal rendition. They are used in black and white and color photography to reduce the amount of light reaching the image plane. You may want to use these filters outdoors so you can photograph at a larger aperture, which reduces depth-of-field or photograph at a longer shutter speed to blur moving subjects such as water.

Neutral density filters come in various densities, requiring the exposure increases shown in Table 17-1. A filter that requires a two *f* stop increase is a good choice for many applications. The filters can be combined for further light reduction.

Table 17-1 Neutral Density Filters

Density	Percentage of light transmission	Increase in exposure in f stops
0.3	50	1
0.6	25	2
0.9	12	3
1.2	6	4
1.5	3	5
1.8	1.5	6

Filters for Black and White Photography

In black and white photography, the various colors are recorded in a range of gray tones from white to black. Filters can be used for purposely darkening or lightening certain colors to emphasize, suppress, separate, increase, or reduce the image contrast. You can lighten or darken any color (see Figure 17-1). To lighten the grey tone of a color, use a filter of the same color or at least from the same side of the color wheel (see Figure 17-2). To darken the gray tone of a color, select the color directly across the wheel or at least from the opposite side. A yellow filter darkens colors from blue-green to violet. Green filters lighten green and darken purple and red; they can be used to lighten shaded green areas under trees (see Figure 17-3).

In black and white photography, a yellow filter produces some improvement in distant shots; orange and red filters can do more. Polarizing filters are most effective in digital photography or with film but only if the light comes from the right direction, as explained in the section on polarizing filters. Complete or almost complete haze penetration can be obtained with a red filter combined with infrared film, but other colors are also changed; for instance, green appears as white.

PARTIAL FILTERING

It may be desirable to filter only part of a scene, such as darkening a bright sky to bring it closer to the brightness level of the landscape below or adding a touch of blue to a white

Figure 17-1 Filters in black and white film photography. Illustration shows how gray tones can be changed drastically in black and white photography. With a blue filter (center) the reds are recorded much darker and the blues much lighter. The reverse is true with a red filter (right).

Figure 17-2 Filters in black and white photography. (1) The color wheel with the colors red (R), yellow (Y), green (G), cyan (C), blue (B), and magenta (M) is a convenient tool for determining how various colors are reproduced in black and white through different filters. A yellow filter (Y) transmits yellow and absorbs blue. (Photo by Ernst Wildi.)

Figure 17-3 Filters for changing gray tones. Photographed through a red filter (R), green (G) is recorded lighter on the negative (N) and darker on the print (P) or on the digital sensor, red is reproduced darker on the negative, lighter on the print or digital sensor. The situation is reversed when a green filter (G) is used.

sky without adding the blue tone to the rest of the image. This is done with graduated filters, a neutral density type for darkening the sky. Such filters are usually in square shapes so that they can be moved in front of the lens in a special filter holder, or just be placed by hand to the proper position in front of the lens.

Graduated filters come in different densities and also as hard- edge types to be used when the dividing line is very definite as a horizon and as a soft type for use when subject brightness fades. If you are not certain whether the filtered effect is completely satisfactory in the final image, take two pictures, one with and one without the filter and see which one is best or whether combining the two in the computer can create completely satisfactory results.

Be careful when using graduated filters as the effect can easily look unreal and attract attention. Also evaluate the image on the focusing screen at the aperture that will be used for the picture, because the dividing line shifts when you open and close the diaphragm.

POLARIZING FILTERS

Light that reaches our eyes or the camera lens is unpolarized, which means light waves vibrate in all directions perpendicular to the light path. If such light reaches glass, water, or other reflecting surfaces at an angle, it becomes polarized, with the light waves vibrating in only one direction (see Figures 17-4 and 17-5).

Polarized light in nature is usually light reflected from water, leaves, rocks, trees, windows, or virtually any other shiny surface except bare metal. Reducing or eliminating reflection

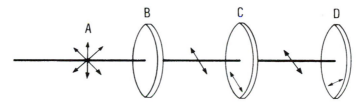

Figure 17-4 Natural and polarized light. Natural, unpolarized light vibrates in all directions (A). As it passes through a polarizing filter (B), the light becomes polarized and vibrates in one direction only. If this polarized light meets another polarizing filter that has its axis of polarization in the same direction as the first (C), the light passes through but with its axis of polarization at right angles to the first (D), it absorbs the light, and we have what is known as cross-polarization.

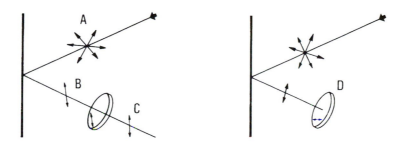

Figure 17-5 Reflected light. When natural, unpolarized light (A) is reflected, it may become polarized, vibrating in one direction only (B). In this state, it passes through a polarizing filter with its axis of polarization in line with the light (left) but not through one (D) at right angles (right).

gives many surfaces a deeper, more saturated color. Reflections can also look natural, as on porcelain or silver, or they can make pictures more beautiful. Eliminating reflections can make water dull and uninteresting. Store windows are often visually effective because of the reflections on the glass. Eliminating the reflections takes all the visual effectiveness away. Watch how the polarizing filter affects the subjects in your composition. You must be aware that the effect of the polarizing filter depends on the angle from which the subject is photographed and is determined by the material that reflects. For a store window, maximum elimination is obtained when the window is photographed from about 35 degrees. When photographing the window from the front, a polarizing filter will not change anything (see Figure 17-8).

Fortunately, the effect of a polarizing filter can easily be seen. Turn the filter on the lens and view the scene from different angles while evaluating the image on the focusing or preview screen. You can even see the effect before you place the filter on the lens. Turn the filter held in front of your eyes while looking at the subject or scene and see what happens. The difference may be dramatic. A polarizing filter need not be turned for maximum effect. You can use it at whatever setting produces the desired results.

Because the light coming from the sky has been polarized by passing through the thin layers of the atmosphere, a polarizing filter can make a blue sky dramatically darker, but only when you are photographing at a 90-degree angle to the direction of a line drawn from the sun to the camera; in other words, with sidelight (see Figure 17-6). Polarizing filters can drastically improve distant shots by eliminating reflections, and thus improving color saturation. This improvement again happens only with sidelight (see Figure 17-7). Many other outdoor scenes can be improved by simply eliminating reflections on some surfaces, so it pays to examine the possibilities and examine the effect over the entire image area. As the polarizing effect in the image depends on the angle of reflection, the resulting effect may differ over the image area, especially in wide angle pictures. Reflections on a store window may be eliminated on one side of the window but not on the other; a blue sky may be darker on the left side than on the right. Such differences can be seen in the viewfinder, so evaluate the image carefully. Polarizing filters work in color and black and white photography, and the improvements are similar.

Polarizing filters require an exposure increase because the polarizing material has a grayish tint. The required increase is the same whether the filter is rotated to the position with minimum or maximum polarization. As polarizing filters reduce or eliminate reflections, polarized images sometimes appear darker than expected but only because the reflections are no longer there.

Figure 17-6 Angle for polarization. Reflected light is polarized only if it hits a surface at an angle between 30 and 40 degrees, depending on the material of the reflecting surface (left). Skies are darkened by a polarizing filter only when the pictures are taken at right angles to the sun (right).

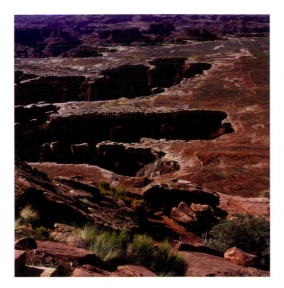

Figure 17-7 Polarizing filter outdoors. These illustrations show how a polarizing filter can improve the results in a side-lit outdoor scene taken digitally or on film by eliminating the haze and bluish cast in the middle and background areas. The contrast is dramatically improved in those areas. (Photos by Ernst Wildi.)

Figure 17-8 Polarizing filter. A polarizing filter on the lens eliminated practically all reflections on the store window by photographing the window from an angle of about 40 degrees and not head on. (Photo by Ernst Wildi.)

Polarizing Filter Types

The original polarizer, known as the linear type, affects the light measuring or automatic focusing system (or both) in some cameras to the point of giving a wrong reading or distance setting. Whether this happens depends on the design of the metering and focusing system in the camera. The problem has been eliminated with a polarizer known as the circular type, which produces the same results in the picture but does not affect the metering or focusing and can therefore be used on any camera.

The circular type is needed on Hasselblad H cameras because the main mirror has a dichroic coating which has a polarizing effect of its own. A linear polarizing filter might eliminate the light from reaching the sensor of the automatic focusing system so circular type filters must be used on H cameras. The H system polarizers are the circular type.

Circular types are not needed on the 200 cameras with a metering system nor when you are metering with a meter prism finder. You can use the linear or circular type of filter on these cameras. The Hasselblad polarizers for the V system cameras are the linear type.

Special Polarizing Filters

There are also special polarizing filters on the market that add color to reflections and highlights rather than eliminating them. This addition of gold or blue or a combination of the two can be striking; for example, in the highlights of a water surface. Like any other special effect, it can also look unnatural and out of place. Evaluate the effect carefully before recording the image in the camera.

THE COLOR QUALITY OF LIGHT

Color transparency films are manufactured for a specific color or light source, and correct color rendition can be obtained only if the color of the light matches that for which the film is balanced. The color quality of light, known as color temperature, is usually expressed in Kelvin (K) and sometimes in Decamired (DM) values. Kelvin and Decamired values are directly related by the following formula:

$$\text{DM value} = \frac{100,000}{\text{Kelvin value}}$$

Daylight color transparency films used in medium-format photography are matched to a 5600 K (18 DM) value. Tungsten films are matched for a 3200 K (31 DM) color temperature. Table 17-2 shows color temperatures for some light sources.

Color Quality in Digital Photography

Although the sensor in a digital camera or digital back is not made for a specific color temperature, you still have to be concerned with the color quality of the light. To obtain the desired

Table 17-2 Color Temperatures of a Few Typical Light Sources

DM	Kelvin	Type of light
8	12500	Shade with clear blue sky
16	6250	Overcast day
18	5600	Sunlight at noon
31	3200	Tungsten lamps
34	2900	100–200 W household lamps
54	1850	Candlelight

color rendition, you must work with white balance control as discussed in detail in Chapter 5. Therefore learning something about the color temperature is helpful.

Light Balance and Conversion Filters

Light balance and conversion filters are used in color film photography to match the color quality of the illumination to that of the film or to purposely obtain a warmer or cooler color rendition in the images.

The filters with a warming effect — the 81 series light balance and 85 conversion type or the Decamired red (R, CR) types — are used when the light is too blue. The filters with a cooling effect — the 82 series light balance and 80 conversion filter or the Decamired Blue (B, CB) types — are used when the light is too red. There are also cases when you do not want to match colors. Early morning and late afternoon scenics are usually exceptionally beautiful because of the warm color of the early morning or late afternoon sunlight. Do not destroy this effect with a cooling filter.

Table 17-3 shows filter values for various situations.

Table 17-3 Filter Values for Various Situations

Purpose	Decamired filter	Wratten filter
To get a warmer rendition with electronic flash	R1.5	81A
To use Tungsten color film in daylight	R13.5	85B
To use daylight film with 3200K light	B13.5	80A
To use Tungsten film with household lamps	B3	82C

Color-Compensating Filters

Color-compensating (CC) filters — available in six colors (yellow, magenta, cyan, red, green, and blue) and in different densities from about 0.05 to DM value 0.50 — are used for changes in the overall color balance or for fine color corrections. These filters are most readily available in gelatin form.

Fluorescent and Vapor Lights

Unlike sunlight or the light from incandescent sources, the light from a fluorescent tube is not evenly distributed through the spectrum, so the results with color film can be unpredictable

(except with special color matching tubes). Film and fluorescent tube manufacturers publish charts showing which CC filters produce the most satisfactory results.

The Decamired Filter System

In the Wratten filter system, there is no direct relationship between the color temperature of the light and the filter value. In the Decamired system that Hasselblad used, the light and filter values are directly related to each other and can be matched with a DM value equal to the difference in the DM values of the film and the light source. For example, if a DM 31 film is used with DM 28 light, you need a 3-DM value filter; CR 3 (red) in this case because the light is bluer. The filters within each color can be combined to obtain different correction values.

EXPOSURE INCREASE

With the exception of UV, haze, and some light balance and compensating types, where the light loss is negligible, lens settings must be adjusted when the meter reading is made with a handheld meter. The necessary exposure increases may be indicated either in filter factors or in aperture values. The two are not the same. When the increase is indicated in aperture values, increase exposure by the indicated value; for example, two f stops if the value is 2. If indicated in filter factors, convert the factors into the aperture values shown in Table 17-4. Hasselblad filters carry all the necessary information engraved on the rim. For example, a filter engraved 60 2 X YG–1 has a size of 60 mm, a color of yellow-green, and a filter factor of 2, requiring an exposure increase of 1 EV value. Filter colors are designated as follows: Y = yellow, YG = yellow-green, G = green, O = orange, and R = red.

Table 17-4 Filter Factors and f Stops/EV Values

Filter factor	1.5	2	2.5	4	6	8	16	32	64
Increase in EV or f stops	½	1	1½	2	2½	3	4	5	6

When the meter reading is made through the lens, as in the Hasselblad H and 200 cameras, or with a meter prism viewfinder on a 503 or other V system camera, the light loss is automatically adjusted in the meter reading.

POLARIZING FILTERS OVER LIGHT SOURCES

You can polarize light from tungsten lights or electronic flash by placing a polarizing filter over the light source. The polarizing filter on the camera lens then eliminates all reflections, at all angles, from all materials. This procedure is necessary to eliminate reflections on bare metal. It is also a superb approach for copying (Figure 17-9). To be most effective, the polarized light must illuminate the subject or document from an angle between 30 and 40 degrees. You then turn the polarizing filter on the camera by visually examining the image on the focusing screen.

Figure 17-9 Polarized light for copying. These illustrations show the improvement when copying digitally or on film with polarized light and a polarizing filter on the lens. (Photos by Ernst Wildi.)

Copying Documents in Polarized Light

A quality copy requires that the plane of the document and the image plane are perfectly parallel to each other. Align the camera as carefully as possible so that horizontal and vertical lines in the document are perfectly parallel to the edges of the focusing screen. Checked screens with grids simplify this alignment.

While all Hasselblad lenses have excellent quality at close distances, you may want to consider the Superwide camera or the Makro-Planars 120 mm or 135 mm in the V system if necessary, in combination with extension tubes. With the HC Macro 4/120 mm in the H system, you can photograph documents as small as 2 in. without close-up accessories.

The Copying Setup

For extensive copying of smaller documents, you may want to consider a special copying stand. For occasional copying a tripod with the center column reversed so that the camera sits between the tripod legs, as also suggested for slide duplicating in Chapter 19, makes a usable arrangement.

Automatic focusing of the H camera should be precise with any type of copy subject. For manual focusing with V system cameras, place a substitute focusing target — something with small, very fine printing — over a copy subject that lacks fine detail. Pre-releasing the camera or locking up the mirror is a good suggestion on any camera. Filters are usually not needed but a yellow filter can be of value when you photograph old, yellowed originals in black and white on film or digitally. The filter lightens the yellow background thereby increasing the contrast.

Lighting

Tungsten lights or electronic flash, especially studio units with modeling lights, are good choices. Lighting must be even from corner to corner and without disturbing reflections. For small documents, one light may be sufficient, but two lights provide better possibilities for larger documents. Place the lights at equal distances on two sides, far enough away to cover the entire area and each at an angle of approximately 35 to 40 degrees. With colored walls or ceilings, turn off all or most of the room lights to avoid the reflection of these colors onto the copy. Keep out daylight. Check that nothing from the room, the chrome parts of the camera, the copy stand or tripod, or the photographer's white shirtsleeve is reflected on the copy, especially when photographing glossy surfaces.

Polarizing the Light Source

The results when copying any type of document, picture, or photograph can be improved, often dramatically, with polarized light by producing images with a higher contrast and better color saturation. Polarized light is recommended for all copying, especially for photographing shiny surfaces, glossy photographs or pictures under glass, and charts on black backgrounds. Polarization can make the background really black and make pencil lines and other marks disappear (see Figure 17-9).

Because the subjects to be copied are at a right angle to the camera axis, a polarizing filter over the camera lens alone does not improve the results. You must also polarize the light that reaches the copy by using filters over the light source(s). Tungsten lights can be used but may create a heat problem for the polarizing material. I recommend studio flash units with modeling lights as a light source. You need sheets of polarizing material large enough to cover the lights and place them about a foot away when using modeling lights that produce some heat. With small portable flash units, the polarizing filter does not have to be larger than the flash head.

You need a regular polarizing filter over the lens to create what is known as cross-polarization, which is created when the polarizing filter on the camera is 90 degrees to the angle of the filters on the light sources (see Figure 17-10). A circular polarizing filter must be used on lenses in the H camera system. Turn the polarizing filter on the camera lens while visually checking the results on the focusing screen. You will probably see a drastic change. Leave the filter in the position that produces the desired results and take the picture after making any exposure adjustment for the polarizing filter on the camera. Take exposure meter readings in your usual fashion. With tungsten light and a built-in meter, take the reading off of a gray card. Consult the histogram in digital work. Check Chapter 18 when using electronic flash with H cameras. Make test exposures.

QUALITY OF FILTERS

Filters used with quality lenses for critical photography must be made to the same quality standards as the lenses. This is especially important when the filters are used extensively

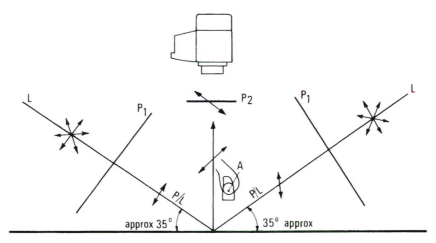

Figure 17-10 Copying setup. A simple setup for copying in polarized light consists of two lights (L), on the left and right, illuminating the copy from the same angle of about 35 degrees. The light from both lamps goes through the polarizing material (P1) so that the light falling on the copy is polarized. A polarizing filter (P2) on the camera lens is turned to produce maximum contrast. Exposure for tungsten lights is based on a reflected or built-in meter reading off a graycard (A) placed on top of the copy or the reading from an incident meter.

and when they are combined with long focal length lenses. Filters for long tele lenses must be of the highest quality. A filter that is not perfectly optically flat may have the effect of a very weak lens element, which decreases the image quality and makes it impossible to focus the lens at infinity. The quality of filters becomes still more important when filters are combined.

Filters Between the Lens

Because the 30 mm Distagon fish-eye lens for the 503 and other V system cameras covers a 180-degree diagonal field of view, it is impossible to attach filters to the front without cutting into the diagonal field of view. Filters can be attached to the rear of the front section and are part of the optical design, which means that the 30 mm Distagon is designed to produce the best sharpness with a filter or clear glass in the lens. Never use the lens without a filter or clear glass. The rear ring of the lens is painted bright red to warn you that there is no glass at the rear.

Gelatin Filters

Gelatin filters can be used in combination with the Proshade including the latest shade VH60-95. Older shades were made for the 3-in. size only. The 3- or 4-in. sizes can be used in the new shades made since 1991. The larger 4-in. sizes must be used with wide angle lenses, long telephotos, and the 110 mm Planar. The 3-in. size can be used for lenses from 60 to 250 mm. The filters should be placed into gelatin filter holders.

SOFT FOCUS EFFECTS

Some images, especially portraits and fashion illustrations, can be more effective with a soft touch, which also suppresses undesirable details and reduces the need for retouching afterward. Only a slight diffusion is necessary for this purpose. A soft focus effect can be produced with special soft focus lenses that used to be available for film photography or with filters placed in front of the regular sharp camera lenses. Using filters makes more sense because they can be used on different lenses, and different filters can produce different degrees of softness. A soft touch can also be produced in the computer to a sharp digital image or to a film image after it has been scanned. While computer manipulations allow you to experiment with the type and degree of sharpness, I still like to suggest considering the Softar filters on the camera lens because I feel that the Softars produce an exceptionally beautiful softness. The Softars are made only for V system lenses.

The Softar Filters

The Softars produce the softness not by blurring the image but by producing sharp images with diffused outlines with the highlights bleeding into the shaded areas. Good soft focus images must not give the impression of unsharpness. Our eyes are not accustomed to seeing blurred things. We always expect to see something sharp, whether we look at the actual subject or a photographic image. Softar images still have the appearance of sharpness (see Figure 17-11). The Softars also produce the same degree of softness regardless of what lens aperture is used. This is important because you want to set the lens aperture for the desired depth-of-field, not for the degree of softness. Some filters made by other companies produce a large degree of softness with the aperture wide open and an almost sharp image when closed down as soft focus lenses do. This is an unacceptable approach for serious photography.

With Softars you produce different degrees of softness with different filters: Softar #1 gives the minimum softness, my choice for most people pictures and Softar #3 the maximum with #2 falling somewhere in between. For most pictures, especially portraits and fashion shots, the slight softness of #1 or #2 is sufficient.

Soft focus images can be beautiful in the flat lighting of an overcast or foggy day or with the lighting from studio lights. The effect can be very striking on back-lit subjects or scenes where the diffusion filter creates a sort of halo effect around every highlight in the scene or subject. Because the effect is produced by bleeding the highlights into shaded areas, the bright areas may produce a halo that can look disturbing against a dark background. Avoid or reduce this effect by photographing against a lighter background, photographing from a different angle, changing the lighting setup, or changing to a weaker soft focus filter.

The Softar filters are made from an acrylic material and should never be cleaned with lens cleaning fluids or other chemicals. The Hasselblad Soft filters in square shapes for use in the Professional Lens Shade produce a very similar effect as the Softars. The different degree of softness is created with different filters and is the same at different lens apertures.

Figure 17-11 Glamour in wedding photography. This is a wedding portrait that beautifully conveys the romance of the wedding day. The diagonal composition makes a moving image different from the ordinary portrait. The out-of-focus flowers on the left keep the eye in the picture focused on the beautiful face and eyes of the bride. This is photographed with a Softar filter on the lens. (Photo by Andy Marcus.)

VISIBLE AND INVISIBLE LIGHT

The light that is visible to the human eye has wavelengths from about 400 (violet) to about 700 nm (red). Beyond the red is infrared radiation, which is not visible to the eye but can be recorded photographically as discussed in Chapter 3 and at the end of this chapter. At the other end of the spectrum, beyond the violet, is ultraviolet radiation, which is also used in photography. The ultraviolet wavelengths are divided into three bands: long wave (320–400 nm), middle wave (280–320 nm), and short wave (ultraviolet 200–280 nm). Figure 17-12 illustrates the wavelength spectrum.

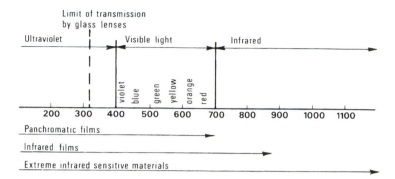

Figure 17-12 The wavelength spectrum. Visible light extends from 400–700 nm; infrared radiation has wavelengths above this, and ultraviolet has wavelengths below it. Panchromatic emulsions record radiation up to about 730 nm, infrared films up to about 880 nm, and extreme infrared materials beyond 1000 nm. Ultraviolet light, at the other end of the spectrum, is recorded on regular emulsions. Glass transmits radiation down to about 320 mm.

Ultraviolet and Fluorescence Photography

In ultraviolet photography, the subject is illuminated with UV light and photographed through a filter, such as the Kodak 18A, that absorbs all the visible light. UV photography is used mainly in the scientific field for the examination of altered documents, engravings, tapestries, paintings, sculptures, etc. Regular film and lenses can be used for photography in the longer wavelength ranges. Special lenses made from quartz elements are necessary when working in the shorter ranges. Such a lens of 105 mm focal length made by Carl Zeiss used to be available for Hasselblad V system SLR cameras.

Fluorescence photography means photographing objects and materials that fluoresce when subjected to UV light, such as a black light (BLB fluorescent tube). The radiation reflected from the subject is visible to the eye and can be photographed on regular films or with digital cameras and with regular camera lenses. A UV filter is recommended on the lens. The often brilliant and striking colors call for color film in film photography. Exposure can be determined with a handheld or built-in meter, but test exposures are suggested.

Electronic flash is another light source for fluorescence work. A filter that absorbs most of the visible light, such as a Kodak 18A, must be placed over the flash unit.

Infrared Photography

Infrared radiation has important applications in scientific photography. There are also exciting possibilities for the experimenting photographer to produce images with unusual tonal renditions on black and white film. For most photographic purposes, wavelengths from 700 to about 900 nm are used.

Almost all light sources used in photography, including daylight, can be used for infrared work. The photography can be done with digital cameras as discussed in Chapter 3 and at the end of this chapter. Film photography must be done on special infrared films, which

unfortunately are not easy to find or do not exist for medium-format cameras. Most infrared black and white photography is done with a red filter on the lens.

Lenses and Focusing

All photographic lenses transmit infrared radiation and are therefore usable. With infrared color films, the lenses are focused normally because the image is created by a combination of infrared and visible light. With infrared black and white film, focus the lens, manually or automatically, as usual based on the image on the focusing screen. Before you take a picture, read the distance setting on the lens, and move this setting opposite the red infrared index, which is engraved on all H system lenses and on all newer lenses in the V system. This adjustment moves the infrared image on the image plane. Figures 17-13 and 17-14 show how to focus for infrared photography. Focusing with H cameras is discussed in Chapter 3.

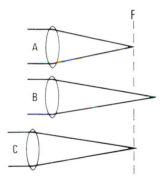

Figure 17-13 Focusing in infrared photography. Infrared radiation (B) forms an image farther from the lens than the visible light (A). The image on the image plane (F) is therefore out of focus unless you compensate for this by moving the lens forward (C).

Figure 17-14 Infrared focusing index. When using a lens with an infrared index, focus the subject visually and read the distance (a) opposite the white index (infinity in this case). Turn the focusing ring so that the distance (infinity) is opposite the red infrared index (b).

The 250 mm Sonnar Superachromat in the V system is chromatically corrected for infrared radiation up to 1000 nm so that the infrared image is formed at the same plane as normal wavelengths. A focus adjustment is not necessary. The image quality in infrared work and in ordinary black and white photography, especially with red filters, is also improved.

Infrared Photography with Digital Cameras

Digital cameras and digital backs have an infrared filter over the sensor to prevent infrared light rays from reaching the sensor. Infrared photography cannot be done without removing the

filter, which, in the case of Hasselblad, can be done at the Hasselblad service centers. This conversion done at the Hasselblad service center also involves recalibrating the sensor position for the image distance without the filter and cover glass. The infrared filter must be re-attached over the sensor for regular photography. Some Hasselblad photographers have used a converted camera without the infrared filter for general photography by placing an infrared blocking filter such as BG 39 over the lens. This filter eliminates the infrared rays before they enter the lens.

Electronic Flash in Digital and Film Photography

ELECTRONIC FLASH PHOTOGRAPHY

Electronic flash, produced by large studio lights or compact units attached to the camera or as part of the camera itself (on the Hasselblad H camera models) is the most common light source for digital or film photography. Electronic flash produces no heat; the duration of the flash is short, which reduces the danger of blurred images; and the color temperature matches that of normal daylight so the two can be combined in color photography.

ON-CAMERA FLASH

A flash unit built into the camera or mounted directly on the camera offers the greatest camera mobility in location work. The flat front lighting is satisfactory for candid and news photography and for fill flash work outdoors. The best position for a camera flash is directly above the lens, preferably 6 to 12 in. above the lens at least for indoor work. The higher placement casts the shadows behind and below the people, where they might not be seen, and also eliminates red eye, the cause of which is illustrated in Figure 18-1. The red eye problem has been reduced or eliminated in digital work since it can easily be corrected during image manipulation.

Because flash is usually used outdoors as a weak secondary light to fill the shaded areas, a unit right above the lens or built into the camera, produces a completely satisfactory fill light without red eye.

Flash Units

The type and size of the required portable flash unit are determined by the amount of light that is needed and the number of flash pictures that need to be taken. A small portable flash with built-in batteries or the unit built into the H cameras produces sufficient light for fill flash pictures of people outdoors since they are usually made at larger apertures to blur the backgrounds. Such a compact unit is also sufficient for indoor work within about a 15-foot (5 m) range. Larger flash units are needed to photograph larger groups or room interiors.

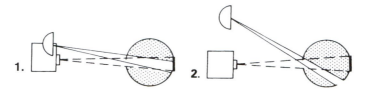

Figure 18-1 Red eye. (1) Red eye is caused by the flash light being reflected off the blood-filled retina. (2). You can avoid this by placing the flash farther from the camera lens so that the retina is shaded.

A larger unit, perhaps with a separate battery pack, is recommended when a large number of flash pictures need to be made requiring more battery power.

The brightness of portable units is indicated in guide numbers, which are based on the ISO setting that is used. Most companies quote the guide number for 100 ISO. The guide number tells you at what distances the flash must be used for the various lens apertures and can also tell you the maximum working distance. Divide the guide number by the distance. For a guide number of 42 and an 8 foot distance, the aperture is 5.2 (f/5.6) the maximum distance for f/2.8 is 15 feet. Guide numbers are given either in feet or in meters, so you must work with the same units for the conversion. At any distance, the flash exposure is determined by the lens aperture (see Figure 18-2) regardless of the shutter speed.

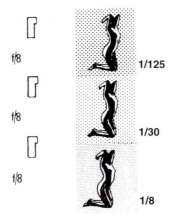

Figure 18-2 Flash exposure. Because the flash duration is likely shorter than the shutter speed, exposure for flash is determined only by the aperture. Exposure for the flash is the same at any shutter speed within the shutter's synchronization capability.

Flash Operation

Portable flash units can be made for manual mode, automatic mode, dedicated mode, or a combination of the three. Modern units, including those built into cameras offer dedicated operation the most logical approach to flash photography.

In manual flash, lens apertures must be manually matched to the flash distance and must be changed when the flash is moved closer or farther away. This approach is time-consuming and should be considered only in special situations.

In automatic flash, a sensor built into the flash unit measures the light reflected off the subject and then determines the flash duration that provides correct exposure and turns off the flash at the proper time. Automatic flash eliminates the need for matching aperture to flash distance. You only need to set the aperture value on the unit and you can then move closer or farther away without any additional adjustments. Automatic flash is a good choice when a dedicated flash system is not available. Dedicated flash should, however, be the choice for all location flash photography indoors and out with Hasselblad camera models that offer dedicated flash.

DEDICATED FLASH

In dedicated flash, the flash exposure (the flash duration) is determined by a sensor built into the camera, which measures the light reflected off the image plane (OTF). This can be the film surface or the surface of the digital imaging sensor. The flash sensor in 503 and other V system and in H system cameras measures the light reflected off a 40 mm center area of the image plane. Visualize the measured area when composing the image on the focusing screen to ascertain that the main subject that must have the proper flash exposure is within that 40 mm center area.

For dedicated operation, flash unit and camera must be electronically interfaced requiring flash units or adapters that are made for a specific camera system.

The Advantages of Dedicated Flash

Dedicated flash can provide better exposures and allow faster shooting while eliminating mistakes for the following reasons:

- The sensor measures the light that actually reaches the image plane in the camera.
- The metering is based on the selected lens aperture, and you can change the aperture without making any other adjustments.
- With the light measured through the lens (TTL),the measured area is matched to the focal length of the lens.
- With any lens on the camera, you can visualize the area measured by the flash sensor when you compose the image on the focusing screen.
- The metering works with direct or bounced flash, whether the flash is on or off the camera.
- You need not compensate when using filters, teleconverters, or extension tubes.
- The ready light may be visible in the viewfinder, so you know when you can take a second picture without removing your eye from the finder.
- An exposure signal may show after the picture whether the image area received a sufficient amount of light for correct exposure.
- The brightness of the flash can be adjusted to create any desired lighting ratio between the flash and existing light.

Dedicated Flash Exposures for Film and Digital Imaging

Although dedicated flash provides consistent exposures in the simplest possible way, there are a few facts you must know and understand to obtain the best possible results.

The sensor in all Hasselblad dedicated flash cameras measures the light reflected off a 40 mm center area of the image plane. The subjects that need to be properly exposed by the flash must be in that center area, as is usually the case. This is seldom a problem because the measuring area is rather large.

At present the Hasselblad dedicated flash systems are adjusted for the reflectance value of film surfaces (OTF). There are slight differences in films, but they are small and need not be considered. Nevertheless, you may want to make your own test with the film that you are using. In digital imaging, the flash light is reflected off the sensor which has a different reflectance value than films. You need to make the recommended adjustment of $1^2\!/_3\,f$ stops but evaluate the histogram carefully as sensors may differ and change. This compensation is not required when using a Hasselblad digital back on the H camera. The camera adjusts automatically for the difference in reflectance values. This is discussed further a little later in this chapter under Dedicated Flash in Digital Imaging.

Subject Color and Brightness

The flash sensor in a dedicated or automatic flash system is adjusted for 18% reflectance and produces perfect exposures only when the subject reflects 18% of the light, as the colors in the 0 column on the chart (Figure 15-6) in the exposure section do (see Figure 18-3). The subject brightness must be considered if the subjects within the 40 mm flash metering circle

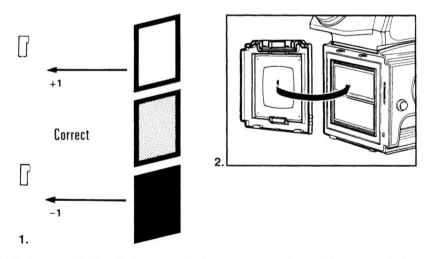

Figure 18-3 Flash tests. (1) The flash sensor in the camera is adjusted for 18% reflectance. Bright subjects turn the flash off earlier, creating underexposure; dark subject areas do the opposite. (2) The new Hasselblad rear covers have a center area that reflects the same amount of light as the film and can be used for checking whether flash illumination is sufficient.

are much darker or much brighter. This does not happen too often and does not need to be considered too seriously when the flash is used as a fill-in light. Usually the measuring area includes an arrangement of many brighter and darker shades, even in wedding photographs, but you should be aware of this fact as it may come up, for example, in copying. You can adjust for differences in the reflectance values by setting the ISO to a lower value for brighter subjects and to a higher value for darker ones. You can also use the flash compensation control. A -1 setting turns the flash off earlier than 0 to compensate for the lower reflectance of darker subjects.

Dedicated Flash in Digital Imaging

Most dedicated units are still based on the film reflectance and need a correction for the different reflection values of the sensors. On the 503CW and 503CWD camera models dedicated flash can be used by setting the ISO on the camera $1\frac{2}{3}$ f stop higher than the ISO set on the digital back; for example, to ISO 160 for an ISO 50 setting on the digital back. Evaluate the results on the histogram. When dedicated flash is used with H3D camera models the letter D appears in the flash menu on the LCD display and the camera automatically makes the adjustment for the different reflectance value of the digital sensor.

Rather than compensating for the digital sensor, some professionals have found that the automatic setting on the flash unit works beautifully. In this case the sensor in the flash unit determines the length of the flash duration. Set the aperture on the lens. Set the flash to automatic and for the aperture set on the lens. When changing the lens aperture, you naturally need to change the aperture setting on the flash also, something that is unnecessary in dedicated use.

FLASH PHOTOGRAPHY WITH H CAMERA MODELS

Flash Units

The eye-level viewfinder of the H camera is equipped with a built-in flash unit (Figure 18-4) with a guide number of 12 (for meters) or 40 (when distances are measured in feet) good enough for family pictures indoors or as a fill light outdoors. The flash illuminates an area within a 56-degree angle horizontally and 44 degrees vertically, producing even illumination with lenses 80 mm and longer. The unit works in dedicated fashion with the light measured from a 40 mm center area on the image plane.

Other shoe mount units can be mounted on the flash shoe. To work in dedicated fashion, they must be specially designed for the H camera. Currently, only flash units compatible with the SCA3002 system from Metz can be used and are used in combination with the Hasselblad SCA3902 adapter made specifically for the H camera. Do not use flash units dedicated to other cameras as damage can occur either to the camera or to the flash. You can identify a dedicated flash by having more than one contact pin at the bottom of the flash shoe. With handle mount flash units in the SCA3002 system, attach the control unit from the flash to the Hasselblad SCA3902 adapter, which is mounted to the viewfinder hot shoe. As usual, flash units used in dedicated fashion are set to TTL.

Figure 18-4 Viewfinder controls. Bring the flash in the operational position by sliding the catch lever (lower illustration) toward the flash symbol. Pressing the flash unit downward closes it. The top illustration shows from left to right the diopter correction wheel, the Exposure Adjustment button, and the Exposure Mode/Light-Metering Mode button.

When using an H camera with a digital back, you can use the TTL metering in exactly the same way as with film. The difference in the reflectance value is automatically taken care of so you need not make an adjustment. Dedicated flash is therefore the recommended approach for location work also for digital capture.

Shutter Speeds, Flash Sync, and Metering Modes

Flash photography can be done at all shutter speeds up to $\frac{1}{800}$ second and in many situations you can also use all measuring modes (certainly M, P, Pv, and S). The A and S modes are not recommended for indoor flash work as the normally dark room light may set a long shutter speed that is unsuitable for handheld work. The P and Pv modes are usable because they set the shutter speed at $\frac{1}{60}$ second or shorter.

You can program the H camera so that it can be released only when a dedicated flash is fully charged (see custom options in Chapter 4). You also have the option of programming the camera so that the flash exposures are made at the moment the shutter is fully open, as normally done (normal sync), or just before the shutter closes (rear sync). This sophisticated option which offers interesting possibilities with moving subjects is done with the rear wheel after pressing the flash button which brings up the Flash Option screen.

You can also program into the camera a flash compensation from $+3$ to -3 EV values to create any desired lighting ratio between the existing light and the flash. The advantages

are described later in this chapter under the section Electronic Flash for Photographing People Outdoors. With non-dedicated units, change the flash exposure by setting the ISO on the flash unit to a higher or lower value; for example, to ISO 400 if the flash illumination is to be reduced two EV values with ISO 100.

Flash Photography with the H Camera

Setting the Flash Exposure
For dedicated flash photography with the built-in or a different flash unit with the SCA3902 adapter, follow these steps:

1. Activate the camera and then press the Flash button. This brings up the Flash Option screen.
2. Turn the front control wheel to set the desired compensation from −3 to +3 in ⅓ increments.
3. Turn the rear control wheel either for normal or rear sync.
4. Lock the setting by pressing the ISO/WB (Drive) button.

In dedicated flash photography, insufficient flash illumination is indicated on the display and in the viewfinder by LOW FLASH. A flash illumination that is excessive for the set aperture is not indicated because it only occurs in close-up photography and if so, the histogram shows the unsatisfactory results. An unusable setting is indicated by a red warning triangle and the message LOW FLASH on the viewfinder LCD display (see Figure 18-5).

Figure 18-5 The viewfinder and grip LCD information in flash photography. The viewfinder display (A) shows that the flash mode was set for rear flash and that the flash exposure is reduced by one EV value. If flash illumination is insufficient, a red triangle appears in the viewfinder together with a flashing green flash symbol (B) and LOW FLASH appears on the grip LCD display. (C) The green flash symbol also flashes when a flash unit is not fully charged. In flash metering, an incorrect aperture is indicated by LOW or HIGH EV value on the display. (D) The display also reminds you to use the AE lock.

Flash Measuring

The center area of the H camera's auxiliary shutter has a reflective center area that can be used for obtaining exposure readings for other flash units; for example, studio flash. The H camera then serves as a flash exposure meter. This is done as follows:

1. Set the flash unit to Manual.
2. Press the Flash button.
3. Turn the rear wheel until FLASH MEASURE appears.
4. Click the Save ISO/WB (Drive) button to see the flash measure screen.
5. Set the aperture to a value based on your first guess.
6. Aim the camera at your subject, and click the AE-L button at the rear of the grip. This fires the flash with the aperture closed down and the mirror locked up so that the light of the flash can reach the measuring area on the auxiliary shutter to be measured by the sensor in the camera. If the set aperture was incorrect by more than two EV values, the screen shows DIFF EV LOW or DIFF EV HIGH. Open or close the aperture, and make another test until the screen shows a value between −2 and +2 EV. Now use the aperture (the front wheel) to set the value to zero or to any desired deviation from zero. The aperture is now set to produce the desired exposure.

Separate flash units are connected to the camera either through the input socket on the left side of the camera body or through the hot shoe accessory holder.

DEDICATED FLASH WITH 503 AND OTHER V SYSTEM CAMERA MODELS

Hasselblad 503, ELX, and ELD models and all 200 camera models have dedicated flash capability and are used together with a flash adapter. The Hasselblad flash adapter SCA390 works with flash units based on the SCA300 system, which is common on European flash units. Some flash manufacturers make adapters for use with Hasselblad V system cameras. The Hasselblad D-Flash 40 can be used in a dedicated fashion on all dedicated flash V system cameras without an adapter.

When 503 and ELX or ELD models are used for dedicated flash, the ISO is set on the flash dial on the side of the camera body (see Figure 18-6). The dial is engraved in ISO values only. To convert to DIN, use the conversion chart in Table 18-1. This dial is operative only in dedicated flash operation. With manual or automatic flash, the film sensitivity must be set on the flash unit.

Camera-Flash Connections with 503 and Other V System Cameras

The Hasselblad D-Flash 40 and the earlier Pro Flash, both made for use with Hasselblad only, have all the necessary electronic interface components built into the unit. Other flash units are used with an adapter with the Hasselblad dedicated flash system in V system cameras and are set to TTL (see Figure 18-7).

The six-pin connector on the cable from the adapter is connected to the receptacle on the side of the camera. If the focal plane shutter in 200 cameras is used for the exposure, no other connection is necessary. The 200 cameras can be used for flash in all exposure modes, but the shutter speed must be $1/90$ second or longer.

Figure 18-6 ISO setting. When dedicated flash is used, the ISO on the 503, 553, and 555 cameras is set by turning the control (A) above the accessory rail until the desired rating is opposite the index. A six-pin connector (B) attaches to the dedicated flash socket on all Hasselblad camera models. The socket is in different locations on different camera models.

Table 18-1 ISO/DIN Conversion Chart

ISO	15	25	50	100	200	400	800	1000
DIN	13	15	18	21	24	27	30	31

If the lens shutter is used on any camera, you must also attach a sync cable going from the flash unit or flash adapter to the sync contact on the lens to synchronize the flash with the shutter in the lens (see Figure 18-8). With a portable or studio flash unit used in the automatic or manual mode (non-dedicated), you only need to connect the sync cable to the sync contact on the camera, if the focal plane shutter is used, or to the sync contact on the lens when the lens shutter is used for the exposure.

V System Camera Operation with Flash

Regardless of how you use the flash, always set the desired aperture and shutter speed on the lens or camera, keeping in mind that the focal plane shutter on 200 cameras must be set at $\frac{1}{90}$ second or longer. If set to a shorter speed, the flash will not fire, a warning will appear in the viewfinder, or the picture will be made automatically at $\frac{1}{90}$ second, depending on the 200 camera model.

Ready Light and Exposure Signal

In the Hasselblad 503 and all other V system cameras designed for dedicated flash, the flash ready light is visible in the camera's viewfinder as either a green flash symbol (in 200 cameras) or a red light on the left side of the focusing screen (on 500 models; see Figure 18-9). The red light also becomes the exposure signal flickering for about two seconds after the flash fires,

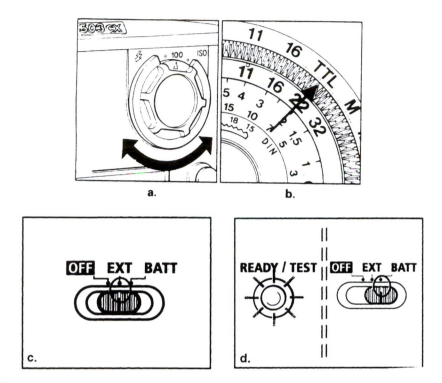

Figure 18-7 Flash settings. With the ISO set on the camera (a), the flash dial is set to TTL (b). This is unnecessary on the Hasselblad D-Flash 40. This unit simply needs to be turned on for either built-in or external battery use (c). The ready Light/Test button is near the ON/OFF switch (d).

indicating a sufficient amount of light. If it does not flicker, you must open the aperture, move the flash closer, or change the ISO. On the 200 model cameras, a flickering signal, LO FLASH, appears on the display immediately after the picture is made, indicating that the flash illumination was insufficient. HI FLASH appears on the display if the light is too strong.

FLASH FOR PHOTOGRAPHING PEOPLE OUTDOORS DIGITALLY OR WITH FILM

Electronic flash is an ideal light source to combine with daylight. Portraits, fashion shots, publicity pictures, and family snapshots are very beautiful when sunlight is used as a backlight or sidelight, which places highlights on the hair, the shoulders, the faces and the cheeks of the people photographed. The contrast between the lighted and shaded areas, however, will usually not produce a flattering result. You must reduce the contrast by adding light to the shaded areas. Electronic flash is ideal. It not only lightens the shaded areas but also brings some light and life into the eyes and improves the colors in people pictures taken in the shade or in the soft light of an overcast day (see Figure 18-10). When you photograph in the warm early morning or late afternoon sunlight, place a warming filter over the flash to match the warm sunlight. Since most location people pictures are done at larger apertures to blur the

Figure 18-8 Flash connections. For dedicated operation of V system cameras, the six-pin cable from the flash unit or adapter goes into the six-pin socket on the camera body (b). When the lens shutter is used, the sync cable must also be connected to the PC socket on the lens (a). When non-dedicated flash is used with the focal plane shutter, the sync cable is connected to the PC socket on the camera (c). To insert the dedicated flash cable, rotate the cable to match the grooved parts. Push the plugs straight into the socket, pushing at the flat top on the L-shaped type (d). Grip at the metallic sleeve to disconnect.

background, you do not need a large flash unit for this type of photography. The unit built into the H cameras is ideal for this purpose.

Selecting Camera, Lens, and Flash Settings

Location people pictures are a combination of flash and daylight, and they are most effective when the two light sources are combined in a natural looking fashion with the flash as a secondary light source, not the main light. Start by metering an important day-lit area that is behind or surrounding the people using your normal metering approach. Based on the meter reading, set the aperture and shutter speed that you feel produces the desired results for the day-lit area.

Determining and Changing the Flash Exposure

For most portrait, wedding, fashion, and family pictures you want to make the flash a secondary light source to lighten the shaded areas and perhaps bring a little light into the eyes. The best flash fill pictures are usually those in which you are not aware that flash was used.

Figure 18-9 Ready light. In the 200 camera models with built-in metering systems, a green flash symbol on the viewfinder display indicates when the flash is ready to be fired (a). A HI FLASH or LO FLASH warning appears after the picture is made if the flash illumination was excessive or insufficient (b). On the other camera models, the ready light is visible at the edge of the focusing screen (c). It flickers after the exposure if the film received a sufficient amount of light.

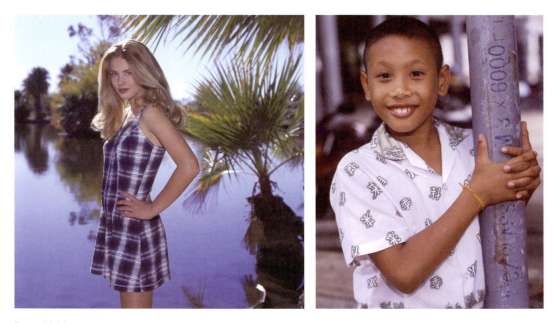

Figure 18-10 Fill flash outdoors. In an outdoor portrait with the sunlight used as a backlight or sidelight, the flash must be reduced so it just brings a little light into the face and eyes without looking like a secondary light source. In the candid picture in a shady location in Thailand, a touch of flash was added just to brighten the eyes and face of the smiling boy. (Photos by Ernst Wildi.)

You do not want to use the flash at its full power that would produce correct exposure for the setting. You want to reduce the brightness to underexpose the areas to be filled in. Reduce it the equivalent of at least one *f* stop for publicity pictures where it is important to see what the person looks like, and maybe even two or three *f* stops for beautiful portraits. I have found a reduction of between two and three *f* stops most satisfactory for this purpose.

This reduction in the flash exposure can be done beautifully in all Hasselblad dedicated flash systems without changing the exposure for the existing light. The flash is reduced on H cameras by programming the desired compensation with the front wheel with the values visible on the Flash Option screen.

Reducing Flash Exposure in 200 Model Cameras

On the 200 camera models you use the built-in meter as usual to determine the lens settings for the daylight. Then program the desired flash exposure into the camera as follows. Set the mode selector to Pr, and press the AE lock repeatedly until the flash function shows up on the viewfinder display. (Figure 18-11). You can now program into the camera flash exposure values from +1 to −3 by pressing the minus or plus adjustment buttons. The values are set in ⅓ stop increments on the 202 and 203 models and in ¼ stop increments on the 205. You will probably find that flash values from −1⅓ or −1½ to −2 or −2½ provide natural results with sunlight from the side or back. Set it to the desired value. It remains programmed into the camera until you change it or the battery is removed.

Figure 18-11 Setting the flash exposure. On 200 cameras with a built-in metering system, the flash exposure is set with the mode selector in the Pr setting. A 0 indicates no reduction in the flash (a). On the 202 and 203 cameras the values are set in ⅓ stop increments, −⅔ in (b). The settings are in ¼ stops on the 205, −2½ in (c).

Reducing Flash Exposure in 503 and Other V System Cameras

On the Hasselblad 503 and other V system cameras offering dedicated operation, reduce the flash by setting the ISO flash dial on the side of the camera body to a higher value. Set to ISO 400 with an ISO 100 daylight setting reduces the flash exposure by two stops. The exposure for the existing daylight is the same since the aperture or shutter speed setting was

unchanged. With non-dedicated flash, exposure is reduced in the same fashion but by changing the ISO setting on the flash unit set for manual or automatic operation.

Fill Flash Used as a Main Light

Flash offers wonderful possibilities outdoors not only as a fill light on sunny days, but also as an additional light on overcast days or in shaded areas, perhaps in nature photography. In such cases the flash becomes the main light and can be most effective if removed from the camera and placed as a sidelight or a backlight using a long sync cable. The flash adds life, gives the impression of sunlight, produces better colors, allows you to work at smaller apertures, and can reduce the likelihood of blurry pictures due to camera or subject movement.

Combining Flash and Existing Light Indoors

In many indoor flash pictures, you probably want to make the room a part of the picture either because the room is beautiful, a ballroom, a church, a restaurant, a museum, or a beautiful home, or just because it looks more natural than having people surrounded by darkness. Use the same approach as discussed for outdoor people pictures by taking a meter reading of the important part of the interior and set aperture and shutter speed accordingly. Since people indoors are more likely the main subject, reduce the flash just slightly (at the most the equivalent of $\frac{1}{2} f$ stop) or not at all.

As the existing light in most indoor locations is limited, you may have to use a tripod. Do not hesitate to use slower shutter speeds than you normally do, because the short flash duration reduces the danger of blur due to camera motion becoming objectionable or even visible at least in the flash-lit subjects. This approach is not necessary when the people are right in front of a background, only when they are in the middle of a room which visually produces a more beautiful picture.

Ghost Images

When flash is used with a moving subject in surroundings with sufficient ambient light, we can produce interesting images consisting of a sharp image of the moving subject surrounded by blurred streaks, conveying the feeling of motion. A dancer photographed at $\frac{1}{8}$ second, for example, can have just enough blur in the moving arms or legs to indicate the motion while at the same time showing sharp details in the dancer's body. A basketball player photographed at $\frac{1}{30}$ second can produce the same results. The shutter speed must be long enough to produce a blur, and the aperture must be set to produce the desired exposure of the existing light.

PRODUCING BETTER FLASH ILLUMINATION

The flash head on built-in and on most portable flash units is small, producing a directional light with sharply outlined shadow lines. You can soften the light and produce people pictures

that look more like those taken in a studio by increasing the size of the light source. For location work, you can add a small soft box, available in sizes up to about seven inches, to the front of the portable flash unit. The box reduces the light somewhat but this loss is more than compensated for by the beautiful results. The portraits no longer have the typical snapshot flash look.

SOME TECHNICAL POINTS

Checking Flash Sync

After removing the magazine or digital back from any Hasselblad SLR camera and connecting the flash to the camera, look through the lens and check the flash synchronization (see Figure 18-12). Set the diaphragm and the shutter speed at the values to be checked. Point the camera, with the flash ready signal lit, toward a light wall. Place your eye behind the rear of the camera and trip the shutter. If you see the flash firing through the fully open shutter, the flash is synchronized. Check different shutter speeds if desired.

Flash Firing Failures

If the flash does not fire, first check the ON/OFF switch. Check whether the ready light is on. Ensure that focal plane shutter cameras are set at $\frac{1}{90}$ second or longer. Check that sync cables are in good order and properly connected. Try another cable. If a contact feels loose, gently squeeze the contact with pliers into an oval shape, thereby making a firmer connection on two sides. The PC contacts on the latest lenses include a cable locking device that makes such separation almost impossible (see Figure 18-12).

Dedicated Flash with the 205TCC

The original 205TCC (not the FCC model) automatically changes to a "flash mode" when the ready light in dedicated flash appears. The display shows the shutter speed physically set on the shutter speed ring, not the one calculated by the meter, and the exposure is made at the set speed. Use the camera in the Manual (M) mode with the shutter speed preset.

Studio Flash for Digital Photography

All flash units produce a voltage through the sync cable when the flash is triggered. Hasselblad equipment is built to the ISO standard 10330, which means that there should be no problems with any known brand of flash equipment and no special operating procedures are required. Should you have any doubt, perhaps with unknown brands, do not connect the flash directly to the digital unit or make certain that the flash unit is grounded to avoid possible damage to the digital unit, which is not covered by the warranty. If you like to avoid any possible problems completely, make the connection to the flash unit via a remote slave triggered by a radio or infrared signal rather than direct.

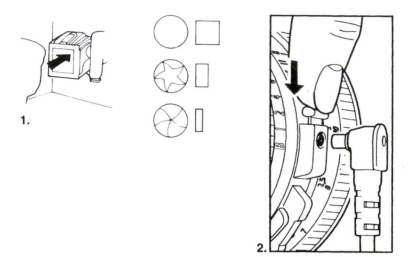

Figure 18-12 Checking flash sync. (1) To check flash synchronization, look through the back of the camera while releasing the camera with the flash attached. You should see the flash firing. For a complete check, test at all shutter speeds. (2) The PC contacts on the latest V system lenses include a locking device.

HASSELBLAD FLASH UNITS

The Hasselblad D-Flash 40

The Hasselblad D-Flash 40 flash unit (see Figure 18-13) is compact and lightweight and has a guide number of 137 (40 in meters) in the N reflector position and 110 (33 in meters) in the W position. The unit is designed for the dedicated flash system in V camera models only. The flash reflector can be moved either to N for lenses 80 mm and longer or to W for use with shorter focal length lenses. The reflector can also be removed for bare bulb use.

The power for the flash can come from five AA batteries, five rechargeable AA NiCads, or an external accessory power pack. The number of exposures per charge is 120 to 1200 from regular AA batteries, 45 to 450 from rechargeable AA types, or 270 to 2250 from the external power pack. The actual number of flashes always depends on the distance between flash and subject.

Other Flash Units

The Hasselblad Pro Flash, the forerunner to the D-40, can be used on Hasselblad and other cameras in the manual or automatic fashion. Shadowless lighting is obtained when light of equal intensity reaches the subject from all directions. Such lighting is produced by a ring-light. The Hasselblad macro flash consists of two small flash units mounted on a bracket around the lens for practically shadowless lighting in close-up photography.

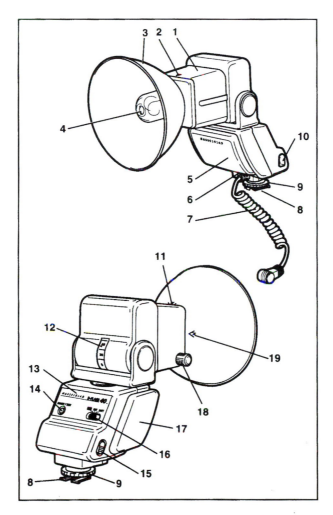

Figure 18-13 The D-Flash 40 operating controls: (1) tilt and swivel head, (2) index mark, (3) adjustable reflector, (4) flash tube, (5) flash body, (6) sync cord jack, (7) sync cord, (8) flash mounting plate, (9) locking nut, (10) external power connection, (11) W indication, (12) tilt scale, (13) model designation, (14) ready light and discharge button, (15) battery cassette latch key, (16) ON/OFF switch and power selector, (17) battery cassette, (18) reflector locking knob, and (19) N position.

Close-Up Photography on Film or Digital

■ ■ ■ ■

CLOSE-UP PHOTOGRAPHY IN DIGITAL IMAGING AND FILM PHOTOGRAPHY

Lenses and close-up accessories form the image on the sensor of a digital camera or digital back in exactly the same way as they do on film, therefore,the techniques discussed in this chapter apply whether you work with film or digitally.The image size recorded digitally with Hasselblad is however different from the image size recorded on film and magnification factors and everything related to it is therefore also different.This topic is discussed in more detail at the end of this chapter where I describe the use of the close-up charts.

For successful close-up photography, it is helpful to understand how lenses form the image in addition to learning how close-up accessories work and how they must be used to obtain the desired results. Close-up photography, however, also has become easier since lens technicians can design lenses with internal focusing that allows you to photograph from infinity down to life-size magnification without the need for any type of close-up accessories. The HC Macro 4/120 in the H camera system offers this possibility.

Figure 14-18 in Chapter 14 shows how the lens elements are moved when focusing from infinity to the minimum focusing distance.The internal focusing either does not change or minutely changes the physical length of the lens when focusing, another benefit of such a lens design.

LENSES AND ACCESSORIES IN CLOSE-UP PHOTOGRAPHY

If you work with, or plan to purchase the HC 4/120 Macro lens, you do not have to read this section on extension tubes or consult the close-up charts at the end of the chapter.You can photograph with this lens from infinity down to life-size magnification without using any close-up accessories. Simply compose the image in the viewfinder, use the automatic focusing to set the distance, and determine the exposure with the built-in meter as you usually do when you work digitally or with film.The information in this chapter, however, will be helpful or necessary for successful close-up work with any other lens in the Hasselblad H or V camera system.

All lenses in the Hasselblad H and V system can be focused down to a certain minimum distance, which depends mainly on the lens design and the focal length of the lens. All of these lenses can be used at closer distances in combination with close-up accessories. Extension tubes are the recommended accessories for this purpose, because they increase the image distance by moving the entire lens further from the image plane.The closer you

want to photograph, the farther away the lens needs to be moved. The length of the tube required to cover a specific area is determined by the focal length of the lens. The longer the focal length of the lens, the longer the required tube. With extension tubes the lenses cover a smaller area but the image is formed in the same way as at longer distances (see Chapter 14). You can cover the same area from different distances with different focal length lenses. The distance between the lens and the subject then determines the perspective with three-dimensional subjects. Different focal length lenses cover different background areas and more or less blur the background (also discussed in Chapter 14).

Working Distance

The distance between the front of the lens and the subject in close-up photography is often called the working distance because it is really the distance within which you can work with the subject, if necessary. In some cases such as surgery you need a long working distance. In dangerous situations such as welding you want a long distance. Longer focal length lenses give this longer working distance. When working on a copy stand or in many other situations a shorter focal length is preferable to reduce the possibility of camera motion affecting the picture sharpness. You may also select a specific focal length lens, such as the 120 mm Makro-Planar in the V system as it is designed optically to produce the best image quality in close-up work.

Magnification

Magnification is the ratio in size between the actual subject and the size of its image recorded in the camera (see Figure 19-1). It is helpful to understand magnification as it determines

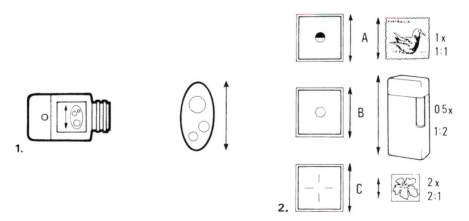

Figure 19-1 Magnification. (1) Magnification is the relationship between the size of the actual subject area and the size of this area recorded in the camera or seen on the focusing screen for the film or sensor size. (2) If the subject is about the same size as the image on the screen, we have 1:1 magnification (A); when the subject is twice as large we have 0.5, or 1:2, magnification (B). When we fill the screen with a small subject that is half as large as its image, we have 2×, or 2:1, magnification (C).

depth-of-field and exposure. The most practical way to determine magnification is to relate the size of the area covered to the size of the same area as seen on the focusing screen. With film, the latter is the full focusing screen area in H or V system cameras. In digital imaging, you must consider the masked down area that corresponds to the sensor size. In all cases magnification is the size relationship of the two. If you cover an area 110 × 147 mm on the 36.7 × 49.0 sensor, you have a 0.3× magnification. The image is one-third the size of the actual subject. Covering an area 367 × 367 mm on the 36.7 × 36.7 sensor means a magnification of 0.1×. If you cover a very small area of 16.5 × 22.1 mm on the 33.1 × 44.2 sensor, you double the size of the subject and have a 2× magnification.

Life-Size Magnification

Life-size magnification refers to recording a subject in the camera in its actual size, which means that the subject size is determined by the size of the sensor or film format in the camera. We have life-size magnification when a subject 36.7 × 49.0 mm is photographed with a 36.7 × 49.0 sensor. A smaller subject of 33.1 × 44.2 mm produces life-size magnification on the smaller 33.1 × 44.2 sensor.

Life-size magnification for the film format is obtained on the HC Macro 120 by setting the focusing ring at its maximum extension. With other lenses you always achieve life-size magnification when you add extension tubes that are equal in length to the focal length of the lens or close to the focal length; for example, 78 mm (H52 and H26 tubes combined) for an 80 mm lens. In life-size magnification, the subject distance is equal to the image distance with the total distance between subject and image plane 4× the focal length of the lens. The necessary exposure increase is 2 f stops, and the total depth-of-field at $f/11$ is about 2 mm (see Figure 19-2).

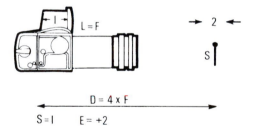

Figure 19-2 Life-size magnification. Life-size (1:1) magnification with extension tubes is obtained when the length of the extension tube or tubes (L) is equal to the focal length (F) of the lens (L = F). The distance from the subject to the image plane (D) is equal to 4× the focal length (D = 4 × F). The exposure increase (E) is always 2 f stops, and the depth-of-field at $f/11$ is about 2 mm. Life-size magnification can be obtained with the HC Macro 120 mm lens in the H system without any close-up accessories.

Depth-of-Field

As in long distance photography, depth-of-field is determined mainly by the lens aperture. Magnification is however also a determining factor in close-up work. Close-up photography

usually means covering a specific size area so the magnification is predetermined. You can, therefore, increase depth-of-field only by closing the lens aperture (or covering a larger area which means a lower magnification). Depth-of-field becomes about twice as large when you close the aperture two stops. At a specific magnification, depth-of-field is the same regardless of the focal length lens you use but unlike at longer distances where about one-third of the depth-of-field is in front and two-thirds behind the subject, it is more evenly divided at close distances. But as always, the blur beyond the depth-of-field falls off more rapidly with a longer focal length lens.

Because depth-of-field is determined only by the magnification and the lens aperture, we can make a simple depth-of-field chart that applies to all cameras and lenses. The chart in Table 19-1 is based on an *f*/11 lens aperture. Column A is for general close-up work based on a circle of confusion of 0.06 mm ($\frac{1}{400}$ in.), which is used for the calculations of the depth-of-field scales in the V system. Column B is for critical work based on a circle of confusion of 0.03 mm ($\frac{1}{800}$ in.). Depth-of-field scales and charts in the H system are based on a circle of confusion of 0.045 mm ($\frac{1}{600}$ in.).

Table 19-1 Depth-of-Field at Various Magnifications

	Total depth-of-field in mm at f/11	
Magnification	*A*	*B*
0.1×	100	50
0.2×	30	15
0.3×	15	7
0.5×	6	3
0.8×	3	1.5
1×	2	1
1.2×	1.5	0.7
1.5×	1	0.5
2×	0.8	0.4
3×	0.4	0.2

WORKING WITH EXTENSION TUBES

Extension tubes of different lengths can be used for close-up photography with the H and V system SLR Hasselblad cameras for digital imaging or film photography. The tubes have no optical components and are mounted between the camera and lens to increase the image distance. You can uses one tube or combine them for a greater extension.

A few basic facts about extension tubes are listed below.

- The longer the tubes with a particular focal length lens, the closer the distance at which you can photograph; consequently, the smaller the area coverage and the higher the magnification.
- Extension tubes of a specific length give a smaller area coverage and a higher magnification with shorter focal length lenses than with lenses of a longer focal length.
- You can cover the same area with a shorter focal length lens and a shorter tube or with a lens of longer focal length combined with a longer tube. The two differ in the working distance, the background coverage, and background sharpness.

Figure 19-3 Close-up beauty photography. Two attention-creating beauty close-up photographs that convey the possibilities and quality of Hasselblad digital close-up photography. Both images are made with Makro-Planar 120 mm in combination with extension tube 8 for the lips and extension tube 32 for the eye. (Photos by Sarah Silver.)

Determining the Length of the Extension Tube

The easiest way to determine the necessary length of the extension for a specific lens and magnification is from the Close-up Charts A and B at the end of the chapter. The charts for the H camera system show all the information for the lenses from 35–150 mm and the 50–110 zoom lens and for film and for the different sensor sizes. The HC Macro 120 mm is not included because it does not need extension tubes for higher magnifications. The V system charts are for the 80 to 250 mm lenses recommended for close-up photography but only for the film format. You will need to recalculate them for the smaller sensors as described under Using the V system Charts for Digital Imaging at the end of this chapter

Exposure

Correct exposure in close-up photography is obtained in the same way as at longer distances. When using a handheld exposure meter, make certain that the meter reading is based on the small area to be photographed. Taking the reading of the graycard held over the subject is often a good approach with reflected exposure meters. A metering system built into the camera or prism viewfinder offers a definite advantage because you can see exactly the area that is measured by the meter. You may still want to use a graycard in difficult subject situations.

A metering system built into a camera or prism viewfinder also eliminates the need for considering the increase in exposure. This is necessary when you move a lens away from the image plane which is done with extension tubes. Whatever the built-in meter says should be correct because the light is measured through the lens and extension tube. The close-up charts for the V system lenses show the necessary increase needed for handheld meters. The H system charts also show this adjustment although the built-in meter is undoubtedly used for this purpose.

OTHER CLOSE-UP ACCESSORIES

Teleconverters for Close-Up Photography

Because teleconverters increase the focal length of a lens while maintaining their minimum focusing distance, they can be used to cover smaller areas without the need to move closer to the subject. The Makro-Planar 120 mm lens, which covers an area about 8 inches (200 mm) wide at the minimum focusing distance, can cover an area as small as 4 in. (100 mm) wide when combined with a 2× teleconverter. The HC 2.8/80 mm in the H system covers an area 11 × 14 inches (27 × 36 cm) at the minimum distance. Combined with the H1.7× teleconverter the lens covers an area as small as 6¼ × 8¼ in. (16 × 21 cm).

A lens/teleconverter combination can also be combined with extension tubes. The tube or tubes are attached to the camera, and the lens/teleconverter combination is attached to the front of the tube or tubes. On the H camera and the HC lenses, image quality is slightly improved when the tube or tubes are mounted between teleconverter and lens. The teleconverter is now attached to the camera, the tube or tubes are attached to the converter, and the lens goes in front of the tubes. This arrangement also provides a somewhat higher magnification but may produce a somewhat higher light falloff at very high magnifications.

The same mounting arrangement can be suggested when the 2× extender is used in combination with the CFE 120 mm Makro-Planar.

Bellows and 135 mm Makro-Planar Lens

The bellows in the V system with a minimum extension of 63.5 mm (2.2 in.) and a maximum of 202 mm (8 in.) also allows moving the lens farther away from the image plane for close-up photography. The bellows has a coupling shaft to maintain the mechanical camera and lens connection but no electronic coupling. The meter reading in 200 cameras therefore must be made with the lens aperture closed down. The 135 mm Makro-Planar is designed with a special rear mount to bring the rear element closer to the image plane so the lens/bellows combination can be used for photography at all distances from infinity down to life-size magnification for the 2¼ film format. The charts in this book provide all the needed information for using the bellows with different focal length lenses for the 2¼ film format. For digital imaging the extension figures apply but the area coverage and magnification is somewhat different because of the smaller sizes of the sensors. They can be calculated as described for the V system close-up charts.

Close-Up Lenses

Any lens, fixed focal length or zoom type, can also be used on any camera at closer distances by attaching a positive lens element to the front of the camera lens. Such close-up lenses, also called Proxar lenses, are designated by their focal length or diopter power. The 1 diopter lens has a 1 m (39½ in.) focal length, a 2 diopter type has a focal length of 0.5 m, and a 2 m focal length is equal to 0.5 diopters.

Close-up lenses are not recommended for serious close-up work as they create a loss of image sharpness on the corners. Proxar lenses are, however, still shown on the V system close-up charts as P 1.0, P 0.5, and P 2.0. Indicated distances are measured from the Proxar lens, not the image plane.

CLOSE-UP PHOTOGRAPHY WITH ALL HASSELBLAD CAMERAS

The single lens reflex concept of all Hasselblad SLR cameras allows you to see in the viewfinder the image as it will be recorded on the digital sensor or on film with any lens and close-up accessory. This is true for all H cameras and all newer SLR models in the V system. Earlier V system cameras without the gliding mirror concept have a cut-off at the top of the focusing screen when close-up accessories are used. The cut-off appears only on the focusing screen, not in the image. Allow for it when you make the composition. The focusing screen on all the newer V models with the gliding mirror concept show the full image covered with any lens and any close-up accessory.

Motor-driven film advance with a built-in motor or motor winder accessory on 503 models eliminates the possibility of moving a tripod-mounted camera between shots and allows you to take sequences of pictures. Locking up the mirror in critical close-up work is recommended with any camera whenever practical.

While most close-up work is best done from a tripod or camera stand, handheld photography is possible and can certainly be considered with moving subjects, especially with the automatic focusing in the H cameras. If you need to focus manually you will find that focusing is frequently easier if you preset the focusing ring on the lens and then move the camera back and forth until the subject is sharp on the focusing screen. In this approach you can hold the camera with both hands in whichever way is most convenient. You need not to use one hand for focusing the lens.

CLOSE-UP PHOTOGRAPHY WITH H CAMERAS

The built-in light-metering system, the possibility of automatic focusing, the focus aids, the extremely smooth lens shutter operation, the mirror lock-up capability, the availability of a true Makro lens, and the many sophisticated features that can be programmed into the camera make the H camera models great tools for close-up photography digitally or on film. The HC 4/120 mm macro lens must be the first choice for close-up photography because it offers automatic exposure and automatic focusing down to this minimum distance. The mirror can be locked up as in all Hasselblad SLR models. On the latest H3D camera models, you can program the delay between the time the mirror is lifted and the time the image is actually taken. This new feature gives additional possibilities for reducing the danger of camera movement showing up in the finished pictures.

The H camera system includes three extension tubes, 13, 26, and 52 mm in length, that can be combined while maintaining the electronic coupling to the HC lenses. Although the tubes can be used with all HC lenses, you want to consider lenses that are 80 mm and longer for close-up work because they provide the best image quality and provide a longer working distance.

The 50–110 mm zoom lens can also be used with extension tubes, but the image does not stay in focus when the focal length is changed. Set the lens first at the focal length that covers the desired area; then focus the image manually or preferably automatically if the distance is within the automatic focusing range (see Charts A and B in this chapter).

If the automatic focusing system does not work with a specific combination of lens and extension tubes, you will get a message on the LCD screen, NOT POSSIBLE WITH THIS LENS. Manual focus may still work and you can then use the Focus Aids for precise focusing.

Complete close-up charts for the HE tubes and HC lenses are included in this chapter.

WORKING WITH THE V SYSTEM CLOSE-UP ACCESSORIES

In addition to the bellows, four extension tubes have been made for Hasselblad 503 and other V system SLR cameras. The numeral in the designations 8, 16E, 32E, and 56E refers to the length of the tube in millimeters; the E indicates that the tubes have the electronic connections for the metering system in 200 camera models and therefore transfer the data from a CFE, FE, or TCC lens to the camera. You can use the tubes without the E on 200 cameras, but you must manually close down the lens aperture for the meter reading, whether you use the focal plane or the lens shutter for the exposure. The E tubes can be used on all V system SLR

cameras. The 8 tube does not have the E because the shutter speed ring prevents its mounting on 200 cameras. A tube with a variable length from 64–85 mm has also been made.

Choosing A V System Lens

All extension tubes can be used with lenses 80 mm and longer, including the 350 and 500 mm focal lengths. The shorter extension tubes can be used with wide angle lenses, but it is not a practical combination usually because the lens is very close to the subject, and the retrofocus wide angle lenses do not produce the very best image quality. The Variogon 140–280 mm and the Hasselblad 60–120 mm zoom lenses can be used and produce satisfactory image quality with the 16 mm extension tube. The image, however, does not stay in focus when you are zooming.

The Makro-Planar 120 mm lens must be the first choice as it is optically designed to provide the best image quality at close distances — the very best at a 1:5 magnification, but is also an excellent lens for use at longer distances. The Biogon 38 mm covering an area about 11 in. square for the 2¼ film format at the 12-in. (0.3 m) minimum distance is another good choice but only for film photography.

Attaching and Removing V System Extension Tubes and Bellows

The Hasselblad V system extension tubes and bellows are equipped with coupling shafts that connect the camera and lens mechanism to maintain the automatic aperture close down and shutter cocking. Extension tubes and bellows mount on the camera exactly like lenses.

Remove extension tubes by pressing the locking button or lever on the tubes while the camera is in the cocked position. To remove tubes, it is of utmost importance to follow the procedure outlined below:

1. Remove the lens first from the tube, tubes, or bellows.
2. Remove the tube or bellows from the camera body.

If more than one tube is used, remove the tube farthest from the camera (the one that is closest to the lens). Then work toward the camera, removing each tube separately, removing the tube attached to the camera body last. Never remove a lens from a tube or bellows that is not attached to the camera. There is no tension to prevent the shaft from rotating, and it may uncock before the tubes and lenses are separated, jamming them together.

Figure 19-4 shows the process of attaching and removing extension tubes.

Figure 19-4 Attaching and removing tubes. When attaching extension tubes (left), start at the camera by attaching the first tube to the camera. Then attach the second tube to the first, and finally attach the lens to the second tube. To remove extension tubes (right), reverse this sequence. First, remove the lens from the outermost tube, then the outermost tube, and finally, remove the tube attached directly to the camera.

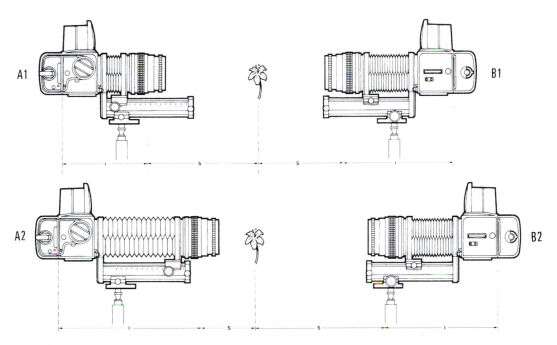

Figure 19-5 Bellows adjustments. A1, A2. With the automatic bellow attached to the tripod the adjusting knob on the side of the engraved scale changes the extension of the bellows by moving the lens, leaving the image plane stationary and thus changing lens-to-image plane distance (I), which determines the magnification. B1, B2. Turning the knob on the other side moves the entire camera setup (camera, bellows, lens) closer to or farther from the subject. It changes the subject distance, S, while maintaining the lens-to-film distance and the magnification.

Operating the Hasselblad Bellows

When working with a tripod, use the tripod socket on the mounting plate of the bellows rather than the tripod socket on the camera. With the bellows mounted on a tripod or stand, change and adjust the lens- to-image plane distance by turning the lower knurled adjusting knob. Change and adjust the lens-to-image-plane distance (and thus the magnification) by turning the upper knob (see Figure 19-5). You may also want to use this knob for fine focusing because the image sharpness on the focusing screen changes more rapidly, thus making focusing more accurate. In actual photography, you will probably use both knobs simultaneously, turning the lower knob until you cover the desired area and then using the upper knob to bring the subject into focus. Chart C at the end of this chapter provides all the technical details about photography with the bellows.

SPECIAL CLOSE-UP APPLICATIONS

Slide Duplicating

Rather than duplicating slides, you can scan your transparencies and place the scanned images on a disc. This is a much simpler process that also offers unlimited possibilities for

changing the image, the colors, improve and retouch the image at the same time. However, if you like to duplicate them with the camera, photograph the slide like a close-up but with the slide lit from the rear and placed on an opal glass to diffuse the light. A black mask with a cut-out the size of the transparency must be used to prevent unwanted light from shining directly into the lens. Electronic flash is best for this purpose.

With this setup you can also produce a digital image by photographing the transparency with a digital Hasselblad camera.

Photography through the Microscope

Hasselblad cameras can be used for photographing through a microscope (see Figure 19-6). But successful photography is based more on techniques of microscopy rather than photography and the image quality is determined mainly by the microscope objectives and the microscope illumination. It is therefore best to study special books on this topic or attend a workshop.

Figure 19-6 Photomicrography. A microscope setup without a camera lens but with a microscope adapter instead.

HOW TO USE THE V SYSTEM CLOSE-UP CHARTS

In all Charts D at the end of the chapter, the close-up accessories are indicated as follows: P for Proxar lenses 2.0, 1.0, and 0.5 and B 64–202 for bellows. The extension tubes are indicated by their length (8, 16, 32, and 56), including combinations of tubes, such as 56 + 8. The left end of each line indicates the values with the lens set at infinity; the right end when the focusing ring is set at its minimum focusing distance.

To read the chart, follow horizontally in the space marked "Area coverage, size of subject" until you reach the number in inches or millimeters of the area (the size of the subject) that you need to photograph. Then go straight down vertically to see which close-up accessories cross the line, and then go farther down to find the depth-of-field at *f*/11, the necessary increase in exposure, and the magnification. The line may cross various close-up accessories,

indicating all the available choices. Note that the indicated exposure increase applies only to extension tubes and bellows, not to the Proxar lenses.

Using the V System Charts for Digital Imaging

All the figures in the V system close-up charts are for the 6 × 6 square format or the long side of the 6 × 4.5 film format.

To use these charts for digital imaging, I suggest that you use the following approach:

To determine the lens and close-up accessory needed to cover a specific size area multiply the long side of that area by the following figures.

> 1.1× (1.12×) for the 36.7 × 49.0 sensor
> 1.2× (1.2×) for the 33.1 × 44.2 sensor
> 1.5× for the 36.7 × 36.7 sensor

Find the resulting figures on the charts where you then find all the close-up information for that specific value.

Example: Area that you need to cover with a 120 mm Makro-Planar is 4 in. (100 mm). Multiplied by above figures the long dimension to use on the chart is 4 3/4 in. (120 mm) for the 33.1 × 44.2 sensor. The 120-mm close-up chart shows that this area can be covered with a 32 mm extension tube.

To determine what areas can be covered with a specific lens and extension tube combination proceed as follows. Take the figures from the maximum size of subject line and

> For the 36.7 ×49.0 sensor multiply by 0.9 (exact figure 0.89×)
> For the 33.1 × 44,2 sensor multiply by 0.8×
> For the 36.7 × 36.7 sensor multiply by 0.7× (exact figure 0.66×)

Example: The 120 mm Makro-Planar set at infinity covers an area about 8 in. (200 mm) with extension tube 32. The same lens and tube combination with the lens set at infinity covers an area about 7¼ in. (180 mm) on the large 36.7 × 49.0 sensor, about 6½ inches (160 mm) on the 33.1 × 44.2 sensor, and about 5½ inches (140 mm) on the 36.7 × 36.7 sensor.

HOW TO USE THE H SYSTEM CLOSE-UP CHARTS

All the necessary information for using the H system extension tubes successfully with different lenses on the H camera are shown in the Chart. All Charts A are inches. All Charts B are in the metric system.

Charts A1 and B1 show the subject-to-image plane distances D the distances from the subject to the front of the lens, the working distances O, the magnification m and and the necessary exposure increase R (needed only when using a separate meter) for the different lenses and different extension tubes. The data in these charts apply to the film format and the different sensor sizes.

All charts #3 to #8 (both in A and B) show the width W and Height H of the area covered with different tubes and lenses and with the lens focused at infinity and at its closest focusing distance. These charts also show the magnification m. Charts A2 and B2 are for the 6 × 4.5 film format, Charts A3 and B3 for the 36.7 × 49.0 sensor and Charts A4 and B4 for the 33.1 × 44. 2 sensor with all dimensions in inches on the A charts and in the metric system in the B charts.

The other charts (A5 to A8 and B5 to B8) give the same information for combinations of extension tubes.

Example: The 150 mm lens set at infinity with extension tube 26 covers an area 13 × 9.6 in. on the film format.

The same lens and tube combination would cover an area 10.3 × 7.7 in. on a 33.1 × 44.2 sensor.

In all charts, figures in blue indicate that this combination of lens and tubes can be used for photography but that the automatic focusing system does not work. You must focus manually using the focus indicators as a guide.

D Subject to film plane distance
O Subject to lens distance
m Magnification
R Exposure reduction (EV), Only used in manual exposure mode

Chart A1	Lens focus setting	13 mm				26 mm				52 mm			
		D	O	m	R	D	O	m	R	D	O	m	R
HCD 4/28 mm	∞	8.6	1.8	0.45	0.3	7.8	0.5	0.90	0.6	-	-	-	-
	1.1	8.0	1.2	0.59	0.4	7.7	0.3	1.05	0.7	-	-	-	-
HC 3.5/35 mm	∞	11	3.1	0.37	0.3	9.3	1.1	0.73	0.6	9.4	0.2	1.44	1.1
	1.6	9.8	2.2	0.47	0.4	9.1	0.9	0.84	0.7	9.3	0.1	1.56	1.2
HC 3.5/50 mm	∞	14	7.0	0.26	0.3	11	3.2	0.52	0.6	10	1.3	1.03	1.0
	2.0	12	4.7	0.38	0.4	10	2.6	0.64	0.7	10	1.2	1.17	1.2
HC 3.5/50 + 1.7×	∞	16	7.0	0.44	0.3	13	3.2	0.87	0.6	12	1.3	1.74	1.0
	2.0	14	4.6	0.63	0.4	12	2.6	1.08	0.7	12	1.2	1.96	1.2
HC 2.8/80 mm	∞	27	22	0.16	0.4	17	12	0.32	0.7	13	6.5	0.63	1.3
	2.3	17	12	0.31	0.7	14	8.3	0.47	1.0	13	5.5	0.78	1.5
HC 2.8/80 mm + 1.7×	∞	29	22	0.27	0.4	19	12	0.53	0.7	15	6.5	1.06	1.3
	2.3	19	12	0.52	0.7	16	8.3	0.79	1.0	15	5.5	1.32	1.6
HC 2.2/100 mm	∞	37	31	0.13	0.35	23	16	0.26	0.67	16	8.8	0.52	1.23
	3.0	22	16	0.27	0.69	18	11	0.40	0.98	15	7.2	0.66	1.49
HC 2.2/100 mm + 1.7×	∞	39	31	0.22	0.35	25	16	0.44	0.67	18	8.8	0.88	1.24
	3.0	24	16	0.45	0.69	20	11	0.67	0.99	17	7.2	1.11	1.50
HC Macro 4/120	∞	53	45	0.11	0.28	32	24	0.22	0.54	23	14	0.44	1.00
	1.3	15	5.2	1.16	1.48	16	4.9	1.31	1.69	16	4.4	1.61	2.07
HC Macro 4/120 + 1.7×	∞	55	45	0.18	0.28	34	24	0.37	0.54	25	14	0.73	1.00
	1.3	17	5.2	1.94	1.47	18	4.9	2.20	1.68	18	4.4	2.71	2.07
HC 3.2/150 mm	∞	78	70	0.09	0.3	45	36	0.17	0.5	29	20	0.35	1.0
	4.3	36	29	0.23	0.3	30	22	0.32	0.5	25	15	0.49	1.0
HC 3.2/150 mm + 1.7×	∞	80	70	0.15	0.3	46	36	0.29	0.5	31	20	0.58	1.0
	4.3	38	29	0.39	0.3	32	22	0.54	0.5	27	15	0.83	1.0
HC 4/210 mm	∞	150	141	0.06	0.3	83	73	0.12	0.5	51	40	0.25	0.9
	5.9	54	45	0.21	0.3	46	36	0.27	0.5	38	27	0.40	0.9
HC 4/210 mm + 1.7×	∞	152	141	0.10	0.3	85	73	0.21	0.5	53	40	0.41	0.9
	5.9	56	45	0.35	0.3	48	36	0.46	0.5	39	27	0.68	0.9
HC 4.5/300 mm	∞	283	272	0.045	0.25	154	143	0.089	0.48	91	79	0.18	0.90
	8.0	77	66	0.19	0.24	66	55	0.24	0.47	54	42	0.34	0.88
HC 4.5/300 mm + 1.7×	∞	284	272	0.075	0.25	156	143	0.15	0.48	93	79	0.30	0.89
	8.0	79	66	0.31	0.22	68	55	0.40	0.45	56	42	0.57	0.86
HC 3.5-4.5/50-110 mm — 50	∞	16	7.2	0.25	0.4	13	3.1	0.51	0.8	12	1.2	1.01	1.4
	2.3	13	3.8	0.38	0.4	12	1.7	0.66	0.8	11	0.4	1.22	1.4
HC 3.5-4.5/50-110 mm — 80	∞	28	20	0.16	0.3	19	10	0.33	0.6	15	5.2	0.65	1.0
	2.3	17	8.0	0.33	0.3	15	5.0	0.52	0.6	13	2.8	0.90	1.0
HC 3.5-4.5/50-110 mm — 110	∞	46	37	0.12	0.2	28	19	0.24	0.5	21	10	0.48	0.8
	2.3	20	11	0.34	0.2	18	7.8	0.49	0.5	16	5.1	0.78	0.8

Blue numbers : AF not possible
- : incompatible combination

Chart A1. Exposure increase, magnification and distances in inches for single extension tubes.

	W	Covered area width
	H	Covered area height
	m	Magnification

Chart A3	Lens focus setting	13 mm			26 mm			52 mm		
		W	H	m	W	H	m	W	H	m
HCD 4/28 mm	∞	4.6	3.3	0.45	2.3	1.7	0.90	-	-	-
	1.1	3.5	2.6	0.59	2.0	1.5	1.05	-	-	-
HC 3.5/35 mm	∞	6.0	4.4	0.37	3.0	2.2	0.73	1.5	1.1	1.44
	1.6	4.7	3.5	0.47	2.6	1.9	0.84	1.4	1.0	1.56
HC 3.5/50 mm	∞	8.5	6.3	0.26	4.2	3.1	0.52	2.1	1.6	1.03
	2.0	5.8	4.3	0.38	3.4	2.6	0.64	1.9	1.4	1.17
HC 3.5/50 + 1.7×	∞	5.0	3.7	0.44	2.5	1.9	0.87	1.3	0.9	174
	2.0	3.5	2.6	0.63	2.0	1.5	1.08	1.1	0.8	1.96
HC 2.8/80 mm	∞	14	10	0.16	6.9	5.1	0.32	3.5	2.6	0.63
	2.3	7.1	5.3	0.31	4.7	3.5	0.47	2.8	2.1	0.78
HC 2.8/80 mm + 1.7×	∞	8.2	6.1	0.27	4.2	3.1	0.53	2.1	1.5	1.06
	2.3	4.2	3.1	0.52	2.8	2.1	0.79	1.7	1.2	1.32
HC 2.2/100 mm	∞	17	12	0.13	8.4	6.3	0.26	4.2	3.1	0.52
	3.0	8.1	6.1	0.27	5.5	4.1	0.40	3.3	2.5	0.66
HC 2.2/100 mm + 1.7×	∞	10	7.4	0.22	5.0	3.7	0.44	2.5	1.9	0.88
	3.0	4.8	3.6	0.45	3.3	2.4	0.67	2.0	1.5	1.11
HC Macro 4/120	∞	21	15	0.11	10	7.4	0.22	5.0	3.7	0.44
	1.3	1.9	1.4	1.16	1.7	1.3	1.31	1.4	1.0	1.61
HC Macro 4/120 + 1.7×	∞	12	8.9	0.18	6.0	4.4	0.37	3.0	2.2	0.73
	1.3	1.1	0.8	1.94	1.0	0.7	2.20	0.8	0.6	2.71
HC 3.2/150 mm	∞	24	18	0.09	13	9.6	0.17	6.3	4.7	0.35
	4.3	9.6	7.1	0.23	6.9	5.1	0.32	4.5	3.3	0.49
HC 3.2/150 mm + 1.7×	∞	15	11	0.15	7.6	5.6	0.29	3.8	2.8	0.58
	4.3	5.7	4.2	0.39	4.1	3.0	0.54	2.7	2.0	0.83
HC 4/210 mm	∞	37	27	0.06	18	14	0.12	8.8	6.5	0.25
	5.9	10	7.8	0.21	8.2	6.1	0.27	5.5	4.1	0.40
HC 4/210 mm + 1.7×	∞	22	16	0.10	10	7.8	0.21	5.4	4.0	0.41
	5.9	6.3	4.7	0.35	4.8	3.6	0.46	3.2	2.4	0.68
HC 4.5/300 mm	∞	49	37	0.045	25	18	0.089	12	9.2	0.18
	8.0	12	8.7	0.19	9.3	6.9	0.24	6.5	4.8	0.34
HC 4.5/300 mm + 1.7×	∞	30	22	0.075	15	11	0.15	7.4	5.5	0.30
	8.0	7.0	5.2	0.31	5.5	4.1	0.40	3.8	2.8	0.57
HC 3.5-4.5/50-110 mm — 50	∞	8.8	6.5	0.25	4.3	3.2	0.51	2.2	1.6	1.01
	2.3	5.8	4.3	0.38	3.3	2.5	0.66	1.8	1.3	1.22
HC 3.5-4.5/50-110 mm — 80	∞	14	10	0.16	6.7	5.0	0.33	3.4	2.5	0.65
	2.3	6.7	5.0	0.33	4.2	3.1	0.52	2.4	1.8	0.90
HC 3.5-4.5/50-110 mm — 110	∞	18	14	0.12	9.2	6.8	0.24	4.6	3.4	0.48
	2.3	6.5	4.8	0.34	4.5	3.3	0.49	2.8	2.1	0.78

Blue numbers : AF not possible
- : incompatible combination

Chart A2. Area coverage in inches with single extension tubes for the 6 × 4.5 film format.

W Covered area width
H Covered area height
m Magnification

Chart A5	Lens focus setting	13 mm			26 mm			52 mm		
		W	H	m	W	H	m	W	H	m
HCD 4/28 mm	∞	4.0	2.9	0.45	2.0	1.5	0.90	-	-	-
	1.1	3.1	2.3	0.59	1.8	1.3	1.05	-	-	-
HC 3.5/35 mm	∞	5.3	3.9	0.37	2.6	1.9	0.73	1.3	1.0	1.44
	1.6	4.1	3.1	0.47	2.3	1.7	0.84	1.2	0.9	1.56
HC 3.5/50 mm	∞	7.4	5.6	0.26	3.7	2.7	0.52	1.8	1.4	1.03
	2.0	5.1	3.8	0.38	3.0	2.3	0.64	1.7	1.2	1.17
HC 3.5/50 + 1.7×	∞	4.4	3.3	0.44	2.2	1.7	0.87	1.1	0.8	174
	2.0	3.1	2.3	0.63	1.8	1.3	1.08	1.0	0.7	1.96
HC 2.8/80 mm	∞	12.3	8.8	0.16	6.0	4.5	0.32	3.1	2.3	0.63
	2.3	6.2	4.7	0.31	4.1	3.1	0.47	2.5	1.9	0.78
HC 2.8/80 mm + 1.7×	∞	7.2	5.4	0.27	3.7	2.7	0.53	1.8	1.3	1.06
	2.3	3.7	2.7	0.52	2.5	1.9	0.79	1.5	1.1	1.32
HC 2.2/100 mm	∞	14.9	10.6	0.13	7.4	5.6	0.26	3.7	2.7	0.52
	3.0	7.1	5.4	0.27	4.8	3.6	0.40	2.9	2.2	0.66
HC 2.2/100 mm + 1.7×	∞	8.8	6.5	0.22	4.4	3.3	0.44	2.2	1.7	0.88
	3.0	4.2	3.2	0.45	2.9	2.1	0.67	1.8	1.3	1.11
HC Macro 4/120	∞	18.4	13.3	0.11	8.8	6.5	0.22	4.4	3.3	0.44
	1.3	1.7	1.2	1.16	1.5	1.1	1.31	1.2	0.9	1.61
HC Macro 4/120 + 1.7×	∞	10.5	7.9	0.18	5.3	3.9	0.37	2.6	1.9	0.73
	1.3	1.0	0.7	1.94	0.9	0.6	2.20	0.7	0.5	2.71
HC 3.2/150 mm	∞	21.0	15.9	0.09	11.4	8.5	0.17	5.5	4.2	0.35
	4.3	8.4	6.3	0.23	6.0	4.5	0.32	3.9	2.9	0.49
HC 3.2/150 mm + 1.7×	∞	13.1	9.7	0.15	6.7	5.0	0.29	3.3	2.5	0.58
	4.3	5.0	3.7	0.39	3.6	2.7	0.54	2.4	1.8	0.83
HC 4/210 mm	∞	32.4	23.9	0.06	15.8	12.4	0.12	7.7	5.7	0.25
	5.9	8.8	6.9	0.21	7.2	5.4	0.27	4.8	3.6	0.40
HC 4/210 mm + 1.7×	∞	19.3	14.1	0.10	8.8	6.9	0.21	4.7	3.5	0.41
	5.9	5.5	4.2	0.35	4.2	3.2	0.46	2.8	2.1	0.68
HC 4.5/300 mm	∞	42.9	32.7	0.045	21.9	15.9	0.089	10.5	8.1	0.18
	8.0	10.5	7.7	0.19	8.1	6.1	0.24	5.7	4.2	0.34
HC 4.5/300 mm + 1.7×	∞	26.3	19.5	0.075	13.1	9.7	0.15	6.5	4.9	0.30
	8.0	6.1	4.6	0.31	4.8	3.6	0.40	3.3	2.5	0.57
HC 3.5-4.5/50-110 mm — 50	∞	7.7	5.7	0.25	3.8	2.8	0.51	1.9	1.4	1.01
	2.3	5.1	3.8	0.38	2.9	2.2	0.66	1.6	1.1	1.22
HC 3.5-4.5/50-110 mm — 80	∞	12.3	8.8	0.16	5.9	4.4	0.33	3.0	2.2	0.65
	2.3	5.9	4.4	0.33	3.7	2.7	0.52	2.1	1.6	0.90
HC 3.5-4.5/50-110 mm — 110	∞	15.8	12.4	0.12	8.1	6.0	0.24	4.0	3.0	0.48
	2.3	5.7	4.2	0.34	3.9	2.9	0.49	2.5	1.9	0.78

Blue numbers : AF not possible
- : incompatible combination

Chart A3. Area coverage in inches with single extension tubes for the 36.7 × 49.0 sensor.

W Covered area width
H Covered area height
m Magnification

Chart A7	Lens focus setting	13 mm			26 mm			52 mm		
		W	H	m	W	H	m	W	H	m
HCD 4/28 mm	∞	3.6	2.6	0.45	1.8	1.4	0.90	-	-	-
	1.1	2.8	2.1	0.59	1.6	1.2	1.05	-	-	-
HC 3.5/35 mm	∞	4.7	3.5	0.37	2.4	1.8	0.73	1.2	0.9	1.44
	1.6	3.7	2.8	0.47	2.1	1.5	0.84	1.1	0.8	1.56
HC 3.5/50 mm	∞	6.7	5.0	0.26	3.3	2.5	0.52	1.7	1.3	1.03
	2.0	4.6	3.4	0.38	2.7	2.1	0.64	1.5	1.1	1.17
HC 3.5/50 + 1.7×	∞	3.9	3.0	0.44	2.0	1.5	0.87	1.0	0.7	174
	2.0	2.8	2.1	0.63	1.6	1.2	1.08	0.9	0.6	1.96
HC 2.8/80 mm	∞	11.1	8.0	0.16	5.4	4.1	0.32	2.8	2.1	0.63
	2.3	5.6	4.2	0.31	3.7	2.8	0.47	2.2	1.7	0.78
HC 2.8/80 mm + 1.7×	∞	6.5	4.9	0.27	3.3	2.5	0.53	1.7	1.2	1.06
	2.3	3.3	2.5	0.52	2.2	1.7	0.79	1.3	1.0	1.32
HC 2.2/100 mm	∞	13.4	9.6	0.13	6.6	5.0	0.26	3.3	2.5	0.52
	3.0	6.4	4.9	0.27	4.3	3.3	0.40	2.6	2.0	0.66
HC 2.2/100 mm + 1.7×	∞	7.9	5.9	0.22	3.9	3.0	0.44	2.0	1.5	0.88
	3.0	3.8	2.9	0.45	2.6	1.9	0.67	1.6	1.2	1.11
HC Macro 4/120	∞	16.6	12.0	0.11	7.9	5.9	0.22	3.9	3.0	0.44
	1.3	1.5	1.1	1.16	1.3	1.0	1.31	1.1	0.8	1.61
HC Macro 4/120 + 1.7×	∞	9.5	7.1	0.18	4.7	3.5	0.37	2.4	1.8	0.73
	1.3	0.9	0.6	1.94	0.8	0.6	2.20	0.6	0.5	2.71
HC 3.2/150 mm	∞	18.9	14.4	0.09	10.3	7.7	0.17	5.0	3.7	0.35
	4.3	7.6	5.7	0.23	5.4	4.1	0.32	3.6	2.6	0.49
HC 3.2/150 mm + 1.7×	∞	11.8	8.8	0.15	6.0	4.5	0.29	3.0	2.2	0.58
	4.3	4.5	3.3	0.39	3.2	2.4	0.54	2.1	1.6	0.83
HC 4/210 mm	∞	29.2	21.5	0.06	14.2	11.2	0.12	6.9	5.2	0.25
	5.9	7.9	6.2	0.21	6.5	4.9	0.27	4.3	3.3	0.40
HC 4/210 mm + 1.7×	∞	17.4	12.8	0.10	7.9	6.2	0.21	4.3	3.2	0.41
	5.9	5.0	3.7	0.35	3.8	2.9	0.46	2.5	1.9	0.68
HC 4.5/300 mm	∞	38.7	29.5	0.045	19.7	14.4	0.089	9.5	7.3	0.18
	8.0	9.5	6.9	0.19	7.3	5.5	0.24	5.1	3.8	0.34
HC 4.5/300 mm + 1.7×	∞	23.7	17.5	0.075	11.8	8.8	0.15	5.8	4.4	0.30
	8.0	5.5	4.1	0.31	4.3	3.3	0.40	3.0	2.2	0.57
HC 3.5-4.5/50-110 mm — 50	∞	6.9	5.2	0.25	3.4	2.6	0.51	1.7	1.3	1.01
	2.3	4.6	3.4	0.38	2.6	2.0	0.66	1.4	1.0	1.22
HC 3.5-4.5/50-110 mm — 80	∞	11.1	8.0	0.16	5.3	4.0	0.33	2.7	2.0	0.65
	2.3	5.3	4.0	0.33	3.3	2.5	0.52	1.9	1.4	0.90
HC 3.5-4.5/50-110 mm — 110	∞	14.2	11.2	0.12	7.3	5.4	0.24	3.6	2.7	0.48
	2.3	5.1	3.8	0.34	3.6	2.6	0.49	2.2	1.7	0.78

Blue numbers : AF not possible
- : incompatible combination

Chart A4. Area coverage in inches with single extension tables for the 33.1 × 44.2 sensor.

Chart A2	Lens focus setting	13 + 26 mm				13 + 52 mm				26 + 52 mm				13 + 26 + 52 mm			
		D	O	m	R	D	O	m	R	D	O	m	R	D	O	m	R
HCD 4/28 mm	∞	7.9	0.08	1.35	0.9	-	-	-	-	-	-	-	-	-	-	-	-
	1.1	7.9	0	1.50	1	-	-	-	-	-	-	-	-	-	-	-	-
HC 3.5/35 mm	∞	9.2	0.5	1.09	0.8	-	-	-	-	-	-	-	-	-	-	-	-
	1.6	9.1	0.4	1.20	0.9	-	-	-	-	-	-	-	-	-	-	-	-
HC 3.5/50 mm	∞	10	2.0	0.78	0.8	10	0.9	1.29	1.3	11	0.7	1.55	1.4	11	0.5	1.80	1.6
	2.0	10	1.7	0.91	1.0	10	0.9	1.43	1.5	11	0.7	1.69	1.7	11	0.5	1.95	1.9
HC 3.5/50 + 1.7×	∞	12	2.0	1.30	0.8	12	0.9	2.16	1.3	13	0.7	2.59	1.4	13	0.5	3.01	1.6
	2.0	12	1.7	1.52	1.0	12	0.9	2.4	1.5	12	0.7	2.83	1.7	13	0.5	3.27	1.9
HC 2.8/80 mm	∞	14	8.2	0.48	1.0	13	5.5	0.79	1.5	12	4.8	0.95	1.8	12	4.3	1.10	2.0
	2.3	13	6.5	0.63	1.3	12	4.8	0.94	1.8	12	4.3	1.10	2.0	13	3.9	1.25	2.2
HC 2.8/80 mm + 1.7×	∞	16	8.2	0.80	1.0	15	5.5	1.33	1.6	14	4.8	1.59	1.8	14	4.3	1.85	2.0
	2.3	15	6.5	1.05	1.3	14	4.8	1.58	1.8	14	4.3	1.84	2.0	15	3.9	2.09	2.2
HC 2.2/100 mm	∞	18	11	0.39	1.0	15	7.2	0.65	1.5	15	6.3	0.78	1.7	15	5.6	0.91	1.9
	3.0	16	8.7	0.53	1.2	15	6.3	0.79	1.7	15	5.6	0.92	1.9	15	5.0	1.05	2.1
HC 2.2/100 mm + 1.7×	∞	20	11	0.66	1.0	17	7.3	1.10	1.5	17	6.3	1.31	1.7	17	5.6	1.53	1.9
	3.0	18	8.7	0.89	1.3	17	6.3	1.33	1.7	17	5.6	1.55	2.0	17	5.0	1.76	2.2
HC Macro 4/120	∞	26	17	0.33	0.8	21	11	0.55	1.2	20	10	0.66	1.4	20	8.9	0.77	1.6
	1.3	16	4.6	1.46	1.9	16	4.2	1.77	2.2	17	4.1	1.92	2.4	17	3.9	2.07	2.6
HC Macro 4/120 + 1.7×	∞	28	17	0.55	0.8	23	11	0.92	1.2	22	10	1.10	1.4	22	8.9	1.28	1.6
	1.3	18	4.6	2.45	1.9	18	4.2	2.97	2.2	19	4.1	3.22	2.4	19	3.9	3.48	2.6
HC 3.2/150 mm	∞	34	25	0.26	0.8	26	16	0.43	1.2	24	14	0.52	1.4	23	12	0.61	1.5
	4.3	27	18	0.41	0.8	23	14	0.58	1.2	22	12	0.67	1.4	22	11	0.75	1.5
HC 3.2/150 mm + 1.7×	∞	36	25	0.44	0.8	28	16	0.73	1.2	26	14	0.87	1.4	25	12	1.02	1.5
	4.3	29	18	0.68	0.8	25	14	0.98	1.2	24	12	1.12	1.4	24	11	1.26	1.5
HC 4/210 mm	∞	61	51	0.19	0.7	44	33	0.31	1.1	40	28	0.37	1.3	38	25	0.43	1.4
	5.9	41	30	0.34	0.7	35	24	0.47	1.1	34	22	0.53	1.3	33	20	0.60	1.4
HC 4/210 mm + 1.7×	∞	63	51	0.31	0.7	46	33	0.52	1.1	42	28	0.62	1.3	40	25	0.73	1.4
	5.9	43	30	0.57	0.7	37	24	0.78	1.1	36	22	0.89	1.3	35	20	1.00	1.4
HC 4.5/300 mm	∞	112	100	0.13	0.7	78	66	0.22	1.1	70	57	0.27	1.3	65	51	0.31	1.4
	8.0	59	47	0.29	0.7	51	38	0.39	0.1	48	35	0.44	1.2	47	33	0.50	1.4
HC 4.5/300 mm + 1.7×	∞	114	100	0.22	0.7	80	66	0.37	1.1	72	57	0.45	1.3	67	51	0.52	1.4
	8.0	61	47	0.49	0.7	53	38	0.66	1.0	50	35	0.75	1.2	49	33	0.84	1.4
HC 3.5-4.5/50-110 mm — 50	∞	12	1.9	0.76	1.1	12	0.8	1.26	1.6	-	-	-	-	-	-	-	-
	2.3	11	0.9	0.94	1.1	12	0.2	1.49	1.6	-	-	-	-	-	-	-	-
HC 3.5-4.5/50-110 mm — 80	∞	16	6.8	0.49	0.8	15	4.2	0.81	1.2	15	3.6	0.97	1.4	15	3.1	1.14	1.6
	2.3	13.7	3.6	0.71	0.8	13	2.3	1.09	1.2	14	1.9	1.27	1.4	14	1.7	1.46	1.6
HC 3.5-4.5/50-110 mm — 110	∞	23	13	0.36	0.7	20	8.5	0.60	1.0	19	7.3	0.72	1.2	18	6.5	0.84	1.3
	2.3	16	6.1	0.63	0.7	16	4.4	0.92	1.0	16	3.9	1.07	1.2	16	3.5	1.21	1.3

Blue numbers : AF not possible
- : incompatible combination

Chart A5. Exposure increase, magnification and distances in inches for combinations of tubes.

Chart A4

Lens	Lens focus setting	13 + 26 mm W	H	m	13 + 52 mm W	H	m	26 + 52 mm W	H	m	13 + 26 + 52 mm W	H	m
HCD 4/28 mm	∞	1.5	1.1	1.3	-	-	-	-	-	-	-	-	-
	1.1	1.4	1.0	1.5	-	-	-	-	-	-	-	-	-
HC 3.5/35 mm	∞	2.0	1.5	1.09	-	-	-	-	-	-	-	-	-
	1.6	1.8	1.4	1.20	-	-	-	-	-	-	-	-	-
HC 3.5/50 mm	∞	2.8	2.1	0.78	1.7	1.3	1.29	1.4	1.1	1.55	1.2	0.9	1.80
	2.0	2.4	1.8	0.91	1.5	1.1	1.43	1.3	1.0	1.69	1.1	0.8	1.95
HC 3.5/50 + 1.7×	∞	1.7	1.3	1.30	1.0	0.8	2.16	0.9	0.6	2.59	0.7	0.5	3.01
	2.0	1.5	1.1	1.52	0.9	0.7	2.40	0.8	0.6	2.83	0.7	0.5	3.27
HC 2.8/80 mm	∞	4.6	3.4	0.48	2.8	2.1	0.79	2.3	1.7	0.95	2.0	1.5	1.10
	2.3	3.5	2.6	0.63	2.3	1.7	0.94	2.0	1.5	1.10	1.8	1.3	1.25
HC 2.8/80 mm + 1.7×	∞	2.8	2.0	0.80	1.7	1.2	1.33	1.4	1.0	1.59	1.2	0.9	1.85
	2.3	2.1	1.6	1.05	1.4	1.0	1.58	1.2	0.9	1.84	1.1	0.8	2.09
HC 2.2/100 mm	∞	5.6	4.2	0.39	3.4	2.5	0.65	2.8	2.1	0.78	2.4	1.8	0.91
	3.0	4.2	3.1	0.53	2.8	2.0	0.79	2.4	1.8	0.92	2.1	1.6	1.05
HC 2.2/100 mm + 1.7×	∞	3.3	2.5	0.66	2.0	1.5	1.10	1.7	1.3	1.31	1.5	1.1	1.53
	3.0	2.5	1.8	0.89	1.7	1.2	1.33	1.4	1.1	1.55	1.3	0.9	1.76
HC Macro 4/120	∞	6.7	5.0	0.33	4.0	3.0	0.55	3.3	2.5	0.66	2.9	2.1	0.77
	1.3	1.5	1.1	1.46	1.3	0.9	1.77	1.1	0.9	1.92	1.1	0.8	2.07
HC Macro 4/120 + 1.7×	∞	4.0	3.0	0.55	2.4	1.8	0.92	2.0	1.5	1.10	1.7	1.3	1.28
	1.3	0.9	0.7	2.45	0.7	0.6	2.97	0.7	0.5	3.22	0.6	0.5	3.48
HC 3.2/150 mm	∞	8.5	6.3	0.26	5.1	3.8	0.43	4.2	3.1	0.52	3.6	2.7	0.61
	4.3	5.4	4.0	0.41	3.8	2.8	0.58	3.3	2.4	0.67	2.9	2.2	0.75
HC 3.2/150 mm + 1.7×	∞	5.0	3.7	0.44	3.0	2.2	0.73	2.5	1.9	0.87	2.2	1.6	1.02
	4.3	3.2	2.4	0.68	2.2	1.7	0.98	2.0	1.5	1.12	1.7	1.3	1.26
HC 4/210 mm	∞	12	8.6	0.19	7.1	5.3	0.31	6.0	4.4	0.37	5.1	3.8	0.43
	5.9	6.5	4.8	0.34	4.7	3.5	0.47	4.2	3.1	0.53	3.7	2.7	0.60
HC 4/210 mm + 1.7×	∞	7.1	5.3	0.31	4.2	3.1	0.52	3.6	2.6	0.62	3.0	2.2	0.73
	5.9	3.9	2.9	0.57	2.8	2.1	0.78	2.5	1.8	0.89	2.2	1.6	1.00
HC 4.5/300 mm	∞	16	12	0.13	9.9	7.3	0.22	8.3	6.1	0.27	7.1	5.2	0.31
	8.0	7.6	5.6	0.29	5.6	4.2	0.39	5.0	3.7	0.44	4.4	3.3	0.50
HC 4.5/300 mm + 1.7×	∞	9.8	7.3	0.22	5.9	4.4	0.37	4.9	3.7	0.45	4.2	3.1	0.52
	8.0	4.5	3.3	0.49	3.3	2.5	0.66	3.0	2.2	0.75	2.6	2.0	0.84
HC 3.5-4.5/50-110 mm (50)	∞	2.9	2.1	0.76	1.7	1.3	1.26	-	-	-	-	-	-
	2.3	2.3	1.7	0.94	1.5	1.1	1.49	-	-	-	-	-	-
(80)	∞	4.5	3.3	0.49	2.7	2.0	0.81	2.3	1.7	0.97	1.9	1.4	1.14
	2.3	3.1	2.3	0.71	2.0	1.5	1.09	1.7	1.3	1.27	1.5	1.1	1.46
(110)	∞	6.1	4.5	0.36	3.7	2.7	0.60	3.1	2.3	0.72	2.6	1.9	0.84
	2.3	3.5	2.6	0.63	2.4	1.8	0.92	2.1	1.5	1.07	1.8	1.4	1.21

Blue numbers : AF not possible
- : incompatible combination

Chart A6. Area coverage in inches with combinations of tubes for the 6 × 4.5 film format.

Chart A6	Lens focus setting	13 + 26 mm W	H	m	13 + 52 mm W	H	m	26 + 52 mm W	H	m	13 + 26 + 52 mm W	H	m
HCD 4/28 mm	∞	1.3	1.0	1.3	-	-	-	-	-	-	-	-	-
	1.1	1.2	0.9	1.5	-	-	-	-	-	-	-	-	-
HC 3.5/35 mm	∞	1.8	1.3	1.09	-	-	-	-	-	-	-	-	-
	1.6	1.6	1.2	1.20	-	-	-	-	-	-	-	-	-
HC 3.5/50 mm	∞	2.5	1.9	0.78	1.5	1.1	1.29	1.2	1.0	1.55	1.1	0.8	1.80
	2.0	2.1	1.6	0.91	1.3	1.0	1.43	1.1	0.9	1.69	1.0	0.7	1.95
HC 3.5/50 + 1.7×	∞	1.5	1.1	1.30	0.9	0.7	2.16	0.8	0.5	2.59	0.6	0.4	3.01
	2.0	1.3	1.0	1.52	0.8	0.6	2.40	0.7	0.5	2.83	0.6	0.4	3.27
HC 2.8/80 mm	∞	4.0	3.0	0.48	2.5	1.9	0.79	2.0	1.5	0.95	1.8	1.3	1.10
	2.3	3.1	2.3	0.63	2.0	1.5	0.94	1.8	1.3	1.10	1.6	1.1	1.25
HC 2.8/80 mm + 1.7×	∞	2.5	1.8	0.80	1.5	1.1	1.33	1.2	0.9	1.59	1.1	0.8	1.85
	2.3	1.8	1.4	1.05	1.2	0.9	1.58	1.1	0.8	1.84	1.0	0.7	2.09
HC 2.2/100 mm	∞	4.9	3.7	0.39	3.0	2.2	0.65	2.5	1.9	0.78	2.1	1.6	0.91
	3.0	3.7	2.7	0.53	2.5	1.8	0.79	2.1	1.6	0.92	1.8	1.4	1.05
HC 2.2/100 mm + 1.7×	∞	2.9	2.2	0.66	1.8	1.3	1.10	1.5	1.1	1.31	1.3	1.0	1.53
	3.0	2.2	1.6	0.89	1.5	1.1	1.33	1.2	1.0	1.55	1.1	0.8	1.76
HC Macro 4/120	∞	5.9	4.4	0.33	3.5	2.7	0.55	2.9	2.2	0.66	2.5	1.9	0.77
	1.3	1.3	1.0	1.46	1.1	0.8	1.77	1.0	0.8	1.92	1.0	0.7	2.07
HC Macro 4/120 + 1.7×	∞	3.5	2.7	0.55	2.1	1.6	0.92	1.8	1.3	1.10	1.5	1.1	1.28
	1.3	0.8	0.6	2.45	0.6	0.5	2.97	0.6	0.4	3.22	0.5	0.4	3.48
HC 3.2/150 mm	∞	7.4	5.6	0.26	4.5	3.4	0.43	3.7	2.7	0.52	3.2	2.4	0.61
	4.3	4.7	3.5	0.41	3.3	2.5	0.58	2.9	2.1	0.67	2.5	1.9	0.75
HC 3.2/150 mm + 1.7×	∞	4.4	3.3	0.44	2.6	1.9	0.73	2.2	1.7	0.87	1.9	1.4	1.02
	4.3	2.8	2.1	0.68	1.9	1.5	0.98	1.8	1.3	1.12	1.5	1.1	1.26
HC 4/210 mm	∞	10.5	7.6	0.19	6.2	4.7	0.31	5.3	3.9	0.37	4.5	3.4	0.43
	5.9	5.7	4.2	0.34	4.1	3.1	0.47	3.7	2.7	0.53	3.2	2.4	0.60
HC 4/210 mm + 1.7×	∞	6.2	4.7	0.31	3.7	2.7	0.52	3.2	2.3	0.62	2.6	1.9	0.73
	5.9	3.4	2.6	0.57	2.5	1.9	0.78	2.2	1.6	0.89	1.9	1.4	1.00
HC 4.5/300 mm	∞	14.0	10.6	0.13	8.7	6.5	0.22	7.3	5.4	0.27	6.2	4.6	0.31
	8.0	6.7	5.0	0.29	4.9	3.7	0.39	4.4	3.3	0.44	3.9	2.9	0.50
HC 4.5/300 mm + 1.7×	∞	8.6	6.5	0.22	5.2	3.9	0.37	4.3	3.3	0.45	3.7	2.7	0.52
	8.0	3.9	2.9	0.49	2.9	2.2	0.66	2.6	1.9	0.75	2.3	1.8	0.84
HC 3.5-4.5/50-110 mm	50 ∞	2.5	1.9	0.76	1.5	1.1	1.26	-	-	-	-	-	-
	50 2.3	2.0	1.5	0.94	1.3	1.0	1.49	2.0	1.5	0.97	1.7	1.2	1.14
	80 ∞	3.9	2.9	0.49	2.4	1.8	0.81	1.5	1.1	1.27	1.3	1.0	1.46
	80 2.3	2.7	2.0	0.71	1.8	1.3	1.09	-	-	-	-	-	-
	110 ∞	5.3	4.0	0.36	3.2	2.4	0.60	2.7	2.0	0.72	2.3	1.7	0.84
	110 2.3	3.1	2.3	0.63	2.1	1.6	0.92	1.8	1.3	1.07	1.6	1.2	1.21

Blue numbers : AF not possible
- : incompatible combination

Chart A7. Area coverage in inches with combinations of tubes for the 36.7 × 49.0 sensoChart r.

Chart A8	Lens focus setting	13 + 26 mm W	H	m	13 + 52 mm W	H	m	26 + 52 mm W	H	m	13 + 26 + 52 mm W	H	m
HCD 4/28 mm	∞	1.2	0.9	1.3	-	-	-	-	-	-	-	-	-
	1.1	1.1	0.8	1.5	-	-	-	-	-	-	-	-	-
HC 3.5/35 mm	∞	1.6	1.2	1.09	-	-	-	-	-	-	-	-	-
	1.6	1.4	1.1	1.20	-	-	-	-	-	-	-	-	-
HC 3.5/50 mm	∞	2.2	1.7	0.78	1.3	1.0	1.29	1.1	0.9	1.55	0.9	0.7	1.80
	2.0	1.9	1.4	0.91	1.2	0.9	1.43	1.0	0.8	1.69	0.9	0.6	1.95
HC 3.5/50 + 1.7×	∞	1.3	1.0	1.30	0.8	0.6	2.16	0.7	0.5	2.59	0.6	0.4	3.01
	2.0	1.2	0.9	1.52	0.7	0.6	2.40	0.6	0.5	2.83	0.6	0.4	3.27
HC 2.8/80 mm	∞	3.6	2.7	0.48	2.2	1.7	0.79	1.8	1.4	0.95	1.6	1.2	1.10
	2.3	2.8	2.1	0.63	1.8	1.4	0.94	1.6	1.2	1.10	1.4	1.0	1.25
HC 2.8/80 mm + 1.7×	∞	2.2	1.6	0.80	1.3	1.0	1.33	1.1	0.8	1.59	0.9	0.7	1.85
	2.3	1.7	1.3	1.05	1.1	0.8	1.58	0.9	0.7	1.84	0.9	0.6	2.09
HC 2.2/100 mm	∞	4.4	3.3	0.39	2.7	2.0	0.65	2.2	1.7	0.78	1.9	1.4	0.91
	3.0	3.3	2.5	0.53	2.2	1.6	0.79	1.9	1.4	0.92	1.7	1.3	1.05
HC 2.2/100 mm + 1.7×	∞	2.6	2.0	0.66	1.6	1.2	1.10	1.3	1.0	1.31	1.2	0.9	1.53
	3.0	2.0	1.4	0.89	1.3	1.0	1.33	1.1	0.9	1.55	1.0	0.7	1.76
HC Macro 4/120	∞	5.3	4.0	0.33	3.2	2.4	0.55	2.6	2.0	0.66	2.3	1.7	0.77
	1.3	1.2	0.9	1.46	1.0	0.7	1.77	0.9	0.7	1.92	0.9	0.6	2.07
HC Macro 4/120 + 1.7×	∞	3.2	2.4	0.55	1.9	1.4	0.92	1.6	1.2	1.10	1.3	1.0	1.28
	1.3	0.7	0.6	2.45	0.6	0.5	2.97	0.6	0.4	3.22	0.5	0.4	3.48
HC 3.2/150 mm	∞	6.7	5.0	0.26	4.0	3.0	0.43	3.3	2.5	0.52	2.8	2.2	0.61
	4.3	4.3	3.2	0.41	3.0	2.2	0.58	2.6	1.9	0.67	2.3	1.8	0.75
HC 3.2/150 mm + 1.7×	∞	3.9	3.0	0.44	2.4	1.8	0.73	2.0	1.5	0.87	1.7	1.3	1.02
	4.3	2.5	1.9	0.68	1.7	1.4	0.98	1.6	1.2	1.12	1.3	1.0	1.26
HC 4/210 mm	∞	9.5	6.9	0.19	5.6	4.2	0.31	4.7	3.5	0.37	4.0	3.0	0.43
	5.9	5.1	3.8	0.34	3.7	2.8	0.47	3.3	2.5	0.53	2.9	2.2	0.60
HC 4/210 mm + 1.7×	∞	5.6	4.2	0.31	3.3	2.5	0.52	2.8	2.1	0.62	2.4	1.8	0.73
	5.9	3.1	2.3	0.57	2.2	1.7	0.78	2.0	1.4	0.89	1.7	1.3	1.00
HC 4.5/300 mm	∞	12.6	9.6	0.13	7.8	5.8	0.22	6.6	4.9	0.27	5.6	4.1	0.31
	8.0	6.0	4.5	0.29	4.4	3.3	0.39	3.9	3.0	0.44	3.5	2.6	0.50
HC 4.5/300 mm + 1.7×	∞	7.7	5.8	0.22	4.7	3.5	0.37	3.9	3.0	0.45	3.3	2.5	0.52
	8.0	3.6	2.6	0.49	2.6	2.0	0.66	2.4	1.8	0.75	2.1	1.6	0.84
HC 3.5-4.5/50-110 mm 50	∞	2.3	1.7	0.76	1.3	1.0	1.26	-	-	-	-	-	-
	2.3	1.8	1.4	0.94	1.2	0.9	1.49	-	-	-	-	-	-
80	∞	3.6	2.6	0.49	2.1	1.6	0.81	1.8	1.4	0.97	1.5	1.1	1.14
	2.3	2.4	1.8	0.71	1.6	1.2	1.09	1.3	1.0	1.27	1.2	0.9	1.46
110	∞	4.8	3.6	0.36	2.9	2.2	0.60	2.4	1.8	0.72	2.1	1.5	0.84
	2.3	2.8	2.1	0.63	1.9	1.4	0.92	1.7	1.2	1.07	1.4	1.1	1.21

Blue numbers : AF not possible
- : incompatible combination

Chart A8. Area coverage in inches with combinations of tables for the 33.1 × 44.2 sensor.

D Subject to film plane distance
O Subject to lens distance
m Magnification
R Exposure reduction (EV), Only used in manual exposure mode

Chart B1		Lens focus setting	13 mm				26 mm				52 mm			
			D	O	m	R	D	O	m	R	D	O	m	R
HCD 4/28 mm		∞	218	45	0.45	0.3	199	13	0.90	0.6	-	-	-	-
		0.35	203	30	0.59	0.4	195	9	1.05	0.7	-	-	-	-
HC 3.5/35 mm		∞	273	78	0.37	0.3	237	29	0.73	0.6	239	5	1.44	1.1
		0.5	250	55	0.47	0.4	230	23	0.84	0.7	237	3	1.56	1.2
HC 3.5/50 mm		∞	365	179	0.26	0.3	281	82	0.52	0.6	259	34	1.03	1.0
		0.6	304	119	0.38	0.4	264	65	0.64	0.7	255	30	1.17	1.2
HC 3.5/50 + 1.7×		∞	415	179	0.44	0.3	331	82	0.87	0.6	309	34	1.74	1.0
		0.6	354	118	0.63	0.4	313	65	1.08	0.7	305	30	1.96	1.2
HC 2.8/80 mm		∞	681	552	0.16	0.4	435	294	0.32	0.7	333	165	0.63	1.3
		0.7	440	298	0.31	0.7	364	210	0.47	1.0	320	140	0.78	1.5
HC 2.8/80 mm + 1.7×		∞	731	551	0.27	0.4	486	294	0.53	0.7	383	165	1.06	1.3
		0.7	490	298	0.52	0.7	414	210	0.79	1.0	370	140	1.32	1.6
HC 2.2/100 mm		∞	947	796	0.13	0.35	578	415	0.26	0.67	414	224	0.52	1.23
		0.9	567	403	0.27	0.69	460	282	0.40	0.98	387	184	0.66	1.49
HC 2.2/100 mm + 1.7×		∞	996	798	0.22	0.35	628	415	0.44	0.67	464	224	0.88	1.24
		0.9	617	403	0.45	0.69	510	282	0.67	0.99	438	184	1.11	1.50
HC Macro 4/120		∞	1353	1154	0.11	0.28	825	613	0.22	0.54	580	343	0.44	1.00
		0.39	390	133	1.16	1.48	394	124	1.31	1.69	408	112	1.61	2.07
HC Macro 4/120 + 1.7×		∞	1402	1154	0.18	0.28	875	613	0.37	0.54	630	343	0.73	1.00
		0.39	440	133	1.94	1.47	444	124	2.20	1.68	458	112	2.71	2.07
HC 3.2/150 mm		∞	1980	1786	0.09	0.3	1133	925	0.17	0.5	728	495	0.35	1.0
		1.3	926	731	0.23	0.3	764	557	0.32	0.5	625	392	0.49	1.0
HC 3.2/150 mm + 1.7×		∞	2030	1785	0.15	0.3	1182	925	0.29	0.5	778	495	0.58	1.0
		1.3	976	731	0.39	0.3	814	557	0.54	0.5	675	392	0.83	1.0
HC 4/210 mm		∞	3810	3574	0.06	0.3	2114	1865	0.12	0.5	1285	1010	0.25	0.9
		1.8	1378	1142	0.21	0.3	1162	914	0.27	0.5	952	677	0.40	0.9
HC 4/210 mm + 1.7×		∞	3859	3574	0.10	0.3	2163	1865	0.21	0.5	1335	1010	0.41	0.9
		1.8	1428	1142	0.35	0.3	1212	914	0.46	0.5	1002	677	0.68	0.9
HC 4.5/300 mm		∞	7178	6910	0.045	0.25	3917	3636	0.089	0.48	2306	1999	0.18	0.90
		2.45	1949	1681	0.19	0.24	1670	1390	0.24	0.47	1377	1070	0.34	0.88
HC 4.5/300 mm + 1.7×		∞	7227	6909	0.075	0.25	3967	3636	0.15	0.48	2356	1999	0.30	0.89
		2.45	1999	1681	0.31	0.22	1721	1389	0.40	0.45	1427	1070	0.57	0.86
HC 3.5-4.5/50-110 mm	50	∞	410	182	0.25	0.4	322	80	0.51	0.8	297	30	1.01	1.4
		0.7	336	96	0.38	0.4	296	43	0.66	0.8	290	11	1.22	1.4
	80	∞	719	500	0.16	0.3	486	255	0.33	0.6	390	132	0.65	1.0
		0.7	432	202	0.33	0.3	370	127	0.52	0.6	341	72	0.90	1.0
	110	∞	1162	935	0.12	0.2	725	486	0.24	0.5	527	261	0.48	0.8
		0.7	515	277	0.34	0.2	449	198	0.49	0.5	407	129	0.78	0.8

Blue numbers : AF not possible
- : incompatible combination

Chart B1. Exposure increase, magnification and distances in the metric system for single extension tubes.

W — Covered area width
H — Covered area height
m — Magnification

Chart B3	Lens focus setting	13 mm			26 mm			52 mm		
		W	H	m	W	H	m	W	H	m
HCD 4/28 mm	∞	116	85	0.45	59	43	0.90	-	-	-
	0.35	90	65	0.59	51	37	1.05	-	-	-
HC 3.5/35 mm	∞	151	112	0.37	77	57	0.73	39	29	1.44
	0.5	119	88	0.47	67	49	0.84	36	27	1.56
HC 3.5/50 mm	∞	215	160	0.26	108	80	0.52	54	40	1.03
	0.6	147	109	0.38	88	65	0.64	48	35	1.17
HC 3.5/50 + 1.7×	∞	127	94	0.44	64	48	0.87	32	24	174
	0.6	89	66	0.63	52	38	1.08	29	21	1.96
HC 2.8/80 mm	∞	350	259	0.16	175	130	0.32	89	66	0.63
	0.7	181	134	0.31	119	88	0.47	72	53	0.78
HC 2.8/80 mm + 1.7×	∞	207	154	0.27	106	78	0.53	53	39	1.06
	0.7	108	80	0.52	71	53	0.79	42	31	1.32
HC 2.2/100 mm	∞	428	317	0.13	214	159	0.26	107	79	0.52
	0.9	207	154	0.27	140	104	0.40	85	63	0.66
HC 2.2/100 mm + 1.7×	∞	255	189	0.22	127	94	0.44	64	47	0.88
	0.9	123	91	0.45	83	62	0.67	50	37	1.11
HC Macro 4/120	∞	510	378	0.11	255	189	0.22	128	95	0.44
	0.39	48	36	1.16	43	32	1.31	35	26	1.61
HC Macro 4/120 + 1.7×	∞	304	226	0.18	152	113	0.37	76	56	0.73
	0.39	26	21	1.94	25	19	2.20	21	15	2.71
HC 3.2/150 mm	∞	622	461	0.09	329	244	0.17	160	119	0.35
	1.3	243	180	0.23	175	130	0.32	114	85	0.49
HC 3.2/150 mm + 1.7×	∞	373	277	0.15	193	143	0.29	97	72	0.58
	1.3	144	106	0.39	104	77	0.54	67	50	0.83
HC 4/210 mm	∞	933	692	0.06	467	346	0.12	224	166	0.25
	1.8	267	198	0.21	207	154	0.27	140	104	0.40
HC 4/210 mm + 1.7×	∞	560	415	0.10	267	198	0.21	137	101	0.41
	1.8	160	119	0.35	122	90	0.46	82	61	0.68
HC 4.5/300 mm	∞	1256	931	0.045	628	465	0.089	314	233	0.18
	2.4	299	222	0.19	235	174	0.24	164	121	0.34
HC 4.5/300 mm + 1.7×	∞	750	555	0.075	375	278	0.15	187	139	0.30
	2.4	178	132	0.31	140	103	0.40	97	72	0.57
HC 3.5-4.5/50-110 mm — 50	∞	224	166	0.25	110	81	0.51	55	41	1.01
	0.7	147	109	0.38	85	63	0.66	46	34	1.22
HC 3.5-4.5/50-110 mm — 80	∞	350	259	0.16	170	126	0.33	86	64	0.65
	0.7	170	126	0.33	108	80	0.52	62	46	0.90
HC 3.5-4.5/50-110 mm — 110	∞	467	346	0.12	233	173	0.24	117	86	0.48
	0.7	165	122	0.34	114	85	0.49	72	53	0.78

Blue numbers : AF not possible
- : incompatible combination

Chart B2. Area coverage in the metric system with single extension tubes for the 6 × 4.5 film format.

W	Covered area width
H	Covered area height
m	Magnification

Chart B5	Lens focus setting	13 mm			26 mm			52 mm		
		W	H	m	W	H	m	W	H	m
HCD 4/28 mm	∞	102	75	0.45	52	38	0.90	-	-	-
	0.35	79	58	0.59	45	33	1.05	-	-	-
HC 3.5/35 mm	∞	132	99	0.37	67	50	0.73	34	26	1.44
	0.5	104	78	0.47	59	43	0.84	32	24	1.56
HC 3.5/50 mm	∞	188	142	0.26	95	71	0.52	47	35	1.03
	0.6	129	96	0.38	77	57	0.64	42	31	1.17
HC 3.5/50 + 1.7×	∞	111	83	0.44	56	42	0.87	28	21	174
	0.6	78	58	0.63	46	34	1.08	25	19	1.96
HC 2.8/80 mm	∞	306	229	0.16	153	115	0.32	78	58	0.63
	0.7	158	118	0.31	104	78	0.47	63	47	0.78
HC 2.8/80 mm + 1.7×	∞	181	136	0.27	93	69	0.53	46	34	1.06
	0.7	95	71	0.52	62	47	0.79	37	27	1.32
HC 2.2/100 mm	∞	375	280	0.13	187	141	0.26	94	70	0.52
	0.9	181	136	0.27	123	92	0.40	74	56	0.66
HC 2.2/100 mm + 1.7×	∞	223	167	0.22	111	83	0.44	56	42	0.88
	0.9	108	80	0.45	73	55	0.67	44	33	1.11
HC Macro 4/120	∞	446	334	0.11	223	167	0.22	112	84	0.44
	0.39	42	32	1.16	38	28	1.31	31	23	1.61
HC Macro 4/120 + 1.7×	∞	266	200	0.18	133	100	0.37	67	50	0.73
	0.39	23	19	1.94	22	17	2.20	18	13	2.71
HC 3.2/150 mm	∞	544	408	0.09	288	216	0.17	140	105	0.35
	1.3	213	159	0.23	153	115	0.32	100	75	0.49
HC 3.2/150 mm + 1.7×	∞	326	245	0.15	169	126	0.29	85	64	0.58
	1.3	126	94	0.39	91	68	0.54	59	44	0.83
HC 4/210 mm	∞	816	612	0.06	409	306	0.12	196	147	0.25
	1.8	234	175	0.21	181	136	0.27	123	92	0.40
HC 4/210 mm + 1.7×	∞	490	367	0.10	234	175	0.21	120	89	0.41
	1.8	140	105	0.35	107	80	0.46	72	54	0.68
HC 4.5/300 mm	∞	1099	823	0.045	550	411	0.089	275	206	0.18
	2.4	262	196	0.19	206	154	0.24	144	107	0.34
HC 4.5/300 mm + 1.7×	∞	656	491	0.075	328	246	0.15	164	123	0.30
	2.4	156	117	0.31	123	91	0.40	85	64	0.57
HC 3.5-4.5/50-110 mm — 50	∞	196	147	0.25	96	72	0.51	48	36	1.01
	0.7	129	96	0.38	74	56	0.66	40	30	1.22
HC 3.5-4.5/50-110 mm — 80	∞	306	229	0.16	149	111	0.33	75	57	0.65
	0.7	149	111	0.33	95	71	0.52	54	41	0.90
HC 3.5-4.5/50-110 mm — 110	∞	409	306	0.12	204	153	0.24	102	76	0.48
	0.7	144	108	0.34	100	75	0.49	63	47	0.78

Blue numbers : AF not possible
- : incompatible combination

Chart B3. Area coverage in the metric system with single extension tubes for the 36.7×49.0 sensor.

W	Covered area width
H	Covered area height
m	Magnification

Chart B7	Lens focus setting	13 mm			26 mm			52 mm		
		W	H	m	W	H	m	W	H	m
HCD 4/28 mm	∞	92	68	0.45	47	34	0.90	-	-	-
	0.35	71	52	0.59	40	30	1.05	-	-	-
HC 3.5/35 mm	∞	119	89	0.37	61	45	0.73	31	23	1.44
	0.5	94	70	0.47	53	39	0.84	28	22	1.56
HC 3.5/50 mm	∞	170	128	0.26	85	64	0.52	43	32	1.03
	0.6	116	87	0.38	69	52	0.64	38	28	1.17
HC 3.5/50 + 1.7×	∞	100	75	0.44	51	38	0.87	25	19	174
	0.6	70	53	0.63	41	30	1.08	23	17	1.96
HC 2.8/80 mm	∞	276	207	0.16	138	104	0.32	70	53	0.63
	0.7	143	107	0.31	94	70	0.47	57	42	0.78
HC 2.8/80 mm + 1.7×	∞	163	123	0.27	84	62	0.53	42	31	1.06
	0.7	85	64	0.52	56	42	0.79	33	25	1.32
HC 2.2/100 mm	∞	338	253	0.13	169	127	0.26	84	63	0.52
	0.9	163	123	0.27	111	83	0.40	67	50	0.66
HC 2.2/100 mm + 1.7×	∞	201	151	0.22	100	75	0.44	51	37	0.88
	0.9	97	73	0.45	66	49	0.67	39	30	1.11
HC Macro 4/120	∞	403	301	0.11	201	151	0.22	101	76	0.44
	0.39	38	29	1.16	34	26	1.31	28	21	1.61
HC Macro 4/120 + 1.7×	∞	240	180	0.18	120	90	0.37	60	45	0.73
	0.39	21	17	1.94	20	15	2.20	17	12	2.71
HC 3.2/150 mm	∞	491	368	0.09	260	195	0.17	126	95	0.35
	1.3	192	144	0.23	138	104	0.32	90	68	0.49
HC 3.2/150 mm + 1.7×	∞	294	221	0.15	152	114	0.29	77	57	0.58
	1.3	114	85	0.39	82	61	0.54	53	40	0.83
HC 4/210 mm	∞	736	552	0.06	369	276	0.12	177	132	0.25
	1.8	211	158	0.21	163	123	0.27	111	83	0.40
HC 4/210 mm + 1.7×	∞	442	331	0.10	211	158	0.21	108	81	0.41
	1.8	126	95	0.35	96	72	0.46	65	49	0.68
HC 4.5/300 mm	∞	991	743	0.045	496	371	0.089	248	186	0.18
	2.4	236	177	0.19	185	139	0.24	129	97	0.34
HC 4.5/300 mm + 1.7×	∞	592	443	0.075	296	222	0.15	148	111	0.30
	2.4	140	105	0.31	111	82	0.40	77	57	0.57
HC 3.5-4.5/50-110 mm — 50	∞	177	132	0.25	87	65	0.51	43	33	1.01
	0.7	116	87	0.38	67	50	0.66	36	27	1.22
HC 3.5-4.5/50-110 mm — 80	∞	276	207	0.16	134	100	0.33	68	51	0.65
	0.7	134	100	0.33	85	64	0.52	49	37	0.90
HC 3.5-4.5/50-110 mm — 110	∞	369	276	0.12	184	138	0.24	92	69	0.48
	0.7	130	97	0.34	90	68	0.49	57	42	0.78

Blue numbers : AF not possible
- : incompatible combination

Chart B4. Area coverage in the metric system for single extension tubes for the 33.1 × 44.2 sensor.

Chart B2	Lens focus setting	13 + 26 mm D	O	m	R	13 + 52 mm D	O	m	R	26 + 52 mm D	O	m	R	13 + 26 + 52 mm D	O	m	R
HCD 4/28 mm	∞	201	2	1.35	0.9	-	-	-	-	-	-	-	-	-	-	-	-
	0.35	200	0	1.50	1	-	-	-	-	-	-	-	-	-	-	-	-
HC 3.5/35 mm	∞	234	13	1.09	0.8	-	-	-	-	-	-	-	-	-	-	-	-
	0.5	231	10	1.20	0.9	-	-	-	-	-	-	-	-	-	-	-	-
HC 3.5/50 mm	∞	262	50	0.78	0.8	262	24	1.29	1.3	269	18	1.55	1.4	277	13	1.80	1.6
	0.6	254	42	0.91	1.0	260	22	1.43	1.5	268	17	1.69	1.7	277	13	1.95	1.9
HC 3.5/50 + 1.7×	∞	312	50	1.30	0.8	312	24	2.16	1.3	319	18	2.59	1.4	327	13	3.01	1.6
	0.6	304	42	1.52	1.0	310	22	2.4	1.5	318	17	2.83	1.7	327	13	3.27	1.9
HC 2.8/80 mm	∞	363	208	0.48	1.0	316	139	0.79	1.5	316	122	0.95	1.8	316	109	1.10	2.0
	0.7	333	166	0.63	1.3	316	122	0.94	1.8	316	110	1.10	2.0	320	100	1.25	2.2
HC 2.8/80 mm + 1.7×	∞	413	208	0.80	1.0	370	139	1.33	1.6	366	122	1.59	1.8	366	109	1.85	2.0
	0.7	383	166	1.05	1.3	366	122	1.58	1.8	366	110	1.84	2.0	370	100	2.09	2.2
HC 2.2/100 mm	∞	464	288	0.39	1.0	389	182	0.65	1.5	376	161	0.78	1.7	371	143	0.91	1.9
	0.9	412	221	0.53	1.2	376	159	0.79	1.7	371	142	0.92	1.9	370	128	1.05	2.1
HC 2.2/100 mm + 1.7×	∞	514	288	0.66	1.0	439	186	1.10	1.5	426	161	1.31	1.7	421	143	1.53	1.9
	0.9	462	221	0.89	1.3	426	159	1.33	1.7	421	142	1.55	2.0	421	128	1.76	2.2
HC Macro 4/120	∞	657	433	0.33	0.8	539	289	0.55	1.2	516	253	0.66	1.2	503	227	0.77	1.6
	0.39	400	117	1.46	1.9	416	107	1.77	2.2	425	103	1.92	2.4	435	100	2.07	2.6
HC Macro 4/120 + 1.7×	∞	707	433	0.55	0.8	589	289	0.92	1.2	566	253	1.10	1.2	553	227	1.28	1.6
	0.39	450	117	2.45	1.9	466	107	2.97	2.2	475	103	3.22	2.4	485	100	3.48	2.6
HC 3.2/150 mm	∞	859	638	0.26	0.8	655	409	0.43	1.2	611	351	0.52	1.4	582	310	0.61	1.5
	1.3	677	457	0.41	0.8	593	346	0.58	1.2	572	312	0.67	1.4	559	287	0.75	1.5
HC 3.2/150 mm + 1.7×	∞	909	638	0.44	0.8	705	408	0.73	1.2	660	351	0.87	1.4	632	310	1.02	1.5
	1.3	727	457	0.68	0.8	643	346	0.98	1.2	622	312	1.12	1.4	610	286	1.26	1.5
HC 4/210 mm	∞	1557	1295	0.19	0.7	1127	839	0.31	1.1	1026	725	0.37	1.3	958	644	0.43	1.4
	1.8	1034	773	0.34	0.7	896	608	0.47	1.1	856	556	0.53	1.3	828	515	0.60	1.4
HC 4/210 mm + 1.7×	∞	1607	1295	0.31	0.7	1177	839	0.52	1.1	1076	725	0.62	1.3	1007	644	0.73	1.4
	1.8	1084	773	0.57	0.7	946	608	0.78	1.1	906	556	0.89	1.3	878	515	1.00	1.4
HC 4.5/300 mm	∞	2839	2545	0.13	0.7	1991	1671	0.22	1.1	1786	1453	0.27	1.3	1643	1297	0.31	1.4
	2.45	1495	1201	0.29	0.7	1293	973	0.39	0.1	1231	898	0.44	1.2	1185	839	0.50	1.4
HC 4.5/300 mm + 1.7×	∞	2888	2544	0.22	0.7	2041	1671	0.37	1.1	1836	1453	0.45	1.3	1693	1297	0.52	1.4
	2.45	1545	1201	0.49	0.7	1343	973	0.66	1.0	1281	898	0.75	1.2	1235	839	0.84	1.4
HC 3.5-4.5/50-110 mm — 50	∞	301	47	0.76	1.1	300	20	1.26	1.6	-	-	-	-	-	-	-	-
	0.7	288	22	0.94	1.1	295	4	1.49	1.6	-	-	-	-	-	-	-	-
HC 3.5-4.5/50-110 mm — 80	∞	418	173	0.49	0.8	378	107	0.81	1.2	375	91	0.97	1.4	376	79	1.14	1.6
	0.7	348	92	0.71	0.8	341	59	1.09	1.2	354	49	1.27	1.4	351	43	1.46	1.6
HC 3.5-4.5/50-110 mm — 110	∞	589	336	0.36	0.7	495	216	0.60	1.0	478	186	0.72	1.2	469	164	0.84	1.3
	0.7	420	156	0.63	0.7	402	111	0.92	1.0	401	98	1.07	1.2	404	88	1.21	1.3

Blue numbers : AF not possible
- : incompatible combination

Chart B5. Exposure increase, magnification and distances in the metric system for combinations of tubes.

Chart B4	Lens focus setting	13 + 26 mm			13 + 52 mm			26 + 52 mm			13 + 26 + 52 mm		
		W	H	m	W	H	m	W	H	m	W	H	m
HCD 4/28 mm	∞	39.3	28.6	1.3	-	-	-	-	-	-	-	-	-
	0.35	35.6	25.8	1.5	-	-	-	-	-	-	-	-	-
HC 3.5/35 mm	∞	51.4	38.1	1.09	-	-	-	-	-	-	-	-	-
	0.5	46.7	34.6	1.20	-	-	-	-	-	-	-	-	-
HC 3.5/50 mm	∞	71.8	53.2	0.78	43.4	32.2	1.29	36.1	26.8	1.55	31.1	23.1	1.80
	0.6	61.5	45.6	0.91	39.2	29.0	1.43	33.1	24.6	1.69	28.7	21.3	1.95
HC 3.5/50 + 1.7×	∞	43.1	31.9	1.30	25.9	19.2	2.16	21.6	16.0	2.59	18.6	13.8	3.01
	0.6	36.8	27.3	1.52	23.3	17.3	2.40	19.8	14.7	2.83	17.1	12.7	3.27
HC 2.8/80 mm	∞	117	86.5	0.48	70.9	52.5	0.79	58.9	43.7	0.95	50.9	37.7	1.10
	0.7	88.9	65.9	0.63	59.6	44.1	0.94	50.9	37.7	1.10	44.8	33.2	1.25
HC 2.8/80 mm + 1.7×	∞	70.0	51.9	0.80	42.1	31.2	1.33	35.2	26.1	1.55	30.3	22.4	1.85
	0.7	53.3	39.5	1.05	35.4	26.3	1.58	30.4	22.6	1.84	26.8	19.9	2.09
HC 2.2/100 mm	∞	143	106	0.39	86	64	0.65	72	53	0.78	61	46	0.91
	0.9	106	78	0.53	71	52	0.79	61	45	0.92	53	40	1.05
HC 2.2/100 mm + 1.7×	∞	85	63	0.66	51	38	1.10	43	32	1.31	37	27	1.53
	0.9	63	46	0.89	42	31	1.33	36	27	1.55	32	24	1.76
HC Macro 4/120	∞	170	126	0.33	102	76	0.55	85	63	0.66	73	54	0.77
	0.39	38	28	1.46	32	24	1.77	29	22	1.92	27	20	2.07
HC Macro 4/120 + 1.7×	∞	102	75	0.55	61	45	0.92	51	38	1.10	44	32	1.28
	0.39	23	17	2.45	19	14	2.97	17	13	3.22	16	12	3.48
HC 3.2/150 mm	∞	215	160	0.26	130	96.5	0.43	108	79.8	0.52	91.8	68.0	0.61
	1.3	137	101	0.41	96.6	71.6	0.58	83.6	61.9	0.67	74.7	55.3	0.75
HC 3.2/150 mm + 1.7×	∞	127	94.3	0.44	76.7	56.8	0.73	64.4	47.7	0.87	54.9	40.7	1.02
	1.3	82.4	61.0	0.68	57.1	42.3	0.98	50.0	37.1	1.12	44.4	32.9	1.26
HC 4/210 mm	∞	295	218	0.19	181	134	0.31	151	112	0.37	130	96.5	0.43
	1.8	165	122	0.34	119	88.3	0.47	106	78.3	0.53	93.3	69.2	0.60
HC 4/210 mm + 1.7×	∞	181	134	0.31	108	79.8	0.52	90.3	66.9	0.62	76.7	56.8	0.73
	1.8	98.2	72.8	0.57	71.8	53.2	0.78	62.9	46.6	0.89	56.0	41.5	1.00
HC 4.5/300 mm	∞	419	310	0.13	251	186	0.22	210	155	0.27	180	133	0.31
	2.45	193	143	0.29	142	106	0.39	126	93	0.44	113	84	0.50
HC 4.5/300 mm + 1.7×	∞	250	185	0.22	150	111	0.37	125	93	0.45	107	79	0.52
	2.45	115	85	0.49	85	63	0.66	75	55	0.75	67	50	0.84
HC 3.5-4.5/50-110 mm	50 ∞	73.7	54.6	0.76	44.4	32.9	1.26	-	-	-	-	-	-
	50 0.7	59.6	44.1	0.94	37.6	27.9	1.49	-	-	-	-	-	-
	80 ∞	114	84.7	0.49	69.1	51.2	0.81	57.7	42.8	0.97	49.1	36.4	1.14
	80 0.7	78.9	58.5	0.71	51.4	38.1	1.09	44.1	32.7	1.27	38.4	28.4	1.46
	110 ∞	156	115	0.36	93.3	69.2	0.60	77.8	57.6	0.72	66.7	49.4	0.84
	110 0.7	88.9	65.9	0.63	60.9	45.1	0.92	52.3	38.8	1.07	46.3	34.3	1.21

Blue numbers : AF not possible
- : incompatible combination

Chart B6. Area coverage in the metric system with combinations of tubes for the 6 × 4.5 film format.

Chart B4	Lens focus setting	13 + 26 mm W	H	m	13 + 52 mm W	H	m	26 + 52 mm W	H	m	13 + 26 + 52 mm W	H	m
HCD 4/28 mm	∞	34.4	25.3	1.3	-	-	-	-	-	-	-	-	-
	0.35	31.2	22.8	1.5	-	-	-	-	-	-	-	-	-
HC 3.5/35 mm	∞	45.0	33.7	1.09	-	-	-	-	-	-	-	-	-
	0.5	40.9	30.6	1.20	-	-	-	-	-	-	-	-	-
HC 3.5/50 mm	∞	62.8	47.0	0.78	38.0	28.5	1.29	31.6	23.7	1.55	27.2	20.4	1.80
	0.6	53.8	40.3	0.91	34.3	25.6	1.43	29.0	21.8	1.69	25.1	18.8	1.95
HC 3.5/50 + 1.7×	∞	37.7	28.2	1.30	22.7	17.0	2.16	18.9	14.1	2.59	16.3	12.2	3.01
	0.6	32.2	24.1	1.52	20.4	15.3	2.40	17.3	13.0	2.83	15.0	11.2	3.27
HC 2.8/80 mm	∞	102	76.5	0.48	62.0	46.4	0.79	51.5	38.6	0.95	44.5	33.3	1.10
	0.7	77.8	58.3	0.63	52.2	39.0	0.94	44.5	33.3	1.10	39.2	29.4	1.25
HC 2.8/80 mm + 1.7×	∞	61.3	45.9	0.80	36.8	27.6	1.33	30.8	23.1	1.59	26.5	19.8	1.85
	0.7	46.6	34.9	1.05	31.0	23.3	1.58	26.6	20.0	1.84	23.5	17.6	2.09
HC 2.2/100 mm	∞	125	93.7	0.39	75.3	56.6	0.65	63.0	46.9	0.78	53.4	40.7	0.91
	0.9	92.8	69.0	0.53	62.1	46.0	0.79	53.4	39.8	0.92	46.4	35.4	1.05
HC 2.2/100 mm + 1.7×	∞	74.4	55.7	0.66	44.6	33.6	1.10	37.6	28.3	1.31	32.4	23.9	1.53
	0.9	55.1	40.7	0.89	36.8	27.4	1.33	31.5	23.9	1.55	28.0	21.2	1.76
HC Macro 4/120	∞	149	111	0.33	89.3	67.2	0.55	74.4	55.7	0.66	63.9	47.8	0.77
	0.39	33.3	24.8	1.46	28.0	21.2	1.77	25.4	19.5	1.92	23.6	17.7	2.07
HC Macro 4/120 + 1.7×	∞	89.3	66.3	0.55	53.4	39.8	0.92	44.6	33.6	1.10	38.5	28.3	1.28
	0.39	20.1	15.0	2.45	16.6	12.4	2.97	14.9	11.5	3.22	14.0	10.6	3.48
HC 3.2/150 mm	∞	188	141	0.26	113	85.3	0.43	94.2	70.6	0.52	80.3	60.1	0.61
	1.3	120	89.5	0.41	84.5	63.3	0.58	73.2	54.7	0.67	65.4	48.9	0.75
HC 3.2/150 mm + 1.7×	∞	111	83.4	0.44	67.1	50.2	0.73	56.4	42.2	0.87	48.0	36.0	1.02
	1.3	72.1	53.9	0.68	50.0	37.4	0.98	43.8	32.8	1.12	38.9	29.1	1.26
HC 4/210 mm	∞	258	193	0.19	158	118.4	0.31	132	99.2	0.37	114	85.3	0.43
	1.8	144	108	0.34	104	78.1	0.47	92.5	69.2	0.53	81.6	61.2	0.60
HC 4/210 mm + 1.7×	∞	158	118	0.31	94.2	70.6	0.52	79.0	59.2	0.62	67.1	50.2	0.73
	1.8	85.9	64.4	0.57	62.8	47.0	0.78	55.0	41.2	0.89	49.0	36.7	1.00
HC 4.5/300 mm	∞	367	274	0.13	220	164.5	0.22	184	137	0.27	158	118	0.31
	2.45	169	126	0.29	124	93.7	0.39	110	82.2	0.44	98.9	74.3	0.50
HC 4.5/300 mm + 1.7×	∞	219	164	0.22	131	98.2	0.37	109.4	82.2	0.45	93.6	69.9	0.52
	2.45	101	75.2	0.49	74.4	55.7	0.66	65.6	48.6	0.75	58.6	44.2	0.84
HC 3.5-4.5/50-110 mm — 50	∞	64.5	48.3	0.76	38.9	29.1	1.26	-	-	-	-	-	-
	0.7	52.2	39.0	0.94	32.9	24.7	1.49	-	-	-	-	-	-
HC 3.5-4.5/50-110 mm — 80	∞	100	74.9	0.49	60.5	45.3	0.81	50.5	37.8	0.97	43.0	32.2	1.14
	0.7	69.0	51.7	0.71	45.0	33.7	1.09	38.6	28.9	1.27	33.6	25.1	1.46
HC 3.5-4.5/50-110 mm — 110	∞	136	102	0.36	81.6	61.2	0.60	68.1	50.9	0.72	58.4	43.7	0.84
	0.7	77.8	58.3	0.63	53.3	39.9	0.92	45.8	34.3	1.07	40.5	30.3	1.21

Blue numbers : AF not possible
- : incompatible combination

Chart B7. Area coverage in the metric system for combinations of tubes for the 36.7 × 49.0 sensor.

Chart B8		Lens focus setting	13 + 26 mm			13 + 52 mm			26 + 52 mm			13 + 26 + 52 mm		
			W	H	m	W	H	m	W	H	m	W	H	m
HCD 4/28 mm		∞	31.0	22.8	1.3	-	-	-	-	-	-	-	-	-
		0.35	28.1	20.6	1.5	-	-	-	-	-	-	-	-	-
HC 3.5/35 mm		∞	40.6	30.4	1.09	-	-	-	-	-	-	-	-	-
		0.5	36.9	27.6	1.20	-	-	-	-	-	-	-	-	-
HC 3.5/50 mm		∞	56.7	42.4	0.78	34.3	25.7	1.29	28.5	21.4	1.55	24.5	18.4	1.80
		0.6	48.5	36.4	0.91	30.9	23.1	1.43	26.1	19.6	1.69	22.7	17.0	1.95
HC 3.5/50 + 1.7×		∞	34.0	25.4	1.30	20.4	15.3	2.16	17.0	12.8	2.59	14.7	11.0	3.01
		0.6	29.0	21.8	1.52	18.4	13.8	2.40	15.6	11.7	2.83	13.5	10.1	3.27
HC 2.8/80 mm		∞	92.1	69.0	0.48	56.0	41.9	0.79	46.5	34.9	0.95	40.2	30.1	1.10
		0.7	70.2	52.6	0.63	47.0	35.2	0.94	40.2	30.1	1.10	35.4	26.5	1.25
HC 2.8/80 mm + 1.7×		∞	55.3	41.4	0.80	33.2	24.9	1.33	27.8	20.8	1.59	23.9	17.9	1.85
		0.7	42.1	31.5	1.05	27.9	21.0	1.58	24.0	18.0	1.84	21.2	15.9	2.09
HC 2.2/100 mm		∞	113	84.5	0.39	67.9	51.0	0.65	56.8	42.3	0.78	48.1	36.7	0.91
		0.9	83.7	62.2	0.53	56.0	41.5	0.79	48.1	35.9	0.92	41.8	31.9	1.05
HC 2.2/100 mm + 1.7×		∞	67.1	50.2	0.66	40.3	30.3	1.10	33.9	25.5	1.31	29.2	21.5	1.53
		0.9	49.7	36.7	0.89	33.2	24.7	1.33	28.4	21.5	1.55	25.3	19.1	1.76
HC Macro 4/120		∞	134	100	0.33	80.5	60.6	0.55	67.1	50.2	0.66	57.6	43.1	0.77
		0.39	30.0	22.3	1.46	25.3	19.1	1.77	22.9	17.5	1.92	21.3	16.0	2.07
HC Macro 4/120 + 1.7×		∞	80.5	59.8	0.55	48.1	35.9	0.92	40.3	30.3	1.10	34.7	25.5	1.28
		0.39	18.2	13.6	2.45	15.0	11.2	2.97	13.4	10.4	3.22	12.6	9.6	3.48
HC 3.2/150 mm		∞	170	127	0.26	103	77.0	0.43	85.0	63.6	0.52	72.5	54.2	0.61
		1.3	108	80.7	0.41	76.2	57.1	0.58	66.0	49.4	0.67	59.0	44.1	0.75
HC 3.2/150 mm + 1.7×		∞	100	75.2	0.44	60.5	45.3	0.73	50.8	38.0	0.87	43.3	32.5	1.02
		1.3	65.0	48.7	0.68	45.1	33.7	0.98	39.5	29.6	1.12	35.0	26.2	1.26
HC 4/210 mm		∞	233	174	0.19	142	107	0.31	120	89.5	0.37	103	77.0	0.43
		1.8	130	97.4	0.34	94.0	70.4	0.47	83.4	62.5	0.53	73.6	55.2	0.60
HC 4/210 mm + 1.7×		∞	142	107	0.31	85.0	63.6	0.52	71.3	53.4	0.62	60.5	45.3	0.73
		1.8	77.5	58.1	0.57	56.7	42.4	0.78	49.6	37.2	0.89	44.2	33.1	1.00
HC 4.5/300 mm		∞	331	247	0.13	198	148	0.22	166	124	0.27	142	106	0.31
		2.45	152	114	0.29	112	84.5	0.39	99.5	74.2	0.44	89.2	67.0	0.50
HC 4.5/300 mm + 1.7×		∞	197	148	0.22	118	88.5	0.37	98.7	74.2	0.45	84.5	63.0	0.52
		2.45	90.8	67.8	0.49	67.1	50.2	0.66	59.2	43.9	0.75	52.9	39.9	0.84
HC 3.5-4.5/50-110 mm	50	∞	58.2	43.5	0.76	35.0	26.2	1.26	-	-	-	-	-	-
		0.7	47.0	35.2	0.94	29.7	22.3	1.49	-	-	-	-	-	-
	80	∞	90.2	67.6	0.49	54.5	40.8	0.81	45.5	34.1	0.97	38.8	29.0	1.14
		0.7	62.3	46.7	0.71	40.6	30.4	1.09	34.8	26.1	1.27	30.3	22.7	1.46
	110	∞	123	92.0	0.36	73.6	55.2	0.60	61.4	45.9	0.72	52.6	39.4	0.84
		0.7	70.2	52.6	0.63	48.1	36.0	0.92	41.3	30.9	1.07	36.5	27.4	1.21

Blue numbers : AF not possible
- : incompatible combination

Chart B8. Area coverage in the metric system for combinations of tables for the 33.1 × 44.2 sensor.

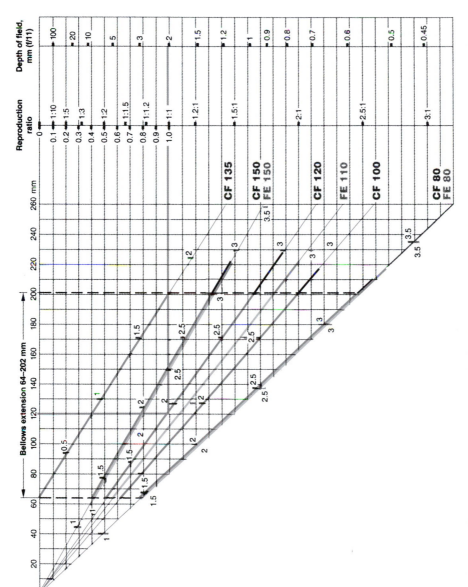

Chart C Close-up chart for bellows. To read the chart, go from the bellows extension (120 mm in this example) straight down until you reach the lens that is used (120 mm). The number 2 indicates the necessary increase in exposure. Now go straight across to find the magnification (1:1) and the depth-of-field at *f*/11 (2 mm).

Planar CF 80mm *f*/2.8, Planar F 80mm *f*/2.8

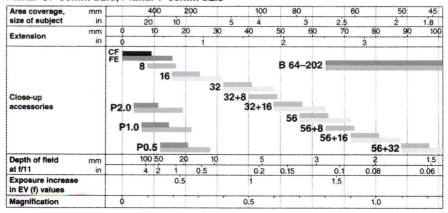

Planar F 110mm *f*/2

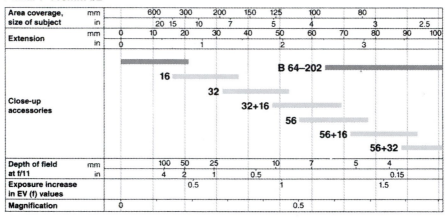

Makro-Planar CF 120mm *f*/4

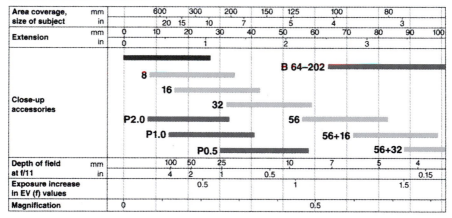

Chart D Close-up charts for 80 to 250 mm Hasselblad lenses an 503 and other V system SLR cameras based on the film format.

Sonnar CF 150mm *f*/4, Sonnar F 150mm *f*/2.8

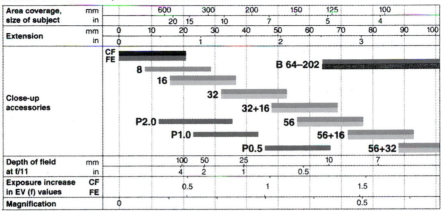

Sonnar CF 180mm f/4

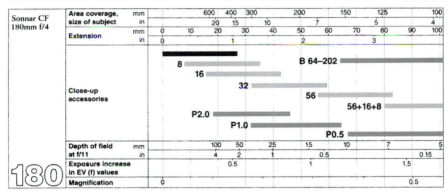

Sonnar CF 250mm *f*/5.6, Tele-Tessar F 250mm *f*/4

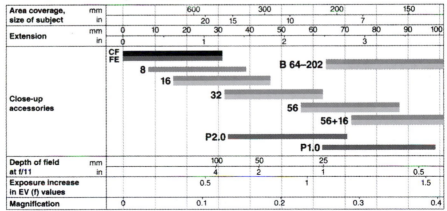

Jonathan Singer

The photographs on this page and the next two pages are of live flowers and are photographed in the actual location where they grow but not in the natural light. They are effectively lit with continuous Tungsten lights. Since these flowers cannot be exposed to the light sources for extensive periods, Jonathan usually does the actual photography in a very short time using a Hasselblad digital camera using a 120 mm Macro lens. There are no image manipulations.

Jonathan Singer

Jonathan Singer

The Hasselblad XPan Panoramic Cameras

PANORAMIC IMAGES ON FILM AND DIGITALLY

In digital photography, panoramic images are relatively easily produced in the computer without the need for a special panoramic camera. Such images are produced in the computer with a software program by stitching together a number of overlapping images specially made for this purpose in a digital Hasselblad camera or digital back.

PRODUCING PANORAMIC IMAGES DIGITALLY

A digitally produced panoramic image can be successful only if the individual images to be stitched together in the computer are carefully planned and photographed. As described in more detail later in this chapter, under Composing Panoramic Images, a visually effective panoramic image, regardless of whether it is produced in the camera or computer, must have important image elements at the left and right end or top and bottom of the image area to emphasize the reason why the image is panoramic and that the image could not be as effective in an "ordinary" format. Therefore you must select the subject for the panoramic image carefully and make certain that the selected image area starts and stops at important image elements.

Select a location that does not have image elements that are too close to the camera to be kept within the depth-of-field range of the lens that you plan to use. The images must be made with a tripod-mounted camera, and you must make certain that the pan head is perfectly level in all directions. A spirit level is very helpful. Without it, make certain that horizontal lines such as the horizon or straight vertical lines are perfectly parallel to the image sides regardless of which direction you turn the camera. Basically any lens can be used but a standard or short telephoto is likely to be more successful than a wide angle. Regardless of what lens you use, set the distance and the aperture so that all elements from the foreground to the background are within the depth-of-field range. Unsharp image areas are frequently disturbing in a panoramic image. Do not use automatic exposure settings. Instead make the lens settings manually based on the most important part of the panorama and keep this lens setting for all the images so they all have the same exposure. Do not use polarizing filters as they affect the image differently when the camera and lens are pointed in different directions.

The panoramic image can be put together from any number of separate images, but the images must overlap by about 20% and overlap preferably in an area without dominant image elements.

CAMERA-PRODUCED PANORAMIC IMAGES

While the digital method is probably the approach that you want to use for producing panoramic images, I still feel there is nothing like producing the panoramic image right in the camera where you can see and study the effectiveness of the final image in the viewfinder and if necessary re-compose to make the panoramic image visually more exciting. This is possible with film and the Hasselblad XPan is an ideal tool for this purpose since it produces images that are $2.7\times$ as wide as high.

XPan CAMERA MODELS

The original XPan camera, introduced in 1998, was superseded in 2003 by the XPan II model with an LCD viewfinder display that includes the shutter speed and exposure information, multi-exposure capability, self-timer delay of 2 seconds or 10 seconds, normal or rear flash sync possibility, and electrical remote release capability (Figure 20-1). The XPan II also has a Mode button and up/down controls next to the camera LCD (see Figure 20-2). The original model had only the AEB button. The operating instructions indicated here apply to both models, unless otherwise mentioned.

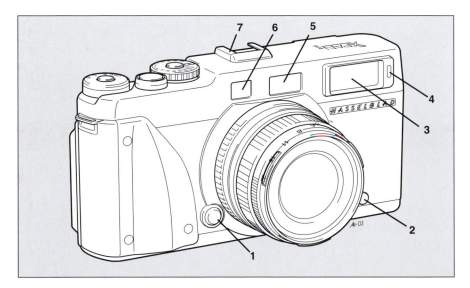

Figure 20-1 The XPan II camera and operating controls: (1) lens release button, (2) PC flash terminal, (3) viewfinder window, (4) self-timer lamp, (5) illumination window, (6) rangefinder window, (7) hot shoe.

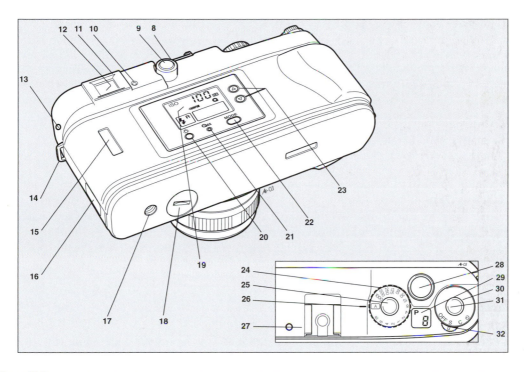

Figure 20-1 (Continued) (8) format selector knob, (9) format selector release, (10) viewfinder eyepiece, (11) viewfinder eyepiece release button, (12) viewfinder LCD, (13) cable release socket, (14) strap lug, (15) film type window, (16) camera back release catch, (17) tripod socket, (18) battery compartment cover, (19) camera LCD display panel, (20) LCD illumination button, (21) mid-roll rewind button, (22) program mode button, (23) up/down controls, (24) shutter speed selector dial, (25) shutter speed selector lock, (26) shutter speed index, (27) film plane mark, (28) shutter release, (29) exposure counter LCD, (30) shooting mode selector, (31) shooting mode selector lock, and (32) shooting mode selector lever.

Figure 20-2 The camera LCD display on XPan II. (1) When the release is pressed halfway, the ISO number disappears and is replaced by the set shutter speed. (2) A flickering shutter speed number indicates that the light is beyond the metering range.

IMAGE FORMAT

The Hasselblad XPan is made for 35 mm film in the standard cassettes but the images can be produced either in the standard 24 × 36 mm format or in a panoramic format of 24 × 65 mm and you can mix the two in any desired fashion on a roll of film. The format change is made by moving a single control, which also adjusts the viewfinder and the frame counter so that all images are always properly spaced on the film (Figure 20-6).

Film Processing

If all images on a roll of film are in the standard 35 mm format, the film can be processed and printed anywhere. If all or some of the images are in the panoramic format, you need a lab that can return the film to you without cutting it. Request that the film be returned in a strip so you can cut it yourself. Prints from panoramic images must be made in a custom laboratory unless you make them yourself with a 6 × 7 negative carrier. Panoramic transparencies need a 6 × 7 slide projector which is difficult to find.

LENSES FOR XPan CAMERAS

Three lenses are available: a 45 mm *f*/4 standard and a 30 mm *f*/5.6 wide angle both focusing down to 27 in. and a 90 mm *f*/4 telephoto that focuses as close as 39 in. The three lenses perform as 30, 45, and 90 mm lenses in the 35 mm format. In the panoramic format the 45 mm lens covers an area along the long panoramic side equal to a 25 mm focal length on the 35 mm format, the 90 mm is equal to a standard 50 mm, and the 30 mm covers a panoramic area equal to a 17 mm lens on the 35 mm format.

Attach the lens to the camera by aligning the index on the camera and lens and then turning the lens clockwise until you hear a click. The viewfinder automatically adjusts to the focal length of the lens on the camera, except with the 30 mm wide angle lens, which is supplied with a special viewfinder that is attached to the flash shoe on the camera. The 30 mm lens, similar to the other two lenses, is focused with the split-image rangefinder in the camera viewfinder. Remove the lens by pressing the lens release button and turning the lens counterclockwise.

Image Illumination

All XPan lenses are optically designed to cover the wide panoramic format but as some light rays enter at a steep angle, a slight darkening at the edges and corners of the image may become noticeable on transparencies taken with the 30 mm lens at any aperture and with the 45 mm lens at apertures *f*/8 or larger. You can eliminate the darkening by attaching a center gray filter (supplied with the 30 mm lens). This filter should be on the 30 mm lens for all panoramic images. You may want to use such a filter on the 45 mm lens when photographing at apertures of *f*/8 or larger. Avoid apertures of *f*/16 and *f*/22 if possible for panoramic pictures.

POWER SUPPLY

The XPan camera's built-in motor is powered from two 3 V lithium batteries type CR-2. Two fresh batteries will provide power for about 3,000 exposures with battery condition indicated in the viewfinder (see Figure 20-3). The camera does not operate without batteries.

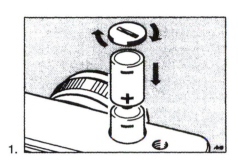
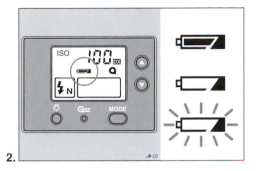

Figure 20-3 Batteries and battery checking. The CR-2 batteries are inserted after the cover is removed using a small coin. The battery condition shown in (2) after the mode selector is set to S. The batteries are in good condition (top), the batteries are low (center), and the batteries are exhausted (bottom).

You turn on the power by moving the mode selector to either S (for single pictures), C (for sequences), or to the self-timer symbol (see Figure 20-4). To save power, the camera switches automatically to a standby mode after three minutes. Set the mode selector to OFF whenever the camera is stored or not used for longer periods of time.

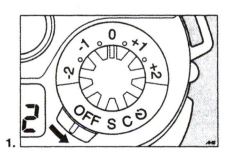
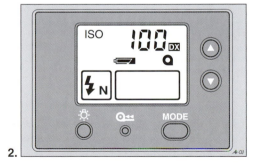

Figure 20-4 The mode selector. (1) The mode selector with the three operating settings: S for single pictures, C for sequences, and self-timer. (2) The film sensitivity is shown on the display. This display also shows that the flash is set for N (normal) in which the flash fires as soon as the shutter is fully open.

FILM LOADING

Before loading a film, set the ISO dial to DX for DX-coded film, to the desired ISO value for non-coded films, or if you want to use a different ISO value for a coded film. You must do this before loading the film because the camera will not transport a non-coded film if the dial is set to DX. The film loading procedure is shown in Figure 20-5.

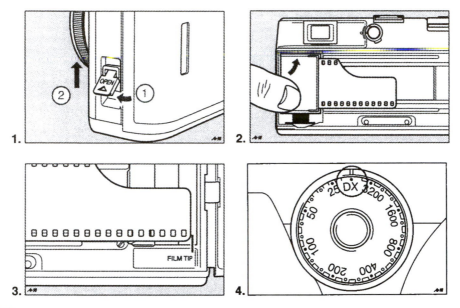

Figure 20-5 Loading the film. (1) Open the camera back with the lock on the side of the camera. (2) The film cassette is properly placed. (3) The beginning of the film is placed against the film tip indicator with the film lying flat in the camera. Close the camera back. (4) The ISO dial is set to DX for coded films or to the film's sensitivity for other films.

You can program the XPan II camera so that the film rewinds completely into the cassette at the end of the roll or rewinds to leave the film tip out of the cassette by switching the camera from OFF to S while holding down the Mode button on the camera's LCD panel. When the cassette symbol shows up, select OUT, if you want the tip of the film out of the cassette, or IN, if the film should rewind completely into the cassette. Confirm the choice by pressing the release halfway.

When the camera cover is closed after loading the film, the entire roll of film winds to the take-up spool and the film moves from the take-up back into the cassette while the pictures are taken. This film transport method differs from typical 35 mm film cameras but has the advantage that all the exposed XPan pictures are in the light-tight cassette where they cannot be ruined if the back cover is opened accidentally. You do not have to rewind the film at the end of a roll.

The film counter shows the number of unexposed frames remaining on the roll of film. The counter changes automatically when you switch from one format to the other

(see Figure 20-6). When evaluating the exposed rolls of film, remember that the last picture you took is frame 1 on the film and so on.

A partially exposed cassette of film can be removed by pressing the mid-roll rewind button below the LCD panel with tip of a ballpoint pen or similar object (see Figure 20-7).

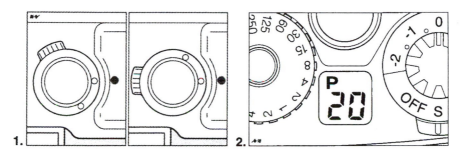

Figure 20-6 Changing the image format. Change the image format by setting the selector knob to either of the two positions. The panoramic position is indicated by the letter P on the top of the dial and on the LCD display. A flashing P indicates that you have changed to the panoramic format when only one frame of the standard size remains on the film.

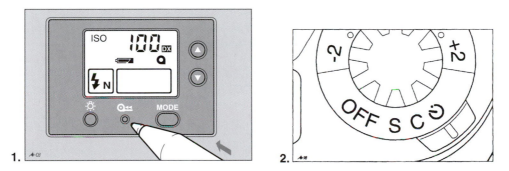

Figure 20-7 Other XPan controls. (1) The display on the LCD panel can be illuminated by pressing the LCD backlight button, which is in the center on the original camera and on the left on the new model. A partially exposed film is rewound by pressing the rewind button, which is in the center on the new camera, on the right on the original model. (2) The self-timer is actuated at the self-timer setting.

OPERATING THE CAMERA

On the original XPan model you put the camera into the operating position with the operating dial set to S, to C or to the self-timer setting where the exposure is made 10 seconds after the release is pressed. On the XPan II you can program the self-timer delay time for either 2 or 10 seconds. The change is made with the up/down buttons on the camera LCD panel, where you can also see the self-timer setting. At the 10-second delay, the self-timer light at the front of the camera lights up for 7 seconds and then flashes for 3 additional seconds. Set to a

2-second delay, the self-timer light starts flashing immediately. Self-timer operation can be stopped by changing the operating control dial to S, C, or OFF.

The exposure is made with the shutter release on the camera which also turns on the metering system. Using a cable release does not turn on the meter.

Remote Releasing

All XPan cameras can also be released with standard cable releases. The XPan II model can also be released with an accessory electrical release cord, which activates the camera (including the metering system) and fires the camera immediately. In Auto mode, you can see the selected shutter speed on the viewfinder display. In Manual mode, pressing the release halfway activates the meter and makes the settings.

Multiple Exposures on the XPan II

On the XPan II model, you can produce multiple exposures, making as many as nine exposures on the same film frame. To program the camera for multiple exposures, press the Mode button on the camera LCD panel for one second and then press it again repeatedly until a flashing double frame symbol appears on the display. Use the Up/Down buttons to select a non-flashing double frame symbol. Confirm your selection by pressing the release halfway, which brings up the double frame symbol on the display.

You can now select up to nine exposures by pressing the Up button, with the numbers shown on the small exposure counter LCD. Keep in mind that most multiple exposures need adjustments in the exposure value; otherwise, the final image will be overexposed.

VIEWING AND FOCUSING

Viewing and focusing are done through an optical viewfinder with a coupled rangefinder. The image in the finder is always sharp, so do not forget to focus the lens as described in Figure 20-8 before taking a picture. The viewfinder is parallax corrected, so the outlined image area

Figure 20-8 Focusing. Focus the lens by watching the bright center area and turning the focusing ring until the ghost image (1) is lined up with the real image (2). Straight vertical lines are best for doing this.

is correct at all distances. The rangefinder in the camera is also used for focusing the 30 mm lens, but viewing is done with the special 30 mm viewfinder that comes with the lens and is attached to the flash shoe.

The eyepiece in the camera's viewfinder has a −1 diopter correction. This standard eyepiece can be exchanged for accessory eyepieces as described in Figure 20-9. When composing panoramic images, be especially careful that important horizontal lines like a water surface or vertical lines like those of a building are perfectly parallel to the frame lines unless you want them slanted purposely.

Figure 20-9 Changing the viewfinder eyepiece. Change an eyepiece by sliding it in and out of the viewfinder frame. On the XPan II, the eyepiece is locked in position. To remove it, press the lock button while simultaneously sliding the eyepiece out of the frame.

COMPOSITION IN THE PANORAMIC FORMAT

Regardless of how you produce panoramic images (in the camera or computer) on film or digitally, effective composition is very important; even more so than in an image in the standard rectangular format. Panoramic images must include important elements that enhance the image all the way from left to the right or from top to bottom. There must never be an empty area that is considered unnecessary on either side or top or bottom of the image. Such areas make the viewer question why the image was made in the panoramic format (see Figure 20-10). The panoramic image must convey the feeling that the panoramic shape was necessary for the subject or scene and that this subject or scene could not have made an effective image in any other shape (see Figure 20-11). When evaluating the image in the viewfinder or on the computer screen, look all the way across the panoramic image to ascertain that the image includes important elements all across the composition.

EXPOSURE CONTROL

The metering system built into XPan cameras measures the center area of the image. Exposure information is shown in the viewfinder including the shutter speed in the XPan II.

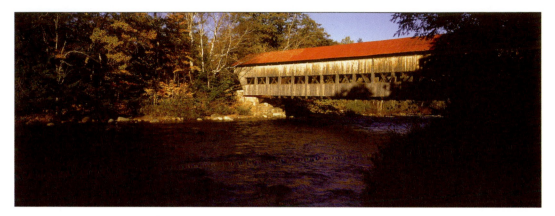

Figure 20-10 Poor panoramic composition. Panoramic image of a covered bridge has dark areas on both sides that are unnecessary for the image. Eliminating those areas results in an image in a more standard shape which actually improves the image.

Figure 20-11 Effective panoramic composition. The panoramic composition with railroad tracks, yellow grass, buildings, and other image elements going all across the image area gives the feeling that the panoramic format was necessary to produce a visually effective image. This feeling must come across in all panoramic images whether they are created in the camera or on the computer.

You can use the cameras in either the Automatic or the Manual mode. For automatic exposures, set the shutter speed dial to A, set the aperture to the desired value, and make the exposure. For manual exposure, set the aperture or shutter speed to the desired value, then set the other until the indications in the viewfinder show the correct setting.

The Automatic mode gives good results with most subjects that are of average brightness and do not include large dark or bright areas such as a white sky, especially in the center.

If the subjects within the measuring area are brighter or darker than the 18% reflectance, you have two options. Use the Automatic mode, but set the exposure compensation dial

(Figure 20-12) to a plus setting when subjects are brighter and to minus for darker subjects. Do not forget to reset the dial to 0 after the exposure. You can also photograph such subjects in the Manual Exposure mode, making the necessary compensation.

The exposure information in the viewfinder is shown in Figure 20-13 for the original XPan and in Figure 20-14 for the XPan II.

Figure 20-12 Shutter speed and compensation dial. (1) The shutter speed dial is set to A for automatic exposures. (2) You can increase or decrease exposures by using the exposure compensation dial.

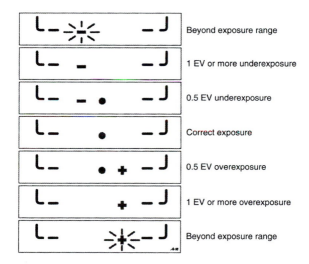

Figure 20-13 Exposure information on the original XPan camera.

Automatic Exposure Bracketing

You can bracket exposures manually or with the Automatic Bracketing mode, which changes the shutter speed automatically. Program the bracketing values as shown in Figure 20-15. Set the XPan II for automatic bracketing by repeatedly pressing the Mode button on the LCD display until AEB and +/− appear on the display. Select the bracketing value with the up/down

Figure 20-14 Exposure information on the XPan II camera model. The indications when the camera is set to automatic exposure are shown on the left: (a) setting beyond metering range (too dark); (b) correct exposure; (c) calculated exposure time less than $\frac{1}{1000}$ second; and (d) setting beyond metering range (too bright). The indications in manual exposure are shown on the right: (a) setting beyond metering range (too dark); (b) more than 1 EV value underexposure; (c) 0.5 EV value underexposure; (d) correct exposure; (e) 0.5 EV value overexposure; (f) more than 1 EV value overexposure; and (g) setting beyond metering range (too bright).

Figure 20-15 Automatic bracketing. (1) On the original XPan camera, the Automatic Bracketing mode is actuated by pressing the AEB button once for ½ stop bracketing and twice for 1 stop bracketing. On the XPan II, bracketing is set with the mode selector and the up/down controls. (2) On both cameras, the bracketing value (1 stop in the illustration) is indicated on the LCD display. The display shows that the camera is also set for the flash to fire at the end of the exposure.

controls, and then press the Mode button or press the release halfway again. To make the three exposures one immediately after the other, simply keep the shutter release pressed; you do not have to remove your eye from the viewfinder. Always finish the sequence of three pictures, otherwise the programmed value remains in the camera. The camera does not operate when

set to the Automatic Bracketing mode with only one or two images left on the film. Turn off the Automatic Bracketing mode by again pressing the AEB button (in the original XPan) or the Mode button (on the XPan II), or it automatically goes off when the camera is turned off.

FLASH PHOTOGRAPHY

Electronic flash can be used at shutter speeds from B to $\frac{1}{125}$ second. The flash unit can be connected to the camera through either the hot shoe on top of the camera or the PC contact at the front of the camera. When photographing in the standard 35 mm format, any flash unit should cover the entire subject area with the 45 and 90 mm lenses but probably not with the 30 mm lens. With the 45 mm lens used in the panoramic format, the flash unit must cover the area of a 25 mm focal length lens. Check the specifications of the flash unit. If the flash does not cover the area, consider bare bulb or bounced flash use.

On the XPan II model, the flash can be programmed to fire at either the beginning or the end of the exposure. To do so, press the Mode button on the camera LCD panel repeatedly until the flash symbol and the letter N or R appears on the display. By pressing the up/down controls, set the mode to N if the flash is to fire at the beginning or to R if it is to fire at the end. Press the Mode button again to confirm the selection.

Projecting Medium-Format Images

■ ■ ■ ■

MODERN DIGITAL PROJECTION APPROACHES

Projecting transparencies with one slide projector or a number of projectors in the case of multi-image presentations is an activity of the past, especially for professional presentations. Photographic images are presented on the screen today with digital projectors which are more compact, simplify producing an effective slide presentation, and eliminate the time-consuming glass mounting of transparencies which was necessary and recommended especially for medium-format transparencies. A variety of software programs are available and are necessary to put the digital slide program together.

This modern projection method is not limited to images that are produced in a digital camera or digital back. You can use the same approach and the same projectors for your present or old images made on transparency film after scanning the images. A slide presentation, therefore, can be produced by combining your latest digital images with images that you may have taken years ago on film. The new digital projection approach also allows you to produce presentations that were impossible before or required more than one projector to accomplish. Slides can be programmed to dissolve into each other, eliminating the need for at least two projectors and a dissolve control to accomplish this effective transition. You can combine slides and videos in the same presentation using the same projector. You can also present your image presentation on the television set, which can be especially effective if you have a high definition (HDTV) set.

Selecting a Digital Projector

Digital projector manufacturers use different approaches to project the image so check the specifications to ascertain that a specific model is made for your image type and size. Also have a close look at the resolution and screen brightness figures. Screen brightness, indicated in lumens, becomes especially important if you plan to project in daylight or in other well-lit areas rather than a surrounding with subdued light or a completely dark projection room is highly recommended for projecting transparencies. Digital projectors can present a completely satisfactory slide show in subdued light.

You also want to check that the lens on the projector provides the desired image size from a usable distance in your projection setup. A zoom lens offers more flexibility. Regardless of what model you chose, be prepared to pay considerably more than you might have paid for a 35 mm projector some years ago.

Scanning Transparencies

You can have your transparencies scanned by an outside source or scan them yourself, which is a relatively simple, although somewhat time-consuming, process. When using an outside source, you may want to confirm that they scan the images individually, not in batches. When selecting a scanner, make certain that it is made for transparencies if that is the original that you plan to scan, and for the film format that you plan to convert to digital images. Most scanners are made for 35 mm, medium-format and even 4×5 in. transparencies and also for color and black and white negatives of the same sizes. Some, on the other hand, are for 35 mm only.

The type of scanner that you want to use is determined by the desired image quality, which will frequently depend on how the scanned images will be used. Check the scanner specifications for such characteristics as resolution, color depth, and dynamic range, and the scanning approach. Scanners in the lower price range are usually of the desktop or flatbed variety where the original image is kept flat by placing it between two glass plates. They produce images that are satisfactory for projection purposes but for best quality, it is wise to refrain from the bottom models and select a higher end consumer or a professional model. You must keep the glass plates absolutely clean as every speck of dust will appear on the scanned image. For best results, scan images individually, not in batches.

For the best image quality with the very best resolution and corner-to-corner quality, consider a drum type scanner that does not use glass plates like the Hasselblad Flextight scanners. The original goes into a glass-free magnetic film holder designed for the various film sizes such as 35 mm, XPan panoramics, $6 \times 4.5, 6 \times 6, 6 \times 7$, and 4×5 in. Some Flextight scanners can also be used for reflective originals up to A4 size and also have batch scanning capability.

MEDIUM FORMAT SLIDE PROJECTION

While the image quality in digital projection is satisfactory, at least on smaller screens, nothing can compare to the brilliance and sharpness of a projected original 2¼ square or 6×4.5 transparency when projected on a large screen. So if you want to treat yourself and your friends or customers to a special visual excitement, project your original Hasselblad film transparencies with a Hasselblad PCP 80 projector or perhaps even two projectors with a standard dissolve control.

HASSELBLAD MEDIUM-FORMAT TRANSPARENCIES

Since laboratories return 120 or 220 transparency films unmounted, you must mount your own slides in glass mounts to avoid slide popping during projection due to the heat in the projection gate.

Glass slide mounts for 2¼-in. square and for 6×4.5 cm have the same outside dimensions, fit the same slide trays, and can be intermixed within a presentation. Make certain that the mounts are thin enough to slide up and down in the precisely made film gate of the PCP 80 and in the Hasselblad 80 capacity slide trays. Store glass-mounted slides in areas with low humidity, otherwise the film base soaks up the moisture from the air.

PERSPECTIVE CONTROL

The Hasselblad PCP 80 projector (see Figure 21-1) is the most professional medium-format slide projector and can be used for the most sophisticated multi-image presentations with standard dissolve and control equipment.

Figure 21-1 Operating controls on the PCP 80: (1) air filter, (2) baseplate (can be removed to clean the projector), (3) automatic circuit breaker, (4) voltage selector (does not exist on the U.S. version), (5) carrying handle, (6) lens holder with projection lens, (7) adjustable feet for leveling, (8) adjustment for matching perspective control to lens, (9) removable condenser lens, (10) perspective control indicator, (11) perspective control adjusting knob, (12) magazine lock, (13) tray, (14) lamp ON switch, (15) lamp OFF switch, (16) forward and reverse slide changing, (17) lens focus control, (18) edit and reset control, (19) transport lock screw, (20) AV socket for programmers, (21) power ON/OFF switch, (22) power cable connection, (23) lamp housing door, (24) eight-pin connector for some programmers, (25) six-pin connector for Hasselblad remote control, and (26) side cover.

The designation PCP comes from the built-in perspective control, which allows you to move the image on the screen up and down by moving the entire optical system from lens to lamp housing up and down with the perspective control knob. Just like in a camera shift control, the plane of the transparency remains parallel to the screen. This sophisticated feature eliminates tilting the projector, which results in distortion and sharpness problems from top to bottom. This floating optical arrangement should be locked when transporting the projector (see Figure 21-2).

Figure 21-2 The transport lock. (A) To unlock the perspective control remove the locking screw (19) completely. (B) Insert screw (19) in the perspective control wheel (11), which operates the perspective control only when the screw is inserted. To lock the transport lock, do the reverse. Always close the lamp housing door before projecting.

The PCP 80 projectors sold on the American market are made for 110 V only and need no adjustment. Other projectors have a voltage selector at the bottom, which must be set to the proper value. The PCP 80 works on 50 or 60 cycles.

IMAGE BRIGHTNESS

The PCP 80 is supplied with two 250 W 24 V (DIN 49820 base 6, 35–15) halogen projection lamps held in a common lamp holder. Should lamp 1 burn out, a microswitch automatically and instantly flips lamp 2 into the projection position. LED lights next to the lamp switch show which lamp is on. The entire lamp holder is removable through the rear of the PCP 80 for convenient lamp changes.

Image sizes on the screen with the various lenses can be calculated as shown in Figure 21-3. To produce even corner-to-corner illumination, each projection lens comes with its own matched condenser lens, which can be changed after the perspective control is set at or near the 0 position (see Figure 21-4). The control lever must also be set to the proper position, which is 150 for the 150 and 75 mm lenses, and 250 for the longer lens.

OPERATING THE PCP 80

The projector and the slides are kept cool with air drawn through air filters into the projector from the bottom. Do not block the filter opening underneath the projector with a tablecloth or other flexible material.

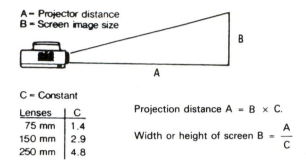

A = Projector distance
B = Screen image size

C = Constant

Lenses	C
75 mm	1.4
150 mm	2.9
250 mm	4.8

Projection distance A = B × C.

Width or height of screen B = $\dfrac{A}{C}$

Figure 21-3 Calculating projection distances and screen sizes.

Figure 21-4 Condenser lenses. Insert or remove the condenser lenses (9) after lifting off the side cover (26). The condenser can be pulled out or inserted only if the perspective control adjustment (10) is at or near 0. The perspective matching control lever (8) must also be set based on the focal length of the lens.

Attaching and removing slide trays is shown in Figure 21-5. You can project only if the tray is locked properly. Turn the tray lock knob until the red light disappears. The slide tray can be removed only when all slides are in the tray. If a slide is left in the gate, press the Edit button.

The PCP 80 operating controls are shown and explained in Figure 21-6. Forward and reverse slide changing and focusing can be operated with the Hasselblad remote control connected to six-pin socket 25. The forward and reverse projection functions can also be operated with a standard Kodak remote control connected to the five-pin socket in the AV door at the rear of the projector. Dissolve and programming units made for American Kodak projectors are connected to the same outlet.

Figure 21-5 Starting the projection. (A) The power cable is connected to the socket (22). The fan is turned on with the power switch (23). (B) Slide trays can be attached only when the tray lock (12) is in the unlocked position, with the red control lamp burning. The slide-changing arm (a) is then in the up position. If the lock cannot be moved to Unlock, press the Edit button to bring the arm up. (D) Attach the slide tray so that its groove (c) engages in the sensor (b) for the 0 position. (C) To attach the tray in any position other than 0, move the sensor outward.

Figure 21-6 Operating controls. (A) The left side control panel has the lamp ON (14) and OFF (15) switches. When lamp 1 is on, the green light (a) is lit. If the yellow lamp (b) is also lit, projection lamp 2 is on, meaning that lamp 1 is burned out. If only the yellow indicating lamp (b) is lit, the projection lamps have been interchanged, but lamp 2 is not lit, or both lamps are burned out. The red lamp (c) is lit either when the magazine lock is not securely locked or when the projector has overheated. (B) On the right control panel are the forward and reverse slide-changing switches (16). Move the lens forward or backward to focus by pressing the front or rear position of the switch (17). Pressing the rear (a) of the switch (18) moves the slide back into the tray without advancing the tray. Pressing the top portion (b) turns off the projection lamp and moves the tray to the first position, where it stops.

Index

■ ■ ■ ■

Welcome to Phocus, the link between raw Hasselblad digital captures and the demands of the professional photographic world.

Phocus is the file processing software that is included with all Hasselblad digital camera products. It has its foundation in the experience gained by many years of continual development of FlexColor, the previous generation of Hasselblad digital software. But Phocus takes a leap forward by utilising a completely new user interface to meet present expectations. Its calm and clean layout, customizable to suit most demands, provides the background for efficient workflow in capture and post production environments.

Phocus provides the tools to convert the brand specific 3FR files into the optimum image and save them in a file format of your choice. The software is powerful enough to provide a professional level image file for direct use. These fully optimized files can then be further developed in post-production software, if desired, with much reduced time and effort at that stage.

Phocus also provides an interface for direct tethered shooting with Hasselblad equipment. This affords the optimum in ease of use and rapid workflow as captures are processed on the fly, appearing in seconds on the computer screen for instant detailed assessment and adjustment.

We hope you will find working with Phocus an easy, pleasurable and beneficial experience. It has been designed to be an extension of the way photographers think in terms of image file processing and enhancement, using regular and recognizable computer interface concepts. Seasoned digital users should feel immediately at home. But don't forget that the Hasselblad team will be there to answer your queries and help you if you get lost somewhere along the way!